SMITHSONIAN
ROCK
AND
ROLL

SMITHSONIAN
ROCK AND ROLL
LIVE AND UNSEEN

BILL BENTLEY

SMITHSONIAN BOOKS
WASHINGTON, DC

Somerset Co. Library
Bridgewater, NJ 08807

INTRO
THAT FINE, FINE MUSIC

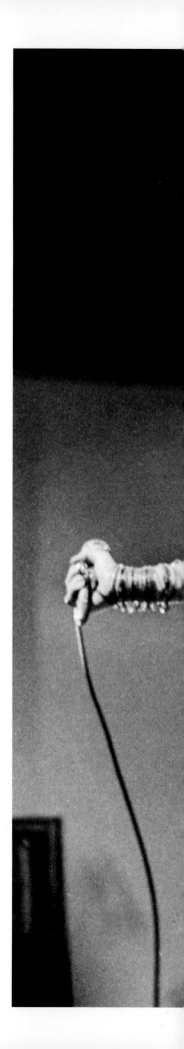

ON SUNDAY MORNINGS, I OFTEN VISIT A BIG WHITE building at the corner of Sunset Boulevard and Cahuenga in Hollywood. Decked out in 1950s-fashionable neon, and looking vaguely nautical with a submarine-like periscope rising behind its facade, it borders on the otherworldly when I walk in at 11 a.m. A vast expanse of vinyl albums, compact discs, cassette tapes, and books fills the ground floor, and posters in saturated colors from every era clamor on the walls. Here at the western edge of the United States—the country that birthed blues, jazz, gospel, and rock and roll in all their permutations—Amoeba Music could be the best record store in the galaxy.

Strolling into Amoeba one morning, I was greeted by a Velvet Underground collection playing at top volume, rearranging the molecules of the store and its first wave of customers. A tribal stomp rippled along the aisles and behind the counters, "Sweet Jane" and "White Light / White Heat" washing over one and all. When the sounds of the spheres possess you, they fill every corner of your soul. Then "Rock & Roll" came on, one of the last songs the group recorded before breaking up in 1970. Lou Reed sneers a challenge as he sings, "Jenny said when she was just five years old / There was nothin' happenin' at all." For many of us, that's how life felt before rock and roll arrived. I was just five myself in July 1956 when Elvis Presley went nuclear on "Hound Dog," a primal howl out of Memphis, Tennessee, that would change the world in a head-spinning chain reaction. Jenny's life is "saved by rock and roll," but rock didn't save our lives as much as make them. A constant companion and confidant, an unshakeable shoulder to cry on, and a celebrant at every crucial juncture of life, the music never lets us down.

Countless tomes have been written about "Hound Dog"'s release more than six decades ago. It was the watershed moment at which rock and roll crossed over old genre boundaries and began to establish its global dominion. In the United States, the music spoke to burgeoning younger generations, who glimpsed in its sound newly flowering freedoms. There could be no going back; the genie was permanently out of its bottle. The soundtrack to a new youth revolt had cast its spell upon everyone within earshot. Those masses of fans, in subsequent years, made rock and roll. Collectively, they *are* rock and roll. Without them, the history of rock is just notes and voices ricocheting around an empty room.

Together fans have worn vinyl down to a nub, unspooled 8-track tapes and cassettes into spaghetti, spun the shine off CDs, and downloaded countless hard drives' worth of MP3s. Memorized every last blessed lyric while hanging posters on their walls from dorm rooms to castles. Tattooed band logos onto their triceps, camped out 'round the clock for concert tickets, labored long and feverish hours over mix tapes and playlists full of love and heartbreak, covered their vehicles in bumper stickers and their refrigerators in handbills, belted out choruses in the shower, and hummed melodies while waiting in line at the DMV. And they have taken photographs: millions and millions of images of their beloved musicians and singers. That ubiquitous festival shot used as a laptop screensaver says it all.

That's where Smithsonian Books enters the picture—literally. Trade and academic press all in one, satellite to a mother institution founded in 1846, the imprint hosted a

Janis Joplin at the Newport Folk Festival, RI, 1968
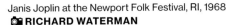 **RICHARD WATERMAN**

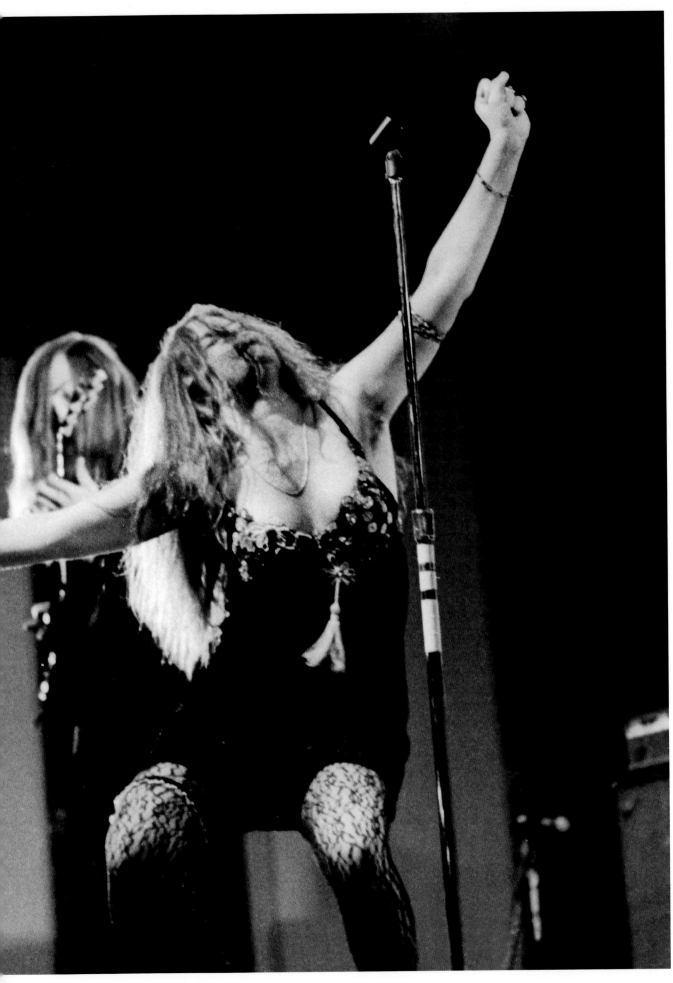

Web site in 2015 to crowdsource fan photographs—personal and unpublished—to include in an overview of rock and roll as seen from the vantage point of its patrons. Thousands of submissions were uploaded over the next year. From professional-quality shots taken on film stock to digital mobile phone snaps, the entire spectrum of rock photography filled Smithsonian servers.

Although the sheer breadth of the offerings was overwhelming, that fact only underlined the importance of an organizational strategy. The publisher sorted through the submissions, categorizing them by performer and date to create a complete historical timeline of rock and roll. Approximately three hundred photographs are included in the following narrative, many of them by amateurs whose enthusiasm and passion for their subjects are here presented to the public for the first time. The balance of the photos were taken by professional "lens whisperers," whose shots were selected to flesh out this overview of rock and roll. The results, spanning six decades, aim for neither encyclopedic authority nor comprehensive finality, but rather an index of supreme influence. Artistic importance isn't the same as popularity, as this guided tour of rock and roll proves at every turn of the page.

Some performers included in these pages—such as the Beatles and Jimi Hendrix—cultivated both artistic influence and mass appeal. Others might not have won as much name recognition but nonetheless stamped a timeless imprint on rock and roll. Laura Nyro's name, for example, does not carry the social import of Janis Joplin's or Madonna's, but her songs of devotion, by now all but canonical standards—"Wedding

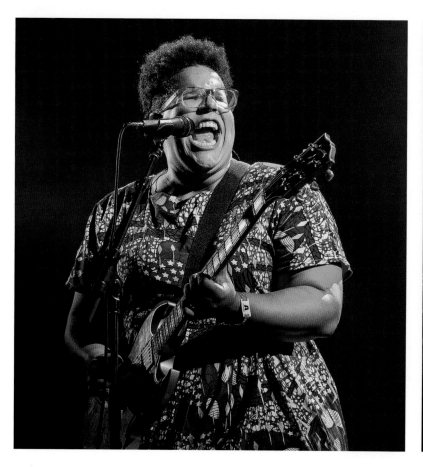

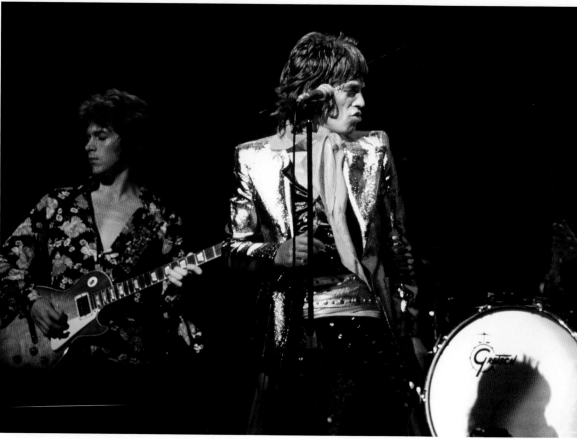

Bell Blues," "Eli's Comin'," "And When I Die"—drill right down into the center of existence. The 13th Floor Elevators, who helped invent psychedelic rock, aren't as well known as superstars such as Jefferson Airplane, yet their small and fervent following underlines the fact that cult performers as well as icons have shaped the music.

Other performers shown here, one could argue, inhabited realms outside the stylistic boundaries of rock and roll. Yet myriad pioneering musicians such as Johnny Cash, Otis Redding, and Marvin Gaye were an essential part of both rock's founding and its evolution; they as well as those more easily categorized as "rockers" conceived so much beauty and power in their sound that they shaped every popular musician who followed them. If rock music stands for anything, after all, it's freedom.

From the start, it was a given that this book would open with Elvis Presley. He didn't invent rock and roll, but he remains its Johnny Appleseed. After the singer jumped ship from small Sun Records in Memphis to mighty RCA Victor, "Hound Dog" bawled out a blueprint for everything the new music could do. A whole army of rockers, many forged in the barn-burning bravado of urban blues, also staked out their provinces in those early days, including Little Richard, Chuck Berry, and Fats Domino. Their music became an invitation to people of all colors and classes, telling them they could meet on the great common ground of sound, learning shared lessons while burying their divisive fears. Music became an equalizer, imparting social lessons in the name of boisterous fun.

Of course, the music was also immensely profitable. And wherever huge amounts of cash turn waters red, mono-lithic corporations snap up the meal, both the big fish and their pale imitators, to capitalize on trends. Yet whenever rock has turned too commercial, wild-eyed alternatives have appeared. Such was the case in the 1960s when the prodigious generation of World War II blitz survivors flooded into American music. As the Beatles, the Rolling Stones, and other card-carrying members of the British Invasion injected nirvana-inducing zeal into their blues-folk-country-derived pop and rock, the countercultural revolution, and rock itself, offered listeners a new prospect of individualism. Visions were encouraged, outrageousness was rewarded, and utopia was expected. The times really were a-changin', as Bob Dylan, the era's poet laureate, chronicled. Motown and San Francisco psychedelia—including the Grateful Dead, Santana, and Sly and the Family Stone—rewrote the rules of music, expression, and community. Rock barreled on an express train to the outer limits, breaking through boundaries into unexplored dimensions, right up until the Woodstock festival proved to be the end of the line. Now yin had met yang. There was no place left for rock to travel, except inward.

Thus the 1970s trawled a less frenetic frontier. James Taylor, Jackson Browne, and Joni Mitchell focused on emotion more than experience, and the rock audience followed them and their acoustic guitars indoors. As always, it took only one or two artists to blaze a different path and blow down the gates again, which is exactly what Led Zeppelin and heavy metal did. Huge amplifiers and elaborate stage sets dominated the mid-'70s scene, and just when every excess had been evidenced, the Ramones got back to basics. Punk rock fused simplistic riffs with riff-raff appearances, but after

Left to right:
Brittany Howard of the Alabama Shakes at the Hangout Music Festival, Gulf Shores, Alabama, May 20, 2016
📷 **ERIKA GOLDRING**

Mick Taylor, Mick Jagger, Charlie Watts, and Keith Richards of the Rolling Stones at the Forum, Inglewood, CA, 1972
📷 **JAMES FORTUNE**

Sid Vicious, Johnny Rotten, Paul Cook (drums), and Steve Jones of the Sex Pistols, London, 1977
📷 © **JANETTE BECKMAN**

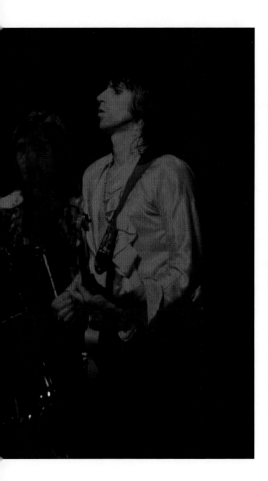

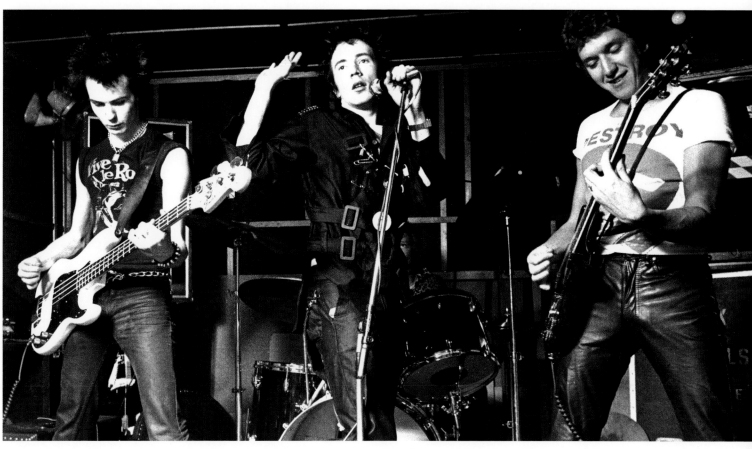

the Sex Pistols imploded and took much of the subgenre with them, the music lit out for new territories. Rock and roll thrives on that principle. Try to pin it down, and it will escape pigeonholing and become groundbreaking. Or just peek into the brand-new bag called hip-hop, which in the 1980s remixed everything under the sun and made the music new.

Prince, the Beastie Boys, and U2 brought musical genius onto MTV and ruled the world with images as well as sound. Megastars including Michael Jackson and Bruce Springsteen erupted at all frequencies, and the coffers of record labels needed daily remodeling to hold the earnings. Sales in the millions became the new norm; although N.W.A. didn't display obvious commonalities with Guns N' Roses, each fortune-earning group drew streetwise inspiration into the mainstream. That broke the music wide open again, and the 1990s saw alternative music from bands such as Nirvana, Pearl Jam, and Green Day thrive. The tide of money flowing into industry accounts slowed in 1999 when Napster, a free downloading service, came online. Omnipresent almost overnight, the service was short-lived but indicated that in the age of the Web, all bets were off. As music executives soon learned, you can't beat free, and by Y2K, the major-label paradigm had begun retracing the steps of the Roman Empire. The premillennial party Prince predicted for 1999, it seemed, had come to pass.

Happily for all but doomsayers wearing placards on Fifth Avenue, the world didn't turn into a puddle with the new century. Neither did rock. Instead, do-it-yourselfers came to the forefront and demonstrated that musicians could operate without corporate behemoths calling all the shots and controlling the future. The Internet turned over the aesthetic and economic reins to artists, and even as record sales shrank and money got tighter, it felt like the 1950s again, when gamblers and go-getters ran the music business and sheer talent was the most important part of the equation. A business grown bloated and beleaguered discovered it could survive even if the fluff had to be trimmed off the top. The wild success of Adele, who transcended U.K. singer-songwriter pigeonholing at nineteen with her operatic oracle of a voice, is evidence that the "trickinations" (as Bob Marley might've said) of big-label promotion can be cleared away by the more democratic winnowing process of downloaded music.

And that is the end point of our journey through the images of rock and roll. It is also, of course, the starting point of a new story of rock, one whose contours and faces we have yet to see. Even six decades after rock and roll's founding, we're still like Jenny, the five-year-old, when she turns on that "New York station" and hears rock and roll for the first time: "She started shaking to that fine, fine music / you know her life was saved by rock and roll." That sound, those feelings, that freedom: that's what Presley promised in 1956, when blues and country commingled like firecrackers and the Fourth of July. No one knew then that a seismic shift was just around the corner, and even now no one can foretell where rock and roll is headed. No matter what the powers that be predict, those plugged into the divine power of rock and roll sense that not all its hands have been played. That's the beauty of the music — the surprise is always waiting out there somewhere. And when it hits, we'll all be shaking.

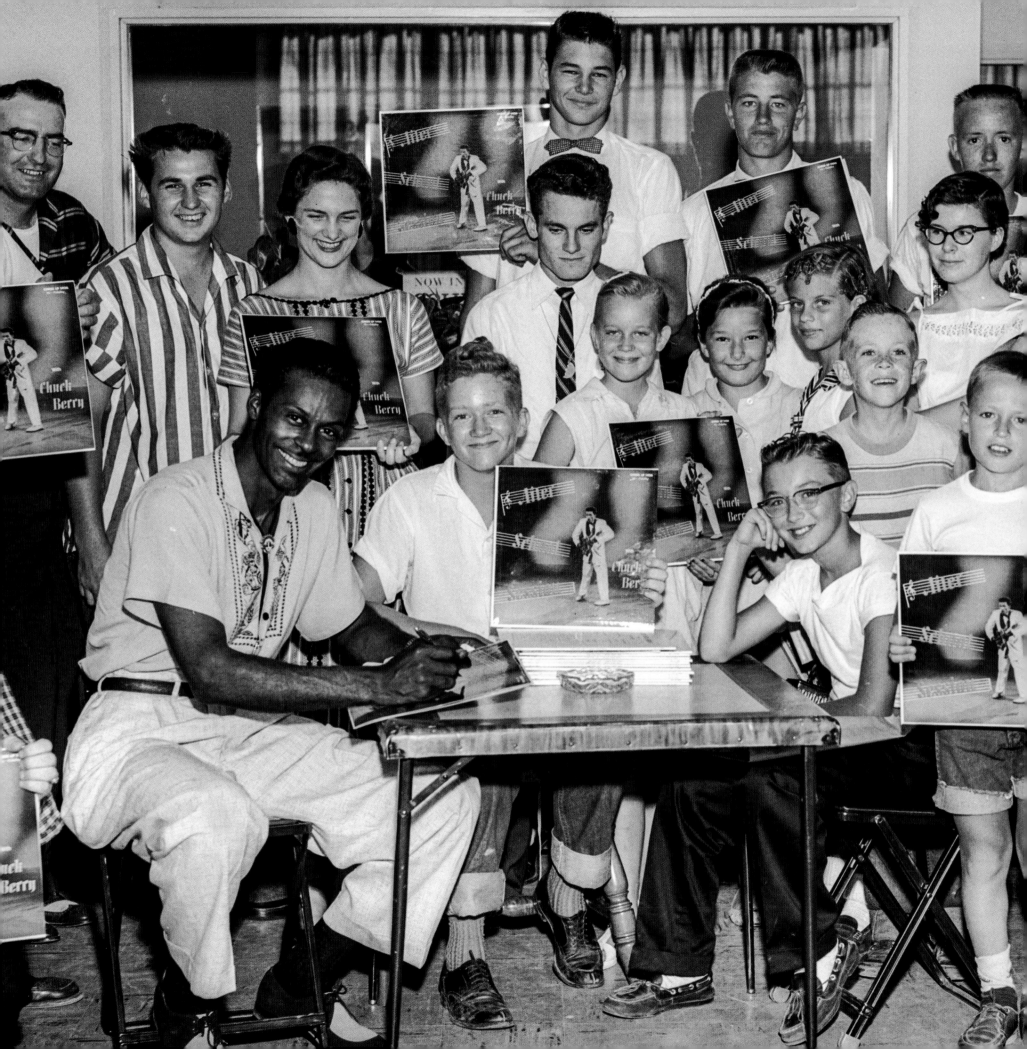

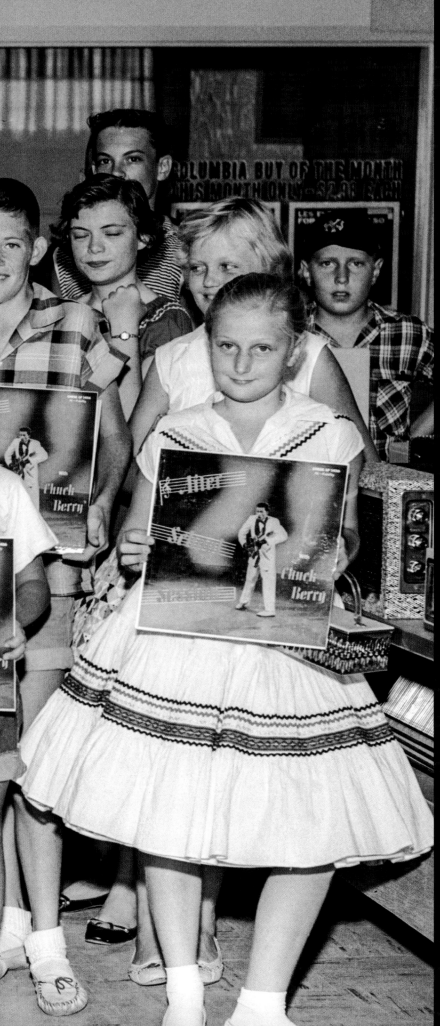

THE BIG BANG
BLUES & COUNTRY
COLLIDE WHILE THE
WORLD TREMBLES

Chuck Berry signs record albums at the
Disk Record Store, Waco, TX, 1957
📷 **JIMMIE WILLIS FROM THE JAMES
JASEK WACO PHOTOGRAPHIC
HISTORY COLLECTION**

CHAPTER 1

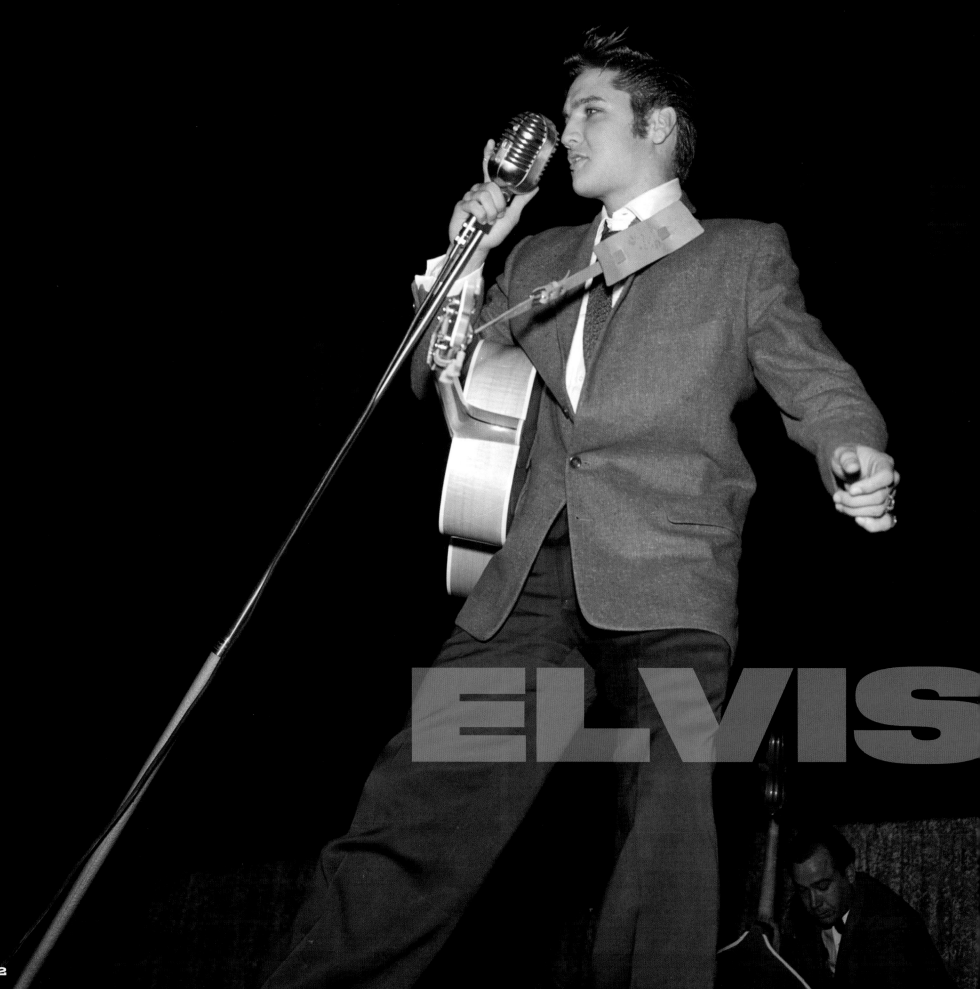

Elvis Presley (1935–77) may not have built the musical neutron bomb that blew apart the modern world in the mid-1950s, but the young Memphis singer born in Tupelo, Mississippi, surely lit the fuse. Once his early Sun Records singles started seeding the South, American life changed irrevocably. Presley took the jacked-up rhythms of the blues, added a dash of homeboy country, and threw in just enough gospel fervor to ensure that the fiery results permeated the soul. His first few songs landed on radio stations with such an impact that young listeners lost control, while their elders witnessed the end of civilization as they knew it. Both sides were on a collision course as early as 1955, one that still hasn't ended. That's because Presley personified freedom on so many fronts—youthful, sexual, racial—that it was clear fans would follow him anywhere. He changed everything, causing John Lennon of the Beatles to declare, "Before Elvis, there was nothing." When "Hound Dog" was released in 1956 on RCA Victor Records and Presley appeared on *The Ed Sullivan Show*, it was a shot heard 'round the music sphere. What followed was a series of smash hits, until he entered the Army two years later. The timeout gave the singer a chance to grow up and find an older audience, but his brigade of early believers had mostly moved on. For the rest of his life, Presley's once ironclad popularity came and went, while his movies ended up being a continuing source of mild embarrassment. By the 1970s, his Las Vegas casino residencies served as a reminder of what had been. Even then, the King stayed the King beyond even the early death many had feared. Long live the King.

Opposite: Elvis Presley and Bill Black (bass).
This page: Presley. Both at the Waco Theater, TX, July 13, 1958
📷 both **JIMMIE WILLIS FROM THE JAMES JASEK WACO PHOTOGRAPHIC HISTORY COLLECTION**

PRESLEY

CHUCK BERRY

Put a club full of rock critics in a room and watch their arguments start. In a poll of the single most important early rock and roller, consensus may well settle on Chuck Berry (1926–2017). Many reasons back that up, but principal among them are his permanently influential guitar rhythms, songs that resonate with the real stories of American life, and an unflagging ability to make audiences move. Berry revered blues and country music, but once he found his way to Chess Records in Chicago and began writing songs such as "Memphis" and "Roll Over Beethoven," there was never much doubt who would lead aspiring guitar slingers to the promised land. Much of that had to do with Berry having invented his own type of playing. Heavily rhythm-oriented, he could make his leads take flight. Without his songs, however, everything might have stayed earthbound. Berry had an astute eye for life as it was honestly lived, and his lyrics observed romantic behavior he saw all around him. It came out looking like universal truth. At first, those songs ("Johnny B. Goode," "Maybellene," "Carol") aimed at the teenage market, but in the end, they appealed to everyone. And although his songbook became rote for every guitarist who'd ever plugged into an amplifier, no one else completely sounded like him. That voice, too, couldn't be duplicated, and he could "play his guitar like ringin' a bell." That's what made the man from St. Louis an unassailable original. A new album from Berry in 2017 offers irrefutable evidence that even though the man is gone, his rock and roll will never die.

Left: Chuck Berry at the Fillmore, San Francisco, August 17, 1967
📷 © **JIM MARSHALL PHOTOGRAPHY LLC**

Opposite: Berry at Hard Rock, Bournemouth, UK, January 16, 1973
📷 **ALEC BYRNE**

Opposite right: Berry at the Maryport Blues Festival, UK, July 25, 2008
📷 **GRENVILLE CHARLES**

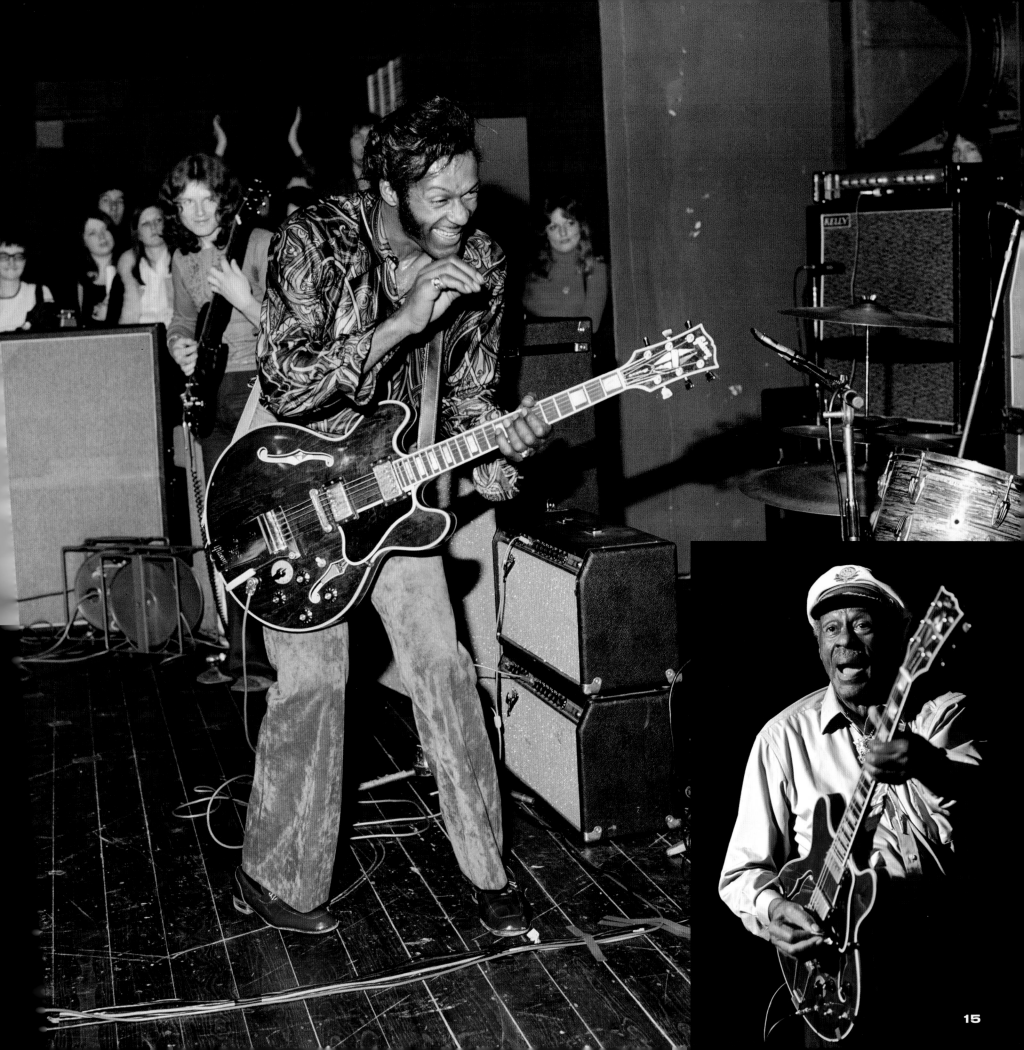

15

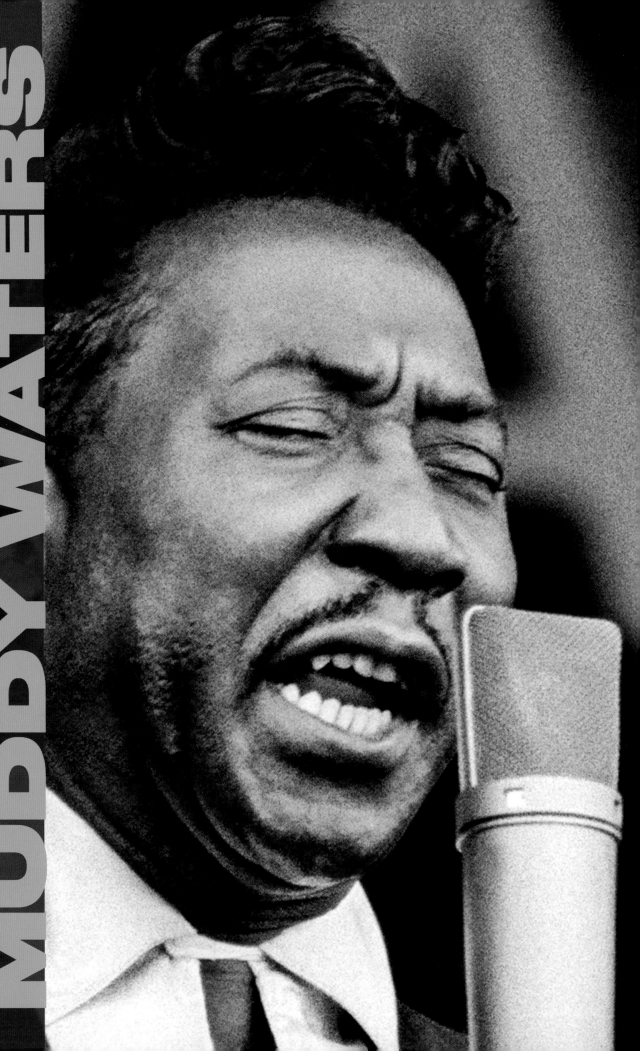

If some cosmic twist of fate dictated only one bluesman per planet, ours would belong to Muddy Waters (1913–83). A total authority as a singer, songwriter, guitarist, and bandleader, the man born McKinley Morganfield could get as low down in performance as some of his blues standards ("Got My Mojo Working," "I Just Want to Make Love to You," "Trouble No More"), but onstage and off, he carried himself with a regal demeanor that never betrayed his controlled emotional delivery. Raised on the Stovall Plantation near Clarksdale, Mississippi, he had experienced the degradation fieldworkers were subjected to, and vowed to escape to a place where he could hold his head high. As soon as he arrived in Chicago in 1943, that ascension began with a serious ace in the hole: his voice. Always thrilling, it had an infinite bottom to it, yet soared over the city's hard-bit South Side. And once Waters made it onto wax, he hit a universal chord. First recorded for Aristocrat Records in 1948, his releases began making their way around the globe. In England, he helped galvanize an entire postwar generation. The Rolling Stones, for one, got their name from one of Waters's heart-blasting blues songs. The man employed the best band in Chicago, too, which was really saying something, and it was a direct line to the emotional core of his audience. No one could put the hurt on a crowd like Waters. "Hoochie Coochie Man," "Long Distance Call," "Mannish Boy," and dozens of other songs incited all within earshot whether they were at the Windy City's Pepper's Lounge or upscale theaters throughout Europe. Urban electric blues had a king, and his name was Muddy Waters. Musicians did their best to wring every ounce of feeling when playing his songs. He made an electrifying resurgence in the 1970s when Johnny Winter, the Texas protégé who dedicated his life to the blues, took his mentor into the studio and recorded two albums charged with a spirit rarely heard. When Waters left this world, the Earth cried for someone who had changed the way people feel.

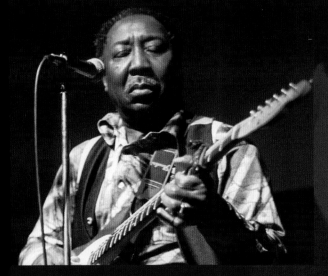

Above: Muddy Waters at Dooley's, Tempe, AZ, spring 1978
📷 **DORIAN BOESE**

Right: Waters at the Newport Folk Festival, RI, 1964
📷 © **JIM MARSHALL PHOTOGRAPHY LLC**

MUDDY WATERS

Bigness matters. An unavoidable presence, it throws shadows others can't escape. As a child near West Point, Mississippi, Chester Burnett (1910–76) acquired the nicknames Big Foot Chester and Bull Cow in deference to his size. By adulthood—after initial mentorship by the "Father of the Delta Blues," Charlie Patton, in the 1930s—he stood 6-foot-6 and became Howlin' Wolf once he devoted himself to the blues. His first producer, Sun Records's Sam Phillips, once said of his voice: "This is where the soul of man never dies." Like legions before him, Howlin' Wolf made his way to Chicago in hopes of planting his flag in the blues firmament. When he arrived, no one had heard a booming gruff voice such as his, or songs like the ones he soon composed: "Killing Floor," "Smokestack Lightning," and "How Many More Years." Unlike any songs previously, they sounded as though they had been dug out of granite, sculpted with an ax, and delivered with all the blood and guts of a Chicago slaughterhouse. At the same time, an urban audience was taking note and growing daily.

Howlin' Wolf had found a home. Growing up, he had wandered on his own, been discharged from the armed services in the early 1940s for a nervous condition, and struggled to find his place in the world. Now he had one. Like any self-starting human with big ambitions, he spent the rest of his years protecting that position. With longtime guitarist Hubert Sumlin, he fashioned a wholly original sound never even remotely duplicated. In 1971, he recorded *The London Howlin' Wolf Sessions* with British rock royalty including Eric Clapton and members of the Rolling Stones, and he can be heard schooling his charges like a professor of bluesology. When he died, Sumlin said, "It was like losing your mama and daddy on the same day." Howlin' Wolf left a big hole in the blues. Bigness creates bigness.

Howlin' Wolf at the Avalon Ballroom, San Francisco, July 26, 1968
📷 © **JIM MARSHALL PHOTOGRAPHY LLC**

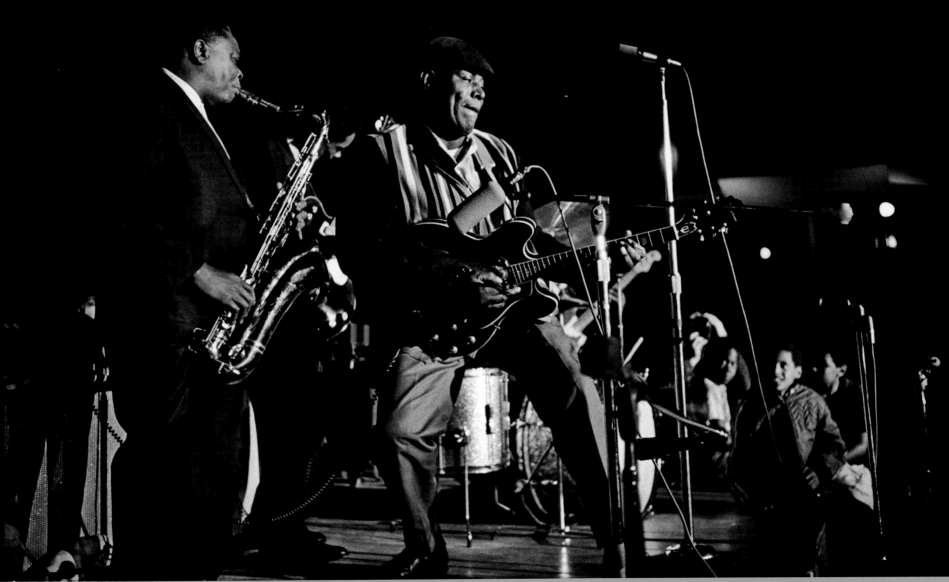

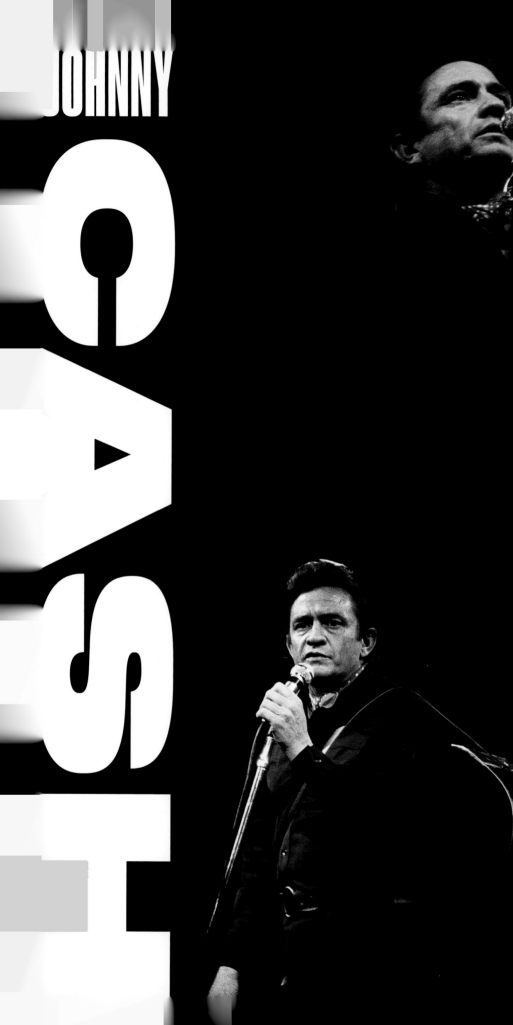

JOHNNY CASH

Country music comes in many moods—spiritual, romantic, celebratory, and lonesome-hearted—but at its core, the music, emerging out of poverty and the struggle to survive, is about hope for redemption. Johnny Cash (1932–2003), born to a poor family mired in the Great Depression, epitomized such hopes. With a no-frills voice that made his rise to the pinnacle of greatness unlikely, he grew up in Arkansas with six siblings and joined the Air Force to get off the farm. Moving to Memphis in 1954, Cash—who'd been singing since toddlerhood—realized that music held the keys to a kingdom far removed from his hardscrabble past. Once his single "Hey Porter" reached the airwaves in 1955, his life opened up. Although he'd been studying radio announcing, Cash turned entirely toward music, tapping into the city's Sun Records ethos with work predicated on bare-bones human emotion. Success prompted a spiral of indulgence during the late 1950s and early '60s, when the singer became a case study in ways to jeopardize a career. By the time he married June Carter in 1968, the man in black was firmly on the roll of country-music giants, but he'd glimpsed another darker side of life. Playing for prisoners in 1968, he recorded the live album At *Folsom Prison*, and its stunning success offered him a chance to revitalize his career. Returning to the Christianity of his youth, battling addiction, and supporting social-justice causes, Cash veered through numerous musical pursuits. Record labels came and went, as did indications of his retirement, but through it all Cash stayed true to his early, stark musical style. *American Recordings* released in 1994, granted him creative and commercial rebirth, revealing an artist in the twilight of his life who refused to give in, or give up.

Top and bottom: Johnny Cash at Madison Square Garden, New York City, December 5, 1969

STEVE BANKS / STUDIO 6

Way down yonder in New Orleans, Antoine "Fats" Domino (b. 1928) remains true royalty. Considered a living personification of all that is great about the city and its seminal soundtrack, he perfected easeful rhythms and roaring horn sections on a continual hit parade of songs such as "I'm in Love Again," "Blueberry Hill," and dozens of other classics. Key to his immortal appeal, he never sounds as though he's trying to impress. He locks into the joyous glide at the heart of the Crescent City allure and revs it up just enough to strap in listeners for the ride. Domino started as a rather timid piano player who slid onstage between sets by more established players, but his fluidity and feel on the instrument prompted audiences to demand him as the main attraction. His first

recording, "The Fat Man," widely considered rock and roll's first million-record seller, began as a wink and nod to his size, but ended up an all-teeth audio grin. That was in 1949, and Mr. "Walking to New Orleans" never looked back. Fats Domino partnered with bandleader/songwriter/producer Dave Bartholomew (b. 1918) in the early 1950s, and everything they touched turned to gold, including a band that multiplied into an even dozen, chockablock with stunning saxophones, strutting trumpets, and drummer Earl Palmer (1924–2008), who helped invent the modern rock beat. The group's namesake never stretched far in different musical directions, but he didn't have to. He telegraphed happiness across the Caribbean as Big Easy frequencies wafted toward Jamaica

to one day influence a young Bob Marley. Domino took the good name of New Orleans far and wide, and even survived Hurricane Katrina in 2005 after being reported dead. The legend once secured big letters spelling FATS on the front of his house so people would know where he lived. Nobody, not ever, expressed his soul any better.

Below left: Fats Domino at the Heart O' Texas Fair and Rodeo, Waco, TX, 1957
📷 **JIMMIE WILLIS FROM THE JAMES JASEK WACO PHOTOGRAPHIC HISTORY COLLECTION**

Below right: Domino at the Hotel Ponchartrain, Detroit, 1978
📷 **LENI SINCLAIR**

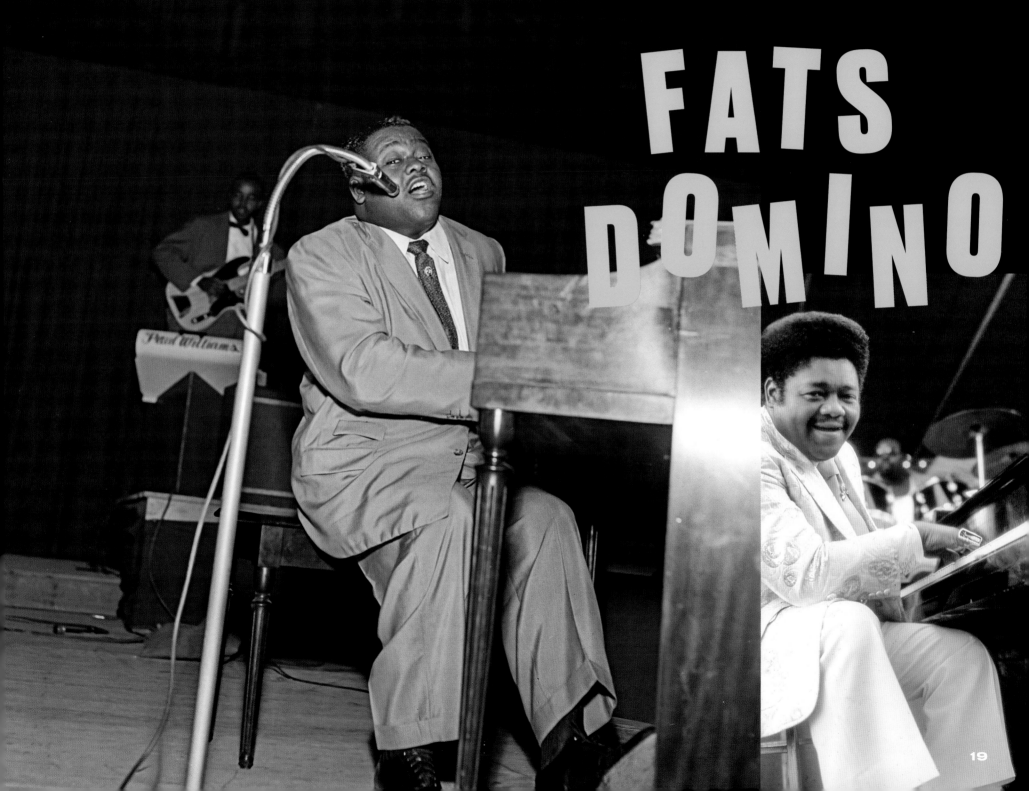

FATS DOMINO

19

LITTLE RICHARD

There's nothing little about Little Richard's place in the birth of rock and roll. Richard Penniman (b. 1932) began life in Macon, Georgia, as the third eldest of twelve children whose church-deacon father bootlegged moonshine on the side. Little Richard quickly learned that it took breaking all the rules on the long road of survival, which is exactly what he did when he developed one of the most captivating sounds and live shows in the history of recorded music. Ever the extrovert, he never shied away from a feminine flair with makeup and hairstyles, nor did he hold back in his attack on the piano and microphone. Little Richard no doubt witnessed his share of Holy Roller performers tear up a church sermon, and quickly realized the effect of all that screaming and shouting on a secular audience. Once he found his way into the nightclubs of New Orleans, he burned down the bandstands with pounding piano lines, kicking legs, and a madman's zeal. Missing only was recorded evidence of the explosions. Cosimo Matassa's studio in the French Quarter had the sound, the musicians, and the ambience that allowed Little Richard to rip it up from note one. Songs such as "Tutti Frutti" and "Ready Teddy" escaped from that room straight into the cosmos. So overwhelming were his stage presence and howls that no one could take their eyes or ears off him. The powers that be cringed, but teenagers converted instantly. Of course, it wouldn't last. During a trip to Australia, Little Richard scared even himself, swearing off rock and roll and turning toward religious music. That wouldn't last either, but the singer never recovered his career momentum. Still, on the list of the greatest rock and rollers of all time, Little Richard's name sits right at the top. Forever.

Below: Little Richard at Underground Atlanta, December 31, 2002
📷 **CHRIS MCKAY**

Right: Richard at Walker Auditorium, Waco, TX, July 17, 1957
📷 **JIMMIE WILLIS FROM THE JAMES JASEK WACO PHOTOGRAPHIC HISTORY COLLECTION**

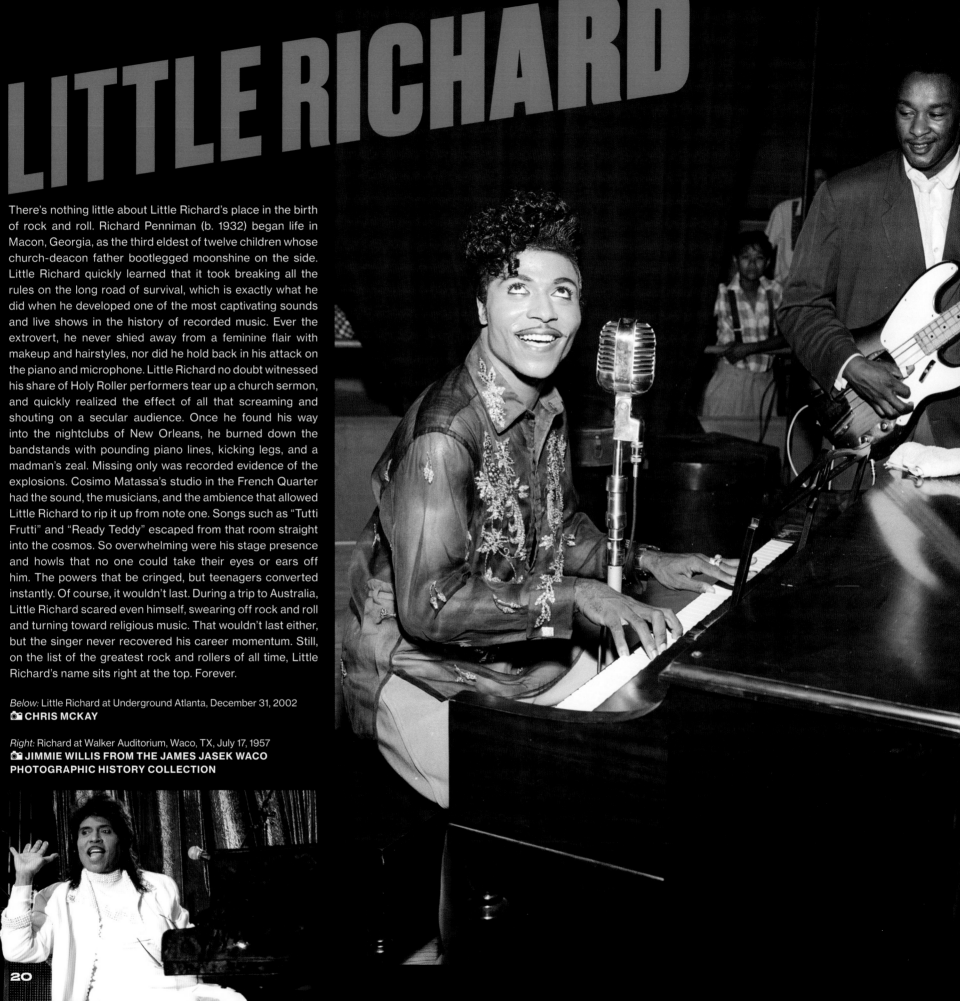

Meet the uncontested bad boy of rock and roll. Famously obstinate and incapable of compromise, Jerry Lee Lewis (b. 1935) has pulled endless rabbits out of a hat in his years, all while maintaining a staggering momentum. The poor kid from Ferriday, Louisiana, would sneak up on juke joints at night to watch through the windows as the musicians tore the roof off. After one of those early forays, he divined his destiny and his father was somehow able to buy the boy a piano. Sitting at the keyboard, Lewis found his place in life. When father and son traveled to Memphis to audition for Sun Records owner Sam Phillips, it didn't go quite as planned, and they left empty-handed. Fortunately, talent perseveres, and "Whole Lotta Shakin' Goin' On" and "Great Balls of Fire" would hit the big time. When Elvis Presley left Sun Records in 1955, Lewis assumed the mantle. For a few years he was unstoppable, but once his marriage to a thirteen-year-old cousin came to light, fame and fortune looked to be in his past. Wrong. Lewis bided his time for a few years and switched to country music, quickly becoming one of the genre's biggest hit makers. Of course, his wayward ways continued through all kinds of controversies, but the music never stopped. The way the man pounded the 88s and poured his heart into songs such as "She Even Woke Me Up to Say Goodbye" and "What's Made Milwaukee Famous" captivated fans no matter their musical allegiance. To this day, Lewis maintains a rebel heart and an immovable desire to touch those who will listen. He remains a convention-defying cornerstone of American music.

Jerry Lee Lewis at the Café de Paris, New York City, June 1958
📷 © UPPA / PHOTOSHOT

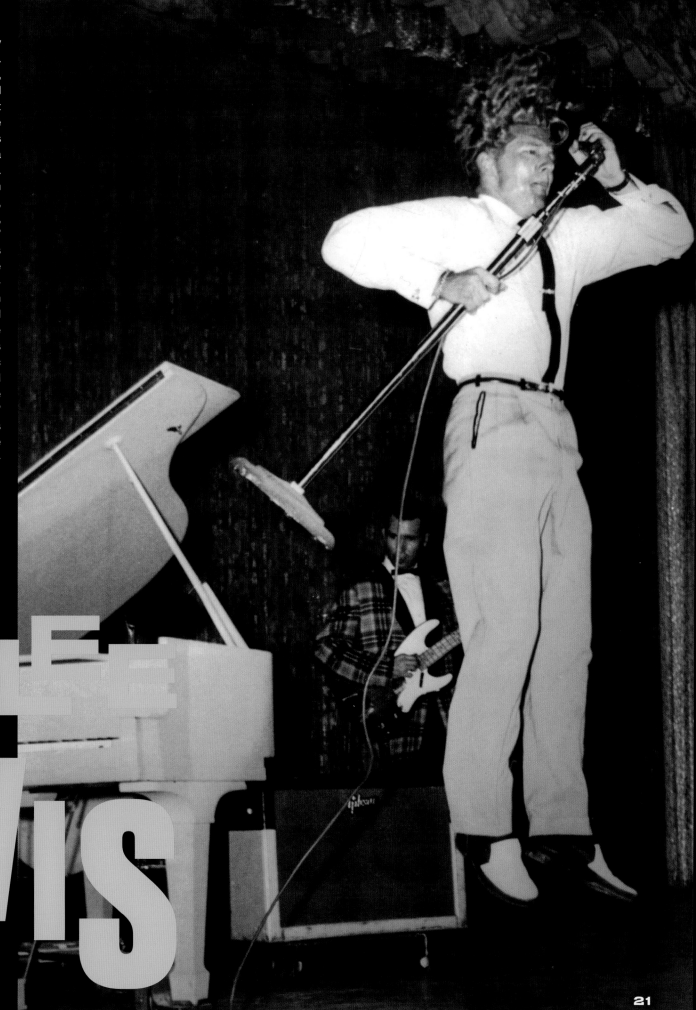

JERRY LEE LEWIS

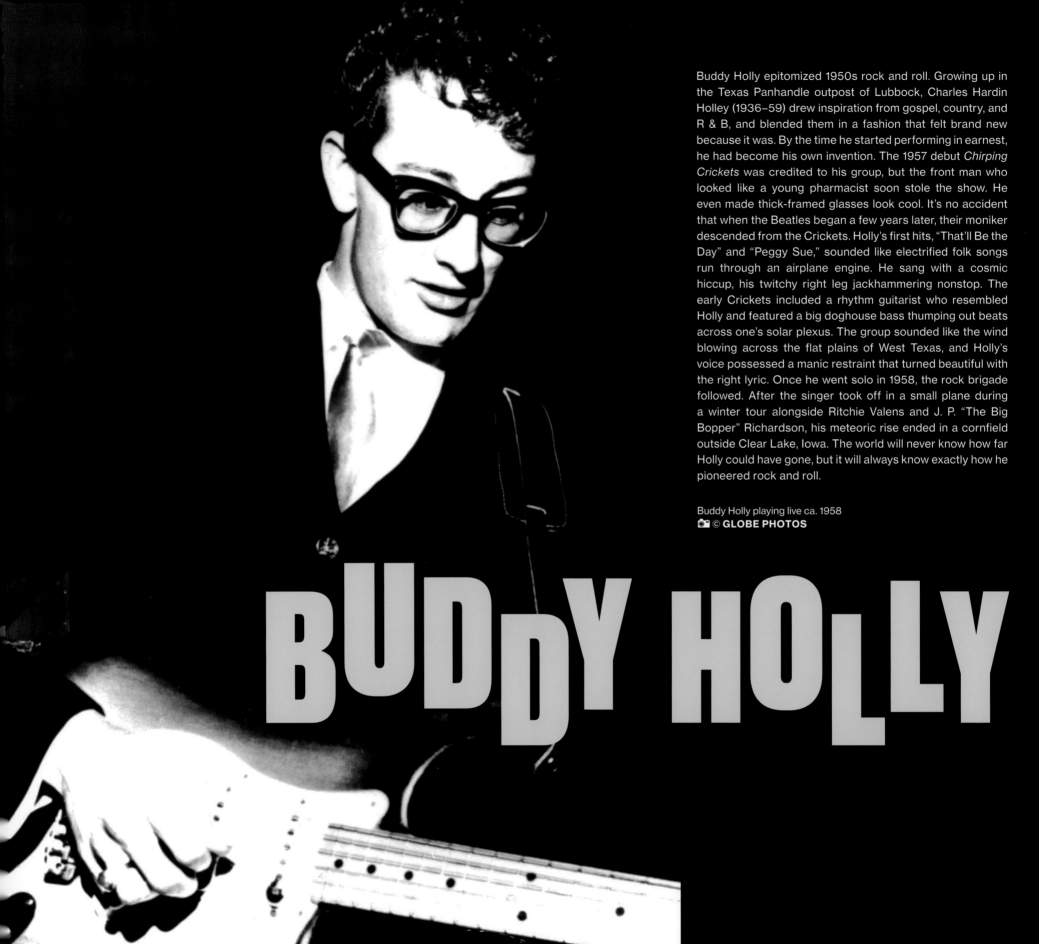

Buddy Holly epitomized 1950s rock and roll. Growing up in the Texas Panhandle outpost of Lubbock, Charles Hardin Holley (1936–59) drew inspiration from gospel, country, and R & B, and blended them in a fashion that felt brand new because it was. By the time he started performing in earnest, he had become his own invention. The 1957 debut *Chirping Crickets* was credited to his group, but the front man who looked like a young pharmacist soon stole the show. He even made thick-framed glasses look cool. It's no accident that when the Beatles began a few years later, their moniker descended from the Crickets. Holly's first hits, "That'll Be the Day" and "Peggy Sue," sounded like electrified folk songs run through an airplane engine. He sang with a cosmic hiccup, his twitchy right leg jackhammering nonstop. The early Crickets included a rhythm guitarist who resembled Holly and featured a big doghouse bass thumping out beats across one's solar plexus. The group sounded like the wind blowing across the flat plains of West Texas, and Holly's voice possessed a manic restraint that turned beautiful with the right lyric. Once he went solo in 1958, the rock brigade followed. After the singer took off in a small plane during a winter tour alongside Ritchie Valens and J. P. "The Big Bopper" Richardson, his meteoric rise ended in a cornfield outside Clear Lake, Iowa. The world will never know how far Holly could have gone, but it will always know exactly how he pioneered rock and roll.

Buddy Holly playing live ca. 1958
📷 © **GLOBE PHOTOS**

BUDDY HOLLY

Rare is the instance in popular culture when someone gets called the inventor of a prevalent style, but in so many ways Ray Charles (1930–2004) could be credited with being the father of soul music. He married church music to rhythm and blues during the 1950s and birthed what we know today as soul music. In his earliest musical incarnation, he studied the styles of fellow piano crooners Charles Brown, Nat King Cole, and others. But once he rolled into Atlantic Records and put the holy spirit into secular songs such as "I Got a Woman" and "What'd I Say," it was as though the church pews had been carried into the nightclub for an evening of righteous reflection and heartfelt testifying. Brother Ray turned the heat past the boiling point, unleashed a stupefying aggregation of musicians onstage, and headed for the clouds from the first downbeat. In the process, a brand-new world came to be. That was just the beginning, too. After he turned his talent on country music and demonstrated the equality of that sound on every front, he carried on a journey like no one else ever has. The man often referred to as the Genius built bridges no matter where he focused. In the end, he rated his own classification in music, and even recorded "America the Beautiful" as though he owned the song. Over so many years, Charles was America's musical envoy, and he will stay that way come what may.

Ray Charles at the Venetian Room in the Fairmont Hotel, Atlanta, November 1974
📷 **STEVE BANKS / STUDIO 6**

RAY CHARLES

In the continuing evolution of American music, different cultures pierce the ozone in profound ways. That's 1958's "La Bamba." Born Richard Steven Valenzuela (1941–59) in the Pacoima neighborhood of Los Angeles, Ritchie Valens absorbed the styles of his Mexican heritage, including mariachi bands and *conjuntos norteños*, and wasn't shy about incorporating those elements into his own burgeoning take on rock and roll. The way he fused cultures made him a force that is still felt today. He took a basic electric guitar progression, goosed it up with south-of-the-border bravura, and fuel-injected enough twang to take it stratospheric. Sounding straight out of an all-night backyard bash, Valens then sang his heart out on one of the first domestic Latino hits. In that wake, the adaptation of an early twentieth-century Mexican folk song soon became a battle cry for teenagers of all backgrounds. A certified star, Valens had other tricks up his sleeve, including the crushing ballad "Donna," and sat poised for one of the most stellar launches of the 1950s. He had it all: the songs, the voice, the passion, and the ambition. What he did not have was good luck. He was on the early rock and roll tour that came to be called "The Day the Music Died," when the small plane he was on crashed, killing him, Buddy Holly, and J. P. "The Big Bopper" Richardson in early 1959. Nearly twenty-eight years later, in conjunction with a hit film, fellow Angelenos Los Lobos took "La Bamba" all the way to No. 1 and reminded everyone of what had been lost decades earlier. Valens brands American music as a musician who broke down barriers and did it with a song for the ages.

Ritchie Valens, hours before his death, performing in Buddy Holly's last Winter Dance Party tour show at the Surf Ballroom, Clear Lake, IA, February 2, 1959
📷 **MARY GERBER**

RITCHIE VALENS

BO DIDDLEY

Few rock and rollers can boast a beat named after them, but that's Bo Diddley (1928–2008). When the guitarist began recording in Chicago, his first hit, "Bo Diddley," trumpeted his stage name with what's often described as the "shave-and-a-haircut" rhythmic pattern, emphasized by the drummer. Others refer to it as the hambone beat. Either way, it caught on immediately with fans and defined Ellas Otha Bates for the rest of his life. His family moved from McComb, Mississippi, to Chicago in the 1940s, and he gravitated to the streets, seeking out players and songs. Before long, Maxwell

Street and other hot spots played host to his primal sounds. Bo Diddley was refining the patented style that would land his name in big lights and history books by working on a live performance that featured him shaking his legs and strumming a box-shaped guitar with unerring precision while standing in a solid split. He also used a maracas player and a female rhythm guitarist at a time when few others would have dreamed of such things. Most of all, Bo Diddley stayed the course of his original sound, heard on "Hey Bo Diddley," "Go Bo Diddley," and "Bo Diddley's a Gunslinger," among

a herd of others. The man was an unabashed branding visionary by putting his name in so many of his hit songs, and it always served him well. Right up until the end, he could walk onstage before a roomful of strangers, plug in one of the myriad guitars he had designed and built, hit the first few chords to any of his songs, and all in attendance instantly knew that Bo Diddley had arrived.

Bo Diddley outside Le Coq d'or Tavern, Toronto, October 18, 1966
courtesy **FREETOWN COLLECTION / CACHE AGENCY**

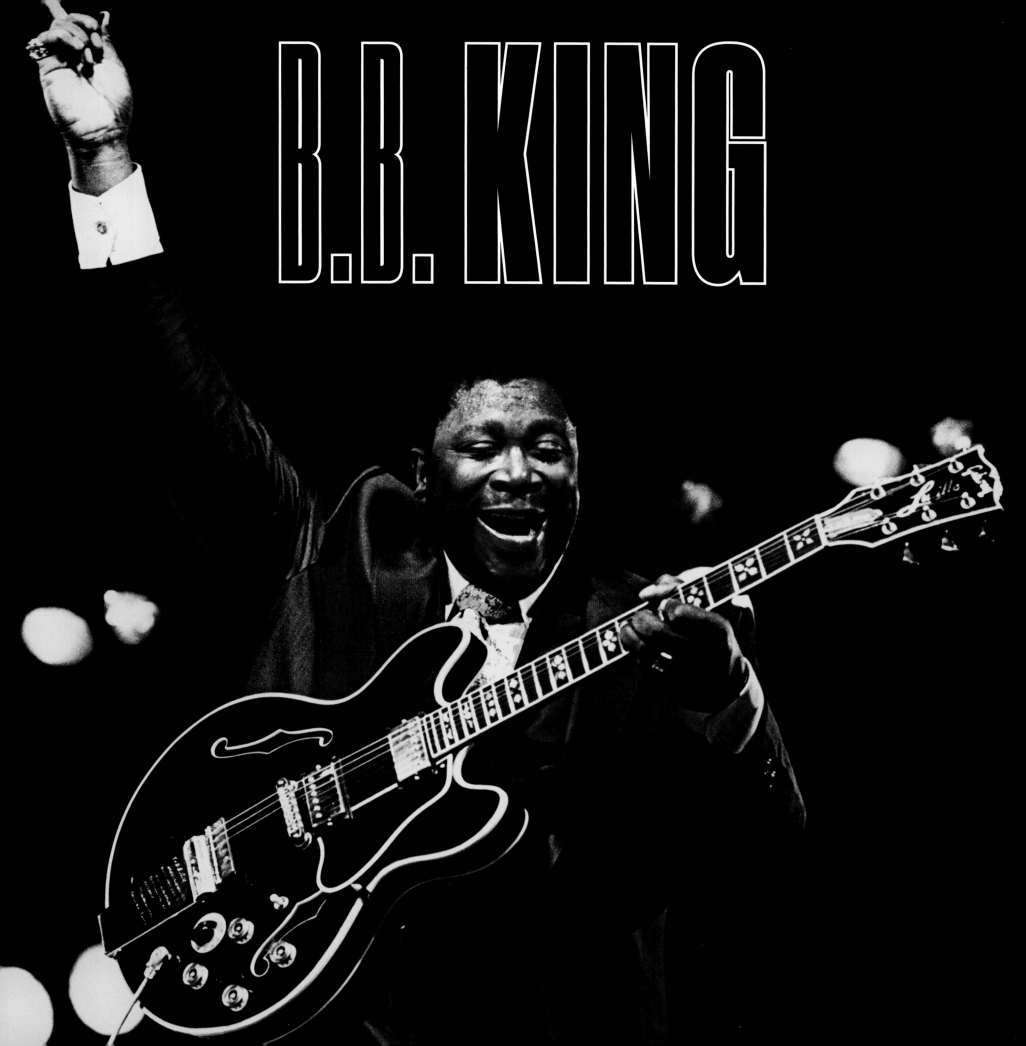

B.B. KING

Consider Riley "B. B." King ground zero for the blues. Although influenced by predecessors such as Texas great T-Bone Walker, the guitarist (1925–2015) made a name for himself with a style entirely his own concoction. Taking the art of string-bending to new heights, King's powerful playing could reduce grown men to tears. He poured a lifetime of pain and pleasure into every note, and then filtered it all through a heart stretching from coast to coast. Born on a cotton plantation in the Mississippi Delta, he endured a lonely childhood that made him long for human connection. Once he got his hands on a guitar, King found his salve. To get in on the action driving the Memphis scene, he set off on a journey that would stretch seventy-five years and take King from the smallest bars in the South all the way to the White House. His is one of the most inspiring stories of any artistic discipline, demonstrating how self-belief coupled with utter dedication to learning can be unstoppable. Right up to the end of his life, King would say that he was still discovering how to play. Onstage, he scrunched his face into a grimace that became a study in sheer humanity, starting with signature opener "Every Day I Have the Blues," and anyone within earshot would enter the motherland. In those moments, King delivered a life preserver to those who needed to find hope in a world that often provided little of it. When "The Thrill Is Gone" crossed over and brought him mainstream success in 1970, he stayed loyal to the music that had taken him so far. King's blues went so deep that there was no way to disrupt that musical makeup. For the next forty-five years, the bluesman from Berclair crisscrossed the third stone from the sun like few other musicians before or since. He made blues respectable by the way he presented himself and his guitar, Lucille, and through a lifetime of sharing a wide-open soul. No wonder he was anointed King of the Blues early on and was addressed as such for the rest of his life.

Opposite: B. B. King at the Dr. Pepper Central Park Music Festival, New York City, July 28, 1979
© 1979 CHARLYN ZLOTNIK

Below: King at Chastain Park Amphitheatre, Atlanta, August 23, 2002
CHRIS MCKAY

Below right: King at San Quentin State Prison, Marin County, CA, 1981
RICHARD MCCAFFREY

Right: King at the Atlantic City Pop Festival, Mays Landing, NJ, August 1969
DAVID WEITZ

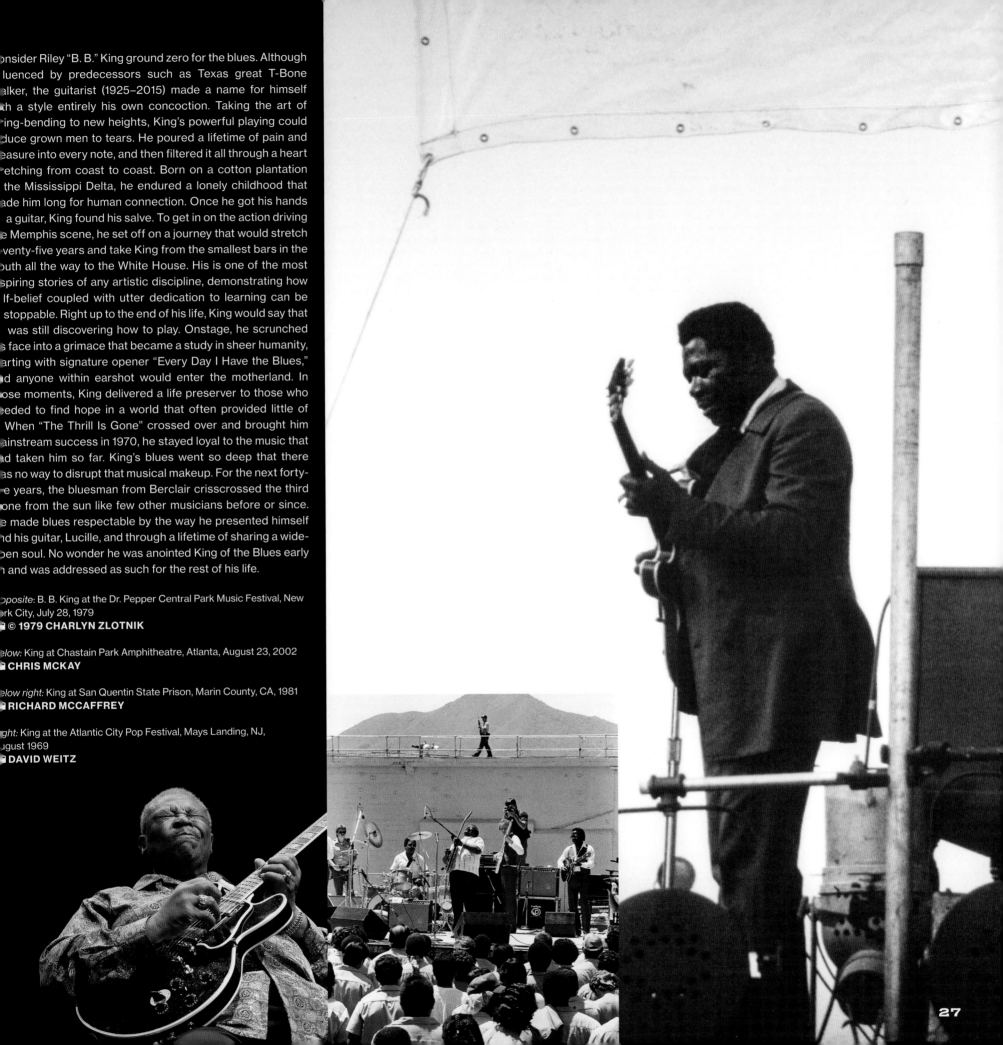

The clarion call of Jimmy Reed (1925–76) went out far and wide in the 1950s. The Mississippian had a way of pitching his voice and harmonica that no one else could duplicate. It was a somewhat simplistic style, but it cut through everything around it. Those who heard it, whether it was the Rolling Stones at their inception in England or the Grateful Dead in California, never forgot it. Reed was counted as one of the few guitar-wielding bluesmen whose songs enjoyed Top 10 play on AM radio next to Elvis Presley and the Coasters. For that alone he might rank as the most influential bluesman of the era. "Bright Lights Big City" and "Honest I Do" have the feel of a singer about to fall off the edge of the world, someone pulled back from the abyss at the last moment of lingering. That was the beauty of Reed:

His backup musicians locked into his sound in a way that has been called "one head music," because if anyone strays and plays outside that singular mindset, everything comes apart. Even after all these years, no other musician has been able to duplicate Reed's trademark achievement. Onstage, he varied from electric dynamism to shambling dissolution, but none of that really mattered because his acolytes knew they were in the presence of a folk genius. Whether their hero was up or down, he was always Jimmy Reed. In his last shows, he forgot many of his lyrics, and during recording sessions, his wife, Mama Reed, would whisper the words into his ear the instant before he had to sing them. Even then, Jimmy Reed tapped the music of the spheres, pulled it down to earth, and made it whole.

jimmy reed

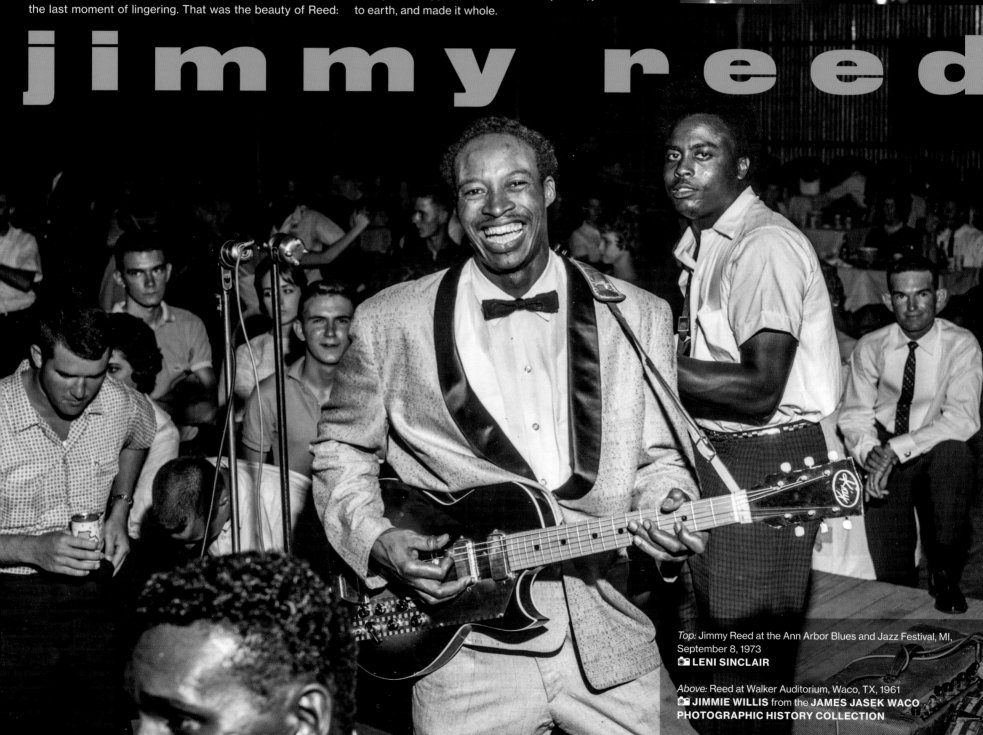

Top: Jimmy Reed at the Ann Arbor Blues and Jazz Festival, MI, September 8, 1973
📷 **LENI SINCLAIR**

Above: Reed at Walker Auditorium, Waco, TX, 1961
📷 **JIMMIE WILLIS** from the **JAMES JASEK WACO PHOTOGRAPHIC HISTORY COLLECTION**

the Everly Brothers

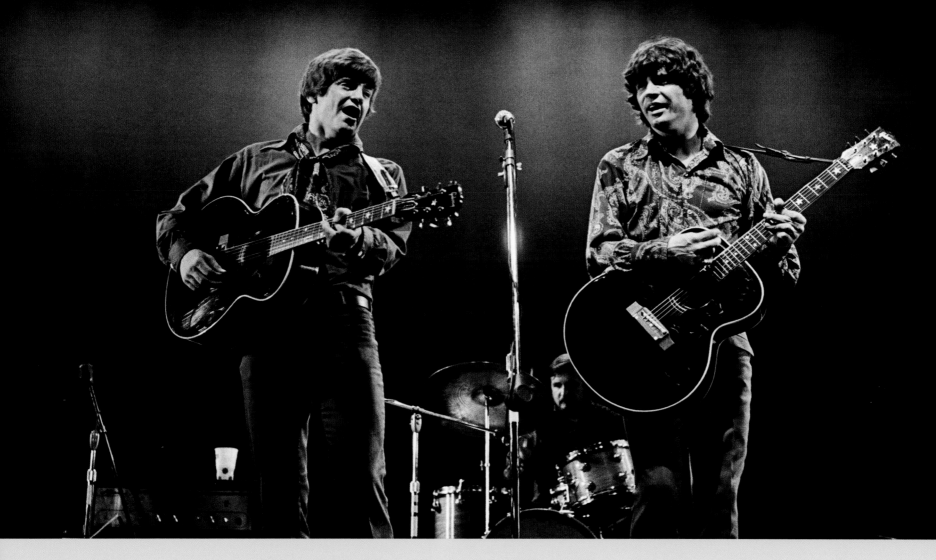

Something in the genetic code of siblings makes their voices blend and soar together like few others. Above all familial rock and rollers, the Everly Brothers made an exponential leap. Don (b. 1937) and Phil (1939–2014) Everly created an extraterrestrial union with their voices. Something happened when they sang, a previously uncatalogued sound. The duo began when they were still young children, working with their parents on radio-show broadcasts in the South. Ike Everly knew what he had in his two sons, and he didn't waste time getting them into a recording studio to develop that gift. From the boys' first notes together, listeners held their breath when they heard the results. Even better, the brothers also were inspired songwriters, both alone and apart, and penned many of their chart-toppers, including "('Til) I Kissed You," "Cathy's Clown," and "When Will I Be Loved," in 1959 and 1960. For many of their early popular years, the Everly Brothers remained in a class of their own, influencing country, rock and roll, and even the Beatles with a heavenly sound. They continually pushed their vocals into places that drove audiences wild and could then take things even further into a no-man's-land of ethereal achievement. The Everly Brothers were among the few rock and roll pioneers to explore more modern songs, and on their 1968 album *Roots*, their adventurous spirit shines today. The brothers also were famous for fraternal feuds, spending years not working together, and sometimes not even speaking, but those rifts often healed through music. Later tours found them the proud possessors of those magical voices of their early years. The chills still flowed.

Phil and Don Everly at the Newport Folk Festival, RI, July 19, 1969
© **JIM MARSHALL PHOTOGRAPHY LLC**

JAMES

"Godfather of Soul" isn't a title bestowed lightly. James Brown (1933–2006) started by shining shoes as a child in Augusta, Georgia, spent time in reform school as a juvenile, and busted loose to change the world once and for all when he began singing and performing. First with the Famous Flames and then with his world-renowned orchestra, Brown achieved greatness with the kind of dedication and perseverance that defy all odds. He not only changed how music is played with his endless innovation in rhythm and blues, then soul, and finally funk, but he ultimately also altered how African Americans can guide their own careers in show business. He became one of the first musicians to take his destiny in hand and shape it as he saw fit. Challenging the conventions of those who controlled the business gave Brown the nickname "Hardest Working Man in Show Business." When he recorded what's widely regarded as the greatest live album ever in 1963's *Live at the Apollo*, King Records refused to pay for it, and so Brown ponied up the dough himself. It stayed on the charts for more than a year, and reshaped how labels viewed live releases. After that, the singer took off on a barnstorming tour of the world that spanned two decades. His musical innovations were staggering, moving from soul-searing ballads such as "Try Me" and "Please, Please, Please" to funkified sophistication with "Papa's Got a Brand New Bag," "Get On Up," and "Cold Sweat." No other artist ever took as many chances in how they could reinvent their repertoire and retain fans. When his fervent followers signed up for James Brownland, they joined forever. Not even late-in-life drama extinguished the fire of all those who caught the fever from Soul Brother Number One.

Left: James Brown, ca. 1960s
📷 courtesy **PICTORIAL PRESS / CACHE AGENCY**

Opposite bottom left: Brown at Ontario Place Forum, Toronto, 1987
📷 **DAN HINDE**

Opposite bottom right: Brown at Rotterdam Ahoy, the Netherlands, April 20, 1986
📷 **LAURENS VAN HOUTEN / FRANK WHITE PHOTO AGENCY**

Opposite top: Brown at Chastain Park Amphitheatre, Atlanta, August 31, 2003
📷 **CHRIS MCKAY**

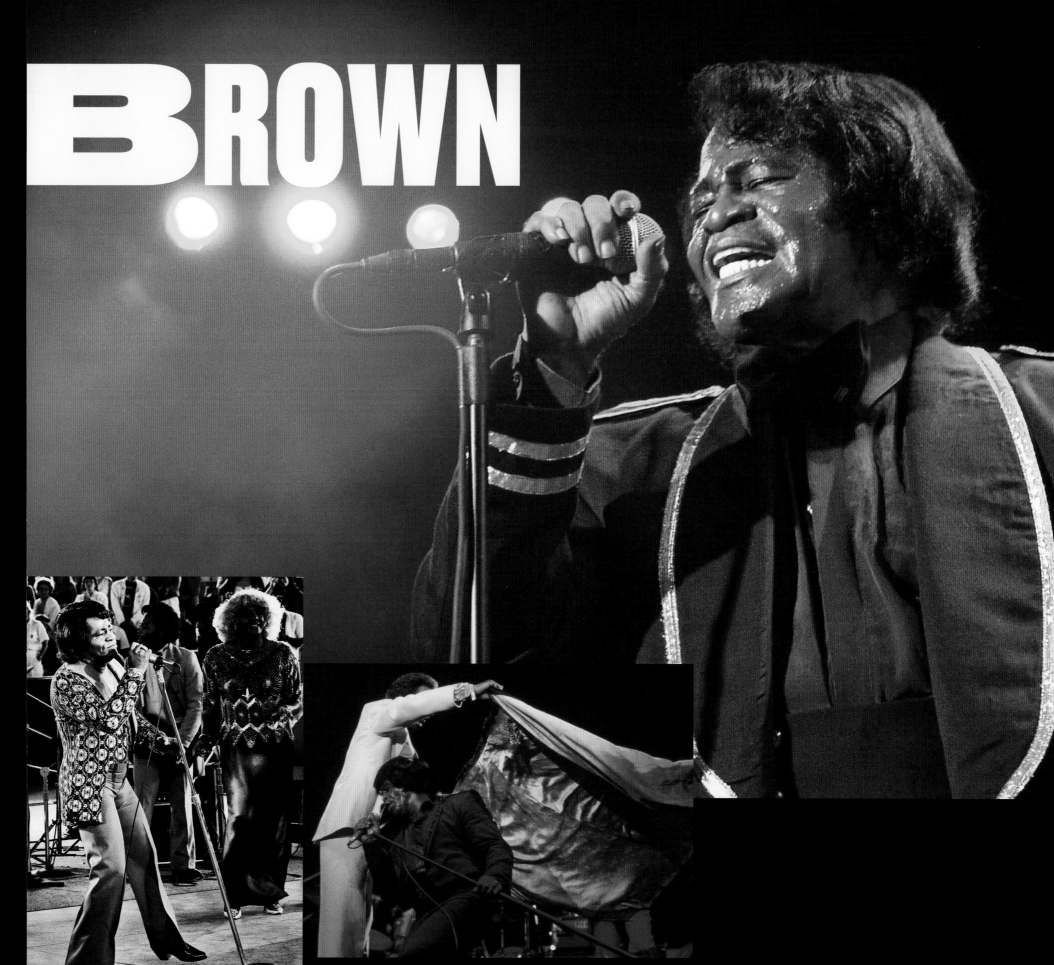

BROWN

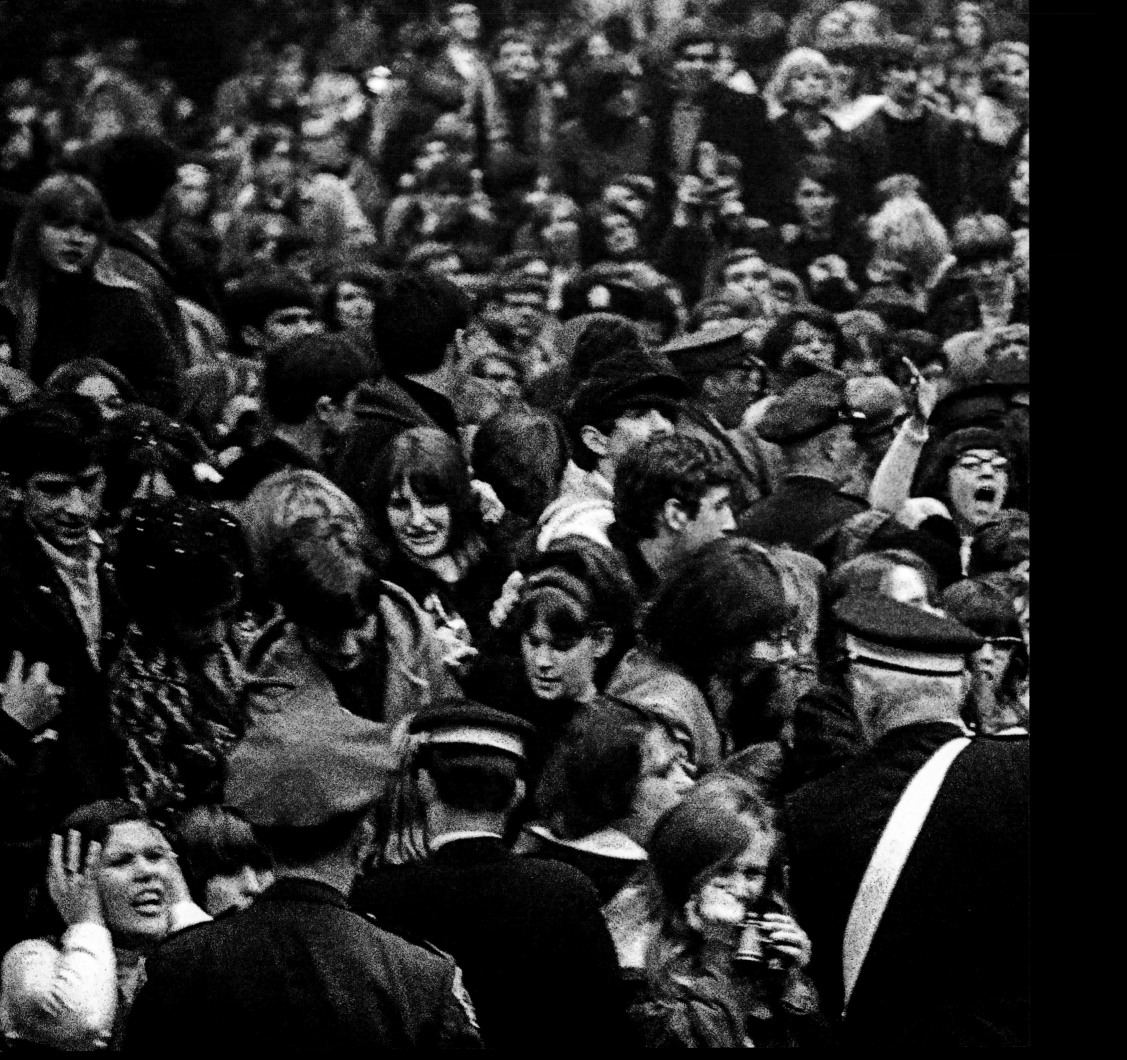

THE BRITISH INVASION AND BEYOND THE FUTURE IS REVEALED

Rolling Stones fans at the Boston Garden,
November 5, 1965
 GERED MANKOWITZ

CHAPTER 2

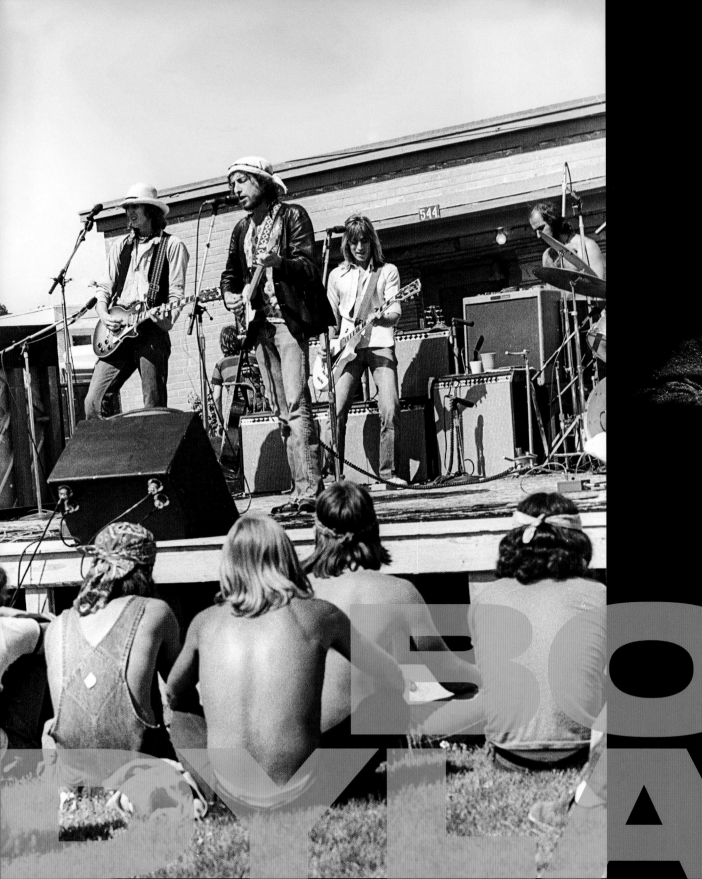
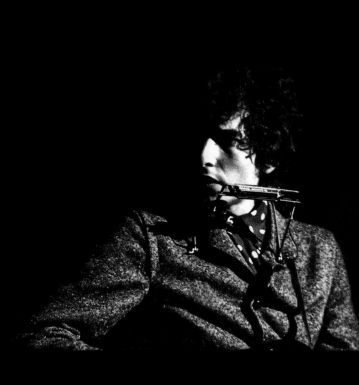

BOB
DYLAN

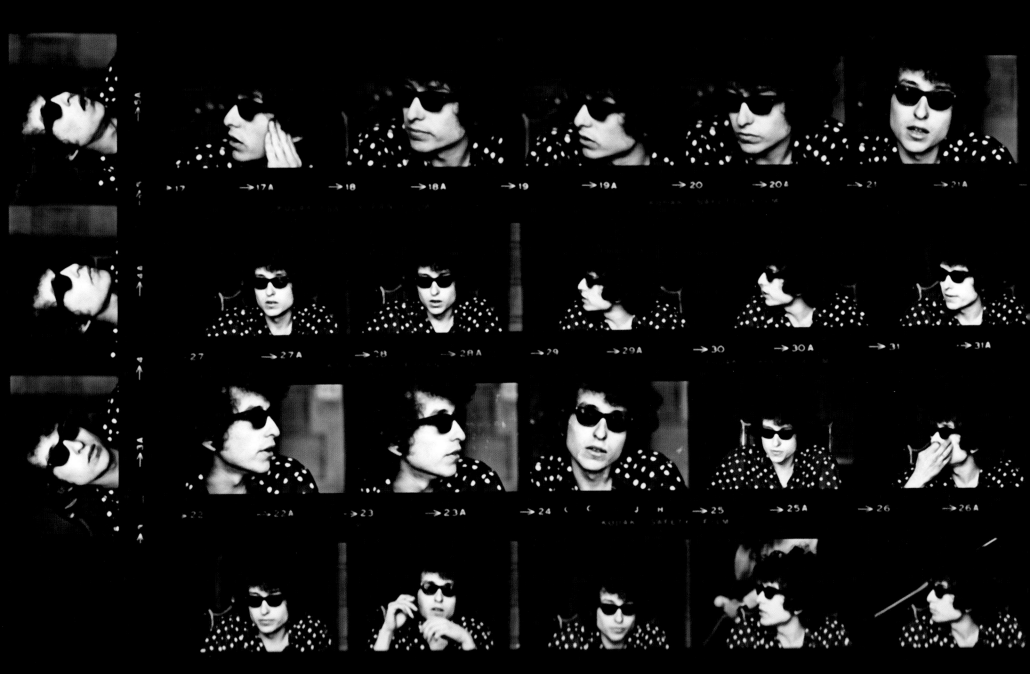

Rock and roll turned into a worldwide belief system because of Bob Dylan. Born Robert Allen Zimmerman (b. 1941) in Hibbing, Minnesota, the young man blew into New York in 1960 to visit idol Woody Guthrie and soon became a central figure on the Greenwich Village scene. His early songs, which fused literary and folk influences and took on topical social and political issues, emerged—and helped to shape—the coming cultural Zeitgeist. His ascent truly began the moment "Blowin' in the Wind" took flight in 1963. By the middle of the decade, his musical horizons began to expand, and the lyrically rich electrified rock songs that followed—including 1965's "Like a Rolling Stone"—kicked musical styles in the States (and worldwide) into a new stratosphere. Both cinematic and gritty, elegaic and transcendent, his narrative rock ballads made him a sort

of prophet of the people, a difficult role to be thrust into. Although he retreated from the NYC scene to Woodstock, New York, in 1966, he released an astonishing run of influential albums in the latter half of the decade, from *Bringing It All Back Home* and *Highway 61 Revisited* (both 1965) to *Blonde on Blonde* (1966) to *John Wesley Harding* (1967) and *Nashville Skyline* (1969). His music and lyrics were as revered by scholars as by popular audiences, and the unpredictable, always controversial Dylan has explored literature and visual arts throughout his decades-long sojourn with songwriting and composing. He still records and tours, the accolades of generations of musicians and a 2016 Nobel Prize under his belt, serving, willingly or not, as an inspirational beacon for others as they blaze their own artistic paths.

Opposite left: T-Bone Burnett, Bob Dylan, Mick Ronson, and an unidentified stagehand on the Rolling Thunder Revue tour at a free concert at the infamous Gatesville State School for Boys, TX, May 15, 1976; during the show Joan Baez and Joni Mitchell got up to dance with the audience.
📷 © **NICOLAS RUSSELL**

Opposite right: Dylan at the Civic Theater, San Diego, December 10, 1965
📷 **RICHARD DOWDY**

Above: Dylan at The Castle, home of Tom and Lisa Law, John Phillip Law, and Jack Simmon, Los Angeles, March 1966
📷 © **LISA LAW**

THE BEATLES

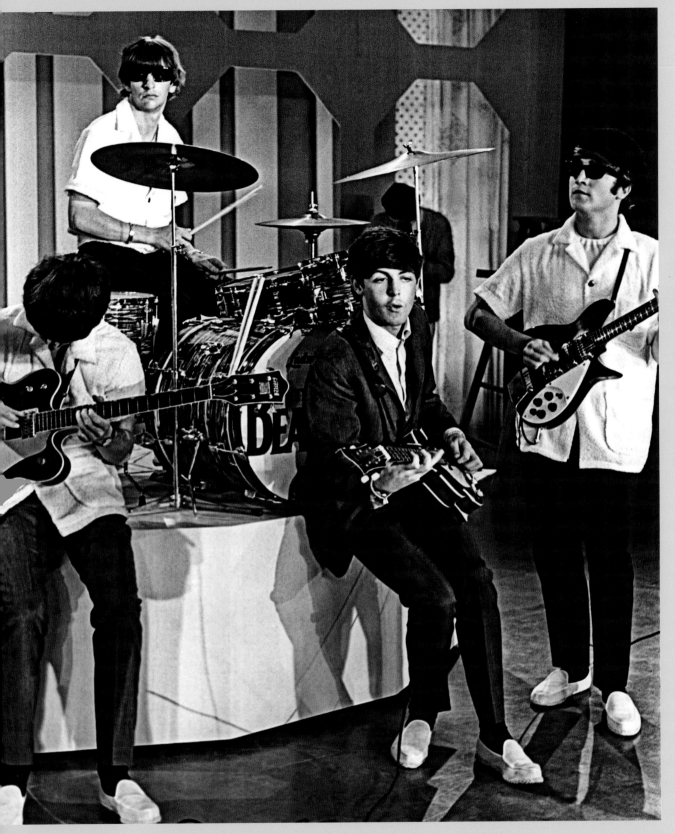

Perfection doesn't strike every day, but when it does, the light it throws on everything before and after can be blinding. When John Lennon (1940–80), Paul McCartney (b. 1942), George Harrison (1943–2001), and Ringo Starr (b. 1940) made their first recordings in London in 1962, the world wasn't ready. Life in postwar England remained buttoned up and bleak, bombed-out ruins still dominating the landscape. The electrical jolt of rock and roll offered by the Fab Four quickly set Britain, and then the rest of the world, free. The budding musicians from Liverpool had schooled themselves in early American rock and roll, everyone from Buddy Holly, the Everly Brothers, and Chuck Berry to rhythm and blues artists including Arthur Alexander and girl group the Cookies. What they did with that education split the musical atom. Riding their early twenties, the Beatles skipped imitation. They internalized all they had learned and let it flow into their music to create something entirely new. In doing so, they taught a master class in just how originality works and blazed a path for popular music that is still being explored. The power of original songs by Lennon and McCartney, and soon Harrison, captivated early audiences with sheer energy ("Love Me Do," "She Loves You," "I Want to Hold Your Hand"), and then changed their worldview ("All You Need Is Love"). Their appearance on *The Ed Sullivan Show* on February 9, 1964, began a meteoric shot to stardom, and yet the Beatles kept outdoing themselves at every step nearly until their breakup in 1970. Song after song, album after album proved them ground zero for modern rock. There's no way to overstate their place in the world, nor can it ever be outdone. The Beatles were, well, the Beatles.

This page: George Harrison, Ringo Starr, Paul McCartney, and John Lennon on *The Ed Sullivan Show*, February 16, 1964
📷 **JHP / CAMERA PRESS / REDUX**

Opposite: Lennon, Starr, McCartney, and Harrison at EMI Studios, London, 1964
📷 © **DAVID HURN / MAGNUM PHOTOS**

OTIS REDDING

Never mind that Otis Redding (1941–67) got his start as a driver/valet for singer Johnny Jenkins and cut the early single "These Arms of Mine" only because his employer had time left over from his own session. Once Redding's song connected with radio, the cast was set. His voice boasted beauty and grit, a sound that made audiences weak in the knees. Aided by Stax Records house band Booker T. & the MG's, the songs poured out of the studio in Memphis as though Redding had pulled down the sky and laid it out for all to hear. In fact, his music brought black and white audiences together in a way that helped change the country. In 1965, *Otis Blue* seemed to stop time altogether, as if the singer from Macon, Georgia, had seen something in the heart of humans and arrived to help. Performing at the Monterey Pop Festival in June 1967 for a mostly young, white audience, he dropped jaws the moment he walked onstage. The frenzy he whipped up there, and at every other venue, became a crusade. Thus, in December 1967, when his small plane crashed into Lake Monona outside Madison, Wisconsin, killing the twenty-six-year-old dynamo and all but one of his band members, the music community once again mourned the day the music died, just as it had with Buddy Holly, J. P. "The Big Bopper" Richardson, and Ritchie Valens. Redding's "(Sittin' on) The Dock of the Bay" became the first posthumous single to hit No. 1, ensuring his immortality and so much more.

Otis Redding at the Whisky a Go Go, West Hollywood, CA, April 1966
📷 © LISA LAW

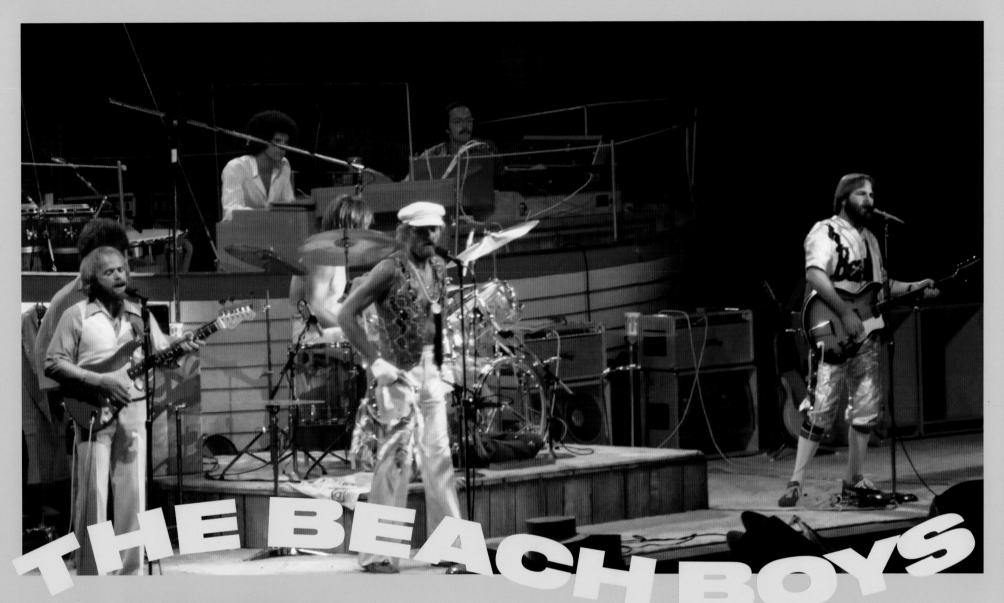

THE BEACH BOYS

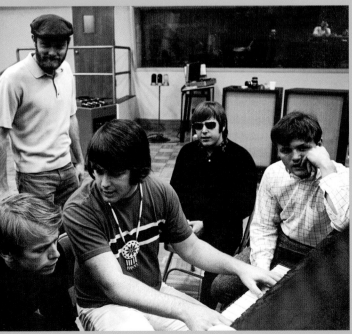

In one of the great incongruities of modern music, the Beach Boys began as a surf-rock band even though only one member, Dennis Wilson (1944–83), regularly surfed. But imagination drives all great creations. His brother, musical savant Brian Wilson (b. 1942), noted his love of the sea and began to craft songs around the Southern California idyll of cars, girls, and the beach. The pair, plus their brother Carl (1946–98), cousin Mike Love (b. 1941), Al Jardine (b. 1942), and early replacement David Marks (b. 1948), began practicing in the Wilson house in Hawthorne, California. In 1961, they released "Surfin'," their first single, utilizing a garage-rock approach to create soaring harmonies influenced by the Four Freshmen and other vocal ensembles. Under Brian's direction, they started out on a course of recordings that would set them apart from other American bands. By 1965, Brian had left the live act, and the surf sound, behind to concentrate on recording, which reached its zenith the following year with *Pet Sounds*, a multilayered masterwork that used everything from standard guitar to whistles to theremin in its unusual instrumentation. It was such a break from the Beach Boys' previous work that their label didn't know how to promote it, although history now counts it as one of the most influential releases of all time. Brian wrestled with mental and physical problems well into the next decade but never stopped questing after the perfect sound. Following the deaths of Dennis and Carl and Brian's on-again, off-again estrangement from Love, the Beach Boys' legacy remains fraught with fissures and financial battles. In the end, however, their shared musical legacy established them as one of America's favorite bands.

Above: Al Jardine (guitar at left), Mike Love (center mic), Dennis Wilson (drums), and Carl Wilson (guitar at right) at the Spectrum, Philadelphia, August 11, 1976
📷 **JOE SCHRIER**

Left: Jardine, Love (standing), Brian Wilson, Carl Wilson, and Bruce Johnston in the studio for *Smile Sessions*, Hollywood, CA, ca. late 1960s
📷 **GUY WEBSTER**

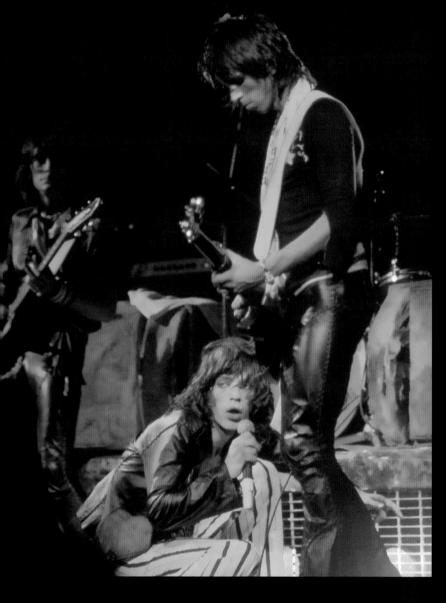

There's just no getting over the blues. Something so funda-mentally life-altering occurs that it changes the temperature of the blood flowing through a body. That's precisely what happened to Brian Jones (1942–69) in founding the Rolling Stones. Primarily a guitarist, but a genius multi-instrumentalist as well, he became obsessed with the raw sound, and particularly the playing, of Jimmy Reed and Elmore James. In London in 1962, his want ad landed singer Mick Jagger (b. 1943) and guitarist Keith Richards (b. 1943), who had bonded as boyhood friends over Muddy Waters and other Chess Records artists. Their mission to indoctrinate any and all into the "blues me or lose me" club changed the course of rock and roll. Completed by drummer Charlie Watts (b. 1941) and bassist Bill Wyman (b. 1936), the Rolling Stones put together a blues cover playlist undeniable in its influence and whipped up a storm of followers in London nightclubs. The Beatles ruled the British Invasion, but the street-fighting Stones gave no quarter. Soon enough, their raucous cover of Waters's "I Just Want to Make Love to You" shook U.K. radio, aided and abetted by a brilliantly realized public relations campaign that took their bad boy-isms to the hilt. Eventually, their music grew into culture-shaping originals such as "(I Can't Get No) Satisfaction" and "Sympathy for the Devil." Jones, the man who touched off the whole chain reaction, fell out of favor. After drowning in his swimming pool, he was replaced first by young wunderkind guitarist Mick Taylor (b. 1949) and then veteran Ron Wood (b. 1947). Jagger and Richards always ran the band anyway, with Watts's unrelenting beat to make it burn. Against every odd known to man and beast, the Rolling Stones' reign is permanently set.

Top left: Ron Wood, Mick Jagger, and Keith Richards at the Chicago Stadium, July 1975
📷 **JIM SUMMARIA PHOTOGRAPHY**

Bottom left: Richards and Bill Wyman at the Forum, Los Angeles, 1972
📷 **JAMES FORTUNE**

Opposite: Charlie Watts (drums), Richards, Wyman, Brian Jones, and Jagger at the Washington Coliseum, Washington, D.C., November 13, 1965
📷 **JOE F. COMPTON**

THE ROL

LING STONES

BOOKER T. & THE MG'S

Backup bands rarely step into the spotlight and steal the thunder. Instrumental groups can't compete with bands with lead singers. Booker T. & the MG's did better than that. As a young student visiting Stax Records in Memphis, Booker T. Jones (b. 1944) hoped to learn about getting into the music business. Coupled with drummer Al Jackson Jr. (1935–75), then-bassist Lewis Steinberg (1933–2016), and Steve Cropper (b. 1941) on guitar, the racially mixed lineup played for fun until the lark became the 1962 megahit "Green Onions." It became a theme for a whole generation of groovers, something they could listen to, dance to, dream to, and led the group to become the go-to house band at Stax, still developing a lock on the soul music scene. When Donald "Duck" Dunn (1941–2012) replaced Steinberg, the quartet developed its own musical ESP. Jackson's beat and down-home sophistication locked in the other instruments, letting them individually explore ideas that pushed "the talent" during recording sessions. Carla Thomas, Otis Redding, Albert King, William Bell, Sam & Dave, and dozens of others luxuriated in the warm and seductive glow of Booker T. & the MG's. At the same time, they rolled their own hits, including "Time Is Tight," "Chinese Checkers," and "Hip Hug-Her." Of course, it proved too good to last. Soul music evolved into new arenas by the mid-1970s, but for a solid decade there, no other American band rivaled the gut-punching power of Booker T. & the MG's.

Left: Donald "Duck" Dunn, Steve Cropper, Booker T. Jones, and Al Jackson Jr.
📷 **ALEC BYRNE**

Below left: Jones at the Beacon Theater, New York City, October 14, 1990
📷 © EBET ROBERTS

Below: Jones, Dunn, Cropper, and Jim Keltner at the Rock and Roll Hall of Fame, Cleveland, September 2, 1995
📷 © **EBET ROBERTS**

A restless, many-headed beast, folk music explores any and all paths. Centuries of previous music dances on its fingertips, but convention rules it nonetheless. When John Phillips (1935–2001) glimpsed popular music and didn't like what he saw, he developed another way. He and his wife, Michelle Phillips (b. 1944), hit the East Coast club circuit hard, but joining with singer Denny Doherty (1940–2007) opened avenues into fresh territory. Cass Elliot (1941–74) completed the picture. At first, the foursome called themselves the Magic Cyrcle. As the Mamas & the Papas, the group spent a few months woodshedding in the Virgin Islands and landed an audition for Lou Adler at Dunhill Records in 1965. Done deal. Their first single, "Go Where You Wanna Go," sounded promising, but no go. The next, "California Dreamin'," embodied the era for generations to come. What made the two men and two women unique was that each was an absolute individual. They didn't veer into one another's lanes vocally, looks-wise, or by virtue of their personalities, but together they made up an appealing whole, one that television cameras and radio airwaves devoured. Before the members developed an incurable case of solo-itis and began drifting apart, the Mamas & the Papas had built a legend as big as the sunny Los Angeles landscape they adopted and helped define. That folk tale has grown into a true American tradition.

John Phillips, Denny Doherty, Michelle Phillips, and "Mama" Cass Elliot at the Monterey International Pop Festival, CA, June 18, 1967
© JIM MARSHALL PHOTOGRAPHY LLC

THE MAMAS & THE PAPAS

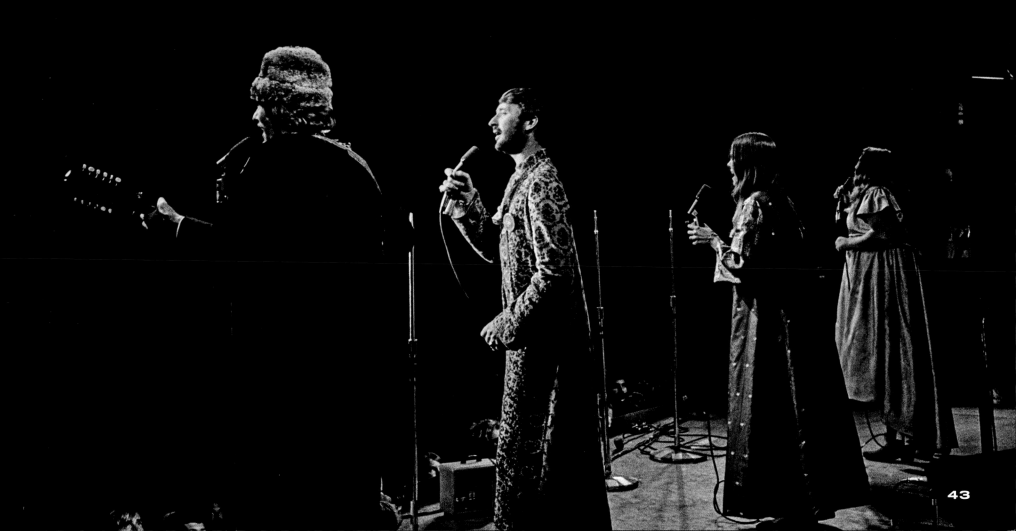

13TH
FLOOR
ELEVATORS

Psychedelic music cannot be traced to one starting point. First synthesized in the late 1930s and later tested by the CIA during the Cold War, LSD changed the course of the 1960s as soon as it escaped the laboratory and crossed into the general population—beginning with musicians. The drug splintered the doors of perception and gave many of its users the freedom to create what no one saw coming. In Austin in 1965, University of Texas student Tommy Hall (b. 1943) experimented with acid and decided the best way to share what he was learning was through rock and roll. He gathered a seventeen-year-old townie named Roky Erickson (b. 1947), who had been fronting a band called the Spades, and drummer John Ike Walton (b. 1942), bassist Benny Thurman (1943–2008), and guitarist Stacy Sutherland (1946–78). Naming their new aggregation the 13th Floor Elevators made sense, because most buildings didn't have such a floor and Hall sought to transport listeners to a place they had never been. Songs such as "Roller Coaster" and "Reverberation (Doubt)" captured the altered states that psychedelics induced. Hall played an electrified jug, while the others experimented with feedback and controlled chaos. First single "You're Gonna Miss Me" was a holdover from the Spades but made a strong dent on the charts. A 1966 tour of San Francisco gave their distinct sound popular context, and Jimi Hendrix's manager even asked them to join the guitar god in England. It wasn't meant to be. The band members returned to Texas to record their second album and soon were arrested on drug charges that spelled their doom. Erickson ended up in a hospital for the criminally insane and has fought his way back to continue recording and touring. The others never found the fame their early explorations predicted, and the band is now more infamous than celebrated. Nevertheless, they invented psychedelic rock alongside the Grateful Dead, Jefferson Airplane, and other Bay Area breakouts. As long as listeners seek the beyond, the 13th Floor Elevators will have a home.

Opposite: Tommy Hall, Benny Thurman, Roky Erickson, John Ike Walton, and Stacy Sutherland

Below: Hall (left) and Erickson (right)
Both at La Maison, Houston, January 1966
📷 all **BOB SIMMONS**

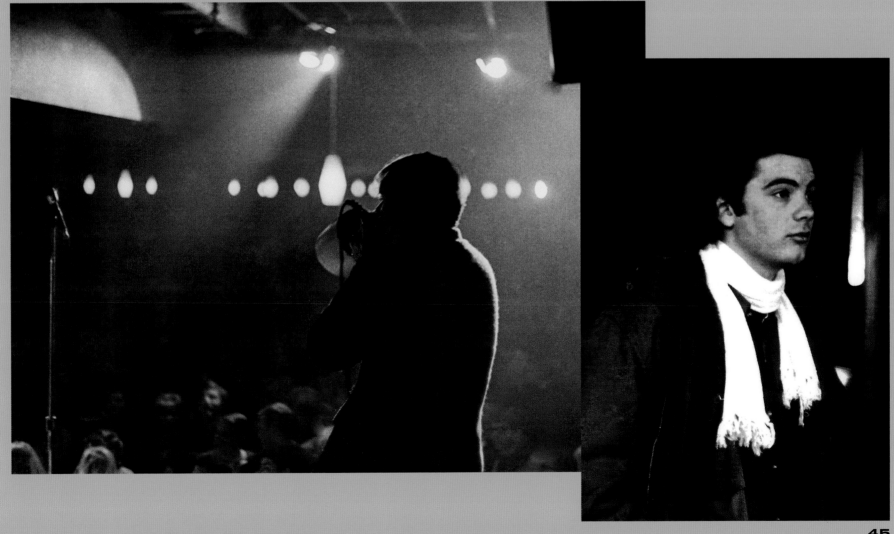

THE KINKS

No other British rock band started with such a basic sonic assault. The Kinks were armed with primary rhythms and monstro guitar chords that evolved into a provoking and artful expression of English elegance. Their first two hits, "You Really Got Me" and "All Day and All of the Night," ran roughshod at retail with little early warning in 1964. They dressed like upper-class schoolboys but stomped out a sound like street hoodlums. Audiences ate it up. Brothers Ray (b. 1944) and Dave Davies (b. 1947) could barely contain their blood feuding, and milked it creatively for every last drop. Drummer Mick Avory (b. 1944) and bassist Pete Quaife (1943–2010) mostly stayed in the background, hammering out an animalistic beat that set crowds ablaze. Once the Kinks cemented top status on the rock roll call, they branched out into albums such as *The Kinks Are the Village Green Preservation Society* and *Arthur* (*Or the Decline and Fall of the British Empire*). Mainstream America didn't know quite what to make of all this very English sophistication, but the band won over a whole new cult of attuned elites who knew something important was happening. By then, bandleader Ray Davies looked at the Kinks as his palette to paint with as he pleased, and so began the intraband fireworks and parade of members. In so many ways, that had no effect on kingdom Kinks, and dedicated followers of this fashionable outfit stayed right with them. In terms of longevity, the Kinks aren't far behind the Rolling Stones, even if the band is now mostly the Ray Davies show. Pushing into his seventh decade, Davies is still sharpening his songwriting skills, and he continues to exhibit a knowing way around an audience's heartbeat as he explores the human landscape of fame and foible.

Right: The Kinks. *Opposite:* Ray Davies, Dave Davies, and Pete Quaife. Both at the Bickershaw Festival, May 1972
📷 both © **BARRIE WENTZELL**

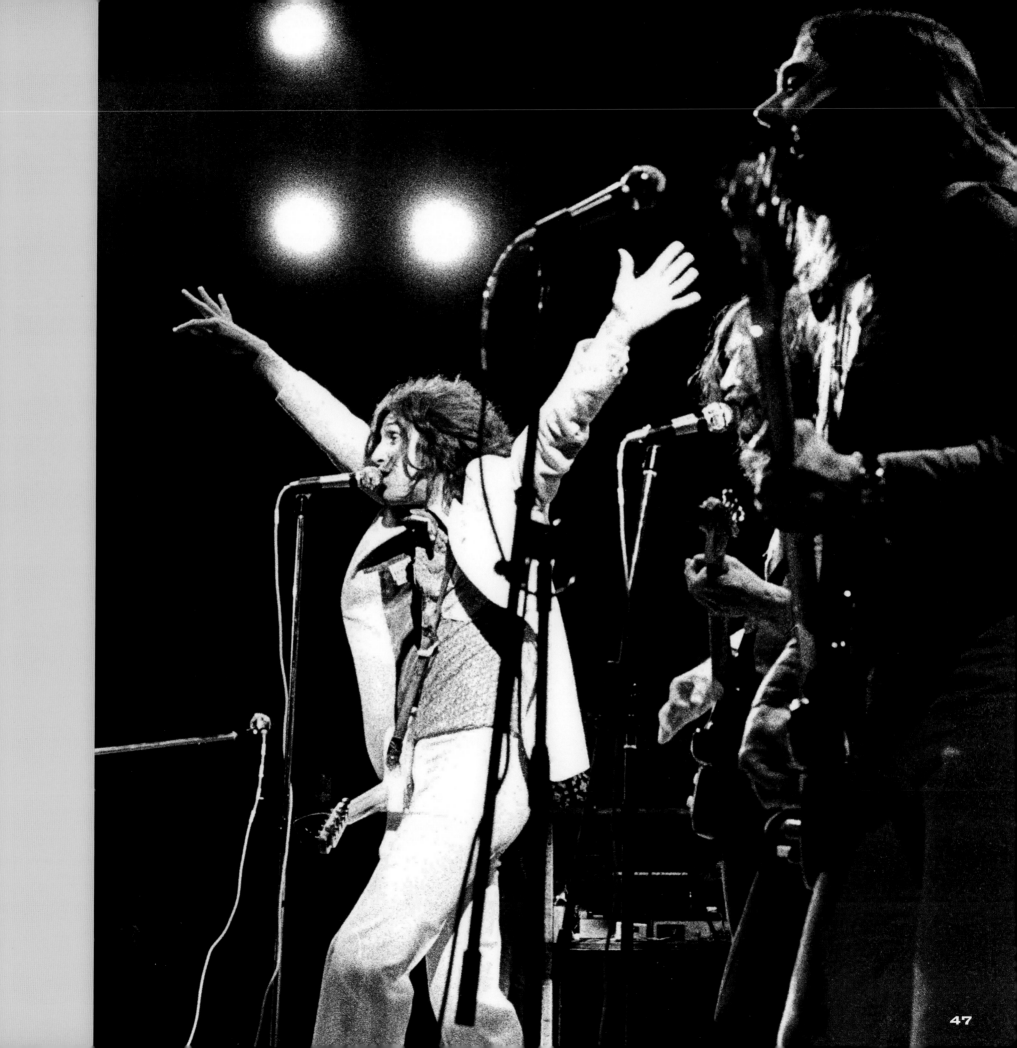

47

Contrast Paul Butterfield's (1942–87) name recognition to his imprint on rock and roll. Upending people's conceptions of what white blues musicians could do, his band first roared out of the Windy City in 1963, and its 1965 self-titled debut album helped to blaze an egalitarian approach to the blues. Lead guitar wonder Michael Bloomfield (1943–81), rhythm guitarist Elvin Bishop (b. 1942), bassist Jerome Arnold (b. 1936), keyboardist Mark Naftalin (b. 1944), and drummer Sam Lay (b. 1935) backed harmonica front man Butterfield, whose Little Walter–inspired playing evolved into an open-ended expression of jazz that was still anchored in the street-tough inclination of the blues. As a unit, they played hard together and never fell back on simply imitating the musicians they revered, such as Muddy Waters, Howlin' Wolf, and Sonny Boy Williamson. It didn't take long for audiences beyond Chicago to key in on Butterfield. Bob Dylan borrowed his rhythm section, which had previously been the mighty Howlin' Wolf's, when he went electric at the Newport Folk Festival on July 25, 1965, and ushered in a new era of what was then tagged as folk rock. Other mesmerizing lineups followed for Butterfield, who helped to pave the way for the introduction of Chicago-style electric blues into rock and roll. As health problems overtook his thunder in the 1980s, he gallantly kept playing. When Butterfield died of a drug overdose in 1987, all those who had achieved so much because of his early innovations said a prayer for the man who had helped to make blues an essential element of rock.

Right: Paul Butterfield at Madison Square Garden, New York City, December 19, 1969
📷 **STEVE BANKS / STUDIO 6**

Below: Elvin Bishop, Michael Bloomfield, and Butterfield at the Monterey Jazz Festival, CA, September 17, 1966
📷 © **JIM MARSHALL PHOTOGRAPHY LLC**

paul butterfield blues band

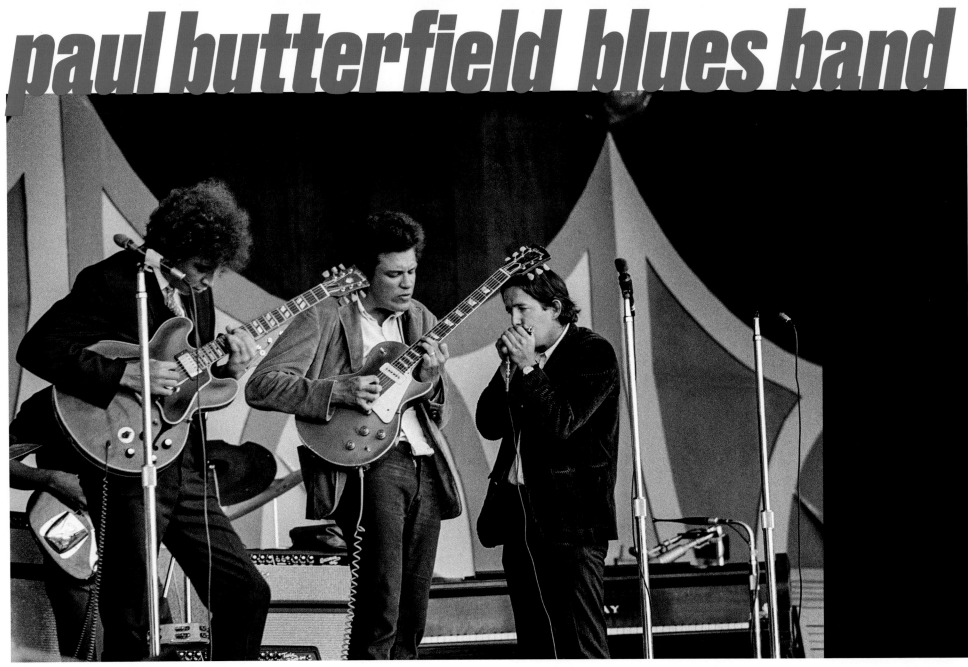

Cream

New music exploding out of mid-1960s England never exceeded the promise of Cream. Branded a supergroup from note one, guitarist Eric Clapton (b. 1945), bass player and singer Jack Bruce (1943–2014), and percussive giant Ginger Baker (b. 1939) played louder than jet airplanes—and for as long as they pleased. The first English guitar god, emerging from the pop ascension of the Yardbirds to take a blues purist turn in John Mayall's Bluesbreakers, Clapton summoned all manner of six-string mania, while Baker and Bruce's volatile chemistry produced truly gargantuan rhythms. Together—a power trio in the truest sense—they could play anything with a sonic assault no other rockers possessed. Earth shook on its axis. Debut LP *Fresh Cream* in 1966 left its mark on this blooming terrain, but *Wheels of Fire* two years later rolled four sides of unadulterated flights of fancy, and still hasn't been surpassed as a demonstration of what three musicians can do when left to their own devices. Short-lived almost by nature, the threesome reverberates into infinity. Mention Cream today, and heads nod, grins widen, and eardrums most likely rattle. Clapton went on to worldwide acclaim, while Baker and Bruce plied their trade with pride in a variety of places (Fela Kuti, Ringo Starr). A 2004 reunion tour in London and then in the United States began with good intentions, but even if artists can return home, they usually don't stay long.

Left and below left: Jack Bruce, Ginger Baker (seated, drums), and Eric Clapton (left); and Baker (on drums) and Bruce at the Fillmore (below left) in San Francisco, August 1967
📷 both © **JIM MARSHALL PHOTOGRAPHY LLC**

Below right: Bruce, Clapton, and Baker at the Chicago Coliseum, October 13, 1968
📷 **MARSHALL BOHLIN**

THE VELVET UNDERGROUND

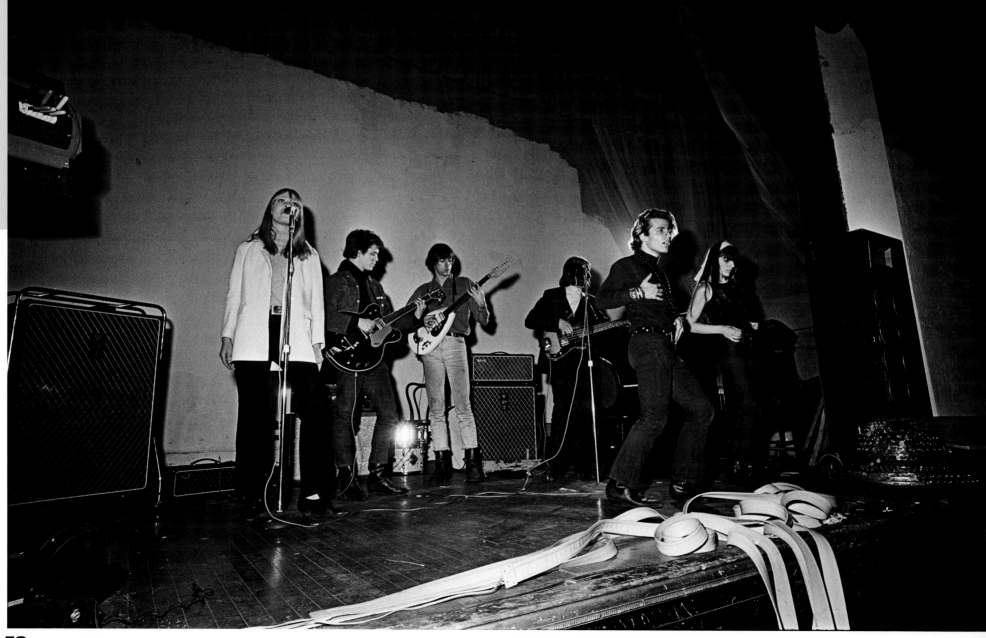

Never have thirty-seven songs changed so much. Over four albums and five years, the Velvet Underground turned rock and roll into everything it had promised. Lou Reed (1942–2013), John Cale (b. 1942), Maureen "Moe" Tucker (b. 1944), and Sterling Morrison (1942–95) began exploring their own definition of reality in 1965 following a few Greenwich Village gigs, none of which resulted in a return engagement. Andy Warhol then became aware of the foursome and offered them psychic support and space to play at his Manhattan headquarters, the Factory. From there, all hell broke loose. Feedback drones, adult lyrics, and the visual light show from the Exploding Plastic Inevitable all became part of a Velvet Underground oeuvre more notorious than well-known. Reed's songwriting thrived, "Sister Ray" unveiling a seventeen-minute study of life in the dark corners of counterculture, while spoken-word piece "The Gift" delivered the tale of a young man who mails himself to his girlfriend before being stabbed in the head—all set to a gurgling sound. This was

uncharted territory for rock and roll, and band members paid a price. Following Cale's departure in 1968 and after Warhol lost interest, a radiant beauty deepened the band's sound, Reed as ever unflinching. Their last recorded song, "Oh! Sweet Nuthin' " in 1970, was sung by Cale replacement Doug Yule after Reed left the band. Its chorus: "Oh, sweet nuthin'. She ain't got nothing at all." For the Velvet Underground, its brief but electrifying run at rock and roll history gave it the world.

Opposite: Nico, Lou Reed, Sterling Morrison, John Cale, and dancers Gerard Malanga and Mary Woronov of the Exploding Plastic Inevitable at the Dom, New York City, April 7, 1966
📷 **LARRY C. MORRIS /** *NEW YORK TIMES* **/ REDUX**

Below: Reed, Morrison, Nico, Ari Boulonge (Nico's son), Maureen "Moe" Tucker (drums), and Cale being filmed by Andy Warhol at the Factory, New York City, 1966
📷 © **STEPHEN SHORE**. Courtesy **303 GALLERY, NEW YORK AND ART + COMMERCE**

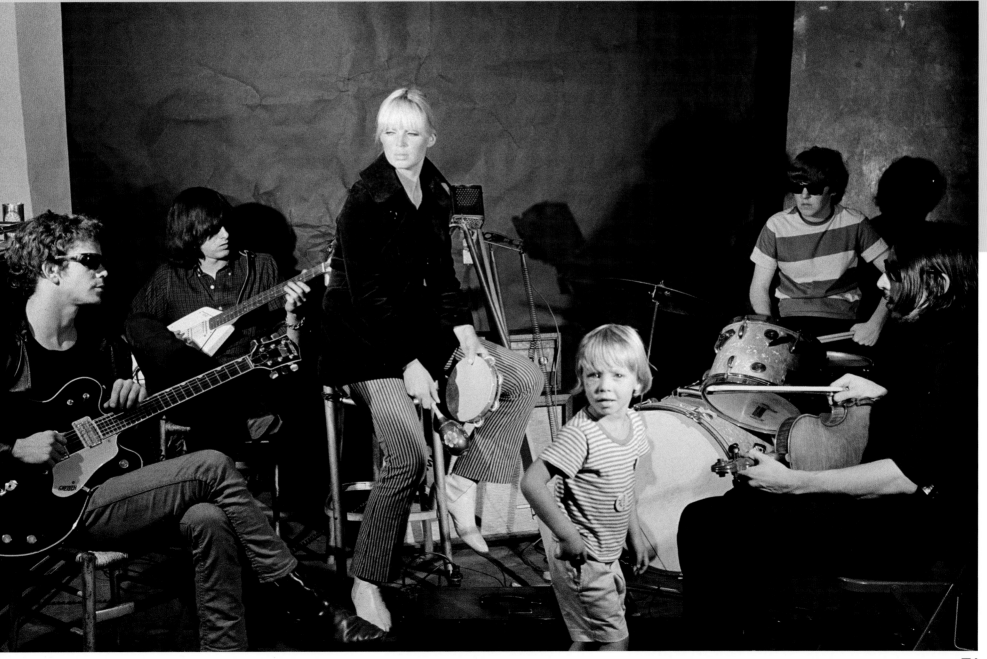

The Who

Roger Daltrey (b. 1944), Pete Townshend (b. 1945), Keith Moon (1946–78), and John Entwistle (1944–2002) came together in 1964, enamored of the mod scene in England and looking for a way to crash the party. They called themselves the Detours, a bit earthbound for the band's upward aspirations, but it didn't take long for them to become the Who. From that day on, the four musicians set their sights on destroying the modern conventions of a British Invasion band, replacing them with incendiary music models and a flamboyant visual flair. That they succeeded so quickly marked them immediately as a regal group that would never settle for less. "I Can't Explain," "I Can See for Miles," and "My Generation" are a few titles that set the rock crowd on edge, but even those couldn't prepare fans for what was to come. The phrase "rock opera" prompted wonder on both sides of the Atlantic, but it took only one spin of the Who's double-album opus *Tommy* in 1969 to redefine expectations of what a rock band could be. Townshend's autobiographical songs dissected social strata, and *Quadrophenia* four years later proved *Tommy* no fluke. In less than a decade, the Who accomplished the mind-bending feat of redefining rock music as anything its creators had the ability to do. Whenever the words "see me, feel me, touch me, heal me" sound, the opening lines of *Tommy* make hearts beat faster as the listener experiences a generation's shining moment of unity.

Right: Roger Daltrey, Houston, 1976
📷 **JAMES FORTUNE**

Opposite, top and bottom left: John Entwistle (far left), Daltrey, Keith Moon, and Pete Townshend at the Monterey International Pop Festival, CA, June 1967
📷 **GUY WEBSTER**

Opposite, top right: Moon at the International Amphitheatre, Chicago, December 1975
📷 **DAVID SLANIA**

Opposite, bottom right: Townshend at the Day on the Green, Oakland Coliseum, CA, October 9, 1976
📷 **GARY KIETH MORGAN**

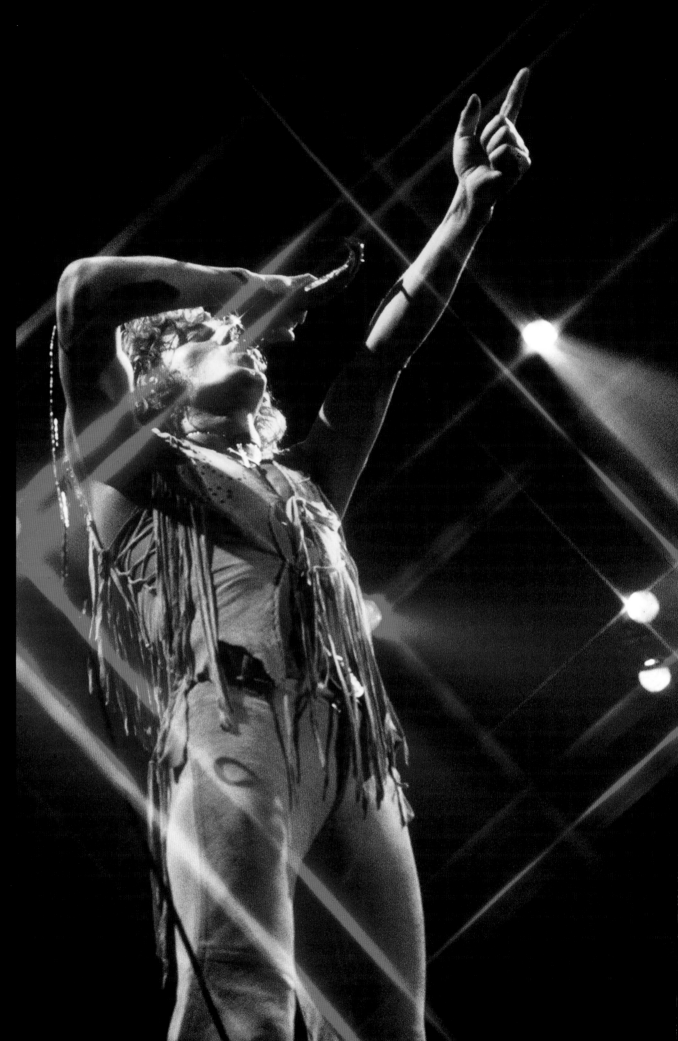

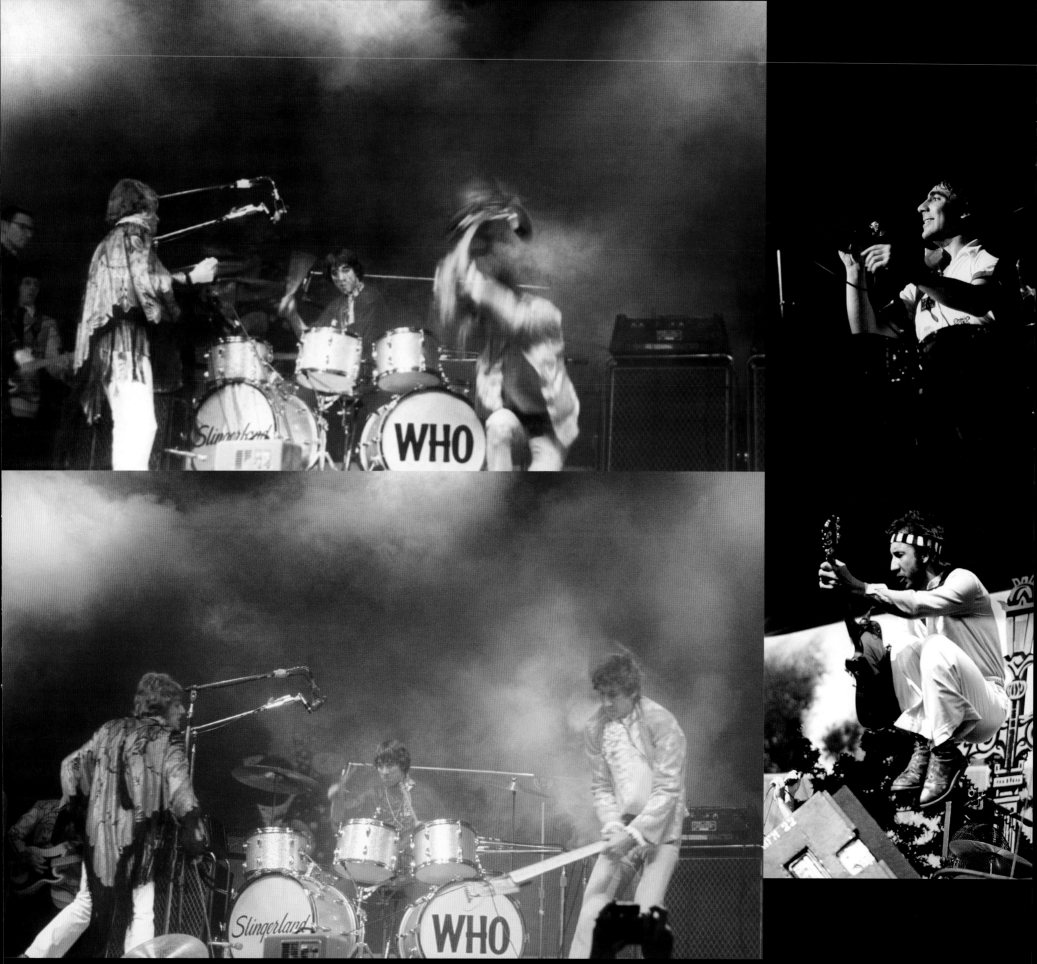

ACID INCENSE & BALLOONS

FROM SOUL QUEENS TO NEW ORLEANS

CHAPTER 3

Pink Floyd at Radio City Music Hall,
New York City, March 17, 1973
 © BOB GRUEN

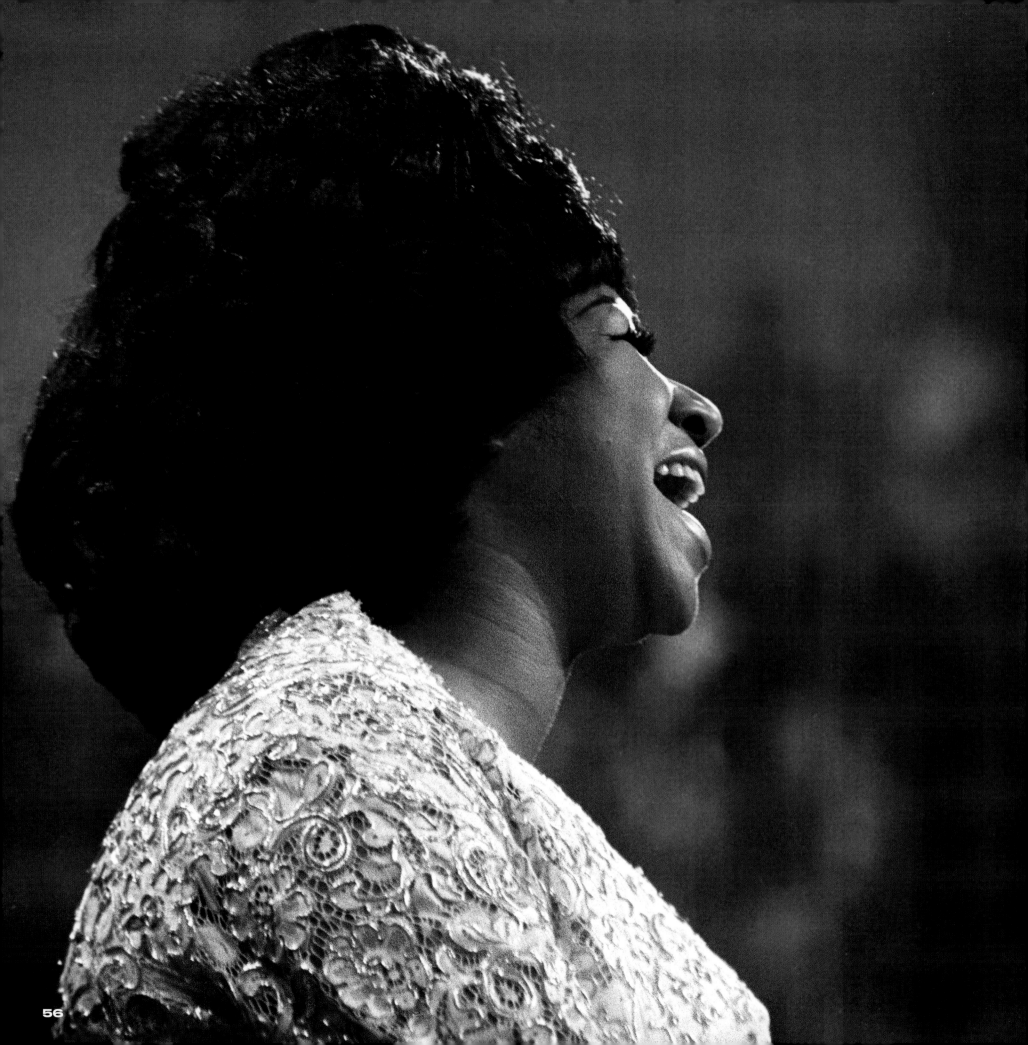

aretha franklin

Who better than Aretha Franklin (b. 1942) to have been born out of the church? Her preacher father, C. L. Franklin, made a name for himself in Detroit, and everyone noticed his daughter's command of a stage. At the outset of her recording career in 1960, when she was just eighteen, Columbia Records couldn't reconcile her vast voice with their gospel and jazz backing. That changed in 1967 when she signed to Atlantic Records and was sent to Muscle Shoals, Alabama, to record "I Never Loved a Man the Way I Love You." In a small studio surrounded by musicians she had never met, the singer led every one of them to the glory road. The resulting album, one of two she released that year, announced a star of such magnitude and resolve that audiences, radio programmers, and what seemed like the whole country stepped back in wonder. Lady Soul, as she became known, crafted an overwhelming attack on the inner feelings of men and women everywhere. She had an unfiltered way of using music to zero in on what was happening inside the soul. That first hit song carved her name in stone, and began as successful a run on the charts as seen before or since. Along the way, she recorded the classic live album *Amazing Grace* in 1972, which put her right back in the church and opened the doors to a spiritual release for all to hear. The circle remains unbroken.

Aretha Franklin at the Democratic National Convention, Chicago, August 26, 1968
all **DON HOGAN CHARLES** / *NEW YORK TIMES* / **REDUX**

GRATEFUL DEAD

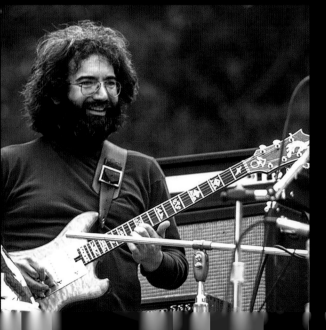

Aural hallucinations? While recording their second album, 1968's *Anthem of the Sun*, the Grateful Dead requested a trip to the desert outside Los Angeles to record air. The engineer left the building. Such was the essence of the Grateful Dead: Seek the impossible, and if that doesn't work, try something equally impossible. They grew out of the organic folk scene around Palo Alto, California, in 1965 and a group originally called the Warlocks that played covers in a pizza parlor. Ken Kesey and his LSD-imbued Merry Pranksters enlisted the band to play their Acid Tests, and the renamed Grateful Dead began a bus trip that never stopped. Guitarists Jerry Garcia (1942–95) and Bob Weir (b. 1947), bassist Phil Lesh (b. 1940), keyboard/harmonica player Ron "Pigpen" McKernan (1945–73), and drummer Bill Kreutzmann (b. 1946) granted themselves the freedom to do whatever they wanted, as their songs expanded into sprawling, sometimes hour-long explorations of all that modern music could conceivably be.

They began a Pied Piper–like odyssey of gathering followers called Deadheads and taking them on cosmic trips into the great unknown. Some sounds might be electronic odes to the heavens, while others came down on the side of country-themed American anthems, but no matter what the Grateful Dead played, it was always dusted with a feeling of having been filtered through a third eye. When Garcia died in 1995, the band's self-styled long strange trip didn't cease, but rather continued in new formations and constellations. The Grateful Dead's "Dark Star" still guides the way.

Above: Ron "Pigpen" McKernan, Bill Kreutzmann, Jerry Garcia, Phil Lesh, and Bob Weir at West Park, Ann Arbor, MI, August 13, 1967
📷 **LENI SINCLAIR**

Left: Garcia at Marx Meadow in Golden Gate Park, San Francisco, May 30, 1975
📷 **RON DRAPER**

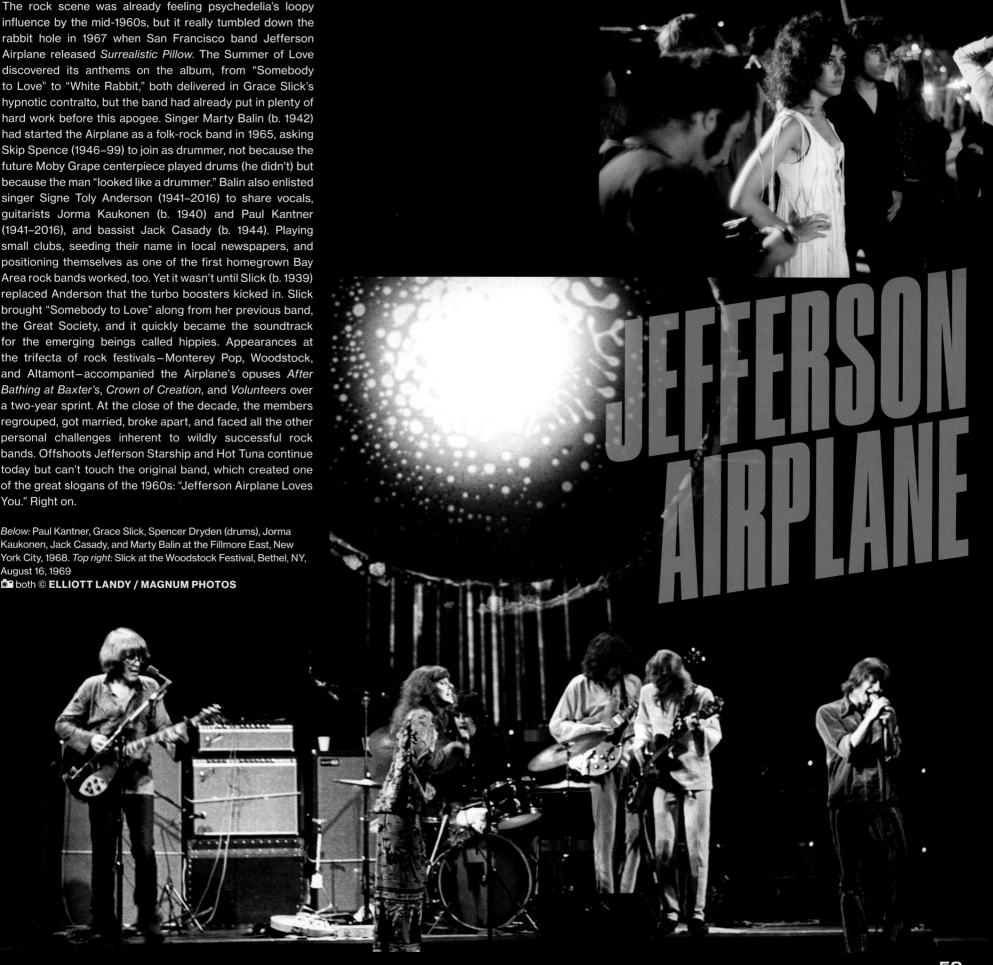

The rock scene was already feeling psychedelia's loopy influence by the mid-1960s, but it really tumbled down the rabbit hole in 1967 when San Francisco band Jefferson Airplane released *Surrealistic Pillow*. The Summer of Love discovered its anthems on the album, from "Somebody to Love" to "White Rabbit," both delivered in Grace Slick's hypnotic contralto, but the band had already put in plenty of hard work before this apogee. Singer Marty Balin (b. 1942) had started the Airplane as a folk-rock band in 1965, asking Skip Spence (1946–99) to join as drummer, not because the future Moby Grape centerpiece played drums (he didn't) but because the man "looked like a drummer." Balin also enlisted singer Signe Toly Anderson (1941–2016) to share vocals, guitarists Jorma Kaukonen (b. 1940) and Paul Kantner (1941–2016), and bassist Jack Casady (b. 1944). Playing small clubs, seeding their name in local newspapers, and positioning themselves as one of the first homegrown Bay Area rock bands worked, too. Yet it wasn't until Slick (b. 1939) replaced Anderson that the turbo boosters kicked in. Slick brought "Somebody to Love" along from her previous band, the Great Society, and it quickly became the soundtrack for the emerging beings called hippies. Appearances at the trifecta of rock festivals—Monterey Pop, Woodstock, and Altamont—accompanied the Airplane's opuses *After Bathing at Baxter's*, *Crown of Creation*, and *Volunteers* over a two-year sprint. At the close of the decade, the members regrouped, got married, broke apart, and faced all the other personal challenges inherent to wildly successful rock bands. Offshoots Jefferson Starship and Hot Tuna continue today but can't touch the original band, which created one of the great slogans of the 1960s: "Jefferson Airplane Loves You." Right on.

Below: Paul Kantner, Grace Slick, Spencer Dryden (drums), Jorma Kaukonen, Jack Casady, and Marty Balin at the Fillmore East, New York City, 1968. *Top right:* Slick at the Woodstock Festival, Bethel, NY, August 16, 1969
📷 both © **ELLIOTT LANDY / MAGNUM PHOTOS**

JEFFERSON AIRPLANE

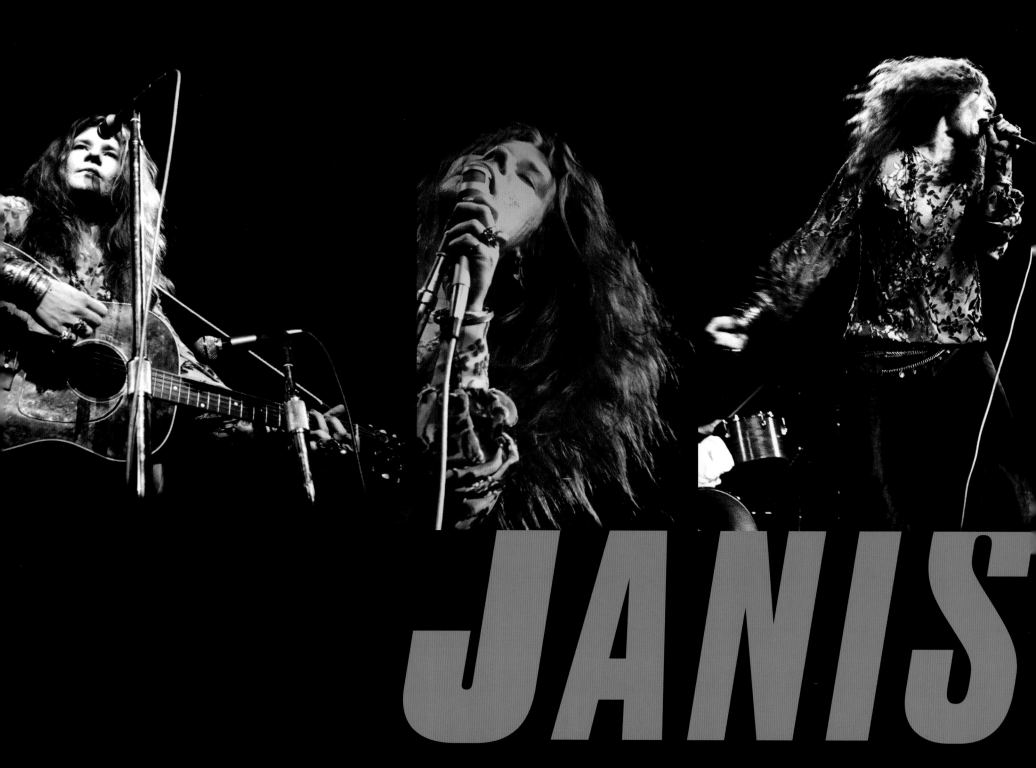

JANIS

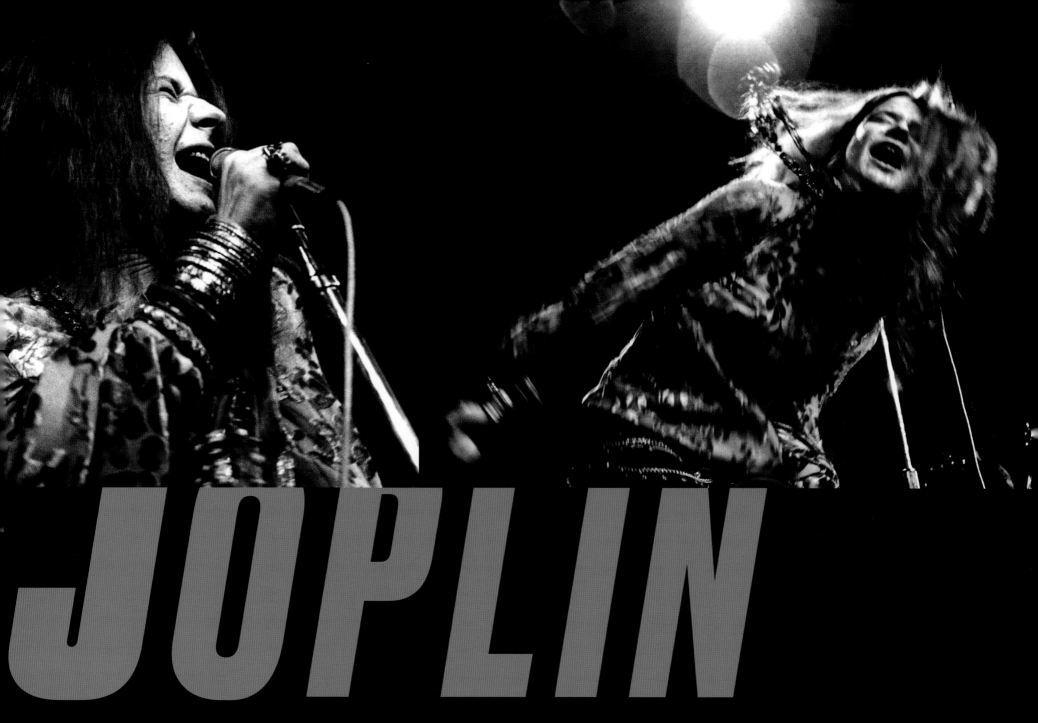

JOPLIN

Little Girl Blue grew up in Port Arthur, Texas, an oil-refining town that didn't want to try to understand those outside the norm. Janis Joplin (1943–70) was so far outside its boundaries that she spent her life trying to find a home. At the University of Texas at Austin, she was voted "Ugliest Man on Campus," sealing her decision to move west to San Francisco's Haight-Ashbury district. The singer joined Big Brother and the Holding Company in 1966, and soon became a figurehead for the counterculture and women everywhere. For herself, she wanted to be a wailing, stomping, cursing,

swinging, no-holds-barred rock singer who owed her soul to the blues and her laugh to the stars. The early days of the band weren't especially auspicious, but they radiated an undercurrent of greatness. Finding her voice among the electric instruments, Joplin unleashed a primal howl and physicality, and quickly destroyed all precepts about female rock singers. Many have tried in her absence, but no one has reached that elevation. Whether touching off rock whirlwind "Down on Me" or unleashing a suffering take on "Cry Baby," Joplin worked words into a prayer for existence. Naturally,

she eventually went solo, a trial-and-error excursion that finally brought the young Texan full circle to the song "Me and Bobby McGee." Tragically, Joplin died before its release, but her cackles and cries fly to this day.

Janis Joplin at Madison Square Garden, New York City,
December 19, 1969
© all STEVE BANKS / STUDIO 6

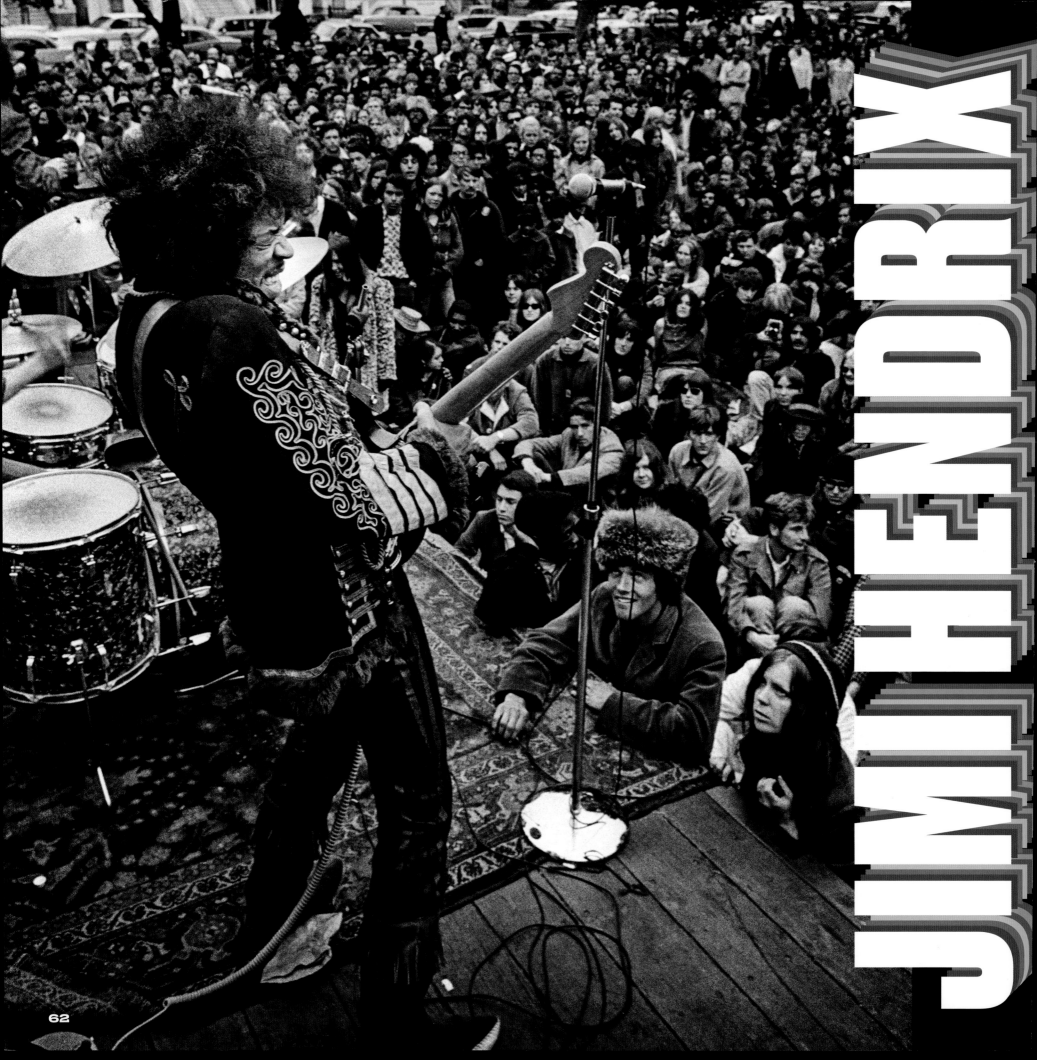

JIMI HENDRIX

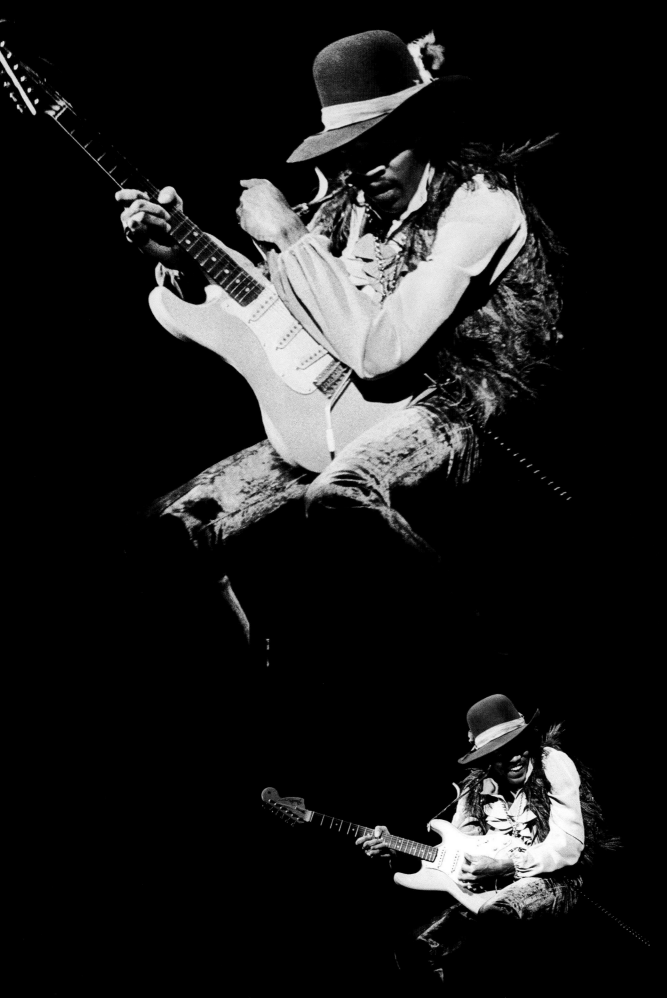

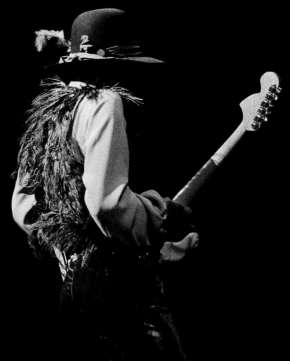

Rock and roll's basic currency is the electric guitar. Nearly all that music begins there, so it takes a certified wizard of wood and wire to move both instrument and genre into a new dimension. Jimi Hendrix (1942–70) did no less beginning in the mid-1960s when he left the African American chitlin' circuit and took a flying leap into the unknown. What he had learned backing bedrock artists such as Little Richard and the Isley Brothers could fill a book on the rudiments of guitar playing, but the reason Hendrix soared to such raging individualism is because he plugged in knowing he had to take electricity somewhere new. Manager Chas Chandler, who knew rock from the inside via his tenure on bass for the Animals, believed England would be the wisest place to launch, so the two took London by storm. Within months, every guitar guru there kissed the ring (and later the sky). Some feared Hendrix would make them obsolete as he ratcheted up every guitar trick known to man, be it playing it behind his back, throwing it in the air, or, yes, eventually setting it ablaze. Backed by the blustery Mitch Mitchell on drums and Noel Redding on bass, Hendrix short-circuited what audiences expected and replaced it with such a sweeping vision of rock's future that his revelations will be studied for as long as guitars plug into amplifiers. And he was correct in 1967 when he predicted that we'd never hear surf music again.

Opposite: Jimi Hendrix at a free concert in the Panhandle, Golden Gate Park, San Francisco, June 1967
📷 © **JIM MARSHALL PHOTOGRAPHY LLC**

This page: Hendrix at the Fillmore East, New York City, May 10, 1968
📷 **STEVE BANKS / STUDIO 6**

THE BAND

The Band had to be called the Band. No other name would have fit such a majestic and memorable amalgamation of musicians. Four Canadians and a ringer from Marvell, Arkansas, almost inadvertently made a sound from beyond time and place. Great White Northerners Robbie Robertson (b. 1943), Garth Hudson (b. 1937), Richard Manuel (1943–86), and Rick Danko (1943–99) joined firecracker drummer Levon Helm (1940–2012) in backing another Arkansan, rockabilly singer Ronnie Hawkins (b. 1935), in the early 1960s. In retrospect, fate turned them into the Hawks so they could coalesce while touring the Southern circuit and experiencing America up close. Especially eye-opening was becoming Bob Dylan's backup band through North America, a 1965 tour that elicited as many boos as cheers from the hardcore folk crowd, with its disdain for raucous, electric rock and roll. Both musical factions eventually settled in Woodstock, New York, Dylan and the Band woodshedding in a house dubbed Big Pink. When the latter debuted in 1968 with *Music from Big Pink*, it turned down the volume of the times by half. Restraint crossed with the voices of a previous era created a rootsy, ethereal ethos. It changed the course of rock music and led to introspection for much of the 1970s. The Band toured America, made other influential albums, and showed the world what mountain music could do. In 1976, Martin Scorsese turned their star-studded farewell concert *The Last Waltz* into a big-screen scrapbook of all the music that had gone into the Band and revealed their impact on American music for the ages.

Above: Robbie Robertson and Levon Helm at Royal Albert Hall, London, June 3, 1971
📷 © **BARRIE WENTZELL**

Right, top to bottom: Richard Manuel, Rick Danko, and Garth Hudson at the Woodstock Festival, Bethel, NY, August 17, 1969
📷 **HENRY DILTZ / MORRISON HOTEL GALLERY**

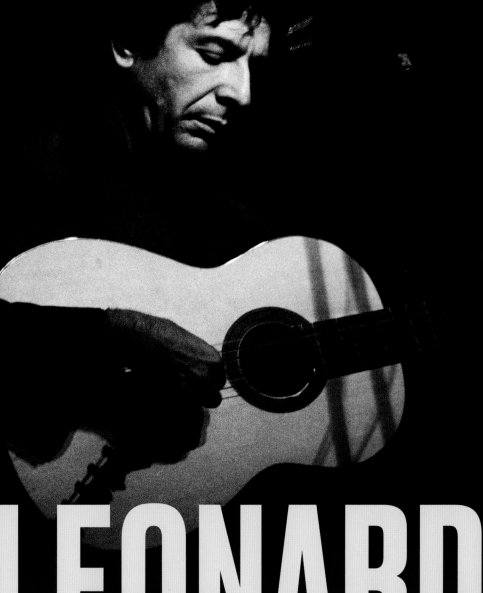

Renaissance man of many means, Leonard Cohen (1934–2016) mastered poetry, painting, and even novels before turning his attention to becoming a singer-songwriter. He viewed all life as a forum for art in whatever outlet it appeared. Once he put music to words in 1967, Cohen became a Canadian all-star in the growing universe of truth seekers and shamans. His voice took adjusting to, emanating from somewhere so deep in his soul that it required an excavation crew to bring it forward, but he never shied away from revealing himself. He dealt in the mystery of love, and allowed his mind to luxuriate in not knowing key aspects of it. He was a connoisseur of romance, and pursued it down whatever alleys beckoned his ears, even collaborating with producer extraordinaire Phil Spector. Cohen's most famous original, "Hallelujah," came out in 1984 and became a calling card for all that beats within the human heart. Not many artists take on a touring run as grueling as Cohen did so late in life, but his, from 2008 to 2013, was necessitated by a manager who fleeced his retirement funds. From dire circumstances come rewards, however, and his final years onstage allowed the world to find out why this man meant so much to so many, and to witness the wisdom that comes from a lifetime of seeking. Cohen delivered to those audiences a creative peak and proved once and for all that greatness knows no bounds, of age or otherwise.

Leonard Cohen at the Bottom Line, New York City, November 29, 1974
📷 © **BOB GRUEN**

LEONARD COHEN

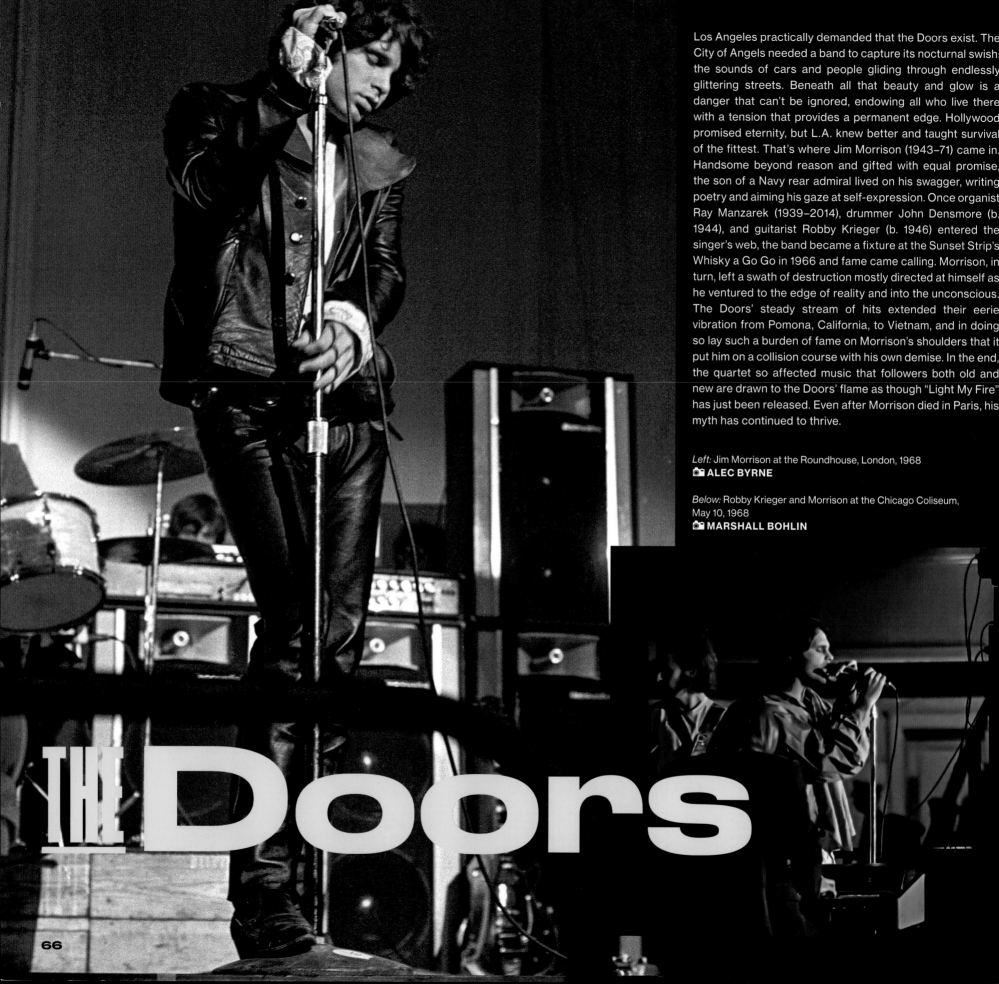

Los Angeles practically demanded that the Doors exist. The City of Angels needed a band to capture its nocturnal swish: the sounds of cars and people gliding through endlessly glittering streets. Beneath all that beauty and glow is a danger that can't be ignored, endowing all who live there with a tension that provides a permanent edge. Hollywood promised eternity, but L.A. knew better and taught survival of the fittest. That's where Jim Morrison (1943–71) came in. Handsome beyond reason and gifted with equal promise, the son of a Navy rear admiral lived on his swagger, writing poetry and aiming his gaze at self-expression. Once organist Ray Manzarek (1939–2014), drummer John Densmore (b. 1944), and guitarist Robby Krieger (b. 1946) entered the singer's web, the band became a fixture at the Sunset Strip's Whisky a Go Go in 1966 and fame came calling. Morrison, in turn, left a swath of destruction mostly directed at himself as he ventured to the edge of reality and into the unconscious. The Doors' steady stream of hits extended their eerie vibration from Pomona, California, to Vietnam, and in doing so lay such a burden of fame on Morrison's shoulders that it put him on a collision course with his own demise. In the end, the quartet so affected music that followers both old and new are drawn to the Doors' flame as though "Light My Fire" has just been released. Even after Morrison died in Paris, his myth has continued to thrive.

Left: Jim Morrison at the Roundhouse, London, 1968
📷 **ALEC BYRNE**

Below: Robby Krieger and Morrison at the Chicago Coliseum, May 10, 1968
📷 **MARSHALL BOHLIN**

THE Doors

When an artist so uncommon appears in front of an unsuspecting audience and takes it on a journey it was unprepared for, it can be thrilling. In the second half of the 1960s, all manner of singer-songwriters raised their hands, but only Bronx-born Laura Nyro (1947–97) boasted a high and striking voice capable of decibel changes on a moment's notice and wrote songs so tender and moving that they automatically emptied tear ducts. In 1968, when she released second album *Eli and the Thirteenth Confession*, everyone understood that a startling new talent had ascended the stage. It didn't take long for others to cover her songs, such as the 5th Dimension's "Wedding Bell Blues" and "Stoned Soul Picnic," and Blood, Sweat & Tears' stunning "And When I Die." That was just for starters. Nyro kept recording, aiming for the ultimate breakthrough, but always landed just shy of the mega mark. By 1971, the pop music merry-go-round had lost its luster, so after Nyro got married, she announced her retirement at twenty-four. When the union ended five years later, she restarted her music career, but her cult following didn't build past its 1960s peak. Nyro continued touring and touching those who remembered the woman who had gotten inside their souls until, like her mother before her, she died prematurely of ovarian cancer. But for the years when she sat at a piano onstage and looked at the crowd, she was the only person in their universe.

Laura Nyro at her United Kingdom debut at Royal Festival Hall, London, 1971
📷 © **BARRIE WENTZELL**

Laura Nyro

67

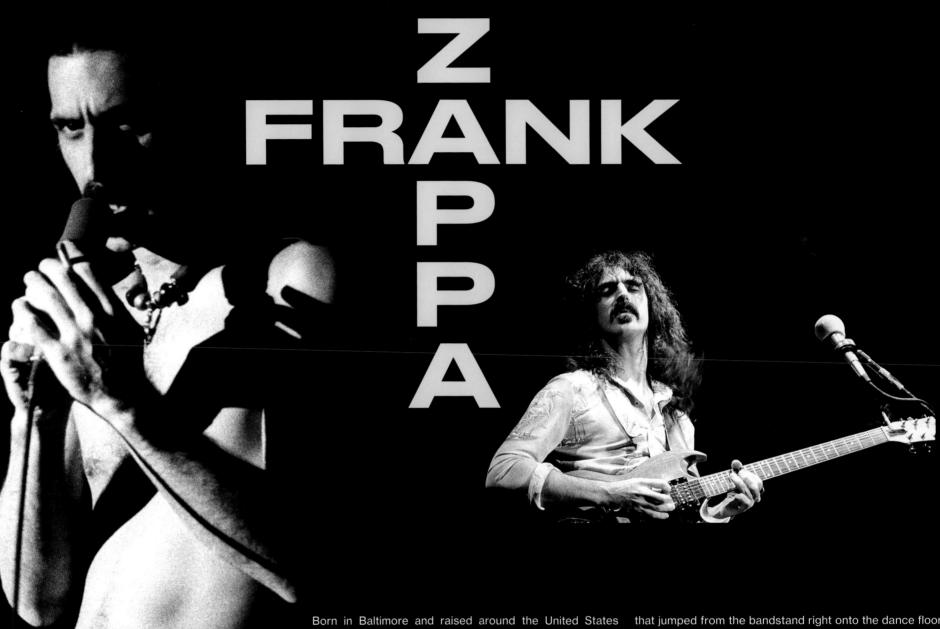

FRANK ZAPPA

Born in Baltimore and raised around the United States before settling near Lancaster, California, as a teenager, Frank Zappa (1940–93) carved out a sprawling career that embraced everything from doo-wop and Karlheinz Stockhausen to Erik Satie. Gathering up every conceivable influence, the guitarist wrote songs that originated in one place, careened into others, and double-backed at the end to sound like the beginning of rock and roll. He enlisted savvy musicians such as a teenage Steve Vai to further this cause, often telling them exactly what to play and how to act onstage, and when he found new talent he wanted to work with, the bandleader never looked back. Once someone stepped into the Zappa orbit, it was all hands on deck. His Mothers of Invention brought Zappa originals to life, conducted down to the nanosecond through confusing excursions that could include the avant-garde, tricked-out tribal stomps based on primal rhythms and polyphonic romps, and gutbucket R & B

that jumped from the bandstand right onto the dance floor. While disdainful of the self-serving drama inside the rock and roll machine, onstage he was the ultimate ringmaster. In the 1970s, he drafted the Turtles' front duo Mark Volman and Howard Kaylan, renaming them the Phlorescent Leech & Eddie. His fans expected the unexpected, and their hero never faltered. Zappa was a true Renaissance man, working in music, art, film, books, and beyond, always nurturing the inherent surprise that sparks the most transcendent rock and roll.

Left: Frank Zappa at Maple Pavilion, Stanford University, CA, November 19, 1977
📷 **GARY KIETH MORGAN**

Above: Zappa on the Bongo Fury tour at the Capitol Theatre, Passaic, NJ, October 25, 1975
📷 **BOB SOLBERG**

CREEDENCE CLEARWATER REVIVAL

As boys, Tom (1941–90) and John Fogerty (b. 1945) fell in love with American roots music and wanted desperately to play it. They enlisted fellow San Francisco Bay Area junior high schoolers Stu Cook (b. 1945) and Doug Clifford (b. 1945), cycled through names (Blue Velvets, Golliwogs), and finally snagged a recording contract in 1964 with Fantasy Records in Berkeley, California. As Creedence Clearwater Revival, the four stamped out one of the most successful runs on the rock and roll charts before or since. John Fogerty's rugged but right voice captivated all who heard it. Songs including "Born on the Bayou" and "Proud Mary" made most listeners assume they were a Louisiana band, one steeped in the misty swamps outside towns such as Opelousas and Lafayette. CCR reiterated that it didn't matter where you lived, but rather where your imagination lay. Starting in 1968, the band followed one Top 10 hit with another, and in 1969 alone put out three best-selling albums. At the outset of the 1970s, John Fogerty's songwriting astutely grasped the southern landscape and divisions running through the seams of America, and he illuminated how those rifts affected the country. Tom Fogerty left Creedence, making it a trio that stayed true to CCR's initial vision, but business miscalculations and creative control issues eventually splintered the band for good. By then, Creedence Clearwater Revival had come to stand for honest music that gave the very best America had to offer.

Right: John Fogerty at the Atlantic City Pop Festival, Mays Landing, NJ, August 1969
📷 **DAVID WEITZ**

Below: Tom Fogerty, Stu Cook, Doug Clifford, and John Fogerty at Royal Albert Hall, London, April 15, 1970
📷 **LAURENS VAN HOUTEN / FRANK WHITE PHOTO AGENCY**

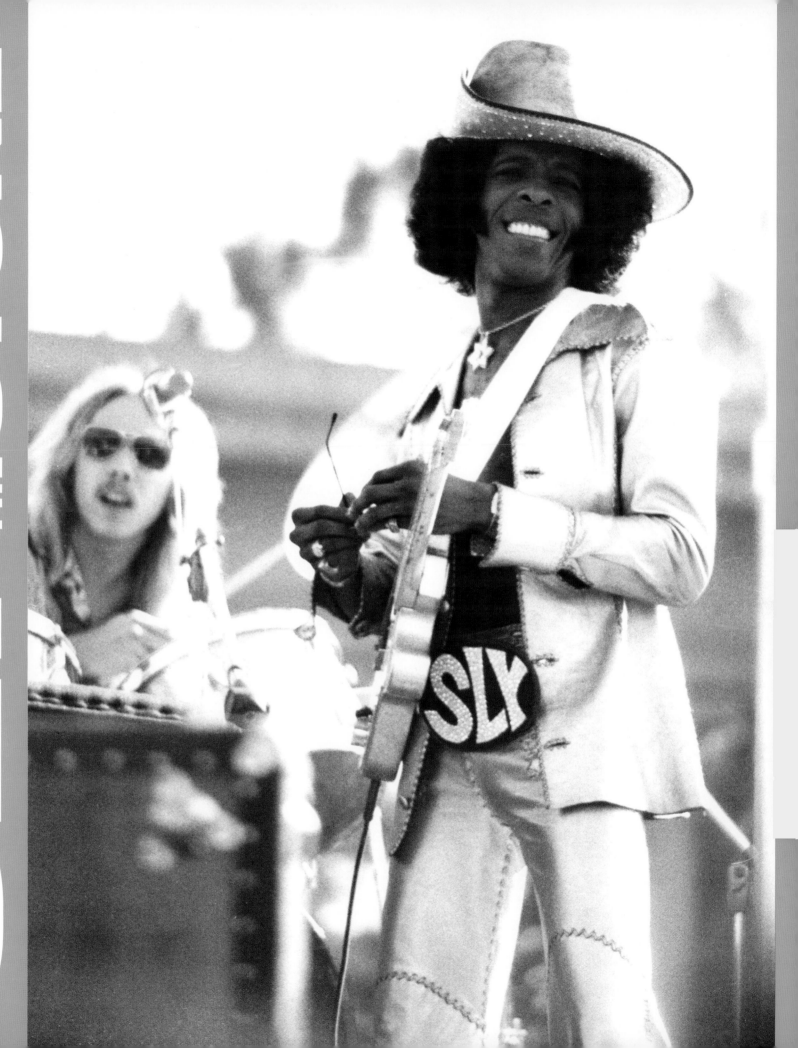

SLY & FAMILY THE STONE

As the racial divide in America eased, musical styles began cross-pollinating with glee. No one did that more daringly than Sylvester "Sly" Stone (born Sylvester Stewart in 1943). In the San Francisco Bay Area, where his family moved from the tiny Texas arts enclave of Denton, Stone not only fell in with a whole new culture being cobbled together there in the 1960s; he took the bull by the longhorns. The bandleader-to-be viewed humanity as his tableau and assembled one of the first mixed-gender and multiracial bands, probably knowing he was going to make history on a variety of fronts. In 1966, he enlisted his brother Freddie Stone (b. 1947) as guitarist, sister Rose Stone (b. 1945) on keyboards and vocals, trumpeter Cynthia Robinson (1944–2015), drummer Greg Errico (b. 1948), saxophonist Jerry Martini (b. 1943), and bassist Larry Graham (b. 1946) for his freedom-busting first edition of the Family Stone. Right out of the gate, their songs redefined what rhythm and blues and rock could do together: "Dance to the Music," "Everyday People," and "Thank You (Falettinme Be Mice Elf Again)." Discouragingly, as the decade waned—and despite the band's landmark performance at Woodstock—national tensions at home and abroad affected Stone deeply. The album *There's a Riot Goin' On* in 1971 documented generational turmoil through emotional catharsis. Musical celebration had become an indictment of American conflict. They say music is the ultimate barometer of a country's temperature, and Sly and the Family Stone's reading of the boiling point stands as historical truth-telling of the highest order.

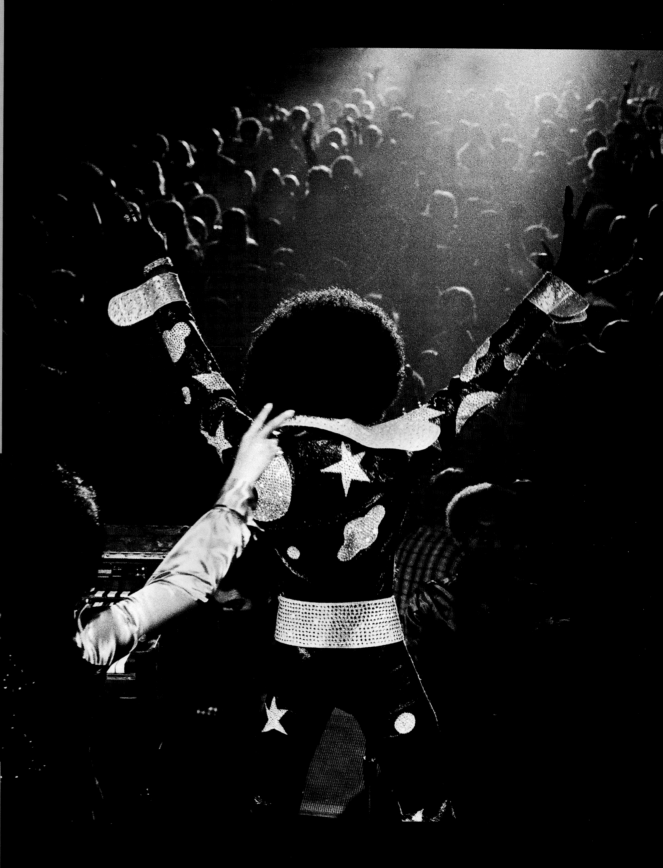

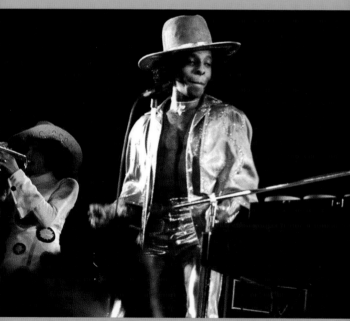

Opposite: Bill Lordan and Sly Stone at Balboa Stadium, San Diego, September 7, 1974
📷 **GARY KIETH MORGAN**

Above: Cynthia Robinson and Stone at the San Diego Sports Arena, October 28, 1973
📷 **GARY KIETH MORGAN**

Right: Stone at the International Amphitheatre, Chicago, August 3, 1973
📷 **JERRY ARONSON**

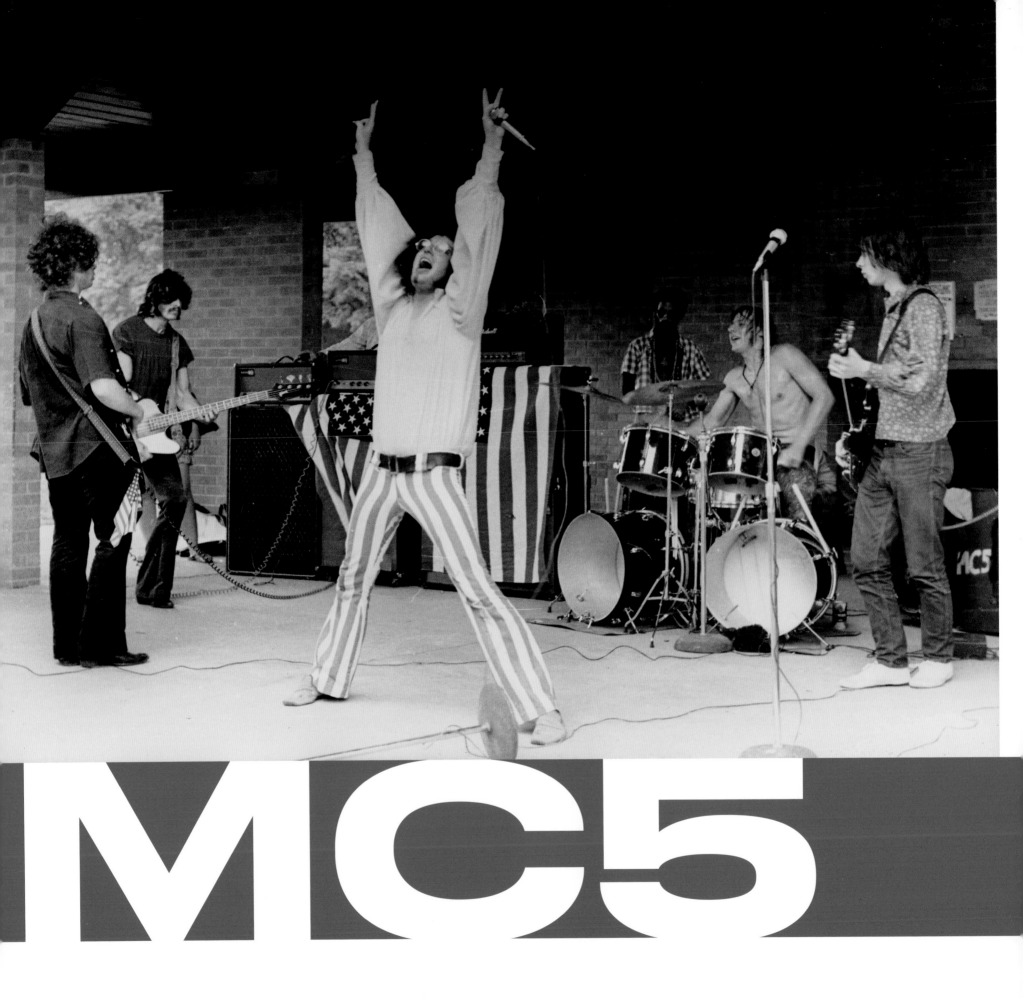

MC5

The most actively political rock band during the turmoil of the late 1960s, MC5 wore their anti-authoritarianism in their songs and on their sleeves. Formed in 1964 in Lincoln Park, Michigan, the group dedicated itself to taking their beliefs to the barricades. Vocalist Rob Tyner (1944–91), guitarists Wayne Kramer (b. 1948) and Fred "Sonic" Smith (1949–94), bassist Michael Davis (1943–2012), and drummer Dennis Thompson (b. 1948) didn't see any way out of the class warfare that gripped their lives. That touched off a collective that felt revolution was the solution. The quintet wrote music that backed up those precepts, including their theme song "Kick Out the Jams." In 1968, they traveled to the Democratic National Convention in Chicago, where it's said that they were the only rock band that showed up, and ended up performing an eight-hour set for demonstrators.

>

By this point, Kramer and Smith's guitar gymnastics created havoc at stun-level volumes, while firebrand Tyner riled audiences to rabid involvement. Political activist John Sinclair became their comrade in arms, with his White Panthers organization taking on the government at every level. All of them were on police watch lists around Michigan, so it started to feel as though the band was headed for the cliff. After Elektra Records disassociated itself from the group, the members scrambled to maintain a momentum they'd built over the past six years. By 1973, it was mostly all over for MC5, but not before they'd made the point that rock and roll had a place in politics as surely as it did in music.

Opposite: Wayne Kramer, Michael Davis, Rob Tyner, Dennis Thompson, and Fred "Sonic" Smith at West Park, Ann Arbor, MI, 1968. *Above:* Smith, Thompson, Tyner, Kramer, and Davis at MC5 house, 1969. *Left:* Thompson, Kramer, Smith, and Tyner (lying down) at the Mount Clemens Pop Festival in Sportsman's Park, Mount Clemens, MI, August 3, 1969
📷 all by **LENI SINCLAIR**

Below: Kramer at the Detroit Institute of Arts, April 9, 2015
📷 **STEVEN HAUPTMAN**

CROSBY, STILLS & NASH

American rock bands produced royal results in the second half of the 1960s. Scene leaders Buffalo Springfield and the Byrds epitomized the progressiveness of folk rock, with Stephen Stills (b. 1945) having co-led the former act alongside Neil Young, and David Crosby (b. 1941) playing creative foil to the latter group's Roger McGuinn. At Joni Mitchell's Laurel Canyon pad in July 1968, Crosby joined in on Stills's "You Don't Have to Cry," to which Hollies member Graham Nash (b. 1942) added harmonies. Together, their three voices soared, and by the end of the song everyone in the room had glimpsed the future. Instant supergroup. One of the decade's breathtaking chain reactions ensued, producing the following spring's eponymous debut—wall-to-wall with standards-to-be in "Suite: Judy Blues Eyes," "Marrakesh Express," "Wooden Ships"—and encored by one of the trio's first live shows: the Woodstock Music & Art Fair in August 1969. Debuts hardly come more auspicious. The musical and vocal interplay among David Crosby, Stephen Stills, and Graham Nash set the country on its ear, and not a year passed between *Crosby, Stills & Nash* and its follow-up *Déjà Vu*, which added Neil Young (b. 1945) and half a dozen more canonical musts, including "Teach Your Children," "Our House," and Mitchell's "Woodstock." In the nearly five decades since then, any CSN or CSNY convergence remains among rock and roll's most righteous occasions.

Left: David Crosby, Stephen Stills, and Graham Nash on the set of *They Shoot Horses, Don't They?* at the Warner Bros. Studios, Burbank, CA, May 21, 1970
📷 **HENRY DILTZ / MORRISON HOTEL GALLERY**

Bottom left: Stills, Crosby, and Nash at the Forum, Los Angeles, June 1977
📷 **DORIAN BOESE**

Bottom right: Crosby at the Wiltern Theatre, Los Angeles, ca. 1986
📷 **STEVE BANKS / STUDIO 6**

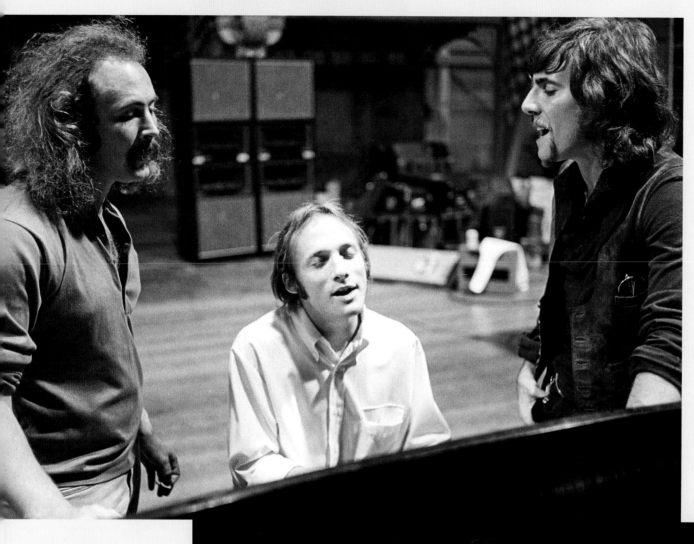

Not many musicians make their radio debut at five or release their first single when they're eleven. Doug Sahm (1941–99) was surely one in a million. He came roaring out of San Antonio espousing every conceivable type of music in the Lone Star state, including country, blues, Tex-Mex, jazz, rock, and even polka. In 1964, while the Beatles held the reins on popular music, Sahm founded the Sir Douglas Quintet hoping to jump on the British bandwagon. His entry, Top 20 hit "She's About a Mover" in 1965, spun just over two minutes of madness, with back-chilling Vox organ runs courtesy of Augie Meyers, slamming maracas, and Sahm's wild-eyed vocals. Bob Dylan immediately signed on as a fan of the Texan, who appeared headed to the top. A marijuana arrest the next year relegated him to the far more forgiving hippie enclave of San Francisco, where he took up with locals such as the Grateful Dead and had another mega-hit in "Mendocino." That concluded his radio smashes, but Sahm's next move was pure bravado: recording sessions with Dylan and a string of LPs that defied all categorization while exhibiting as much fun as any person is allowed. When he moved to Austin in 1972, Sahm provided a flash point for the town's escalation into the present-day Live Music Capital of the World. There, he later cobbled together the Texas Tornados with Meyers and certified Lone Star legends Flaco Jiménez and Freddie Fender, nabbing the commercial brass ring as easy as shucking a tamale.

Below: Doug Sahm and his son Shawn Sahm at a *Rolling Stone* photo shoot at Belvedere Street Studio, San Francisco, November 1968
📷 **BARON WOLMAN / ICONIC IMAGES**

Right: Sahm at the Palomino Club, North Hollywood, CA, October 1978
📷 **JOEL APARICIO**

DOUG SAHM

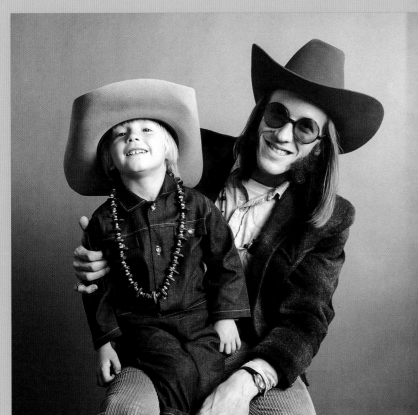

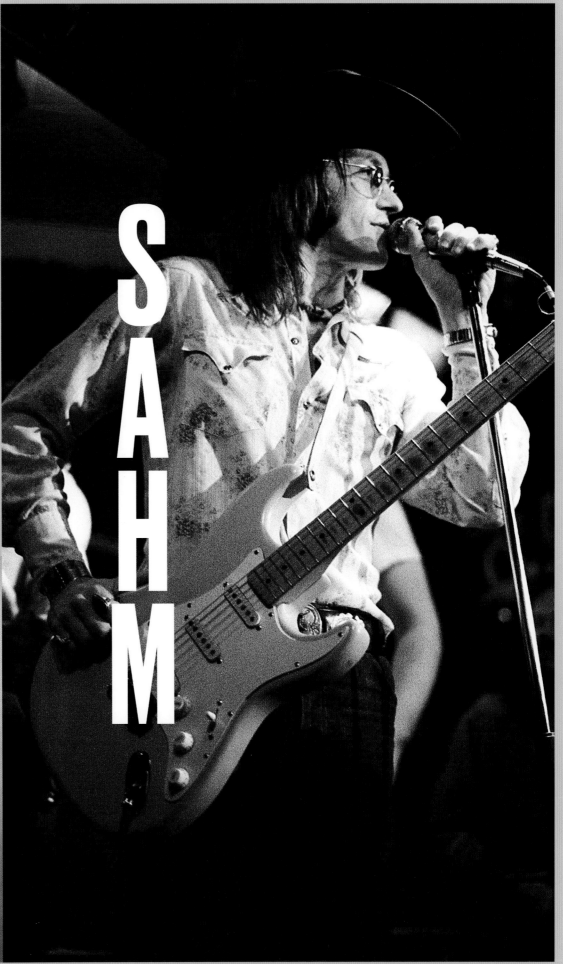

DR. JOHN

They called him the Night Tripper, and he most definitely had a satchel of gris-gris in his hand. Mac Rebennack (b. 1940) christened himself Dr. John in 1968 because the singer scheduled to fill that role didn't show. The Crescent City kingpin got some leftover studio time from a Sonny & Cher session in Hollywood and recorded *Gris-Gris* with a roomful of New Orleans natives and enough attitudinal adjustment to light up Los Angeles. No one had heard swampy romps such as "I Walk on Gilded Splinters," "Mama Roux," or "Croker Courtbullion" inside or outside Louisiana, and taking a fashion cue from Mardi Gras costumes, Dr. John would alight onstage looking like a hoodoo queen from outer space. The fact that his emergence occurred at the height of LSD experimentation in the counterculture made the pianist a perfect role model for how to take it to the limit and then keep going. Studio-happy starting in the 1950s, this one-man history of NOLA second-lined through the 1970s with many bodacious albums and even a Top 10 hit in "Right Place Wrong Time." He cut a couple of all-keys LPs that revealed some the origins of American music by spotlighting his early hometown heroes Professor Longhair, Huey "Piano" Smith, James Booker, and of course Allen Toussaint. Whenever New Orleans is mentioned or evoked, Dr. John's undimmed aura pops up, too, right on time, with an affirmative declaration for questions one and all: "Yeah, you right."

Left: Dr. John at Ford Auditorium, Detroit, October 27, 1973
📷 **LENI SINCLAIR**

Above: Dr. John at Sheffield City Hall, Yorkshire, UK, October 2001
📷 **GRENVILLE CHARLES**

Considering Ike Turner's part in the foundation of rock and roll, his later life as half of Ike (1931–2007) & Tina Turner (b. 1939) makes perfect sense. At the dawn of this genre, the guitarist fronted the Kings of Rhythm, while also talent scouting and producing for independent record labels. When Jackie Brenston cut "Rocket 88" in 1951 to help kick-start the latest youth music fad, it was Turner producing and supplying the backup group. He had an ear for the unique, so on the night a young Anna Mae Bullock found herself on Turner's stage as a substitute singer, a celestial groove clicked and the duo didn't stop until they'd turned Tina Turner into a superstar. Following first hit "A Fool in Love" in 1960, a decade of songs such as "It's Gonna Work Out Fine" established the pair as rhythm and blues dynamite. Colossal endeavor "River Deep–Mountain High" in 1966 with super-producer Phil Spector resulted in one of the era's landmark moments, but the record-buying public didn't agree, and it took a flamboyant cover of "Proud Mary" to conquer the charts. By then, their live shows were turning bandstands and concert halls upside down. Tina Turner left the marriage and went on to international superstardom as a solo act, proudly living on the path begun back in East St. Louis when she first got onstage with Ike Turner.

Below: Ike and Tina Turner at the Newport Pop Festival, Northridge, CA, June 20, 1969
📷 **ED CARAEFF / ICONIC IMAGES**

Right: The Turners at the hungry-i, San Francisco, October 1967
📷 **BARON WOLMAN / ICONIC IMAGES**

IKE & TINA TURNER

IGGY

James Osterberg Jr. (b. 1947) adapted the name Iggy Pop from his band the Iguanas. The young musician from Muskegon, Michigan, had rounded up some like-minded teenagers at his Ann Arbor high school, taken over the drum kit, and roared full steam ahead into a career as extravagant as it's been everlasting. Fronting the Stooges next, he took inspiration from Jim Morrison and the Doors, and knocked it up a dozen notches sonically to get the attention he desired so badly. After signing to Elektra Records in 1968, the Stooges appeared to be on the fast track to success. Velvet Underground co-founder John Cale produced their debut, and the music press covered the outlandish singer both onstage and off, eventually anointing him one of the fathers of punk rock. The band's albums didn't sell, though.

>

POP

After becoming acquainted with David Bowie in the early 1970s and finding a kindred spirit and enthusiastic supporter in the English pop star, Iggy Pop saw new doors opening and didn't waste any time running through them as quickly as he could. Even now, seventy this year and semi-retired from live performance, he remains as controversial for his daredevil stage maneuvers as he does for the actual music, all of it adding up to his fandom among tastemakers the world over. Grand survivor of stupefying musical madness, the esteemed Iggy Pop never backed down from a dare or delight.

Opposite: Iggy Pop at the Whisky a Go Go, West Hollywood, CA, July 1974
📷 **JAMES FORTUNE**

Left: Pop at the Huron High School athletic field, Ann Arbor, MI, 1971
📷 **LENI SINCLAIR**

Above: Pop at the Old Waldorf, San Francisco, 1977
📷 © **CHESTER SIMPSON**

There are bands that extend the very boundaries of what music can be. Pink Floyd formed in England in 1965, aiming for the furthest reaches of the rock and roll universe. Singer, songwriter, and guitar savant Syd Barrett (1946–2006) joined up with childhood friend and bassist Roger Waters (b. 1943), who had put together a group with classmates Nick Mason (b. 1944) on drums and Richard Wright (1943–2008) on keyboard. They were thick as thieves with London's outré set, playing at extremely cool underground clubs while specializing in psychedelic lyrics and experimental songs stretching well past any normal limits. Pink Floyd was one of the first post-Beatles British bands inventing its own template for what it could do and how far it could go. The 1967 debut, *The Piper at the Gates of Dawn*, announced the quartet's arrival with a dense and expectant air prompting the kind of cult adoration that turned them into musical messiahs. Psychedelia quickly got the better of Barrett, who departed in 1968. Guitarist David Gilmour (b. 1946), who had gone to school with Barrett, already had begun pushing Pink Floyd's interstellar overdrive. The band never wavered during the 1970s, conjuring several of the best-selling rock albums of all time: *The Dark Side of the Moon* (1973), *Wish You Were Here* (1975), and *The Wall* (1979), still worshiped and enlisting converts by the day.

Right: David Gilmour, Nick Mason, and Richard Wright on the Dark Side of the Moon tour, UK Winter Tour, 1974
📷 © **JILL FURMANOVSKY**

Top: Roger Waters (bass) and Gilmour (guitar) at the San Diego Sports Arena, April 21, 1975
📷 both **GARY KIETH MORGAN**

PINK FLOYD

J. GEILS BAND

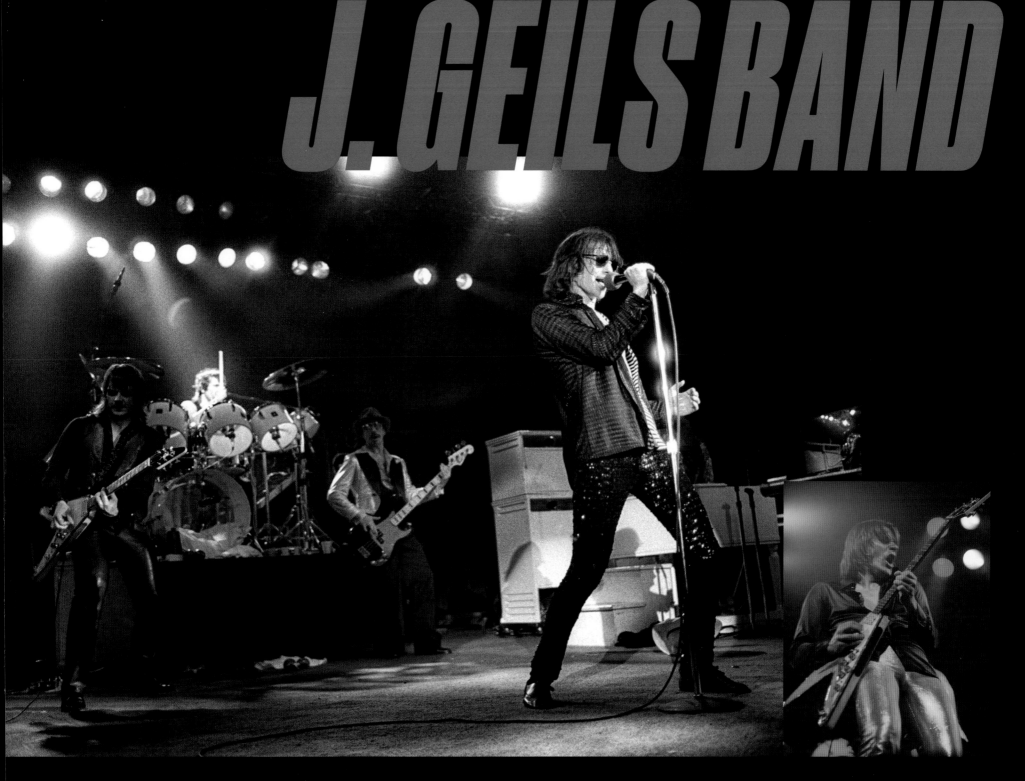

By 1970, enough young blues bands had made their mark that the Blues Hotel was practically flashing a "No Vacancy" sign—unless a band could offer an electrifying new twist on the music. The J. Geils Band had the goods. In 1967, guitarist J. Geils (1946–2017) and bassist Danny Klein (b. 1946) had looked around Massachusetts and discovered drummer Stephen Jo Bladd (b. 1942), harp cat Richard Salwitz (aka Magic Dick, b. 1945), and singer Peter Wolf (b. 1946), all with extensive music backgrounds. The five, plus keyboardist Seth Justman (b. 1951), built their famously antic sets and self-titled 1970 debut album on only the finest R & B, including

the Contours' "First I Look at the Purse," the Valentinos' "Lookin' for a Love," and Otis Rush's "Homework," fleshing that out with smart originals such as "Hard Drivin' Man," "Ice Breaker," and "Wait." The J. Geils Band evolved into a wild bunch who decimated audiences wherever they landed. Garnering patronage from hardcore blues fans as well as rock and rollers, two famously fickle groups, the Boston bruisers enlisted MTV's masses with their 1980s hits "Love Stinks," "Centerfold," and "Freeze-Frame" without diluting their act. Yet as sales went stratospheric, Wolf fled for a solo career in 1983, and the band bottomed out. Reunion

performances kept the blazing fire burning for those who had caught the Geils fever decades ago, but Jay Geils himself stepped out of the band in 2012, ending the run of rock's ultimate house-party band.

Above left: J. Geils, Stephen Bladd, Danny Klein, and Peter Wolf at the Oakland Coliseum, CA, March 1979
📷 © **CHESTER SIMPSON**

Above right: J. Geils at the Auditorium Theatre, Chicago, October 22, 1974
📷 **DAVID SLANIA**

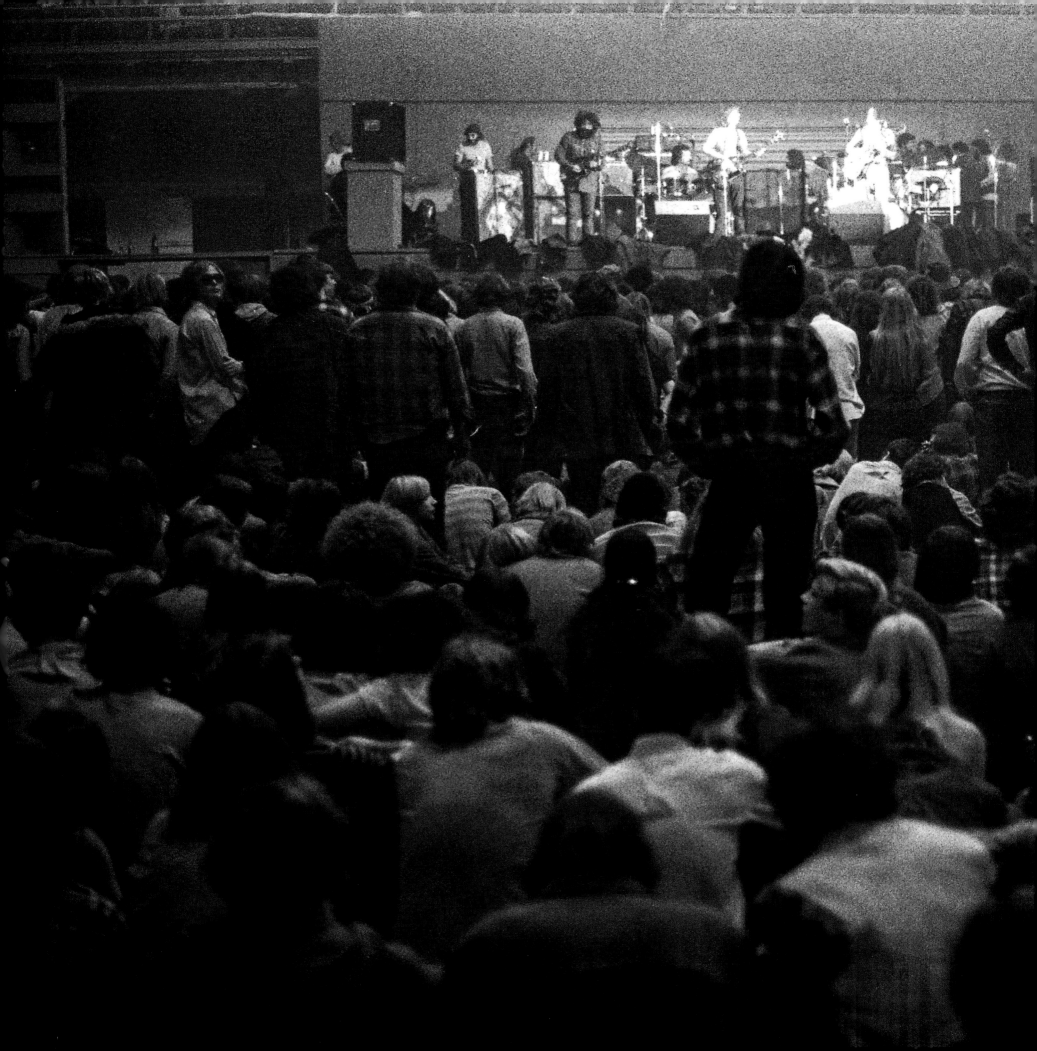

INNER VISIONS &
OUTLANDISH TRIPS
THE LAND OF THE
FREE AND THE SAVED

CHAPTER 4

The Grateful Dead at the Chicago Coliseum,
November 27, 1970
📷 **MARSHALL BOHLIN**

Joni Mitchell

As new folk music upwelled throughout America in the mid-1960s, alongside the British Invasion and the emerging psychedelic rock scene, singer-songwriters became increasingly inventive and original, among them the Canadian Joni Mitchell (b. Roberta Anderson, 1943). Her distinctly personal lyrics and melodies, played mostly on open-tune guitar or piano, drew upon folk traditions to create psychological journeys through romance, politics, and the American landscape. Her debut, produced by David Crosby after he caught an early performance, was 1968's *Song to a Seagull*. Although it didn't gain a large audience, it primed listeners for the Grammy-winning *Clouds* (1969), which included "Chelsea Morning" and "Both Sides Now," a triumphant amalgam of folk, pop, rock, and jazz. Mitchell began to establish her own cross-category genre, and with 1971's *Blue*, she engendered such devotion that seemingly everyone in the country considered her songs required listening. *Court and Spark* (1974) evidenced Mitchell's growing interest in jazz, which would occupy her for years and lead to collaborations with Charles Mingus, Jaco Pastorius, and other legends, the fruits displayed on her fusion albums *Hejira* (1976), *Don Juan's Reckless Daughter* (1977), and *Mingus* (1979). Decades of idiosyncratic musical explorations followed, and her confidently self-guided career—she was among the few to control her own publishing rights—has continued to serve as a model for adventurous songwriters from Elvis Costello to Björk to Aimee Mann.

Top left: Joni Mitchell at Kleinhans Music Hall, Buffalo, NY, February 11, 1974
📷 **AMY JAFFE**

Top middle: Mitchell at the Anaheim Convention Center, CA, March 5, 1974
📷 **GARY KIETH MORGAN**

Above: Mitchell in Laurel Canyon, CA, 1969
📷 © **JIM MARSHALL PHOTOGRAPHY LLC**

marvin gaye

When record-mogul-in-the-making Berry Gordy incorporated Motown Records in 1960, his grandest dreams couldn't have envisioned that the music made at his Hitsville U.S.A. studio in Detroit would reshape the face of popular music. Singer-songwriter-drummer Marvin Gaye (1939–84), who, like so many at the time, got his start singing in church, counts as one of Motown's earliest responders, adding his talents to everything he touched. Initial hits "Can I Get a Witness" and "Stubborn Kind of Fellow" pointed the way to a rhythm-heavy sophistication on classics "Hitch Hike," "Pride and Joy," "I Heard It through the Grapevine," and a series of duets with Mary Wells, Kim Weston, and Tammi Terrell. Gaye added a jazz-like vocal range to street-smart studio productions that captivated young and old listeners alike. Disturbed by the war in Vietnam and racial strife in America, he focused his attention on the social debate raging nationwide. It was new territory for Motown, and one that owner Gordy didn't want to explore. Gaye subsequently recorded *What's Going On* against label objections, and when executives balked at putting it out, his perseverance in seeing its 1971 release resulted in one of the most important and successful albums in Motown's history. Follow-up *Let's Get It On* (1973) continued a winning streak that included 1978 cult favorite *Here, My Dear* and final hit "Sexual Healing" in 1982. Gaye's life ended when his father shot and killed him, a tragic finale for a certified superstar.

Left and below left: Marvin Gaye, October 1976
📷 © **BOB GRUEN**

Below middle: Gaye at the Omni, Atlanta, 1975
📷 **STEVE BANKS / STUDIO 6**

Below right: Gaye at Carnegie Hall, New York City, August 25, 1974
📷 © **BOB GRUEN**

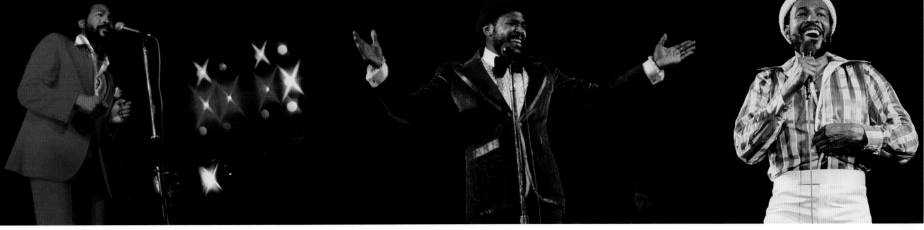

After Ritchie Valens's pioneering hit "La Bamba," Carlos Santana (b. 1947) almost single-handedly infused Latin music into rock and roll. His father, José, a mariachi musician with a golden voice (cue up *Havana Moon* closer "Vereda Tropical"), schooled him on guitar in Jalisco, Mexico, before moving the family to Tijuana and then San Francisco. It was there that the young guitarist started the Santana Blues Band in 1966, seriously under the spell of the Paul Butterfield Blues Band and its brilliant lead guitarist, Michael Bloomfield. When that group canceled an engagement one Sunday at the Fillmore, Santana anchored a hastily assembled substitute band and staked his claim—*after* previously being nabbed by promoter Bill Graham while climbing through a window to see the Butterfield band because he couldn't afford a ticket. Shortening the band moniker to simply Santana, and adding congas and timbales to flesh out the percussion, the bandleader—with the help of Graham—led the wild-eyed group all the way to the Woodstock festival in 1969. The group's career-making performance there showed with piercing exactitude how Santana melded rock, jazz, salsa, and other Afro-Latin rhythms into a fiery whole. Audiences had never heard anything like it. Thereafter, Carlos Santana shot off on a fifty-year career twisting and turning through music business fortunes—including eight Grammys for 1999's *Supernatural*—but he has never stopped injecting rock and roll with Latin energy and instrumentation. It's in his blood.

Right: David Brown, Carlos Santana, José Areas, and Michael Carabello at the Woodstock Festival, Bethel, NY, August 16, 1969
📷 **JASON LAURE / FRANK WHITE PHOTO AGENCY**

Below left: Carlos Santana at Shoreline Amphitheatre, Mountain View, CA, October 23, 2011
📷 **JÉRÔME BRUNET PHOTOGRAPHY**

Below right: Carlos Santana at Eastern New Mexico University, Portales, 1979
📷 **KELLY BERRY**

santana

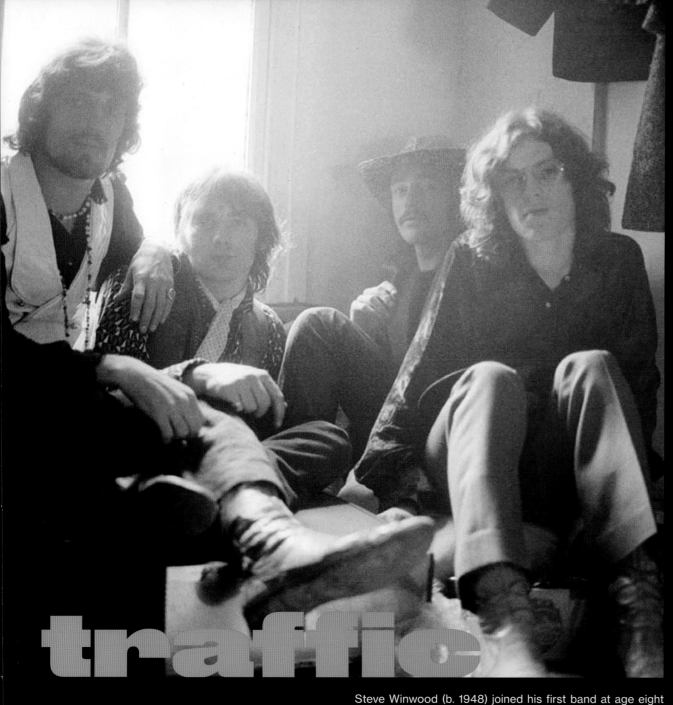

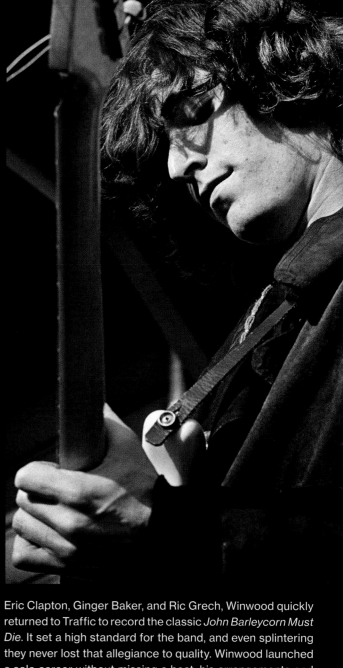

traffic

Steve Winwood (b. 1948) joined his first band at age eight and played in British-rock hitmaker the Spencer Davis Group by the time he was fourteen. The band's two biggest singles, "Gimme Some Lovin'" and "I'm a Man," bore his name in the songwriting credits in their race up the charts when he was still a teenager. From Birmingham, England, the keyboardist and guitar great possessed a voice with an uncanny range and timbre, akin to R & B figurehead Ray Charles, which left the music universe and its fans to listen and wonder how someone so young could sound so mature. In 1967, Winwood, Dave Mason, Chris Wood, and Jim Capaldi retired to the countryside with their band Traffic, seeking solace in nature to write and record outside the pop demands of London. That they succeeded so admirably stands as one of the genre's highest peaks. Even with a detour in 1969 back into the high-pressure stakes of supergroup Blind Faith, with

Eric Clapton, Ginger Baker, and Ric Grech, Winwood quickly returned to Traffic to record the classic *John Barleycorn Must Die*. It set a high standard for the band, and even splintering they never lost that allegiance to quality. Winwood launched a solo career without missing a beat, his arrangements and vocals never losing the spirit of the artists who inspired him. Whether touring on his own or in a band with Clapton, he'll always be an English artist who has cherished the souls of American legends.

Above left: Jim Capaldi, Chris Wood, Dave Mason, and Steve Winwood in the photographer's studio, London, 1968
📷 **GERED MANKOWITZ**

Above right: Winwood playing a free concert near Pier 10, San Francisco, March 18, 1968
📷 © **JIM MARSHALL PHOTOGRAPHY LLC**

Among those United Kingdom artists profoundly affected by African American music styles, few transcended their first loves like Van Morrison (b. 1945). Born in Belfast, Northern Ireland, the only child of an avid record collector, Morrison gravitated to blues and jazz while still in grade school and graduated to blowing sax in Irish bands as a teenager. Hometown act Them fashioned its sound on the liberating aspects of American musicians on the order of Lead Belly, Ray Charles, and Bobby "Blue" Bland. The group's biggest hit, 1964's "Gloria," defined its author and singer as a bluesman with the lyrical authenticity of a southern playwright. By the time his "Brown Eyed Girl" breached the Top 10 in 1967, Morrison looked set for life. The singer's second solo album the next year, *Astral Weeks*, announced a masterful improviser who had his own take on popular music, but commercial success didn't strike. It took follow-up *Moondance* (1970) drawing the world spotlight to establish him as one of the most revered musicians on either side of the Atlantic. He lends a physical presence to the inner workings of the human spirit, bringing them to life in a way that other artists only hope for. Now into his sixth decade making music, Morrison sustains a level of songwriting and singing that qualifies him as one of the great wonders of popular music.

Below: Van Morrison at the Santa Monica Civic Auditorium, CA, May 19, 1973
📷 **ED CARAEFF / ICONIC IMAGES**

Right: Morrison at Harvard Square Theatre, Cambridge, MA, March 14, 1974
📷 **BARRY SCHNEIER**

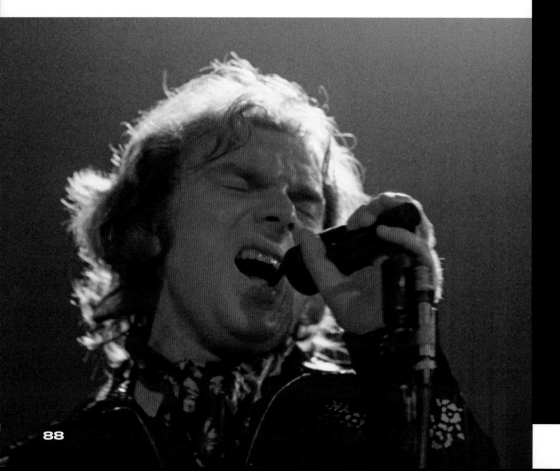

van morrison

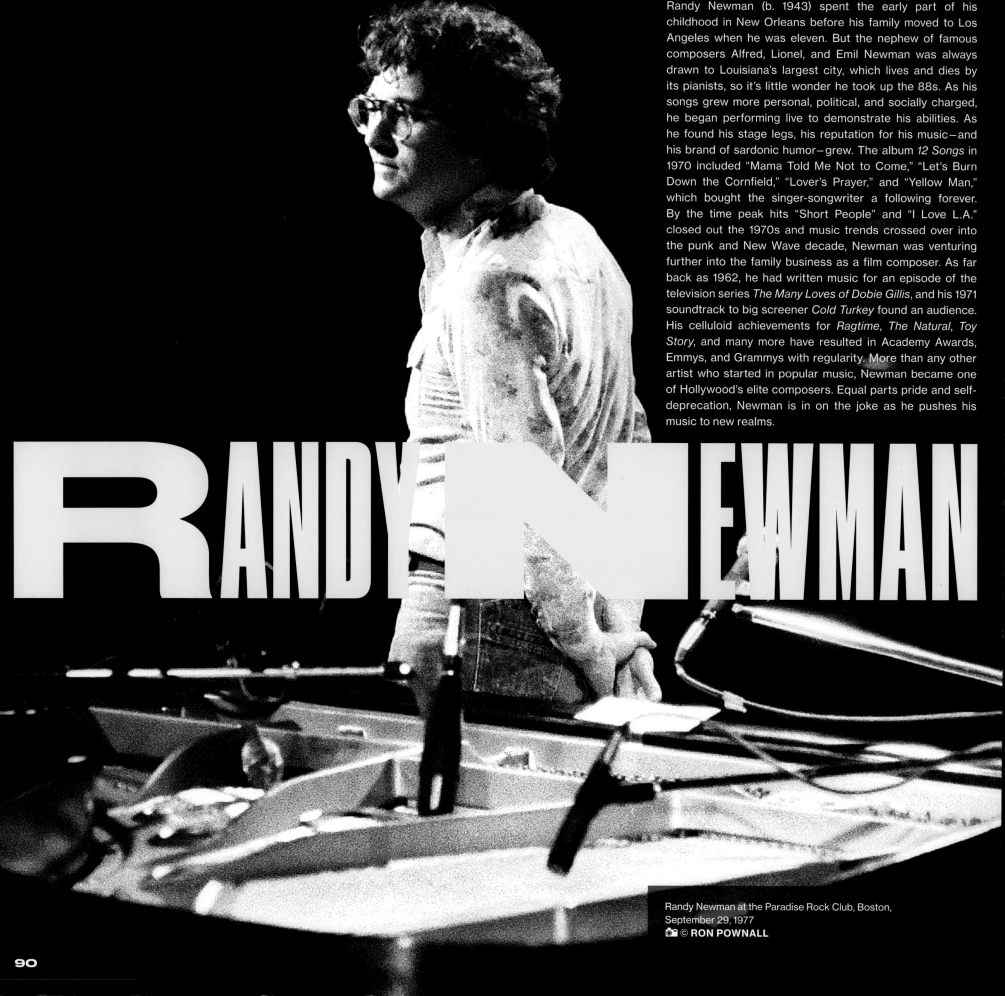

Randy Newman (b. 1943) spent the early part of his childhood in New Orleans before his family moved to Los Angeles when he was eleven. But the nephew of famous composers Alfred, Lionel, and Emil Newman was always drawn to Louisiana's largest city, which lives and dies by its pianists, so it's little wonder he took up the 88s. As his songs grew more personal, political, and socially charged, he began performing live to demonstrate his abilities. As he found his stage legs, his reputation for his music—and his brand of sardonic humor—grew. The album *12 Songs* in 1970 included "Mama Told Me Not to Come," "Let's Burn Down the Cornfield," "Lover's Prayer," and "Yellow Man," which bought the singer-songwriter a following forever. By the time peak hits "Short People" and "I Love L.A." closed out the 1970s and music trends crossed over into the punk and New Wave decade, Newman was venturing further into the family business as a film composer. As far back as 1962, he had written music for an episode of the television series *The Many Loves of Dobie Gillis*, and his 1971 soundtrack to big screener *Cold Turkey* found an audience. His celluloid achievements for *Ragtime*, *The Natural*, *Toy Story*, and many more have resulted in Academy Awards, Emmys, and Grammys with regularity. More than any other artist who started in popular music, Newman became one of Hollywood's elite composers. Equal parts pride and self-deprecation, Newman is in on the joke as he pushes his music to new realms.

RANDY NEWMAN

Randy Newman at the Paradise Rock Club, Boston, September 29, 1977
© **RON POWNALL**

JAMES TAYLOR

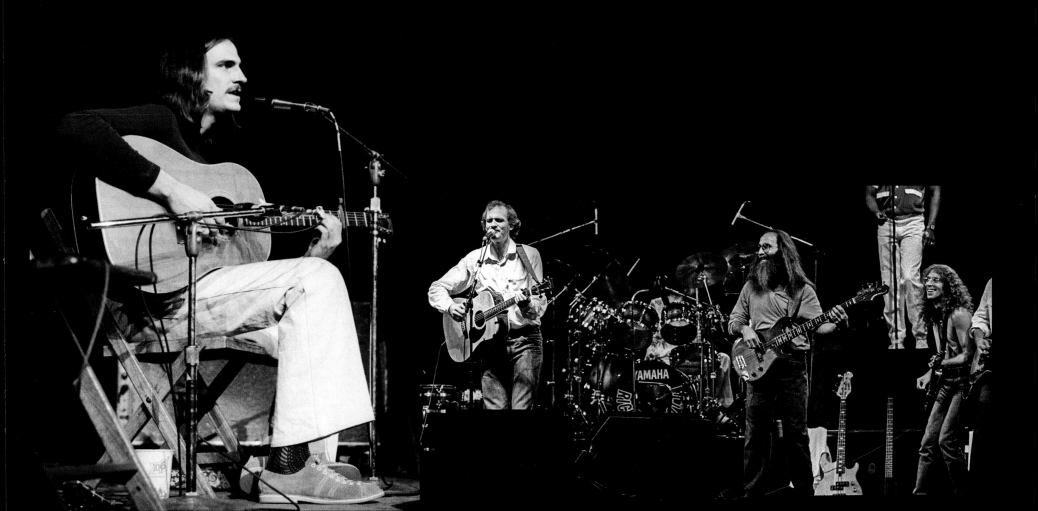

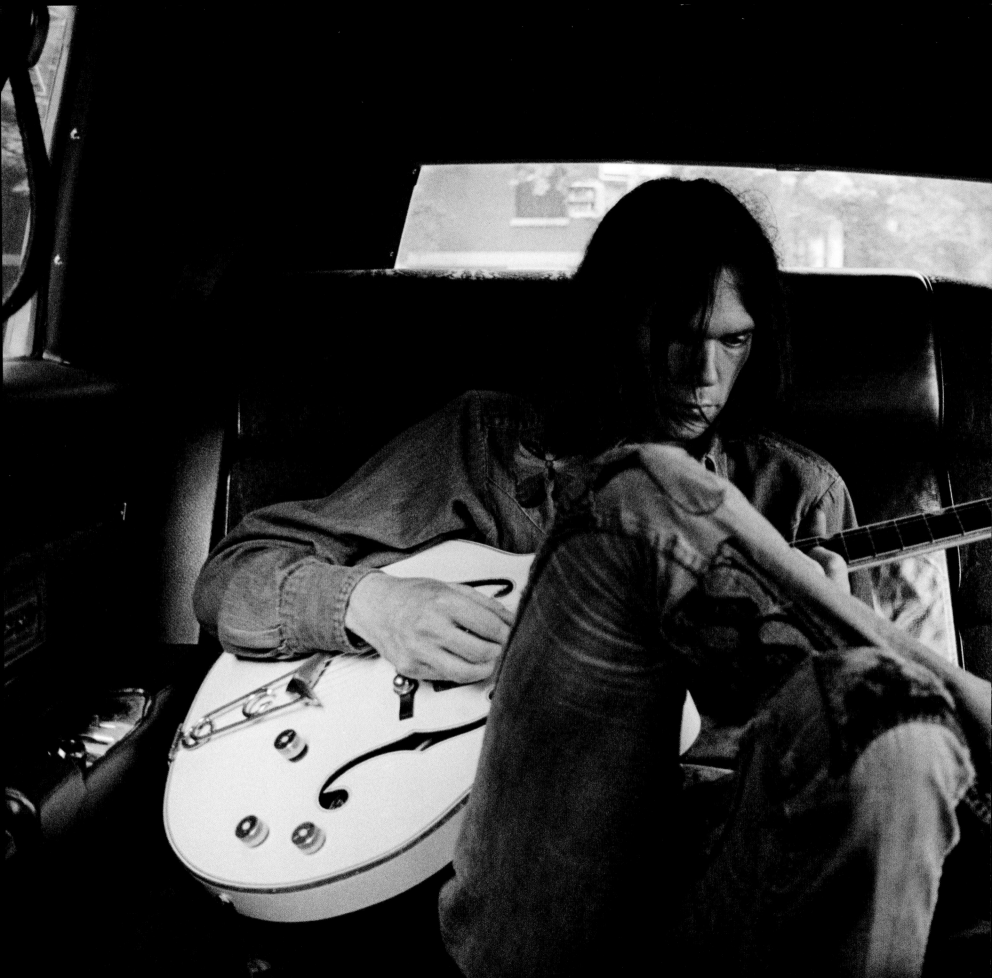

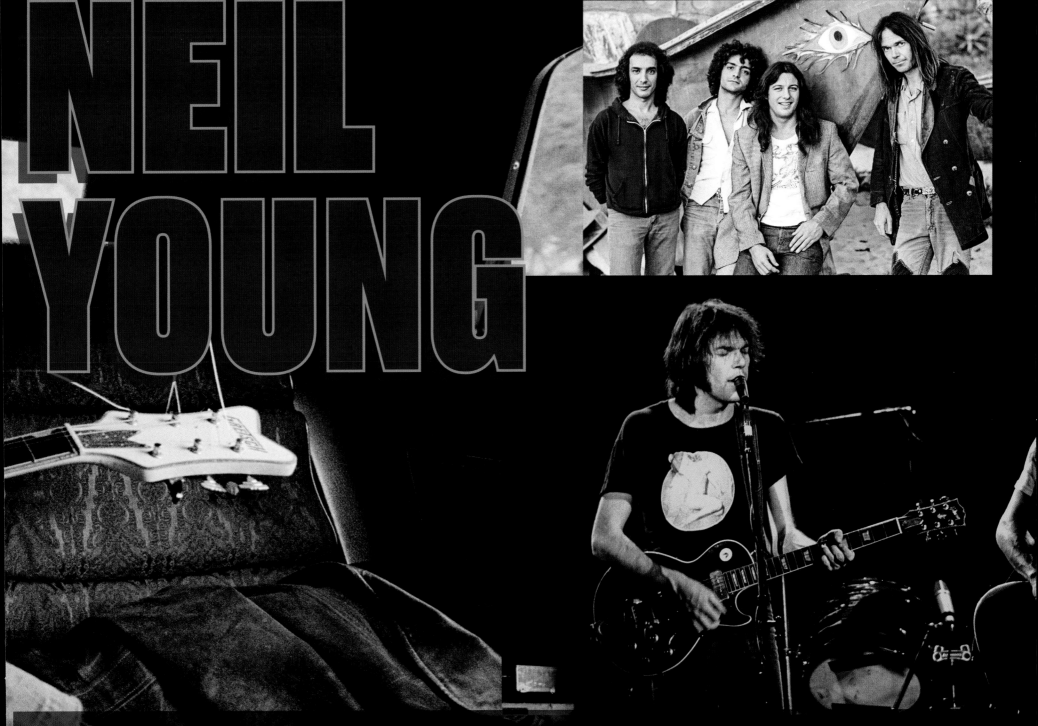

NEIL YOUNG

In 1966, Neil Young (b. 1945) had gone as far as he could with his Canadian music career, so he got in his 1953 Pontiac hearse called "Mort" and took off for Hollywood. He recently had met musicians in New York who told him about opportunities there, and once he arrived in California he saw one of them heading the opposite direction on Sunset Boulevard and stopped him. Before long, he and Stephen Stills assembled Buffalo Springfield with three other musicians, and Young hasn't stopped since. Second solo album *Everybody Knows This Is Nowhere* included "Down by the River" and "Cinnamon Girl," whose existential mojo Young continues mining for maximum artistic delight. There aren't many rock and rollers who debuted in the 1960s and have comparable catalogs and sales, but what

made this one a hero to his profession is his fearlessness. Young once famously said that when the middle of the road became too familiar, he liked to head for the ditch. His music has included stage plays, collaborations with Crosby, Stills & Nash, and solo performances made up of songs he has rarely performed. He's rock and roll's ultimate high-wire act, someone who would rather fail than play it safe. Young has always challenged himself, including trying to save Lionel Trains, building an electric 1959 Lincoln automobile, directing feature films, co-founding Farm Aid with Willie Nelson and John Mellencamp, helping bankroll the Bridge School for children with disabilities, and creating the Pono music system for advanced digital sound. Long may Young run.

Opposite: Neil Young playing a Gretsch White Falcon guitar in a moving limousine, New York City, June 1970
📷 © **JOEL BERNSTEIN**

Top right: Neil Young (far right) with his band Crazy Horse—Ralph Molina, Billy Talbot, Frank Sampedro, Malibu Beach, CA, November 1975
📷 **HENRY DILTZ / MORRISON HOTEL GALLERY**

Above: Young with his band Crazy Horse at the Berkeley Community Theater, CA, November 2, 1976
📷 **GARY KIETH MORGAN**

Captain Beefheart (1941–2010) strolled onto rock and roll's main stage in 1966 having reworked a Bo Diddley single, and, although not entirely original, "Diddy Wah Diddy" sounded like it had been beamed in from another solar system. A Southern California art prodigy born Don Glen Vliet (later changed to Don Van Vliet), he crafted an entourage called the Magic Band and proceeded to peel back the layers of reality until he found what suited him. Band members' nicknames alone spoke to their musical escapades: Drumbo, Antennae Jimmy Semens, Zoot Horn Rollo, Rockette Morton, and the Mascara Snake. At his communal rental in Los Angeles' San Fernando Valley, Captain Beefheart then taught each one exactly what to play. Third album of thirteen total, 1969's *Trout Mask Replica* on Frank Zappa's Straight Records, sounded like fingernails raking across a chalkboard to some, while others swore he was a feral visionary. No one walked away bored. Captain Beefheart, with a voice coming from what sounds like a grizzly, did not color within the lines. That fierce, creative core never varied. Finally in the mid-1980s, weary of a music business he believed hadn't dealt him fair and square, Captain Beefheart re-entered the visual arts and became a celebrated painter. "Train the cabooses," he once shouted, hoping for a realignment of humanity's intentions and a turn toward higher planes of consciousness. Which is exactly where the Captain lived from his first day on earth.

CAPTAIN BEEFHEART

Captain Beefheart at the Rainbow Theatre, London, April 7, 1973
📷 © JILL FURMANOVSKY

As the 1960s waned, Eric Clapton (b. 1945) ranked as guitar hero No. 1. After stints in the Yardbirds, John Mayall & the Bluesbreakers, Cream, and Blind Faith, the Englishman had reached international stardom's summit. So in 1969, when he started palling around with American troupe Delaney & Bonnie, he developed a sheer love of playing southern roots music. Soon enough, drummer Jim Gordon (b. 1945), keyboardist Bobby Whitlock (b. 1948), and bass player Carl Radle (1942–80) splintered off from the group, following Clapton under the incognito moniker Derek and the Dominos. Once they loaded into a Miami recording studio under the wing of production mastermind Tom Dowd, something happened. Songs evolved into majestic forays that rocketed from the depths of the blues to the rock firmament, and when guitar demon Duane Allman dropped in, the sessions went ballistic. The resulting double album, 1970's *Layla and Other Assorted Love Songs*, spread by word of mouth because Clapton's every move ended up in the press. Even with such fame, not much happened. Deep music heads were thrilled, but the masses didn't jump onboard until the single "Layla" started building on the radio two years later. By then, Derek and the Dominos had fallen into tatters. Clapton returned to a successful solo career, where he has remained ever since. For one album and a handful of concerts, though, Derek and the Dominos called down the heavens.

DEREK & THE DOMINOS

Bobby Whitlock, Eric Clapton, and guest Dave Mason at the Lyceum Theatre, London, October 11, 1970
© **BARRIE WENTZELL**

95

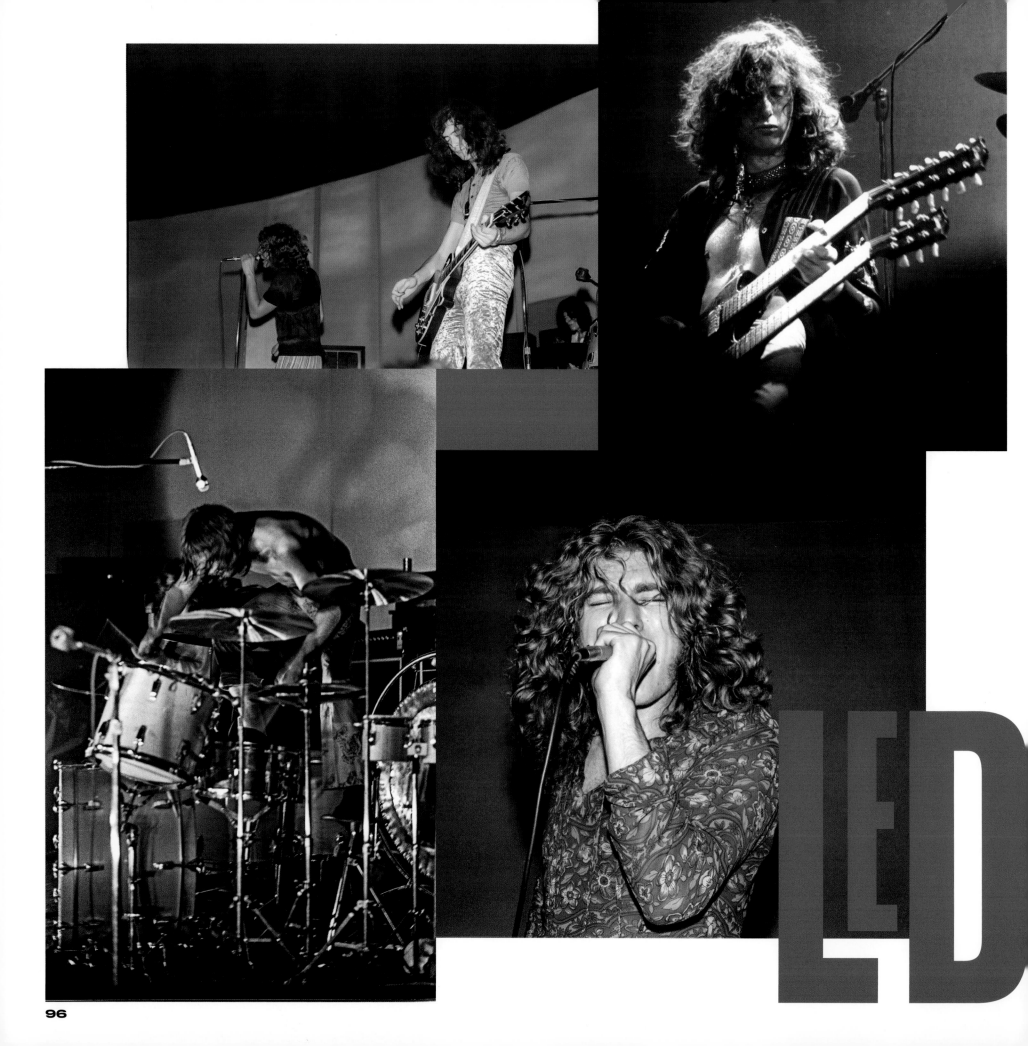

LED

If anyone is the lighthouse for 1970s hard rock, complete with long-lost folk flourishes and over-the-top lifestyle excesses, this English quartet sits highest on the rock. Final bandleader of the Yardbirds Jimmy Page (b. 1944) scouted bare-chested hippie Robert Plant (b. 1948), who brought in his mate John Bonham (1948–80). Joined by John Paul Jones (b. 1946), they began their narrative as the New Yardbirds. Legend has it that Keith Moon came up with the name Led Zeppelin to describe their future prospects. Their January 1969 debut didn't crash and burn like its cover art, but *Led Zeppelin II* that October redefined heavy. Shredding outrageous sonics from all directions, Page became the guitar hero for a new decade as Plant found his legs as front man. The foursome's untitled fourth album, one of the landmark musical achievements of the 1970s, alongside Pink Floyd's *The Dark Side of the Moon* and Fleetwood Mac's *Rumours*, made them the most successful group in the world. Just as their music stretched the aural and performance limits of the time, their offstage notoriety made them equally famous as bad boys. It all peaked with the 1975 double-LP *Physical Graffiti*. From there came a gradual decline in sales and critical encouragement, and Bonham's death in 1980 crashed the enterprise. The surviving members went on to other satisfying musical pursuits, but there will always be only one Led Zeppelin.

This page: John Paul Jones, Robert Plant, Jimmy Page, and John Bonham at the Day on the Green, Oakland Coliseum, CA, July 24, 1977
📷 **GARY KIETH MORGAN**

Opposite, clockwise from top left:
Plant, Page, and Bonham at the Kinetic Playground, Chicago, 1969
📷 **MARSHALL BOHLIN**

Page and his double-neck Gibson EDS at the San Diego Sports Arena, March 10, 1975
📷 **GARY KIETH MORGAN**

Plant at the Kinetic Playground, 1969
📷 **MARSHALL BOHLIN**

Bonham at the Kinetic Playground, 1969
📷 **MARSHALL BOHLIN**

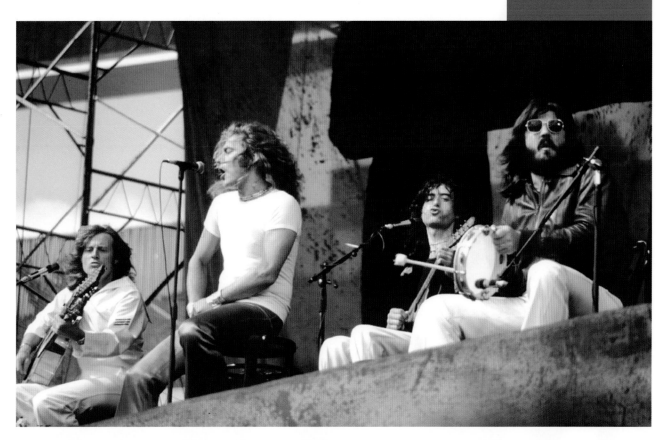

ZEPPELIN

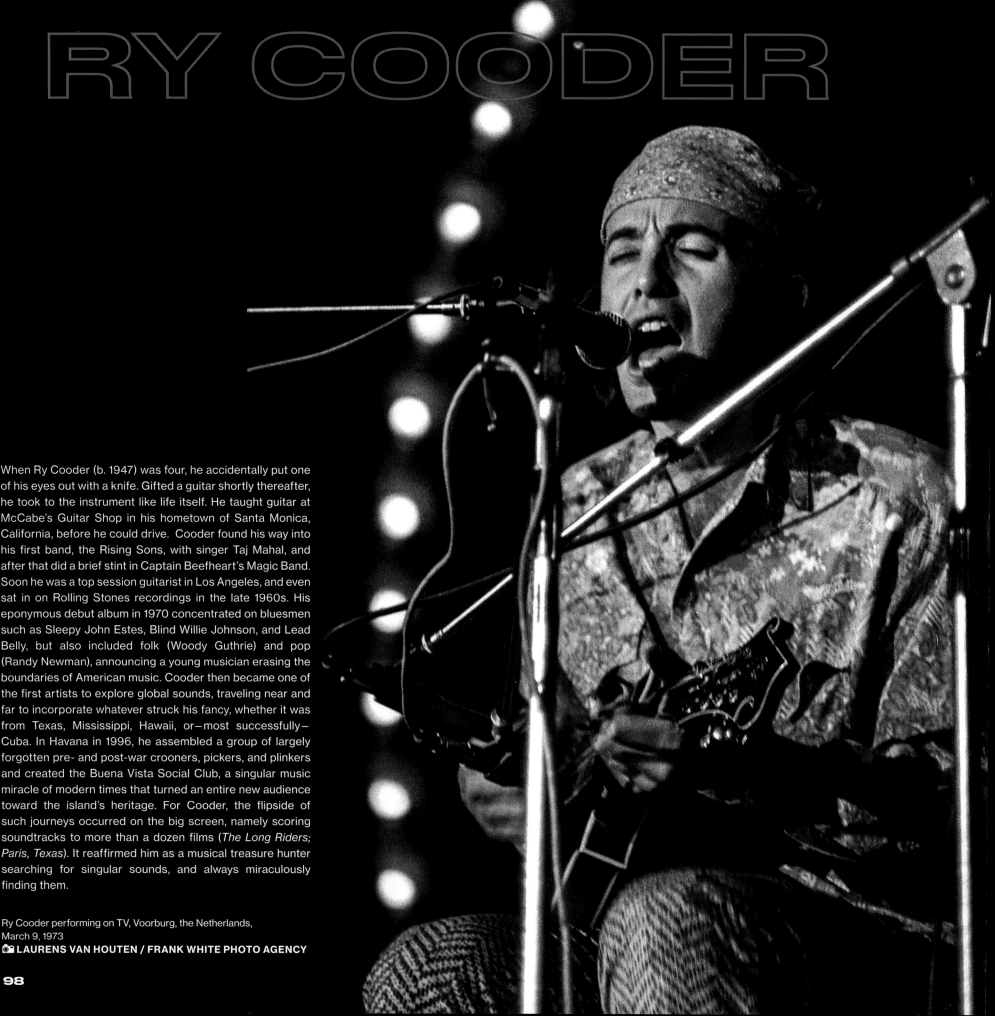

RY COODER

When Ry Cooder (b. 1947) was four, he accidentally put one of his eyes out with a knife. Gifted a guitar shortly thereafter, he took to the instrument like life itself. He taught guitar at McCabe's Guitar Shop in his hometown of Santa Monica, California, before he could drive. Cooder found his way into his first band, the Rising Sons, with singer Taj Mahal, and after that did a brief stint in Captain Beefheart's Magic Band. Soon he was a top session guitarist in Los Angeles, and even sat in on Rolling Stones recordings in the late 1960s. His eponymous debut album in 1970 concentrated on bluesmen such as Sleepy John Estes, Blind Willie Johnson, and Lead Belly, but also included folk (Woody Guthrie) and pop (Randy Newman), announcing a young musician erasing the boundaries of American music. Cooder then became one of the first artists to explore global sounds, traveling near and far to incorporate whatever struck his fancy, whether it was from Texas, Mississippi, Hawaii, or—most successfully— Cuba. In Havana in 1996, he assembled a group of largely forgotten pre- and post-war crooners, pickers, and plinkers and created the Buena Vista Social Club, a singular music miracle of modern times that turned an entire new audience toward the island's heritage. For Cooder, the flipside of such journeys occurred on the big screen, namely scoring soundtracks to more than a dozen films (*The Long Riders; Paris, Texas*). It reaffirmed him as a musical treasure hunter searching for singular sounds, and always miraculously finding them.

Ry Cooder performing on TV, Voorburg, the Netherlands, March 9, 1973
📷 **LAURENS VAN HOUTEN / FRANK WHITE PHOTO AGENCY**

The Allmans were southern men. Their ability to play a song for an hour without repeating themselves became the stuff of legend on the rock circuit in the late 1960s and immediately gave them kinship with the Grateful Dead, yet the Allman Brothers Band's points of origin made all the difference in how they approached blues- and jazz-influenced rock. Bandleader Duane Allman (1946–71) did for guitar in America what Eric Clapton managed in the United Kingdom (their summit-howling "Layla"), while younger brother Gregg Allman (1947–2017) broiled the organ behind a voice any Mississippi Delta bluesman would've sworn belonged to a relative. Guitarist Dickey Betts (b. 1943), second fiddle

to no six-stringer, plus bassist Berry Oakley (1948–72) and drummers Butch Trucks (1947–2017) and Jai Johanny "Jaimoe" Johanson (b. 1944), packed up alongside their band's namesakes and relocated from Jacksonville, Florida, to Macon, Georgia, in 1969 to be near their label Capricorn Records. That same year, the group's self-titled debut album signaled an inventiveness, virtuosity, and sophistication rarely heard in such barn-burning blues. The double live *At Fillmore East* in 1971 left listeners in a state of shock about the band's overwhelming chemistry. Months later, Duane Allman died at twenty-four in a motorcycle accident. Fifty-one weeks later, Oakley, also twenty-four, fell victim to the

same fate in virtually the same spot. Losing two members under such circumstances knocked the Brothers down, but not out. The Allman Brothers Band continued to play until finally rolling to a stop in 2014, their roar demonstrating the true spirit of their provenance.

Below: Duane Allman (top left); Dickey Betts, Duane Allman, and Jaimoe Johanson (top right); Gregg Allman (lower right), all at the Fillmore, San Francisco, January 1971; Butch Trucks (first drum kit), Johanson (second drum kit), Berry Oakley (bass), Dicky Betts (guitar), Duane Allman (guitar), and Gregg Allman (keyboard) in Golden Gate Park, San Francisco, 1971
📷 all © **JIM MARSHALL PHOTOGRAPHY LLC**

ALLMAN BROTHERS BAND

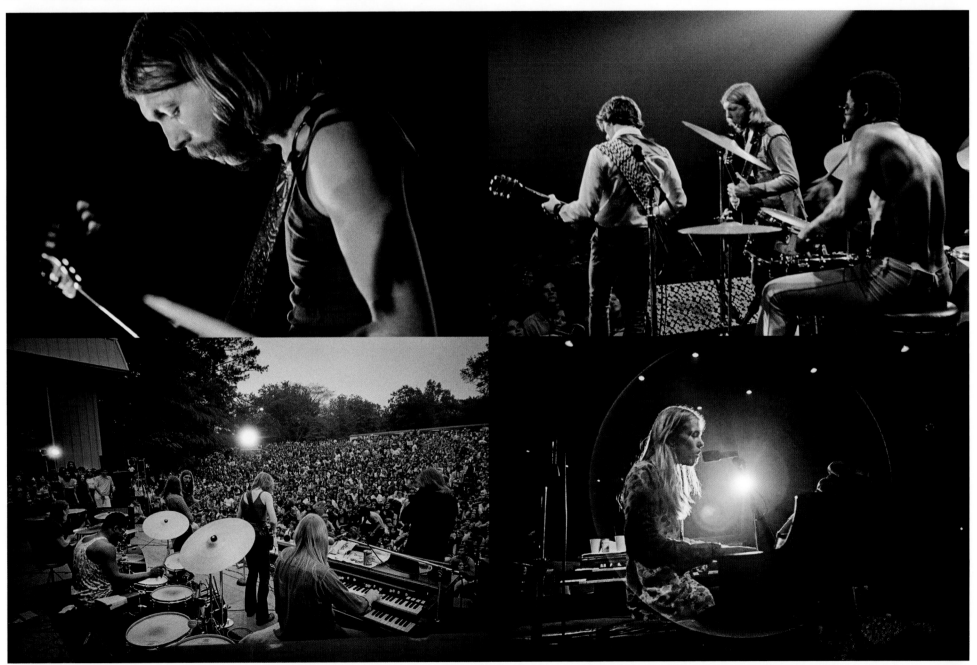

Carole King

Songwriters are a whole different type of person. They work almost exclusively in seclusion, either alone or with a partner. They often don't know who's going to be singing their songs, and they have to keep them broad enough for multiple interpretations. They also often don't know whether *anyone* will be singing those songs. Carole King (b. 1942) was the most successful female songwriter in the latter half of the twentieth century. She started composing while still a teenager, and married collaborator Gerry Goffin when she was seventeen. "Will You Love Me Tomorrow" by the Shirelles hit first, in 1960, followed by other early successes such as "The Loco-Motion," recorded by King's babysitter Little Eva. Then the dam broke: "Up on the Roof" by the Drifters, "One Fine Day" by the Chiffons, "(You Make Me Feel Like) A Natural Woman" by Aretha Franklin, and dozens of others. Like many songwriters, King dreamed of becoming a recording artist herself and in pursuit moved to Los Angeles' Laurel Canyon at the end of the decade. Her second album, 1971's *Tapestry*, hit the jackpot, topping the charts for fifteen weeks, and remained a bestseller for an incredible six years. Almost every song on it became a radio staple, including "You've Got a Friend," "It's Too Late," "I Feel the Earth Move," and "So Far Away." There's no besting an album like that, as King defines the art of songwriting.

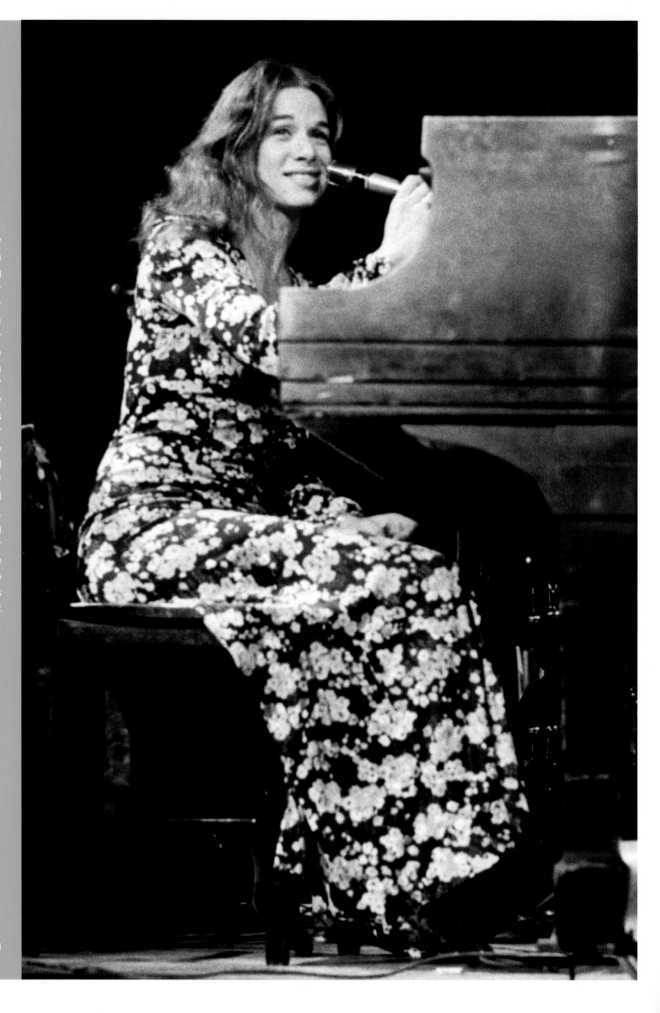

Carole King at Madison Square Garden, New York City, March 10, 1971
📷 © BOB GRUEN

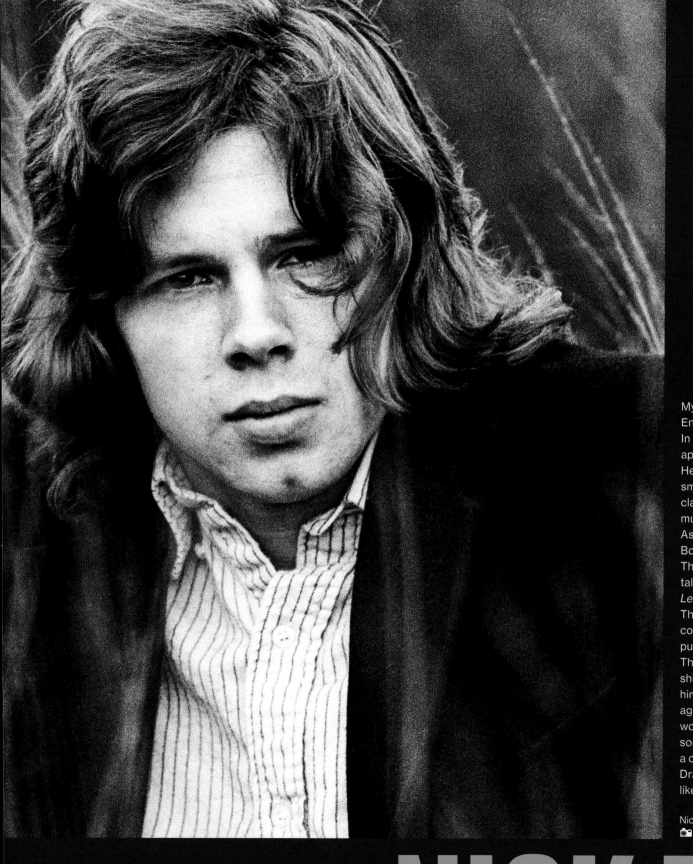

Mystery musical enigma = Nick Drake (1948–74). The young Englishman recorded three albums before taking his own life. In that brief career, there were few shows, few promotional appearances, and even less information about this man. He suffered crippling depression, but managed to leave a small body of music that affects ensuing generations. Piano, clarinet, and saxophone as a youngster gave way to folk music from a richly poetic soul. Fairport Convention bassist Ashley Hutchings introduced Drake to record producer Joe Boyd while the singer attended the University of Cambridge. The twenty-five-year-old American recognized genuine talent and got Drake signed to Island Records at twenty. *Five Leaves Left* in 1969 sold fewer than five thousand copies. The next two albums did no better. Boyd did everything he could to get Drake heard, even though the artist resisted all publicity and could barely speak when meeting new people. This doomed innocence drew people close. He put up no shields and did not shy away from the feelings that caused him so much pain. Taking an overdose of antidepressants at age twenty-six, only he knew it was time for him to leave the world. Years after he died, word finally began to spread. His songs were repackaged, some used in advertisements, and a cult of personality arose that no doubt would have terrified Drake. Now that he lives again through his music, it seems like the only way Drake could accept fame.

Nick Drake on Wimbledon Common, London, May 1969
THE KEITH MORRIS ARCHIVE

NICK DRAKE

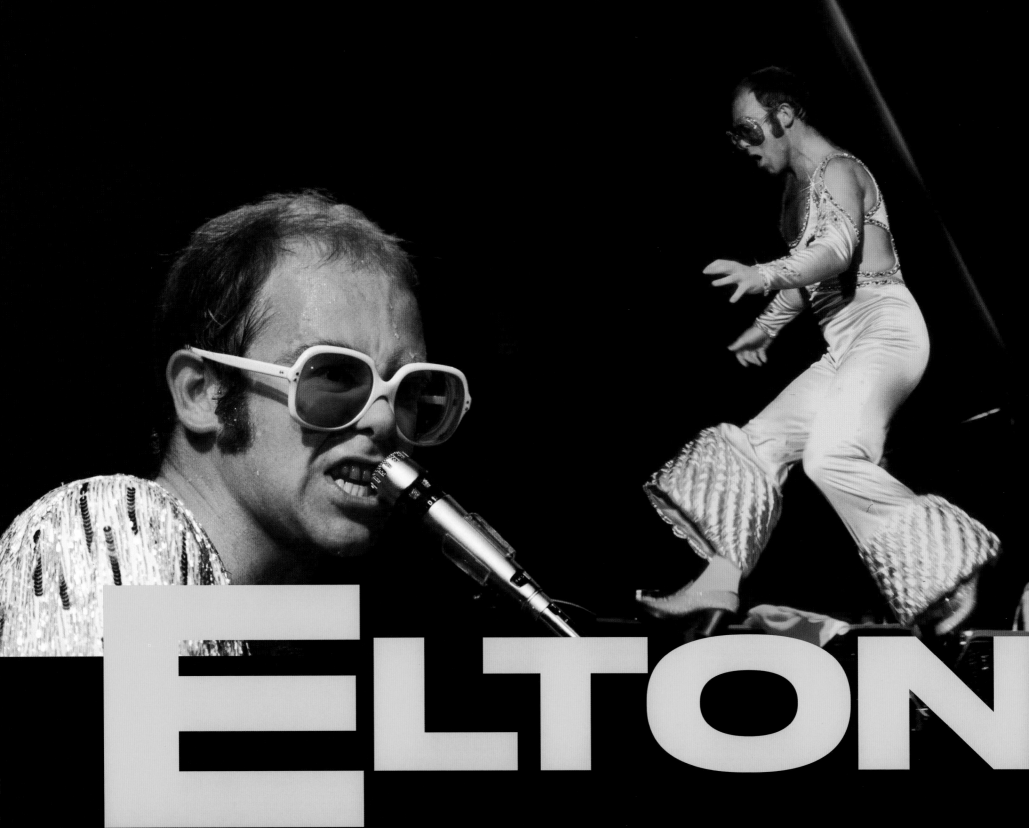

ELTON

Sir Elton Hercules John, CBE (b. 1947): a tall tale ready-made for Broadway. Born Reginald Dwight near London, the gifted pianist joined his first band, Bluesology, in 1962. Recording sessions suited him, and when he teamed up with English lyricist Bernie Taupin five years later, they put words to his romantic pop operas that then shot up the charts on the strength of vocal melodies rich with universal yearning. As stakes increased, they perfected a baroque Americana on three-peat *Tumbleweed Connection* (1970), *Madman across the Water* (1971), and *Honky Château* (1972). Throughout the 1970s, John maintained an even higher standard, recording some of the biggest hits of the decade ("Your Song," "Daniel") and putting on fantastical, maniacal shows. A steady stream of hits through the 1980s ("I'm Still Standing")—interrupted by throat surgery—made him the kind of pop star who exists outside of music, a celebrity of electric audacity. In 1995, he and Andrew Lloyd Webber wordsmith Tim Rich capped their contributions to the previous year's *The Lion King* with an Academy Award, and the piano prince opened another byway in his long and varied journey to knighthood. He's so grounded in music that he still listens to almost every new release and was such a voracious customer at the late, lamented Tower Records in Hollywood that the store used to open early for him. *Wonderful Crazy Night* in 2016 connected John's past and future as one lifelong love affair with words and music.

Opposite: Elton John at the Forum, Inglewood, CA, October 1974
📷 both **JAMES FORTUNE**

Right: John at the Forum, 1974
📷 **ABEL ARMAS II**

JACKSON BROWNE

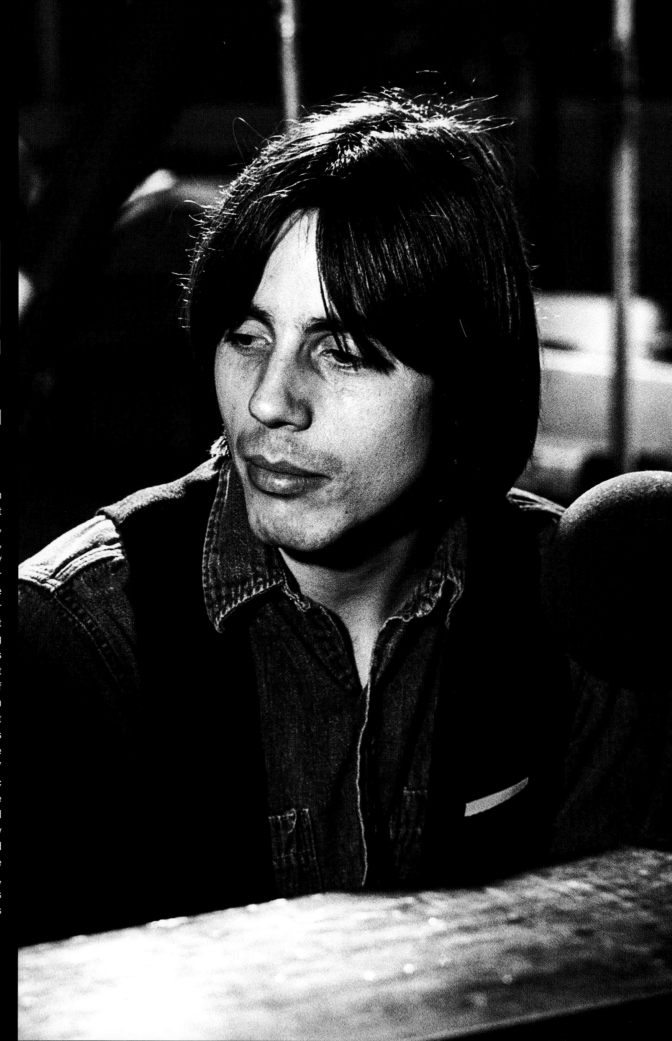

For someone who epitomized Los Angeles' Laurel Canyon music community in the early 1970s, it's surprising that Jackson Browne (b. 1948) was born in Germany. His father, a career Army journalist for *Stars and Stripes* newspaper, had been stationed overseas, but once the family returned stateside, they lived with the kids' grandfather in Southern California. In the 1960s, a teenage Browne moved to Greenwich Village, became a staff songwriter for Elektra Records, and collaborated with original Velvet Underground singer Nico on her solo bow. The pairing showcased Browne's compositional range, a gift that has served him well. After he returned to Los Angeles, a job at the Troubadour nightclub introduced him to members of the emerging scene, including Eagles Glenn Frey and Don Henley, and soon his abilities coalesced into an important presence. Browne's songs were so evocative of changes the culture and people were experiencing that he became a spokesman through signature songs "The Pretender," "Doctor My Eyes," "These Days," and many more eclectic examples of the highest order of music being made then. He was also an active participant in the political and ecological causes of the early 1970s, showing how music and the new ideas being promoted by the counterculture could go hand in hand. So much influence had fallen to musicians that he took great care to utilize the forum responsibly. In doing so, he earned mass appeal and respect. His deepest concerns have spanned far and wide, but the passion behind them is unchanged.

Jackson Browne at the RCA recording studio, Hollywood, CA, 1974
📷 **JAMES FORTUNE**

Few superstars gain the world and then walk away, only to come back with a different name and attain another strain of fame. Born Steven Demetre Georgiou (b. 1948) in London, the son of Greek and Swedish immigrants had been an outcast at school, but he fit in around the coffeehouses where he honed his songwriting. His distinctive, trembling tenor did the rest, and on 1970's *Tea for the Tillerman*, he cracked the code to success on the grandest scale imaginable. "Where Do the Children Play?" and "Wild World" made a global impact by virtue of his plaintive vocals, which have plucked heartstrings ever since. Follow-up *Teaser and the Firecat* eleven months later doubled down with "Morning Has Broken," "Moonshadow," and "Peace Train," the height of Cat Stevens mania. In 1977, he converted to Islam, changing his name to Yusuf Islam the next year, and then walked away from the music business for three decades. He restarted his craft in 2006, and while the three resulting albums haven't rivaled his Cat Stevens catalog, his lifelong fans stayed on the Peace Train with him. When he began again, he didn't ask for favors, and often walked a controversial line with his new identity. No other modern artist has made that kind of stand and come out on the other side so strong. It's all in the believing.

Right: Cat Stevens at the Capitol Centre, Largo, MD, May 3, 1974
📷 **ALAN LANCE**

Below: Stevens at Ahoy Rotterdam, the Netherlands, May 2, 1976
📷 **LAURENS VAN HOUTEN / FRANK WHITE PHOTO AGENCY**

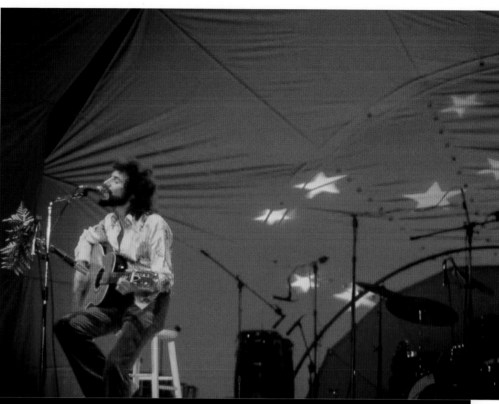

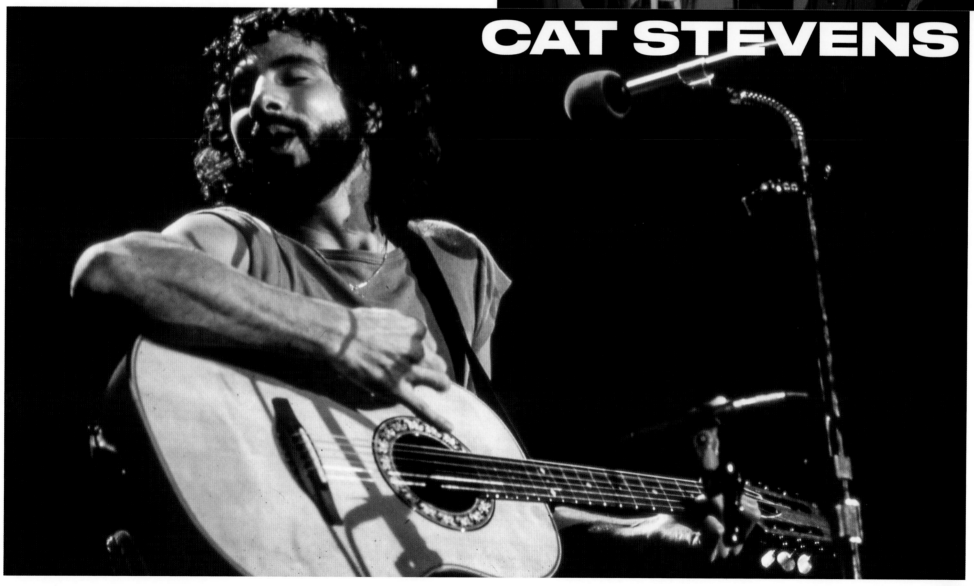

CAT STEVENS

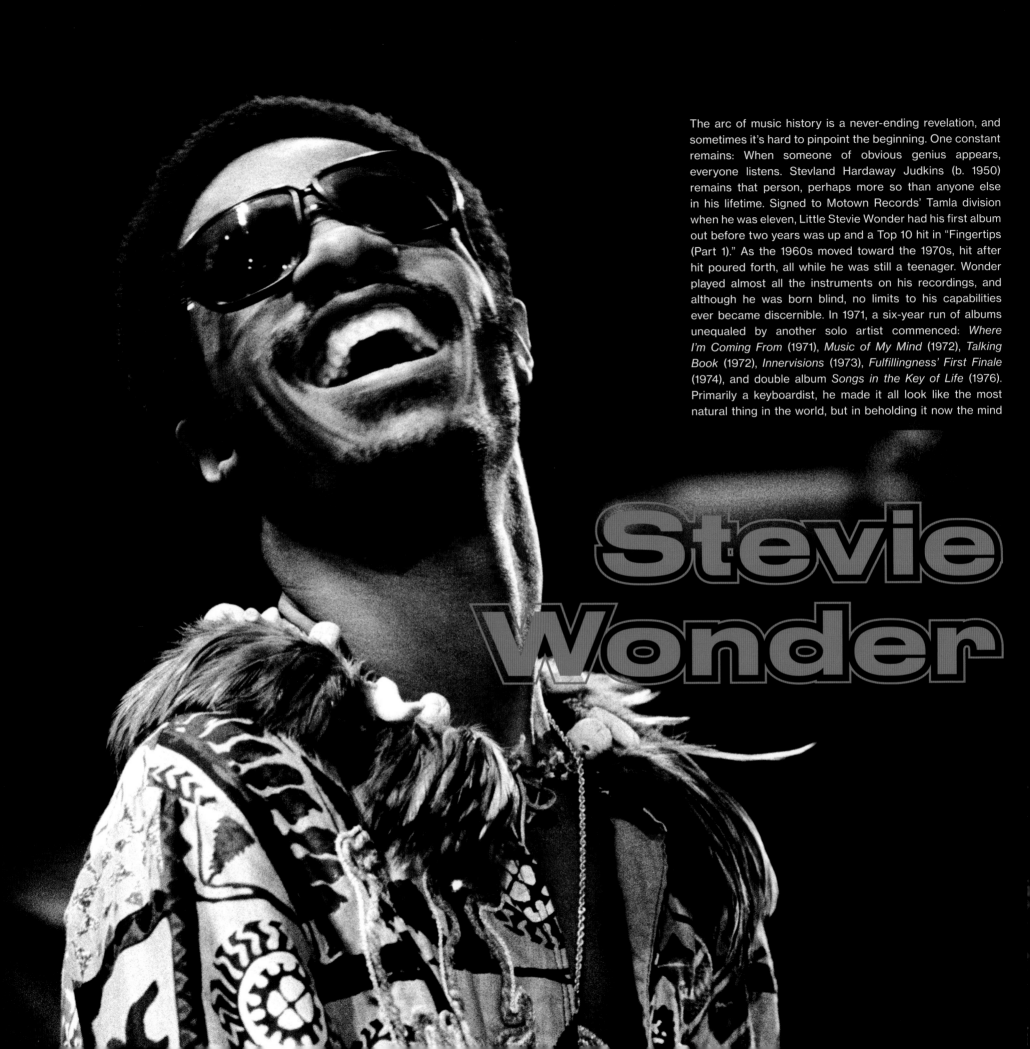

The arc of music history is a never-ending revelation, and sometimes it's hard to pinpoint the beginning. One constant remains: When someone of obvious genius appears, everyone listens. Stevland Hardaway Judkins (b. 1950) remains that person, perhaps more so than anyone else in his lifetime. Signed to Motown Records' Tamla division when he was eleven, Little Stevie Wonder had his first album out before two years was up and a Top 10 hit in "Fingertips (Part 1)." As the 1960s moved toward the 1970s, hit after hit poured forth, all while he was still a teenager. Wonder played almost all the instruments on his recordings, and although he was born blind, no limits to his capabilities ever became discernible. In 1971, a six-year run of albums unequaled by another solo artist commenced: *Where I'm Coming From* (1971), *Music of My Mind* (1972), *Talking Book* (1972), *Innervisions* (1973), *Fulfillingness' First Finale* (1974), and double album *Songs in the Key of Life* (1976). Primarily a keyboardist, he made it all look like the most natural thing in the world, but in beholding it now the mind

Stevie Wonder

boggles. The expressive vocals, inventive rhythms, soul-stirring musical progressions, incisive lyrics—so often it seemed as though there was no earthly way one person could have recorded all those songs. His live shows remain a marvel of sheer sonic love and reveal all that's inside him. Wonder has to let it out. It's his calling.

Opposite: Stevie Wonder at the Rainbow Theatre, London, January 20, 1974
📷 © **JILL FURMANOVSKY**

Right: Wonder at the Empire Pool, Wembley, London, September 2, 1980
📷 © **JILL FURMANOVSKY**

Lower right: Wonder at the San Diego Sports Arena, November 21, 1974
📷 **GARY KIETH MORGAN**

Below: Wonder at the Astrodome, Houston, January 25, 1976
📷 **JERRY ARONSON**

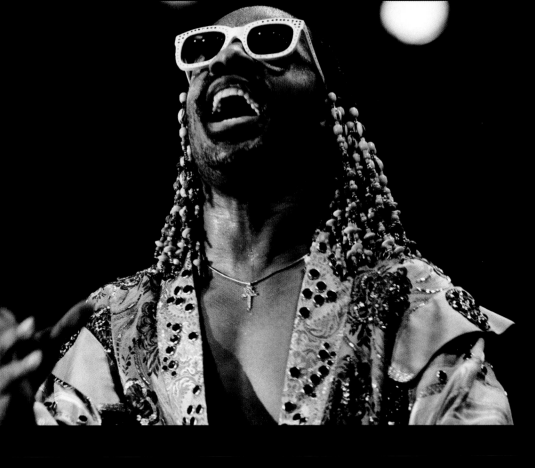

BLACK SABBATH

Tony Iommi (b. 1948) co-founded Black Sabbath in Birmingham, England, in 1968. The first wave of the British Invasion had gone ashore, and bands such as Led Zeppelin were taking its place. With bassist Geezer Butler (b. 1949), singer Ozzy Osbourne (b. 1948), and drummer Bill Ward (b. 1948), Iommi, a guitarist who had lost the tips of two fingers at a sheet-metal factory, wired a palpable menace into the songs, which before long became woven with occult themes, horror movies, and anything else good for a fright. The title of their second LP, 1970's *Paranoid*, says it all: They were running one hundred miles per hour on a dangerous grade of suspicion. Osbourne took it too literally, and got the boot in 1979, replaced by booming Elf singer Ronnie James Dio (1942–2010). No heavy metal-leaning group that came afterward escaped their influence. In the 1980s and 1990s, a wide array of members and sporadic reunions kept hopes alive that someday the original lineup would reform. Decades of speculation ended in 2013 when Butler, Osbourne, and Iommi regrouped for an album titled *13*. Their victory lap lasted until 2017 and a final concert in Birmingham. Black Sabbath made and then broke enough rock and roll rules that their longevity in the face of Iommi's ongoing cancer treatment tallies up to nothing short of miraculous. Devil horns up.

Clockwise from top left:
Geezer Butler at the International Amphitheatre, Chicago, February 11, 1974
📷 **DAVID SLANIA**

Tony Iommi at Alexandra Palace, London, August 2, 1973
📷 © **JILL FURMANOVSKY**

Ozzy Osbourne at Alexandra Palace, London, August 2, 1973
📷 all © **JILL FURMANOVSKY**

Osbourne at Black Sabbath's reunion show at Rod Laver Arena, Melbourne, Australia, 2013
📷 **JOHN RAPTIS**

Osbourne at the International Amphitheatre, Chicago, February 1972
📷 **DAVID SLANIA**

Few artists break through nearly two decades into their career, but 1989's *Nick of Time* proved as remarkable as Bonnie Raitt (b. 1949) herself. Born in Burbank, California, to Broadway star John Raitt and pianist Marjorie Haydock, the red-tressed slide guitarist was opening for Mississippi Fred McDowell at a Greenwich Village nightclub in 1970 when a *Newsweek* reporter wrote a glowing review. Her debut on Warner Bros. the following year touched off a parade of proud releases that established her as a singer of integrity and rootsy feeling. Album sales weren't notable, but a devout, vocal following sustained her through to a defining cover of Del Shannon's classic "Runaway" in 1977. Her releases continued to show artistic depth, but the following decade didn't go well for Raitt, who found herself label-less by 1988. *Nick of Time* rewrote the narrative. New home Capitol Records matched her to producer Don Was, and the resulting album summited the Top 200 sales chart and won three Grammys, including Album of the Year. From that point forward, the industry rallied around Raitt as she established an artistic presence once and for all. In 2012, she finally founded her own label, Redwing Records, demonstrating a self-empowerment that had incubated for decades. Raitt's commitment to political and ecological causes has gone hand in hand with her commitment to music since the beginning of her career, and her devotion to humanitarian issues is regarded with respect by every segment of the business.

Right: Bonnie Raitt at Kenan Stadium, University of North Carolina, Chapel Hill, April 19, 1980
📷 **JOHN ROTTET**

Below: Raitt at the Harvard Square Theatre, Cambridge, MA, May 1974
📷 **BARRY SCHNEIER**

BONNIE RAITT

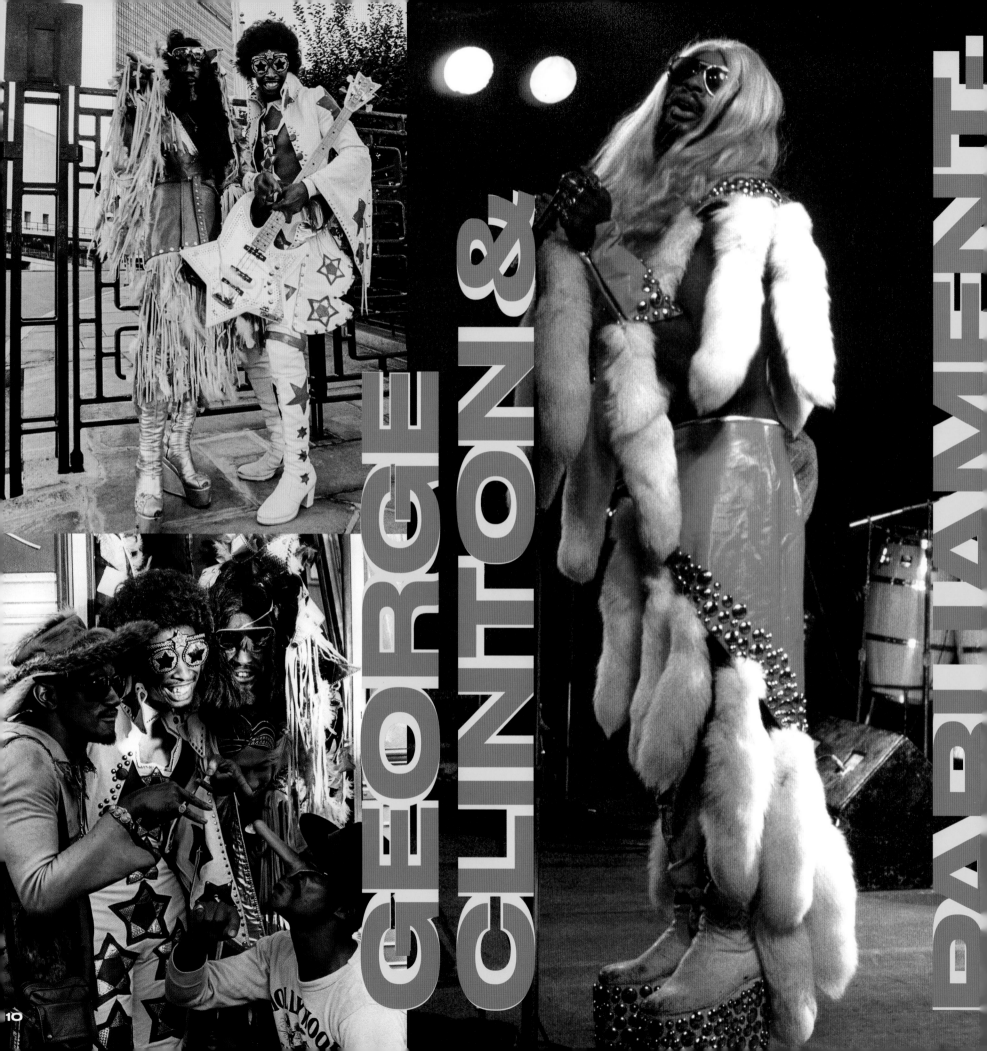

GEORGE CLINTON & PARLIAMENT.

FUNKADELIC

In the ever-shifting annals of African American music, few guiding lights are so flamboyant in their musical journey that they become their own genre. George Clinton (b. 1941) earned the distinction about four decades ago. Born in North Carolina and raised in New Jersey, Clinton probably experienced total culture shock when he moved north from the Deep South. Racial divisions a bit less stark, 1940s Jersey teamed with jazz and emerging R & B. By the 1960s, Clinton had signed to Motown Records, but only later, as a member of the doo-wop progressives the Parliaments, did he taste success with the 1967 hit "(I Wanna) Testify." Immediately thereafter, he began producing artists for smaller Detroit labels, all the while working toward an advanced degree in funkology and do-it-yourself inventiveness. During that time, music got recorded on the run, with little thought for long-term marketing plans and touring. If a song became a hit, it received the attention to try to take it further. When Parliament-Funkadelic formed in 1970, outrageous costumes, stage sets, onstage antics, and innovations translated into fame and big sales. Ringmaster Clinton combined all of his talents—writing, singing, producing, staging—into a cultural experience no one else could match that decade. His name meant something to audiences, and he worked it for all he was worth. Solo albums and modern-day P-Funk adventures continue today, when the man's out-thereness brings wondrous shakes of the head. A capital "F" crowns the prime purveyor of Funk.

Opposite left: Bernie Worrell, Bootsy Collins, George Clinton, and two unidentified members. Both at United Nations Plaza, New York City, September 1977
📷 both © **BOB GRUEN**

Opposite right: Clinton at the Oakland Arena, CA, 1976
📷 © **CHESTER SIMPSON**

Below: Parliament-Funkadelic performing, December 1978
📷 © **BOB GRUEN**

THE WILD SIDE MOVES IN FASTEN SEAT BELTS NOW

Al Green

After soul music swaggered through the 1960s, the cultural downturn of the following decade buttoned it up as disco threatened and labels dialed back their commitment to the genre. No one told producer Willie Mitchell at his Memphis headquarters for Hi Records. Superstar Al Green (b. 1946) anchored a roster of half a dozen perennials (including Ann Peebles and Syl Johnson) who continued full bore. Green met Mitchell at a show in Midland, Texas, in 1969, and eventually the hits started rolling in: "I Can't Get Next to You," "Tired of Being Alone," "Let's Stay Together," "I'm Still in Love

with You," and more. The singer, born in Arkansas and raised in Grand Rapids, Michigan, had a lock on the soul charts, and everything he sang turned to gold. The musicians at Hi Records' Royal Studio—drummers Howard Grimes and Al Jackson Jr., guitarist Mabon "Teenie" Hodges, bassist Leroy Hodges, and keyboardist Charles Hodges—were the perfect in-the-pocket players to craft an instantly identifiable sound, minimalistic but always bursting with feeling. The way Green's sweet and sultry voice floated over the instruments and swooped in for extraordinary effect defined southern

soul throughout the 1970s. The music changed in 1979 when Green fell off a stage and took it as a God-given sign that he needed to return to the church, where he had begun. Since then, the Reverend Al Green ministers at his Full Gospel Tabernacle Church in Memphis while, as 2003's *I Can't Stop* proves, he has continued to record at peak voice.

Eddie Folk, Al Green, and Aaron Purdie at the Rainbow Theatre, London, May 18, 1973
📷 © **JILL FURMANOVSKY**

England often throws a curve ball into the development of new music, much the way it did in the early 1970s with Roxy Music. American bands stuck pretty close to their roots then, but the English trafficked in style and attitude. Roxy Music's debut album in 1971 coalesced around initial instigators Bryan Ferry (b. 1945) and Graham Simpson (1943–2012), whose dramatic flair drew in guitarist Phil Manzanera (b. 1951), saxophonist Andy Mackay (b. 1946), and synthesizer guru Brian Eno (b. 1948). The latter pioneered "treatments," which made Roxy Music cutting edge. Bassist John Gustafson (1942–2014) and violinist Eddie Jobson (b. 1955) were also early contributors. Their synthesis of disparate influences helped usher in a sophisticated era dubbed glam. Front man Ferry had a keen eye for fashion, and the group went to careful lengths to ensure an ever-present stylishness onstage and on tape. "Re-Make/Re-Model" opened their debut as a succinct declaration of purpose. "Do

the Strand" and "Street Life" carried on the tradition. Their look and sound affected incoming punk and New Wave, too, something that often gets overlooked. Ferry spun romantic élan all the way to 1982 swan song *Avalon*, after which a lucrative solo career maintained him in the finest attire. At a 2011 Roxy Music reunion for its fortieth anniversary, the lead crooner stayed fierce in his dedication to delivering an elegance and subdued excitement in his music and live performances.

Left: Bryan Ferry at the Rainbow Theatre, London, March 31, 1973
📷 © **JILL FURMANOVSKY**

Below: Paul Thompson, Bryan Ferry, Brian Eno, Phil Manzanera, Eddie Jobson, and Andy Mackay at an outdoor festival at the Crystal Palace, London, 1972
📷 © **BARRIE WENTZELL**

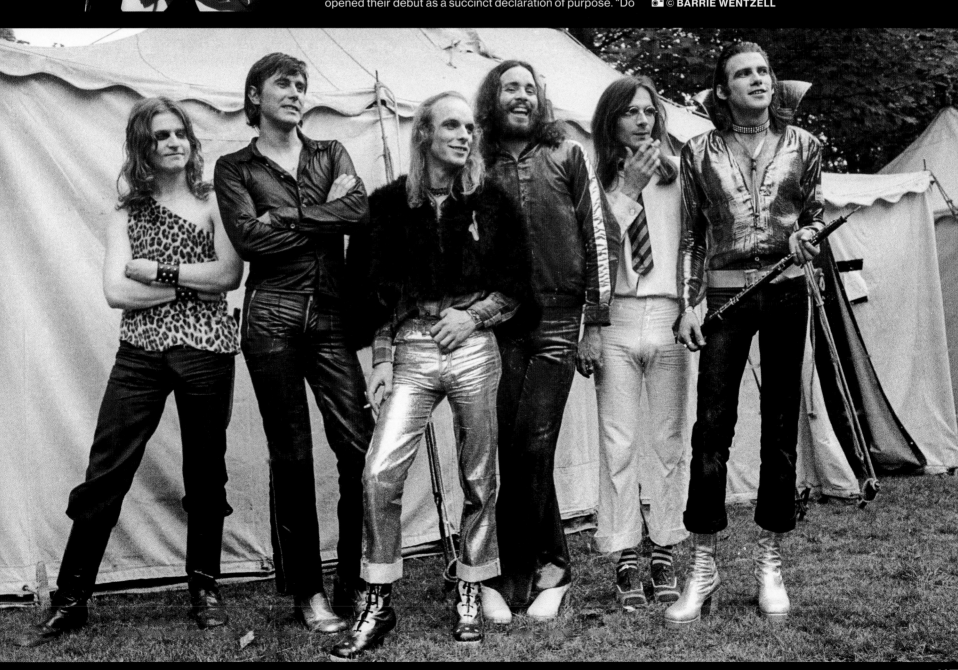

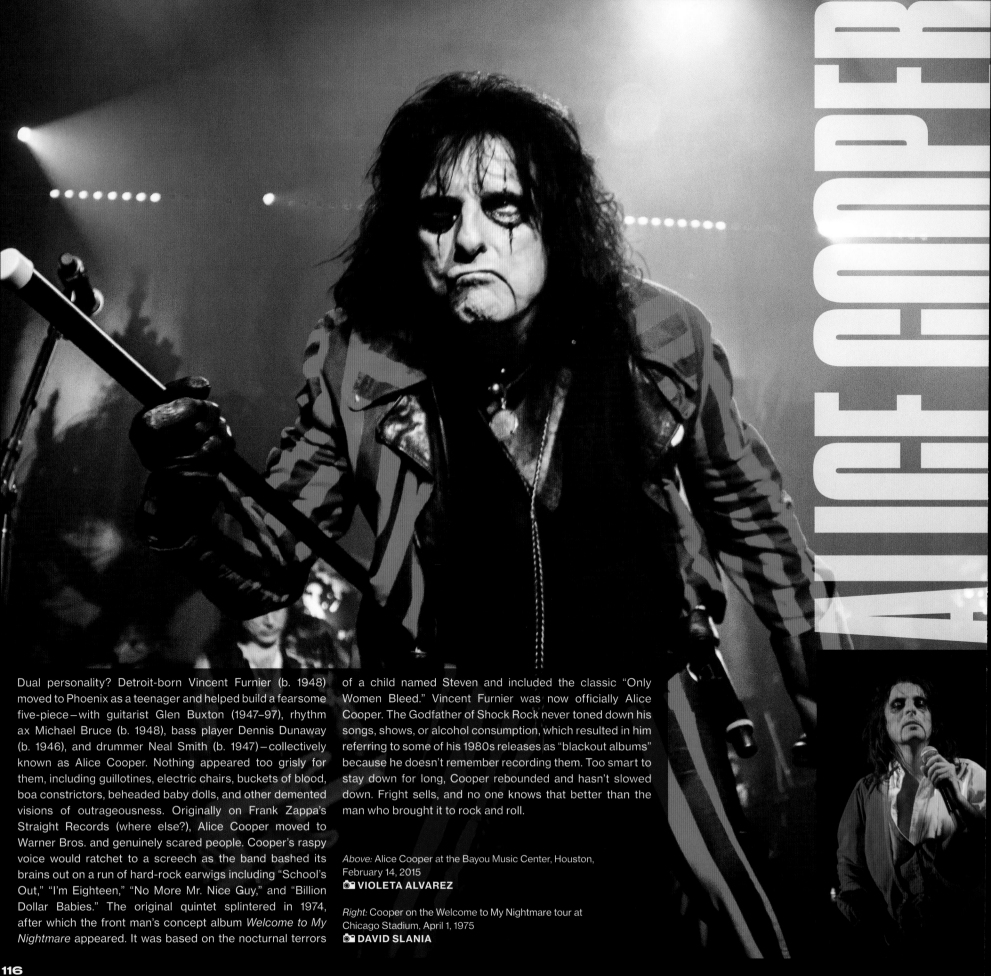

Dual personality? Detroit-born Vincent Furnier (b. 1948) moved to Phoenix as a teenager and helped build a fearsome five-piece—with guitarist Glen Buxton (1947–97), rhythm ax Michael Bruce (b. 1948), bass player Dennis Dunaway (b. 1946), and drummer Neal Smith (b. 1947)—collectively known as Alice Cooper. Nothing appeared too grisly for them, including guillotines, electric chairs, buckets of blood, boa constrictors, beheaded baby dolls, and other demented visions of outrageousness. Originally on Frank Zappa's Straight Records (where else?), Alice Cooper moved to Warner Bros. and genuinely scared people. Cooper's raspy voice would ratchet to a screech as the band bashed its brains out on a run of hard-rock earwigs including "School's Out," "I'm Eighteen," "No More Mr. Nice Guy," and "Billion Dollar Babies." The original quintet splintered in 1974, after which the front man's concept album *Welcome to My Nightmare* appeared. It was based on the nocturnal terrors

of a child named Steven and included the classic "Only Women Bleed." Vincent Furnier was now officially Alice Cooper. The Godfather of Shock Rock never toned down his songs, shows, or alcohol consumption, which resulted in him referring to some of his 1980s releases as "blackout albums" because he doesn't remember recording them. Too smart to stay down for long, Cooper rebounded and hasn't slowed down. Fright sells, and no one knows that better than the man who brought it to rock and roll.

Above: Alice Cooper at the Bayou Music Center, Houston, February 14, 2015
📷 **VIOLETA ALVAREZ**

Right: Cooper on the Welcome to My Nightmare tour at Chicago Stadium, April 1, 1975
📷 **DAVID SLANIA**

LYNYRD SKYNYRD

Considering the land of Dixie birthed rock and roll, southern bands asserted themselves only after Lynyrd Skynyrd picked up the standard wielded by the Allman Brothers Band. Formed in 1964 in Jacksonville, Florida, the eventual peak combination of Ronnie Van Zant (1948–77), Gary Rossington (b. 1951), Allen Collins (1952–90), Ed King (b. 1949), Billy Powell (1952–2009), Bob Burns (1950–2015), and Leon Wilkeson (1952–2001) developed a take-no-prisoners live edge that spread the gospel according to rock. When producer Al Kooper heard them, he knew he had found the mother lode. The group's first album appeared in 1973, but their sophomore release the next year featured "Sweet Home Alabama," a song of defiance answering those who looked down on people from below the Mason-Dixon Line for a lack of either education or culture. This band, named for the members' high school phys ed teacher Leonard Skinner, stuck out its chest for the region's greater recognition, and pity those who got in its way. In 1977, three days after the release of peak recording *Street Survivors*, a chartered plane carrying the band ran out of gas and crashed in the woods of Mississippi, killing lead singer Van Zant, recently added guitarist Steve Gaines (1949–77), and his backup-singer sister Cassie Gaines (1948–77), along with the pilot, co-pilot, and a band crew member. The new LP's cover art, picturing Lynyrd Skynyrd engulfed in flames, was immediately replaced. Younger brother Johnny Van Zant (b. 1959) took up the reins, and the band's flag-bearing southern legend continues today.

Top: Steve Gaines, Billy Powell, Ronnie Van Zant, Gary Rossington, Allen Collins, and Leon Wilkeson, July 2, 1977
Above: Gaines, Van Zant, and Rossington, July 4, 1977
Both at the Oakland Coliseum, CA
both **RICHARD MCCAFFREY**

Right: Van Zant and Collins at the Hammersmith Odeon, London, February 15, 1976
STEVE EMBERTON / CAMERA PRESS / REDUX

PAUL SIMON

F. Scott Fitzgerald once said there are no second acts in American lives. That obviously doesn't apply to Paul Simon. Born in Newark, New Jersey, and growing up in Queens, Simon (b. 1941) hit as the compositional half of Simon & Garfunkel, visiting all the dizzying heights of pop celebrity by penning classics such as "The Sound of Silence," "Mrs. Robinson," and even a modern-day standard in "Bridge over Troubled Water." He and childhood friend Art Garfunkel became two of the most successful artists of the 1960s. Not bad for men who once called themselves Tom & Jerry and had a minor brush with fame on the single "Hey Schoolgirl" in 1957. When Simon & Garfunkel ended in 1970, Simon gathered his words and wit, and followed up his U.K. solo debut of five years earlier, *The Paul Simon Songbook*, which he'd had withdrawn. *Paul Simon* in 1972 included "Mother and Child Reunion" and "Me and Julio Down by the Schoolyard," and for the rest of the decade he created a canon of lasting influence. He expressed pain and pleasure with equal insight, repeatedly with Grammy-winning results. In 1986, *Graceland* rocketed him to a new plateau. Inspired by the township music of South Africa, Simon recorded there with the country's best musicians and singers, including Ladysmith Black Mambazo, and took home a Grammy for Album of the Year in 1987, and then Record of the Year for "Graceland" the following year. Unparalleled. *Stranger to Stranger* in 2016 sported a radio hit, "Wristband," and Simon is eyeing his third act even now.

Above and right: Paul Simon at the Spectrum, Philadelphia, March 27, 1991
📷 both **JOE GENTILE**

Often it takes a harmonic convergence of musicians to get a new band's vibrational axis just right. When Lowell George (1945–79) counted among the ranks of Frank Zappa's Mothers of Invention in the 1960s, pianist Bill Payne (b. 1949) came to audition. Payne didn't get the gig, but he did meet George. Soon after, the two enlisted bassist Roy Estrada (b. 1943) from the Mothers along with drummer Richie Hayward (1946–2010), and Little Feat was hatched. They represented many sides of the Los Angeles outlook, with a cinematic scope of rock music. They were signed on the spot by Warner Bros. Records in 1969 on the strength of songs reflecting an acid-baked scene and flaunting beatnik-inspired wordplay and a dash of southern music stylings. Estrada walked and was replaced by bassist Kenny Gradney, along with guitarist Paul Barrere (b. 1948) and conga maestro Sam Clayton. This lineup killed from the first downbeat. Third release *Dixie Chicken* in 1973 boasted everything fans expected from the band, along with enough wide-open songs to draw newbies, too. The title track became a theme sing-along at the shows, and by follow-up *Feats Don't Fail Me Now* they had gathered a national fan base. The band's sound expanded to include more electronic keyboards, and followers sensed George pulling back. Mega-tours and critical idolatry continued until 1979, when George defected for a solo career. He died that same year, leaving Featheads adrift until 1987, when Payne and company took up the Little Feat flag and marched on.

Right: Lowell George at the Auditorium Theatre, Chicago, November 2, 1974
📷 **DAVID SLANIA**

Below: Paul Barrere, George, and Kenny Gradney at the Paramount Theater, Austin, TX, May 29, 1977
📷 © **KEN HOGE**

LITTLE FEAT

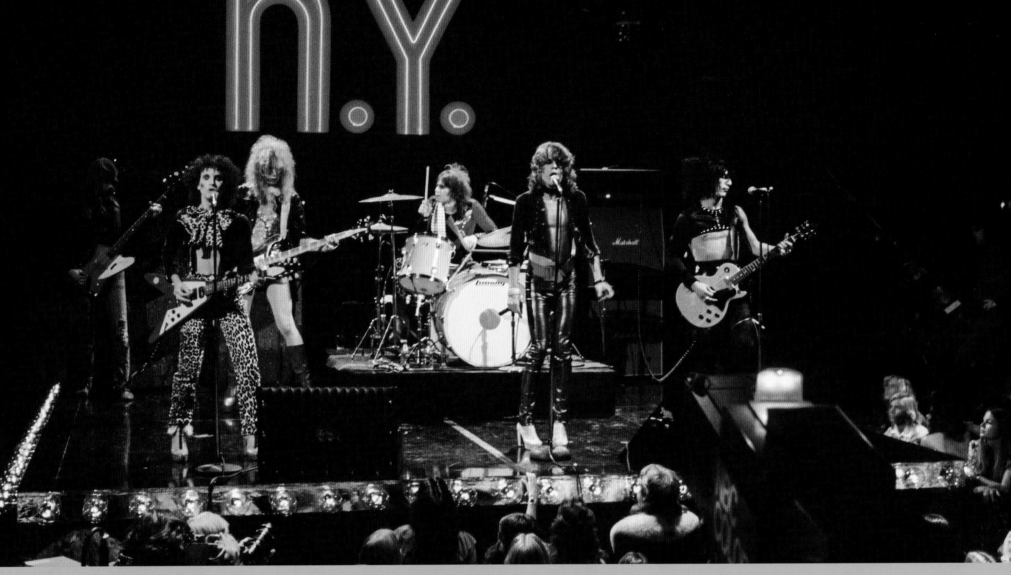

NEW YORK DOLLS

In 1971, New York City was gearing up for two decades of musical decadence. Setting the mood for the coming era of excess were the New York Dolls, who infiltrated the city's imagination that year with their ultra-glam look and anarchic sound, which presaged both heavy metal and punk. Dressed with androgynous aplomb, singer David Johansen (b. 1950), guitarist Johnny Thunders (1952–91), bassist Arthur Kane (1949–2004), guitarist and pianist Sylvain Sylvain (b. 1951), and drummer Jerry Nolan (1946–92) were like the Dead End Kids on an unchaperoned holiday. The New York Dolls were more than musicians; they were a phenomenon. They drew on old rock and roll, big-city blues, show tunes, the Rolling Stones, and girl groups, and that was just for starters. Their self-named 1973 debut, produced by rock Svengali Todd Rundgren, bottled the lightning of their no-holds-barred performances, and their 1974 follow-up, *Too Much Too Soon*, acquired a cult following, too, but they couldn't quite get across the Hudson River to captivate the entire country. An early English tour delighted upcoming DIY pioneers, who often credited the Dolls with providing a blueprint for their own future exploits. Inevitably, though, the runs in Johansen's stockings started to show, Thunders left for darker pastures, and the whole thing ran aground in 1975. By then, however,

CBGB had opened in New York, opening the floodgates for the Ramones and the rest of the Dolls-inspired demolition derby to roar into town.

Top: Sylvain Sylvain (in leopard), Arthur Kane, Jerry Nolan, David Johansen, and Johnny Thunders on the Midnight Show Special, Los Angeles, September 11, 1973
📷 © **BOB GRUEN**

Below: Sylvain before a show at Bunratty's, Allston, MA, early 1990s
📷 **CHRIS CUNEO**

LOU REED

When his time with the Velvet Underground ended unceremoniously in August 1970, no one knew whether Lou Reed (1942–2013) would continue in music. After departing the avant-garde group he had led for five years, the man who had written "Heroin," "Venus in Furs," and "I'm Waiting for the Man" disappeared, returning home to live with his parents. His solo debut came out two years later, but his second release of 1972, *Transformer*, signaled his return to rock and roll at full force. The album's career-defining hit, "Walk on the Wild Side," said everything about its creator, and shined such a telling and titillating light on New York City that the song followed Reed for the rest of his life. A provocateur at heart, he loved nothing more than stirring up discussion and dissent among fans and foes alike. He always thought that if people reacted normally, he was doing something wrong. In the Velvet Underground, his goal had been to write rock and roll songs about some of the same subject matter covered by novelists Raymond Chandler, William S. Burroughs, and John Rechy. Reed could never understand why the subjects and gritty styles those writers explored should be taboo in rock. He spent the balance of his life changing that, and when he died at age seventy-one, he had won out. Recorded with Metallica, his last album prompted some of the worst reviews of his career, but he knew that, too, would change with time, like so much of his groundbreaking white light/white heat music.

Top left: Lou Reed, 1974
📷 **ANDREW KENT**

Top right: Reed at the filming of the *Legendary Hearts* video, New York City, 1983
📷 **KATHY FINDLAY**

Above: Reed on the Rock and Roll Heart tour at the Berkeley Community Theatre, Berkeley, November 30, 1976
📷 **RICHARD MCCAFFREY**

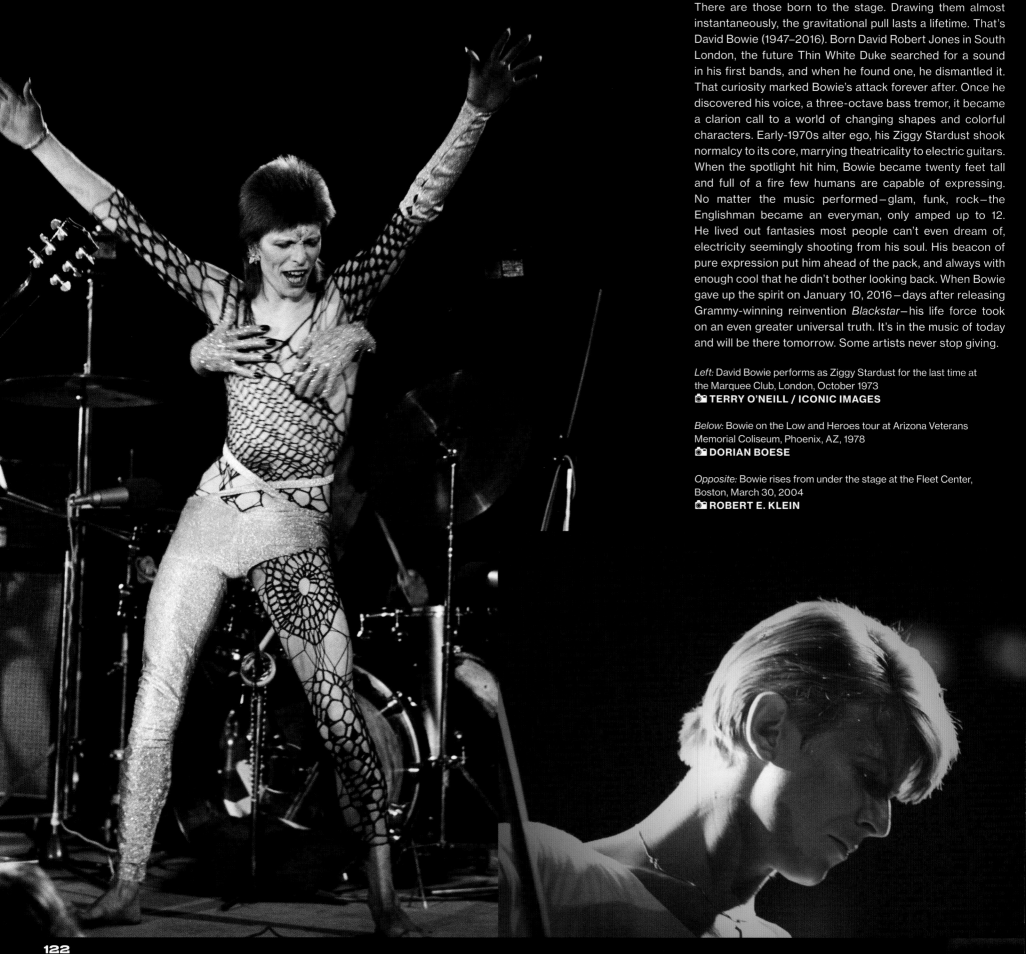

There are those born to the stage. Drawing them almost instantaneously, the gravitational pull lasts a lifetime. That's David Bowie (1947–2016). Born David Robert Jones in South London, the future Thin White Duke searched for a sound in his first bands, and when he found one, he dismantled it. That curiosity marked Bowie's attack forever after. Once he discovered his voice, a three-octave bass tremor, it became a clarion call to a world of changing shapes and colorful characters. Early-1970s alter ego, his Ziggy Stardust shook normalcy to its core, marrying theatricality to electric guitars. When the spotlight hit him, Bowie became twenty feet tall and full of a fire few humans are capable of expressing. No matter the music performed—glam, funk, rock—the Englishman became an everyman, only amped up to 12. He lived out fantasies most people can't even dream of, electricity seemingly shooting from his soul. His beacon of pure expression put him ahead of the pack, and always with enough cool that he didn't bother looking back. When Bowie gave up the spirit on January 10, 2016—days after releasing Grammy-winning reinvention *Blackstar*—his life force took on an even greater universal truth. It's in the music of today and will be there tomorrow. Some artists never stop giving.

Left: David Bowie performs as Ziggy Stardust for the last time at the Marquee Club, London, October 1973
📷 **TERRY O'NEILL / ICONIC IMAGES**

Below: Bowie on the Low and Heroes tour at Arizona Veterans Memorial Coliseum, Phoenix, AZ, 1978
📷 **DORIAN BOESE**

Opposite: Bowie rises from under the stage at the Fleet Center, Boston, March 30, 2004
📷 **ROBERT E. KLEIN**

DAVID BOWIE

STEELY DAN

Jazz influences play an integral part in rock and roll, often more overtly than in other forms of music. When Donald Fagen (b. 1948) and Walter Becker (b. 1950) formed Steely Dan in 1972, their love of American improvised music filtered into everything they wrote and played. They considered it a vital component of all they wanted to achieve. As students at Bard College in New York, they believed the poetry of Gregory Corso, Allen Ginsberg, and Lawrence Ferlinghetti to be among the highest art forms, and their band name derives from a phrase in William S. Burroughs's novel *Naked Lunch*. When they started writing songs, the two men often wandered into scenes inspired by criminal characters and drug use, and they always insisted on perfection when it came to recording techniques and playing ability. They infused those demands with human feeling and swinging tempos, creating a virtuosic, near-surrealistic collision of downtown and uptown attitudes. First hits "Do It Again" and "Reelin' in the Years" may not have sounded sophisticated to a mass audience, but Fagen's voice was born of soul music, and Becker's guitar could go both high and low. They enlisted the best rock and jazz studio musicians, and their run of successful albums right up to 1980's *Gaucho* was unsurpassed by most acts of their era. Rebooting in 1993, they began recording again and, this time, touring—something they'd ceased in 1974. Steely Dan fans finally got a chance to experience what they'd devoured on wax, tapes, CDs, and digital for decades.

Above: Jeff "Skunk" Baxter and Donald Fagen (center) at the Waikiki Shell, HI, March 29, 1974
Left: Fagen and Walter Becker at the Record Plant, Los Angeles, July 7, 1977
📷 both **HENRY DILTZ / MORRISON HOTEL GALLERY**

THE EAGLES

Southern California birthed more bands than any city in America, and the Eagles own the trademark. Glenn Frey (1948–2016) moved to Los Angeles from Michigan, while Don Henley (b. 1947) came from Texas. Each led a band: Frey fronted Longbranch Pennywhistle and Henley sang for Shiloh from behind the drum kit. The two met while backing Linda Ronstadt in 1971, and when they immediately started devising their own act, she suggested Bernie Leadon (b. 1947) as lead guitarist. Randy Meisner (b. 1946) made four and thus completed the first Eagles. A variety of lead vocalists, heavenly harmonies, and an aesthetic embodying the renegade side of 1970s Los Angeles generated only six albums in their initial incarnation through 1980, but that cache became a soundtrack for people's lives during that decade and some of the best-selling releases of all time. Meisner left, Don Felder (b. 1947) joined and departed, and Timothy B. Schmit (b. 1947) stepped in, but when Joe Walsh (b. 1947) became an Eagle in time for 1976's *Hotel California*,

the lineup peaked to the tune of multimillions. Calls for their reunion went unabated until 1993's Hell Freezes Over tour and subsequent live release. Double album *Long Road Out of Eden* in 2007 touched off two final rounds of touring that lasted until less than six months before Frey's death in 2016. With his passing, so went the Eagles. Except that groups at this level don't really go away completely. Unless hell freezes over.

Top: Randy Meisner, Don Henley (drums), Glenn Frey, Don Felder, and Joe Walsh on the Hotel California tour at the Oakland Coliseum, CA, 1976
📷 **GARY KIETH MORGAN**

Lower left: Walsh at Chicago Stadium, Chicago, January 1977
📷 **DAVID SLANIA**

Lower right: Henley at Poplar Creek Music Theater, Hoffman Estates, IL, July 3, 1985
📷 **PAUL NATKIN / PHOTO RESERVE, INC.**

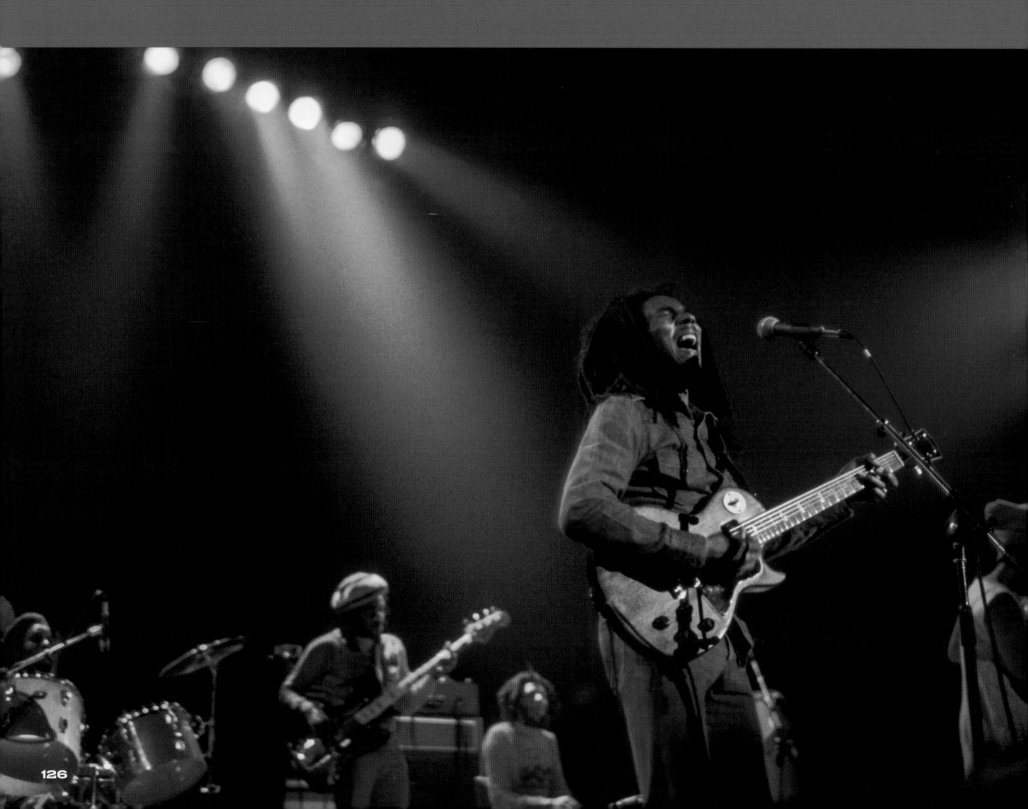

BOB MARLEY

Onstage in 1975, Bob Marley (1945–81) swelled with Rastafarian spiritualism, possessed by a musical clarity that drives groundbreakers to new frontiers. At thirty, the biracial Jamaican singer had lived several lifetimes since co-founding the Wailers as a teenager with childhood brothers-in-arms Peter Tosh and Bunny Wailer. Reggae wasn't a genre brand then, but Toots Hibbert had written "Do the Reggay" for his band the Maytals in 1968, and its addictive rhythmic pulse instantly drew an audience. As the new style spread throughout the Caribbean and parts of the United States and England, Marley amplified overt devotion using the new sound he helped popularize. In fact, the front man's electric magnetism onstage sparked the broader movement. Groundbreaking albums *Catch a Fire* and *Burnin'* in 1973 exposed Americans to the form, propagated in large part by the marketing savvy of Island Records head Chris Blackwell. A tidal wave of interest also fueled by Jimmy Cliff's hit film *The Harder They Come* and soundtrack reached a head when Marley went solo in 1974 with *Natty Dread*. A star was born. The youthful counterculture still growing worldwide bowed to a musician who burned white hot while delivering a message of love and hope. As the 1970s slipped toward the 1980s, the times called for the liberation he represented. Marley's death at thirty-six from cancer jolted the music universe, but in many ways increased his influence still more. If reggae has a face, it is Marley's.

Opposite: Marley and the Wailers—Carlton Barrett (drums), Aston "Family Man" Barrett, percussionist, and one of the I-Threes—on the Exodus tour at Forest National, Brussels, March 1976
Right: Marley at home, Hope Road, Jamaica, 1977
📷 both **DAVID BURNETT / CONTACT PRESS IMAGES**

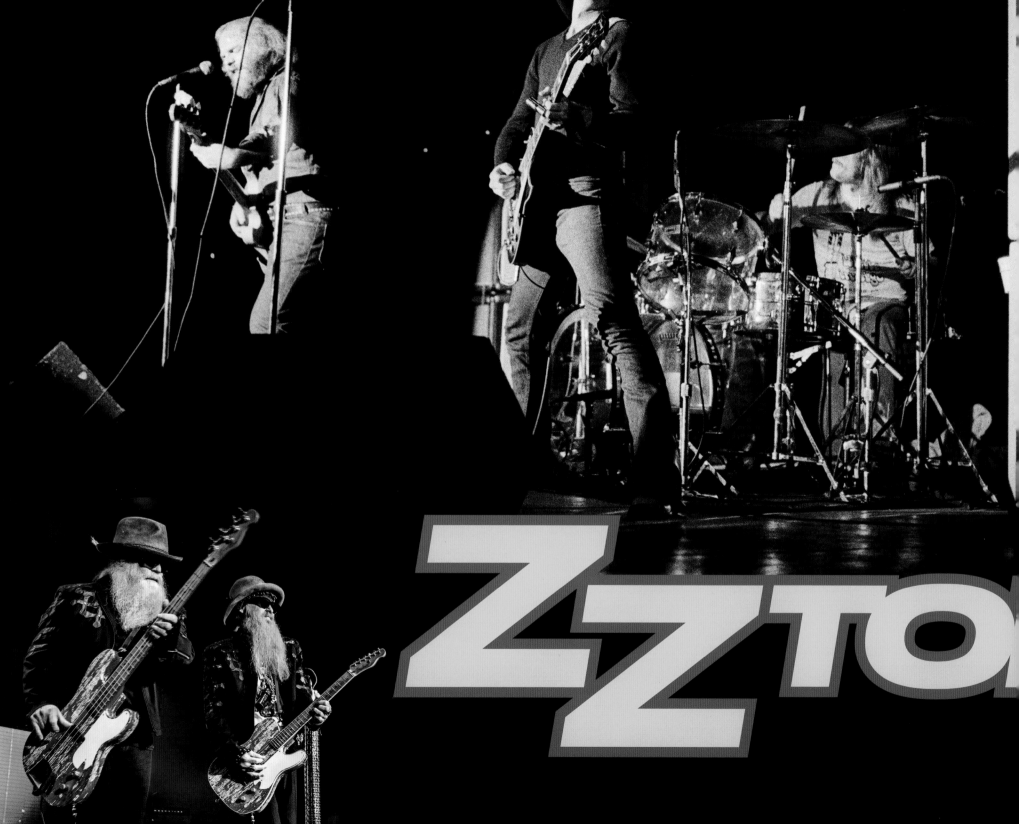

What they used to call "the little ol' band from Texas" is now one of the longest-running groups in rock and roll with its original lineup intact. Guitarist Billy Gibbons (b. 1949), bassist Dusty Hill (b. 1949), and drummer Frank Beard (b. 1949) came together in 1969 Houston, triangulated by a love of the blues, a desire to electrify it with southern boogie, and a good dose of fun. With manager/co-producer Bill Ham steering the ship, the threesome threw down on some big-as-Texas outrageousness, each album selling more than the previous and their tours expanding until one included live buffalo, rattlesnakes, and coyotes onstage. National resource for no-frill-and-all-thrills raunch, they were distinctive down to their glitter jackets and twirling guitars. When Gibbons and Hill showed up after a six-month break with beards down to their chests, a new trademark was born, including no beard on the one named Beard. *Eliminator* in 1983 debuted electronic flourishes and its MTV tie-ins sent ZZ Top through the roof. Songs such as "Legs" and "Sharp-Dressed Man" sold the album 10 million times. Only way left to top the Top would be a moonwalk courtesy of their Houston neighbors at NASA. Gibbons, Beard, and Hill have persevered because they have Texas blues in their bones, a Space City outlook on what's possible, and a sense of humor coming from a place where AstroTurf was born. That gives them a righteous edge on shooting for the stars.

Opposite top: Dusty Hill, Billy Gibbons, and Frank Beard (drums) on Alice Cooper's Billion Dollar Babies Holiday tour at the Greensboro Coliseum, NC, December 1973
📷 © **BOB GRUEN**

Opposite bottom: Hill and Gibbons at the Woodlands Pavilion, Houston, May 2, 2015
📷 **VIOLETA ALVAREZ**

Right: Hill and Gibbons on the Eliminator tour at the Capital Centre, Largo, MD, August 6, 1983
📷 **CHARLIE BELL SR.**

Below: Hill and Gibbons on the Afterburner tour at McNichols Sports Arena, Denver, July 30, 1986
📷 **CHRIS DEUTSCH**

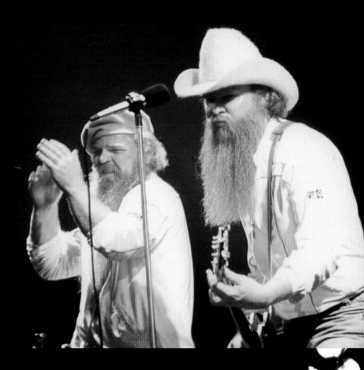

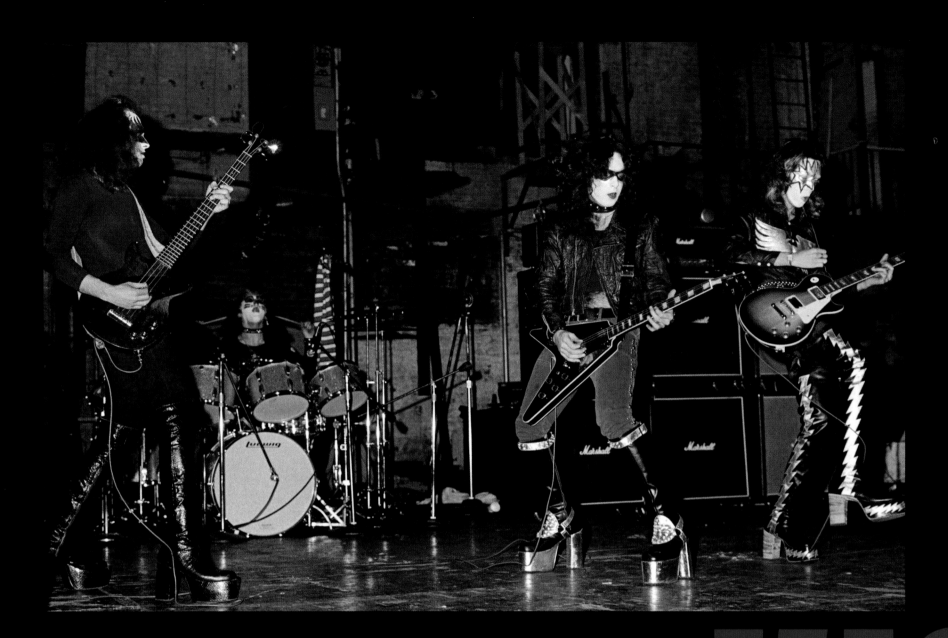

Part pro wrestlers, part comic book characters, KISS was all chutzpah with plenty of teenage kicks. In 1973 New York, the quartet debuted with all the subtlety of a flamethrower. Gene "The Demon" Simmons (b. 1949), Paul "Star Child" Stanley (b. 1952), Ace "Spaceman" Frehley (b. 1951), and Peter "Catman" Criss (b. 1945) combined fire-breathing, blood spitting, and pyrotechnics on a rock and roll stage vibrant enough to be gestating punk and New Wave. With faces painted in cartoon vividness and costumes straight out of a late-night creature feature, they created a KISS Army, and teens and pre-teens across the nation enlisted. In the process, they sold more than 100 million albums. Undeniably effective LPs such as *Destroyer*, which spawned Top 10 ballad "Beth," *Love Gun*, and *KISS Alive II*, all in a year-and-a-half span, became major happenings matched by tours that became outsize events in every city they visited. Critics called the group kid stuff, but fans loved every smoke bomb and drop of fake blood.

Rock-star lifestyle purveyors Frehley and Criss, both fan favorites, were shown the door in the 1980s, but that didn't stop them from reuniting on occasion to rally the base. Simmons eventually landed his own reality television show, and KISS merchandise continues to set sales records well into the new century. P. T. Barnum would be proud.

Above: Gene Simmons, Peter Criss, Paul Stanley, and Ace Frehley at the Fillmore East, New York City, December 26, 1973
📷 © **BOB GRUEN**

Opposite, clockwise from top left: Simmons breathing fire at the Chicago Stadium, January 22, 1977; Frehley at the Aragon Ballroom, Chicago, November 8, 1974; Simmons and Frehley at the Chicago Stadium; Stanley at the Chicago Stadium; Criss at the Chicago Stadium, all January 22, 1977
📷 all **DAVID SLANIA**

KISS

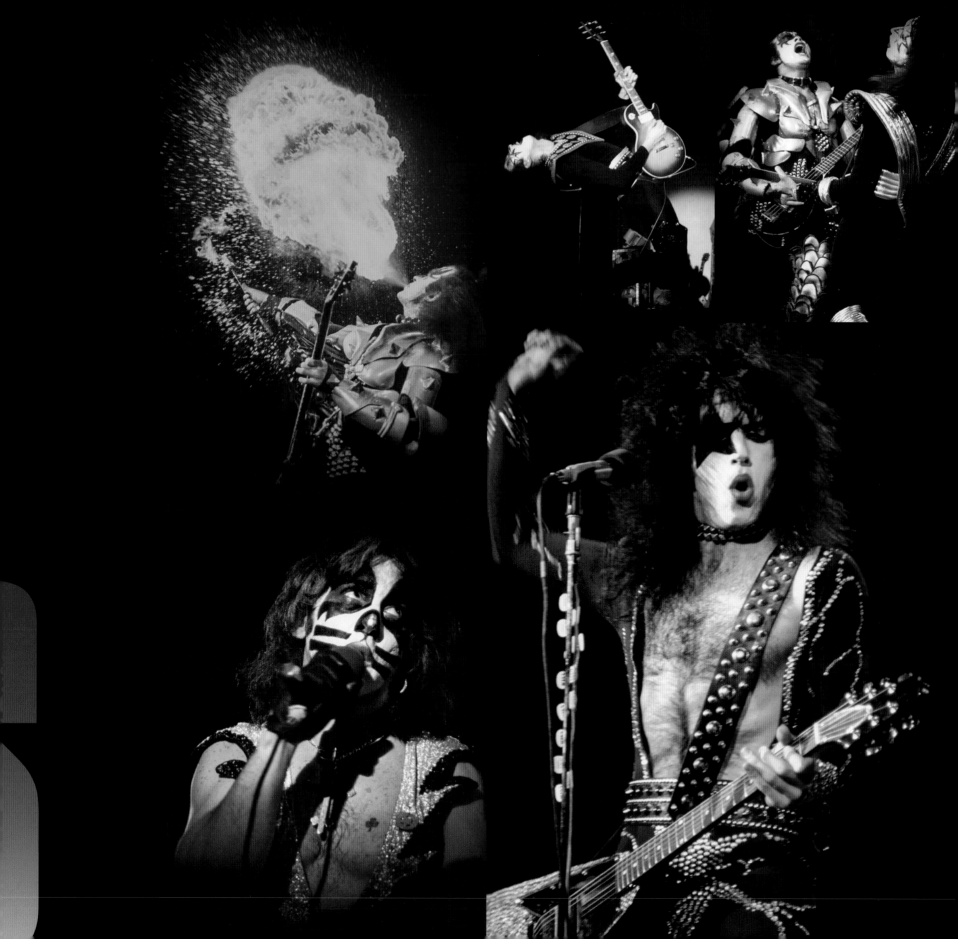

Linda Ronstadt

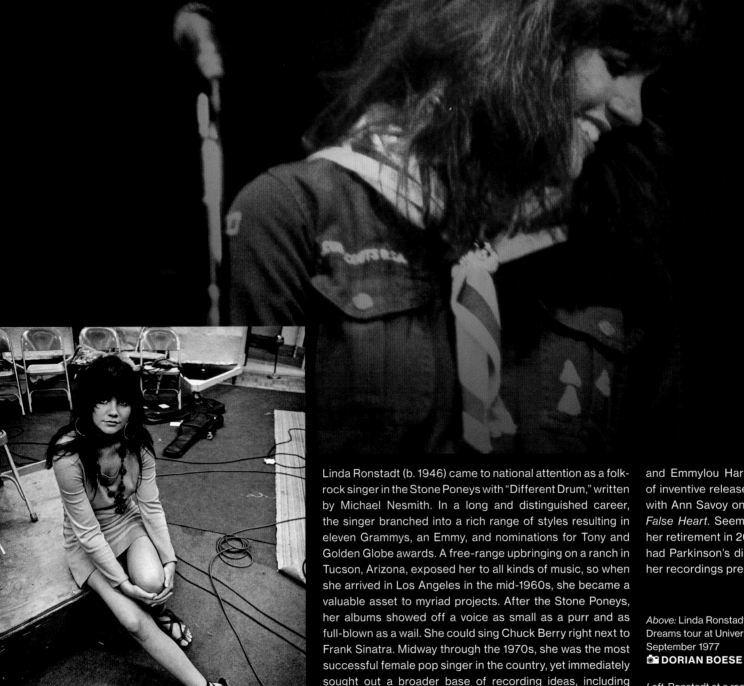

Linda Ronstadt (b. 1946) came to national attention as a folk-rock singer in the Stone Poneys with "Different Drum," written by Michael Nesmith. In a long and distinguished career, the singer branched into a rich range of styles resulting in eleven Grammys, an Emmy, and nominations for Tony and Golden Globe awards. A free-range upbringing on a ranch in Tucson, Arizona, exposed her to all kinds of music, so when she arrived in Los Angeles in the mid-1960s, she became a valuable asset to myriad projects. After the Stone Poneys, her albums showed off a voice as small as a purr and as full-blown as a wail. She could sing Chuck Berry right next to Frank Sinatra. Midway through the 1970s, she was the most successful female pop singer in the country, yet immediately sought out a broader base of recording ideas, including an appearance on Broadway in *The Pirates of Penzance*. Mariachi-themed sets and a pair of albums with Dolly Parton

and Emmylou Harris titled *Trio* continued her succession of inventive releases. One of her last recordings paired her with Ann Savoy on a collection of Cajun songs titled *Adieu False Heart*. Seemingly unstoppable, Ronstadt announced her retirement in 2011, and two years later revealed that she had Parkinson's disease and could no longer sing. Luckily, her recordings preserve one of America's richest voices.

Above: Linda Ronstadt in her Cub Scout uniform on the Simple Dreams tour at Universal Amphitheatre, Universal City, CA, September 1977
📷 **DORIAN BOESE**

Left: Ronstadt at a recording session for Michael Bloomfield, Al Kooper, and Stephen Stills's *Super Session* album, Los Angeles, 1968
📷 © **JIM MARSHALL PHOTOGRAPHY LLC**

TOM WAITS

Taking up residence at the corner of Heartbreak Boulevard and Lonely Avenue, Tom Waits (b. 1949) was drawn there by the characters, the kicks, and the sheer abandon of life on the other side of the tracks. Born in Pomona, California, to a pair of schoolteachers, he spent some of his youth living in National City near the Mexican border, and the freedom there of having nothing left to lose got under his skin. When he started performing, Waits got in line at Los Angeles' Troubadour club with the other hopefuls, and his beatific strains of beatnik poetry and bopping jazz rhythms crossed with a voice made of sandpaper stood out. Luckily, the record business was trolling for uniqueness, so when the pianist signed to Asylum Records, he joined an A-team of creatives. Lee Hazelwood, the Eagles, and Tim Buckley recorded his songs, but 1976's *Small Change* and its single "Step Right Up"

b/w "The Piano Has Been Drinking" took the song contortionist full frontal pop and he started to go nationwide. He found warmth with those on the losing end of the so-called American dream, and knew all the best places for refreshments on Skid Row. His 1980 marriage to Kathleen Brennan, their move to New York, and his increasing presence in movies resulted in triumphs such as Jim Jarmusch's *Down by Law* (1986). Unlike those of many story-tellers from the 1970s, Waits's recordings have deepened and become more provocative. He even got a voice part in *The Simpsons* episode "Homer Goes to Prep School." Waits arrived.

Tom Waits at the Ivanhoe Theater, Chicago, November 21, 1976
📷 © KESH SORENSEN

BRIAN eno

No one else travels in the same rarified sphere as Brian Eno (b. 1948). Practically inventing ambient music, he did it through experimental, sometimes nebulous instrumentalism that sank deep into the consciousness of listeners in a somewhat random way, yet affected them on a subtle but profound level. Eno started out as a painter in art school in the late 1960s, often calling himself a "non-musician." That didn't prevent the young Englishman from joining Roxy Music to man the synthesizer before society at large knew what those were. The band found a devoted audience, but Eno left in 1973 to make his own music. Albums such as *Here Come the Warm Jets* (1974), *Another Green World* (1975), and *Ambient 1: Music for Airports* (1978) had no precedents and blew the minds of those whose doors of perception were already stuck open. Eno led his exploratory fans through a variety of adventures, some vocal, some instrumental, some visual, some philosophical, but all intriguing. In the late 1970s, he

began a wildly successful producing career that included David Bowie's Berlin trilogy, Devo, the Talking Heads, and David Byrne. U2 came calling the following decade. All those collaborations are landmarks in creativity, particularly Byrne's *My Life in the Bush of Ghosts*, which employed taped radio broadcasts, musical "treatments," and original recordings to assemble a free-flowing trip to another land. Eno spelled backward is One, which surely means something that will someday be discovered.

Left: Brian Eno at Basing Street Recording Studios, London, November 5, 1979
© **JILL FURMANOVSKY**

Below: Eno at the Whisky a Go Go, West Hollywood, CA, December 19, 1972
KEVIN C. GOFF

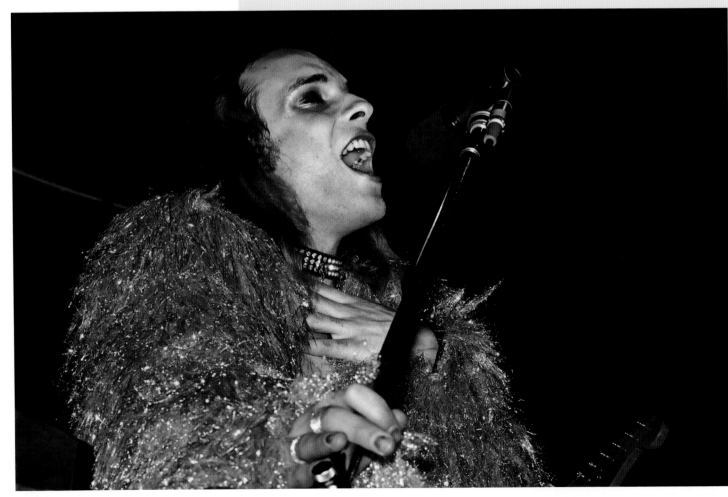

AC/DC

In 1975, launching a blues-rock band from Australia might as well have entailed space travel. Fortunately, brothers Malcolm (b. 1953) and Angus Young (b. 1955), who were the youngest of eight in a family that had emigrated from Glasgow to Sydney on a travel promotion, weren't easily deterred. Also a Scot down under, singer Bon Scott (1946–80) gave them a mentor to follow, and their 1975 debut, *High Voltage*, threw the circuits partly open. *Highway to Hell* four years later sealed a lifetime pact with global worship. When notorious overindulger Scott died in London on a tour break, the Youngs recruited English screecher Brian Johnson (b. 1947), and the resulting *Black in Black* (1980) remains a perennial top seller. Angus Young's trademark schoolboy uniform and Chuck Berry-on-speed licks contrasted with his sibling's staunch rhythm guitar stance. While their commercial fire raged, MTV debuted on August 1, 1981, and hard rock went through the roof. AC/DC enjoyed that ride up until 2014 and the release of their seventeenth album, *Rock or Bust*. Although a Top 5 hit in the United States, absent was Malcolm Young, who had retired because of early dementia.

Johnson did not complete the ensuing world tour when physicians advised him to quit performing or risk losing his hearing altogether. Longtime drummer Phil Rudd (b. 1954) was replaced after being arrested on myriad unsavory charges. Axl Rose from Guns N' Roses completed the remaining shows. Justice prevailed.

Above: Angus Young at the Day on the Green at the Oakland Coliseum, CA, September 2, 1978
📷 **BARON WOLMAN / ICONIC IMAGES**

Top right: Bon Scott and Cliff Williams at the Lubbock Municipal Coliseum, TX, July 4, 1978
📷 **KELLY BERRY**

Middle right: Brian Johnson and Young on the Fly on the Wall tour at McNichols Sports Arena, Denver, October 25, 1985
📷 **CHRIS DEUTSCH**

Bottom right: Phil Rudd (drums), Young, and Williams (bass) at the Lubbock Municipal Coliseum, July 4, 1978
📷 **KELLY BERRY**

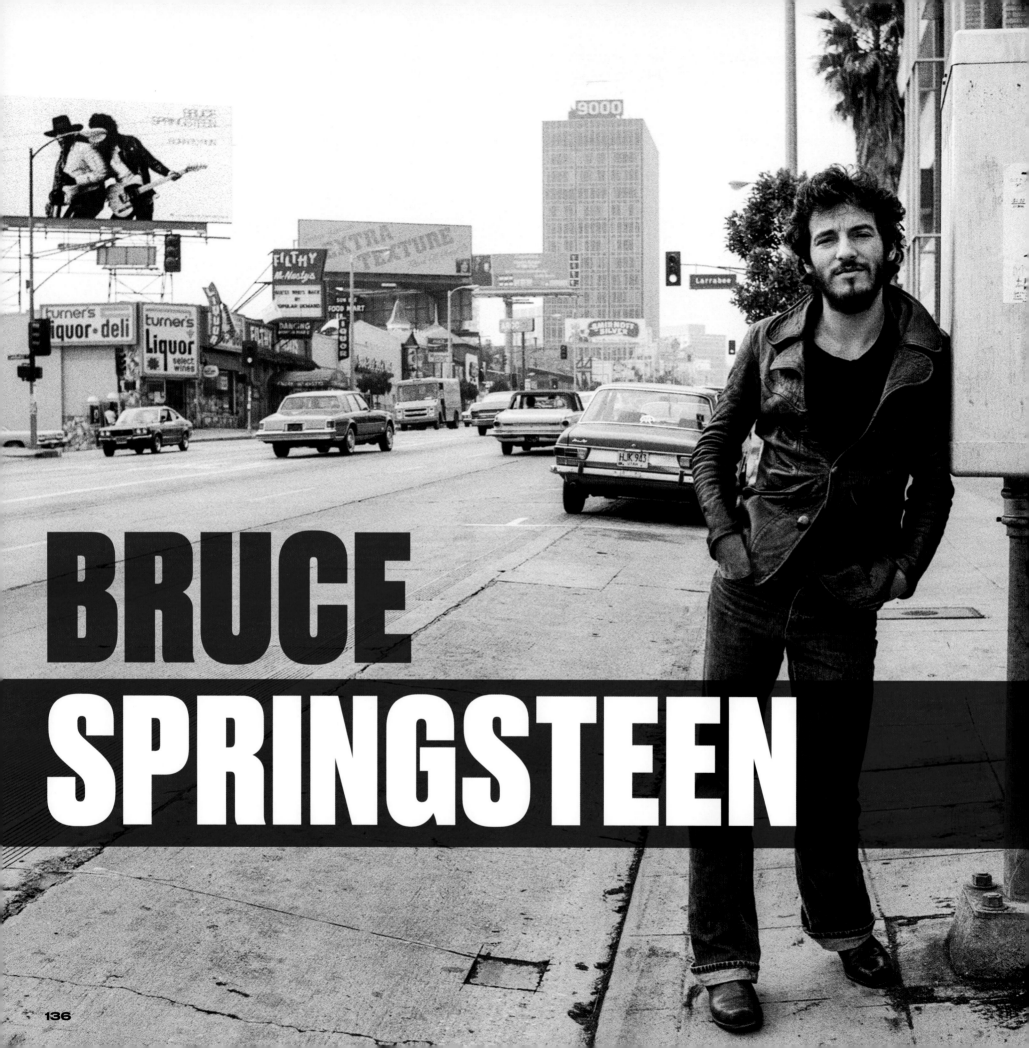

BRUCE SPRINGSTEEN

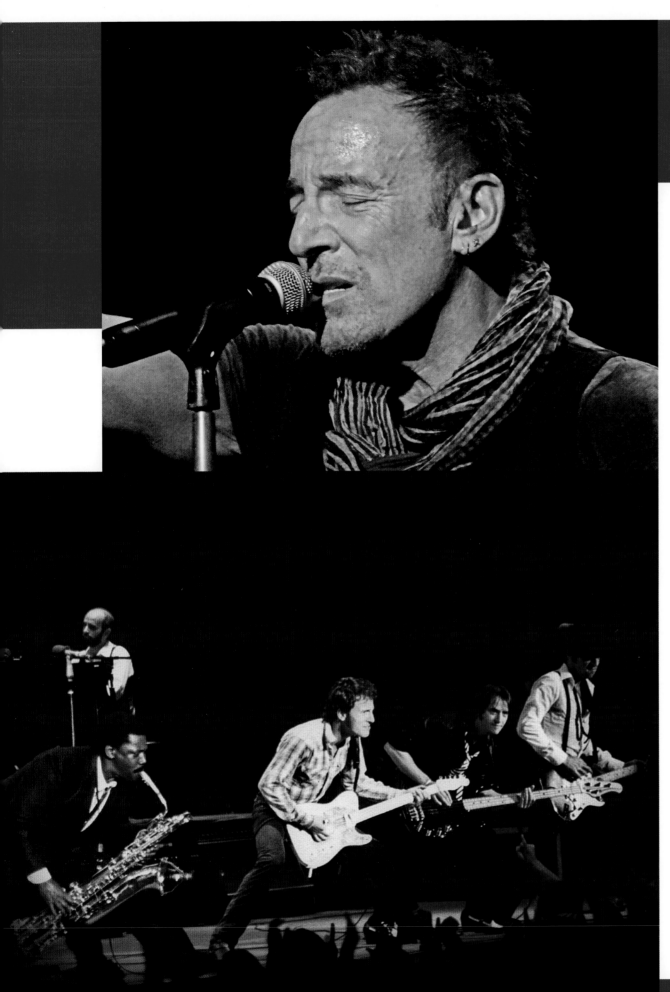

Every generation needs a hero. In the early 1970s, sports and politics had receded somewhat into the background, which left the stage to Bruce Springsteen. He still wears the crown, his insights and highlights growing by the year. Born in Long Beach, New Jersey, rather than Asbury Park, Springsteen (b. 1949) received a Catholic education, which gave him endless avenues for revolt. In 1956, he saw Elvis Presley on *The Ed Sullivan Show* and that was that. Early bands the Castiles, Earth, Steel Mill, the Sundance Blues Band, and Dr. Zoom & the Sonic Boom honed his singing, songwriting, and guitar playing. A concussion from a motorcycle crash got him a pass from the Vietnam War, and from that day forward, music owned Springsteen. Those were unhinged times, defined by President Richard Nixon's imploding leadership, anti-war demonstrations, and an economy leaving much of the country adrift. When Springsteen cold-called for and landed an audition with legendary record man John Hammond at the Columbia label, his career began in earnest. His first two albums announced a major new voice, but 1975's *Born to Run* put him and his fiery E Street Band on the short list of all-time great acts. A decade later, *Born in the U.S.A.* took him global. Springsteen is unmatched in his undeterred quest to grow and improve. It continues to this day with 2016's best-selling autobiography *Born to Run*, a how-to book complete with assembly instructions for one of America's most inspiring legacies.

Opposite: Bruce Springsteen on the Sunset Strip, West Hollywood, CA, 1975
📷 **TERRY O'NEILL / ICONIC IMAGES**

Above left: Springsteen singing "I Want to Marry You" on the River tour at Quicken Loans Arena, Cleveland, February 23, 2016
📷 **RON VALLE PHOTOGRAPHY**

Left, left to right: The E Street Band—Roy Bittan (keyboard), Clarence Clemons, Springsteen, Garry Tallent, and Steven Van Zandt—at the Los Angeles Sports Arena on the original River tour, fall 1980
📷 **DORIAN BOESE**

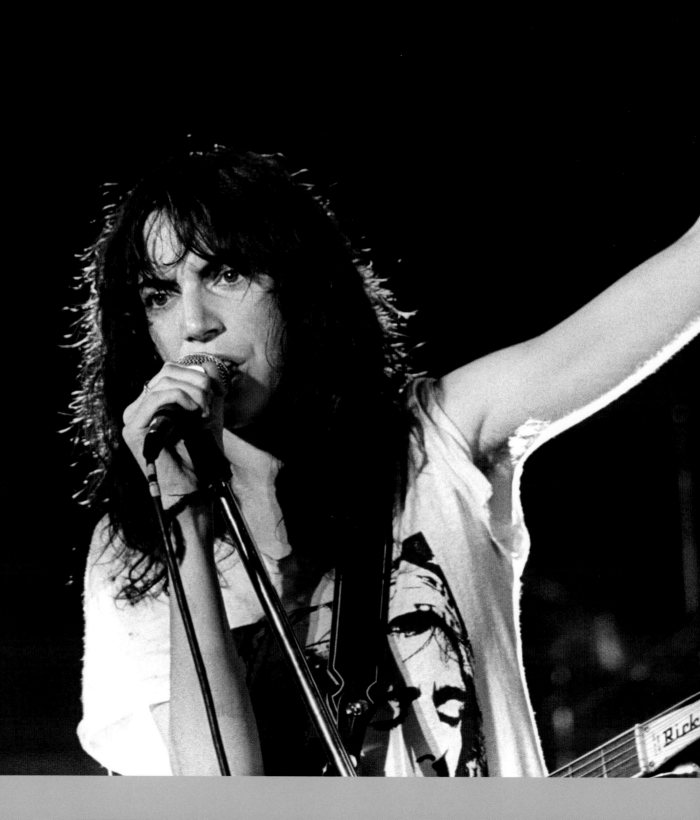

Patti Smith

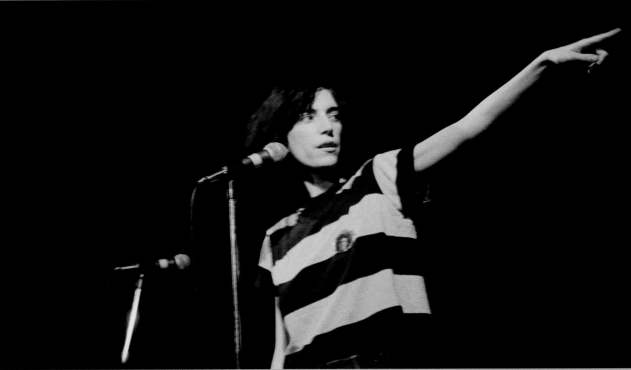

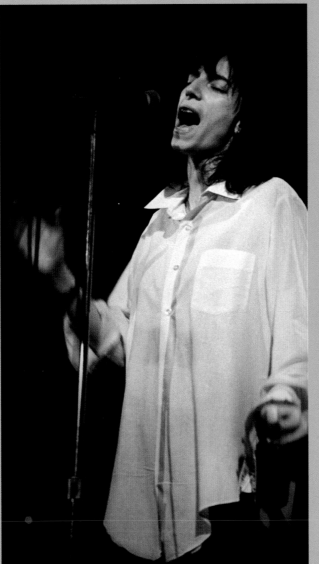

Mixing media works best when the person doing it operates from a higher calling, one fueled by a desire for singular creation. Patti Smith (b. 1946) has many and varied interests, and her artistry works best when they coalesce. The Chicago-born artist traveled to Paris in 1969 with her sister and took up busking and street performance art, which evolved into poetry, painting, and spoken-word shows when she returned to New York. Those, in turn, resulted in her recording a single, "Hey Joe" / "Piss Factory," in 1974. When the city's underground scene started opening up to new artists, Smith was among the first in the spotlight. She knew what to do with it, too: *Horses* arrived in 1975, freshly produced by Welshman John Cale, a charter member of the seminal Velvet Underground, and was an entrance so powerful that Smith was credited with founding a new movement that mixed spoken-word performance with punk. Her multifaceted creative endeavors—including a pivotal partnership with photographer Robert Mapplethorpe, a turn as a playwright alongside Sam Shepard, and stage acting—made her a high priestess of the New York art scene. Her live shows exalted catharsis and drew those looking for new forms of expression; it's notable that Smith, whose mother was a Jehovah's Witness, encountered charismatic religious figures as a child, because Smith herself musically became one. Journalists have called her the poet laureate of punk, but no labels or boundaries will ever contain Smith.

Opposite: Patti Smith at Convention Hall, Asbury Park, NJ, August 5, 1978
📷 © **EBET ROBERTS**

Top: Smith at the Boarding House, San Francisco, November 1975
📷 **BARRY SCHNEIER**

Left: Smith at the Longbranch, Berkeley, CA, 1976
📷 © **HUGH BROWN**

AEROSMITH

Aerosmith's bad-boy boogie sprang out of the blues-laced rock emanating from the British Invasion. Guitarist Joe Perry (b. 1950), bassist Tom Hamilton (b. 1951), singer-harmonica player Steven Tyler (b. 1948), drummer Joey Kramer (b. 1950), and rhythm guitarist Ray Tabano (b. 1946), soon replaced by Brad Whitford (b. 1952), took a cue from the Rolling Stones and the Yardbirds, infusing Chicago blues with the dynamics and determination of second-wave English acts such as hard-rocking Led Zeppelin. They succeeded beyond their wildest dreams. Perry and Tyler made for a perfect front tandem—another Jagger/Richards—the former bursting with nasty licks and hooks, while the latter's extroverted singing and screeching reached the back of every house and then some. Boston took to them like gangbusters, and once they started recording in 1973, Aerosmith assumed a lead position. Their third album, *Toys in the Attic*, went mega-huge in 1975 and by the end of the decade they'd lodged a dozen chart hits. That's usually where the trouble starts, and by 1981 Perry and Tyler had left the band. Like other redemptive rock and roll tales, they reunited in 1984, and by then Tyler had taken his vocals

to histrionic heights. First-wave rappers Run-D.M.C. covered *Toys in the Attic's* trademark smash "Walk This Way" to spectacular effect on MTV, and Aerosmith's 1987 return with *Permanent Vacation* cemented the comeback with "Dude (Looks Like a Lady)." *Pump* (1989), *Get a Grip* (1993), and *Nine Lives* (1997) followed in commercial triumph. Along with baked beans and the Red Sox, Aerosmith—still boasting its classic lineup more than forty years later—remains Boston's best-loved export.

Opposite: Steven Tyler at Lubbock Municipal Auditorium, TX, July 4, 1978
📷 **KELLY BERRY**

Right: Joe Perry and Tyler at the Cow Palace, Daly City, CA, December 1, 1977
📷 **GARY KIETH MORGAN**

Below: Tom Hamilton, Brad Whitford, Joey Kramer (drums), Tyler, and Perry at the Santa Barbara Bowl, CA, July 7, 2015
📷 **PATTI GUTSHALL**

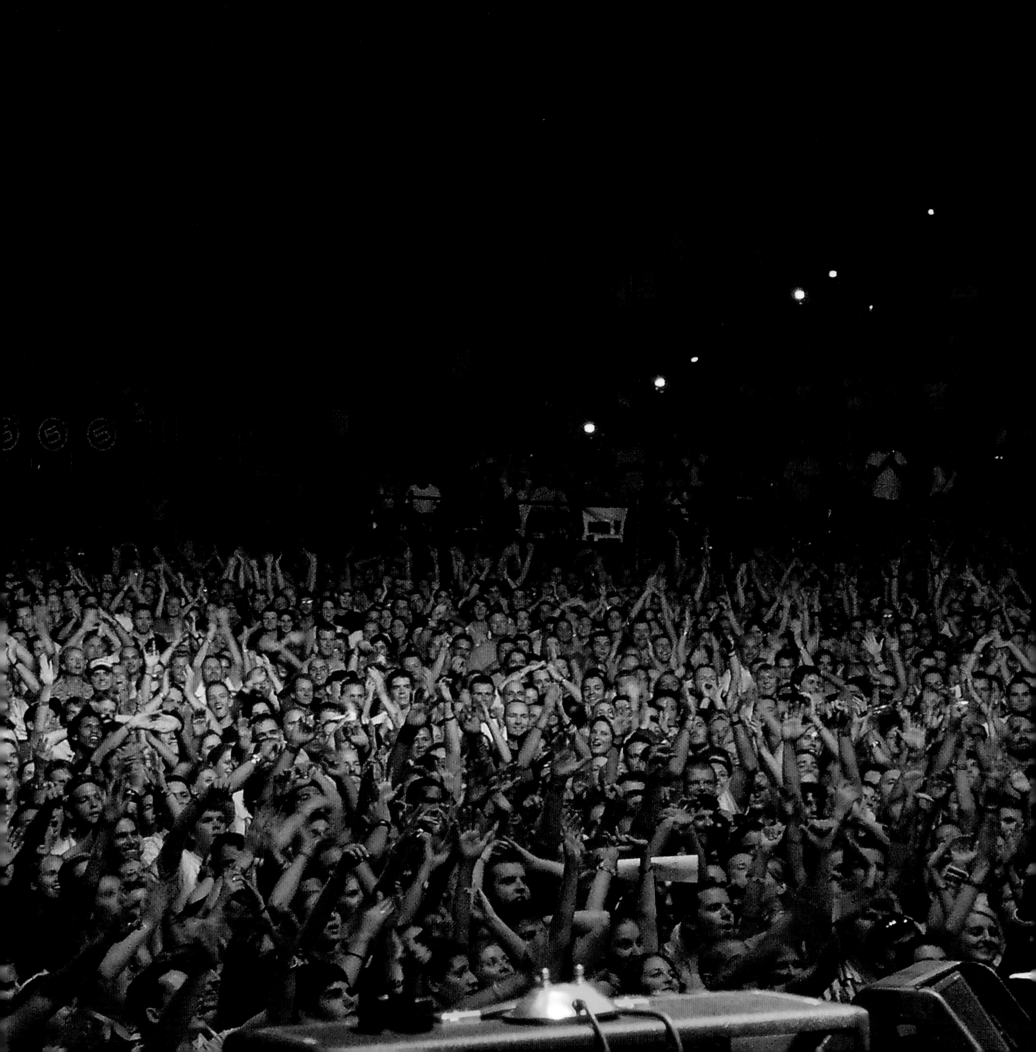

SAFETY PINS & FLASHY SPINS EVERYONE WANTS TO HAVE FUN

Michael Stipe facing the crowd at an R.E.M.
concert in Eastern Europe, 2005
📷 DAVID BELISLE

CHAPTER 6

THE RUNAWAYS

Some parents fear their children will run away with the circus. In Los Angeles, they dread their kids will hang out on Hollywood Boulevard. That's where the all-girl Runaways rolled beginning in 1976, neither homeless nor hustling but playing down 'n' dirty rock. Manager Kim Fowley—the infamous L.A. scenester whose successes and failures were sometimes indistinguishable— had a reputation that preceded him, but he might have been the only adult to whom the young five-piece listened. When the first two Runaways, drummer Sandy West (1959–2006) and guitarist Joan Jett (b. 1958), met and decided to form a women-only rock band, their approach was practically unheard of: they played all their own instruments on recordings and presented themselves however they pleased. Joined by singer Cherie Currie (b. 1959) and bassist Micki (Michael) Steele (b. 1955), who was replaced in the classic lineup by Jackie Fox (b. 1959; now Jackie Fuchs) plus second six-stringer Lita Ford (b. 1958), they immediately got the attention of the record business. They were something new, and even if they exploded at the same time as punk, the Runaways weren't a punk band. They weren't a girl group, either. They were a *rock* band, and they fought to keep the idea of novelty out of the music industry's definitions of them. A tour with the Ramones in 1977 pushed them in a DIY direction, but ultimately their celebrity stemmed from their musicianship, songs, and shows. It was a well-won victory and helped every woman who followed their example, while leaving a treasure trove of recordings as inspiration to any girl who ever wanted to join the rock and roll circus.

Above: Lita Ford, Joan Jett, Sandy West, and Jackie Fox, London, ca. 1978
📷 © **JILL FURMANOVSKY**

Left: Jett (left) and Ford (right) at Dooley's, Tempe, AZ, 1978
📷 both **DORIAN BOESE**

ELVIS COSTELLO

Musical chameleon and certified genre cross-pollinator Elvis Costello (b. 1954) first appeared on the fringes of the U.K. pub rock scene in the early 1970s. Once he devoted his attention to writing original songs and changed his name to Elvis Costello (he was born Declan MacManus), the London singer quickly advanced to the front lines of the New Wave, then remaking popular music. Debut album *My Aim Is True* in 1977 made a rare impact and set the artist up for life. His image, rather more adult than most of his peers', set him apart, which can perhaps be chalked up to his father, Ross MacManus, a longtime vocalist with the Joe Loss Orchestra. On Costello's second long-player, *This Year's Model*, he began a decades-long association with backing band the Attractions—keyboardist Steve Nieve, bassist Bruce Thomas, and drummer Pete Thomas—who honed his sardonic lyricism to razor-sharp precision. By the 1980s, Costello had made a splash analogous to that of his namesake. The ensuing decades have yielded a fascinating oeuvre from the artist, whose musical endeavors continually mine fresh territory, whether he's joining English chamber legacy the Brodsky Quartet, performing with everyone from the Charles Mingus Orchestra to Green Day frontman Billie Joe Armstrong, writing and recording with Burt Bacharach, Allen Toussaint, and a dozen others, or continuing to amble down uncharted roads in a nearly unparalleled pursuit of original expression. Initially viewed as the quintessential angry young man, Costello still sounds like he's just getting started.

Left: Elvis Costello on his first U.S. tour at the Old Waldorf, San Francisco, November 16, 1977
📷 © **CHESTER SIMPSON**

Below: Elvis Costello & the Attractions on their first U.S. tour at the Bottom Line, New York City, 1977
📷 © **ROB KUCZIK**

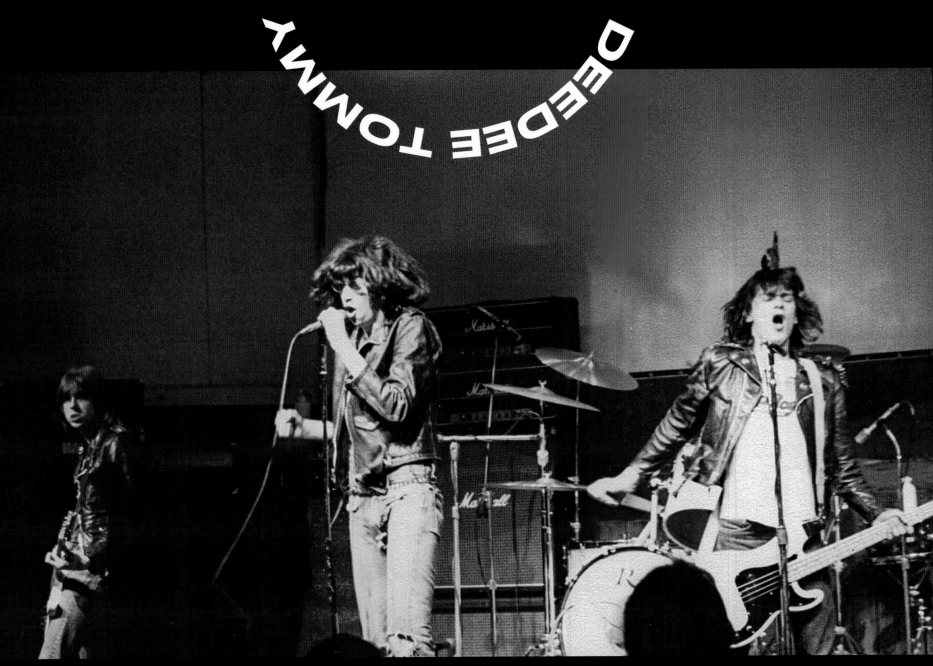

JOHNNY JOEY
RAMONES
DEEDEE TOMMY

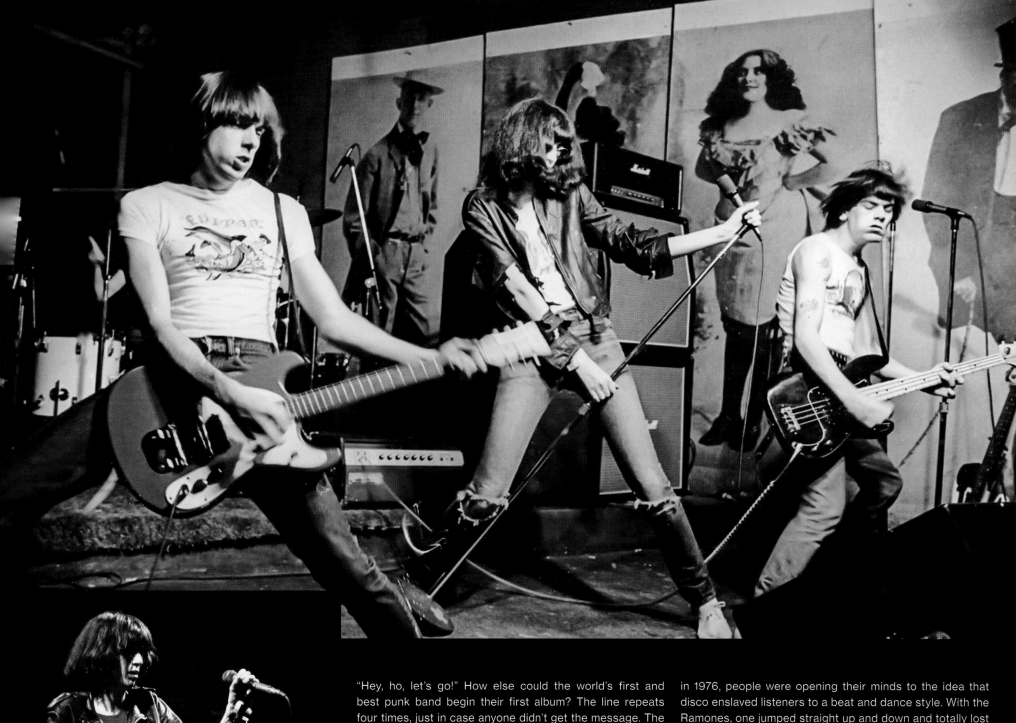

"Hey, ho, let's go!" How else could the world's first and best punk band begin their first album? The line repeats four times, just in case anyone didn't get the message. The Ramones stripped rock and roll to a definitive core, their bashing beat, hyper-strummed guitar chords, and mondo bass announcing that all the foolishness of progressive 1970s rock was hereby over. There was a new gang in town. They wore torn clothes, all took the same last name, and they played songs that lasted only a couple of minutes. When singer Joey Ramone (1951–2001), guitarist Johnny Ramone (1948–2004), bassist Dee Dee Ramone (1951–2002), and drummer Tommy Ramone (1949–2014) first reared their heads in New York in 1974, punk rock took a while to gain a foothold, but when the CBGB club enlisted them as house band, nothing was ever the same. Songs about sniffing glue and other high-minded affairs didn't perform well in the hinterlands, but one thing was certain: The Ramones wouldn't be ignored. When their thirty-minute debut arrived

in 1976, people were opening their minds to the idea that disco enslaved listeners to a beat and dance style. With the Ramones, one jumped straight up and down and totally lost control of all inhibitions. The Ramones swaggered through the 1980s but started changing band members. Their last album, 1995's ¡Adios Amigos!, meant well, but the moment had passed. As had all four original members by 2014. Like the Beatles, they changed music forever.

Opposite: Johnny, Joey, and Dee Dee Ramone at Dooley's, Tempe, AZ, 1978
📷 **DORIAN BOESE**

Above: Johnny, Joey, and Dee Dee at CBGB, New York City, 1976
📷 © **ROBERTA BAYLEY**

Left: Joey and Dee Dee at the State Theater, Minneapolis, January 21, 1978
📷 **SCOTT SEGELBAUM**

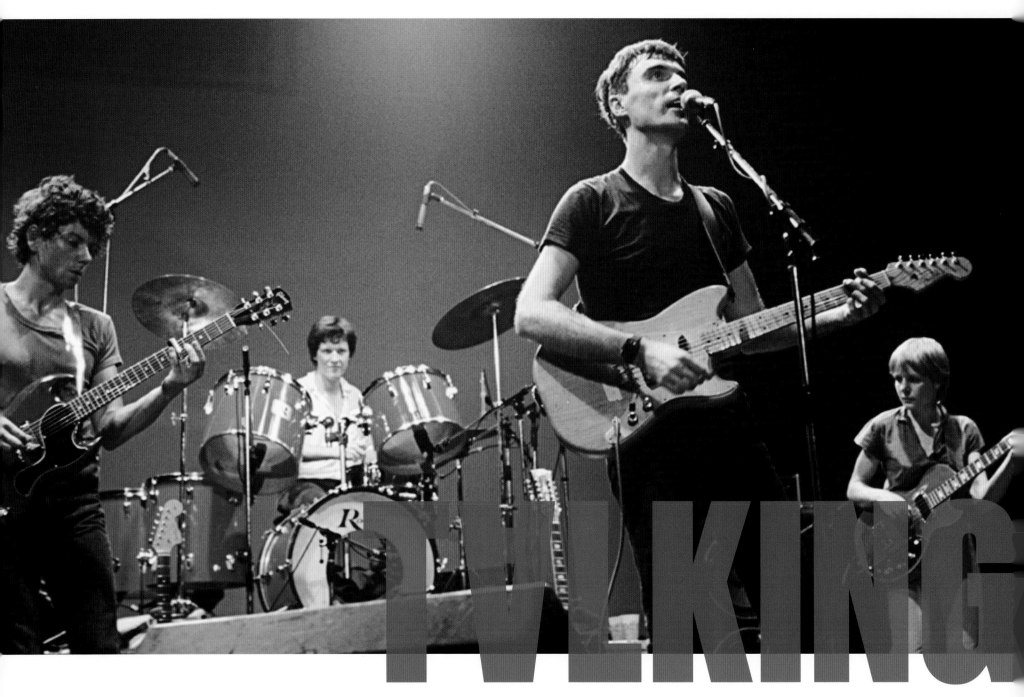

Art rock comes in every flavor, from the esoteric to the danceable, and Talking Heads covered those bases and countless ones in between. In 1975, singer-guitarist David Byrne (b. 1952) joined two fellow art-school students, drummer Chris Frantz (b. 1951) and bassist Tina Weymouth (b. 1950) in New York, where punk was blowing open new portals for musicians and nonmusicians alike. Talking Heads used those openings to inject quirk and hypnotic rhythms into their unpredictable music; after their first single, "Love → Building on Fire," guitarist-keyboardist Jerry Harrison (b. 1949) came aboard for their debut LP, *Talking Heads: 77*. That album's "Psycho Killer" put the band atop the crest of the new-music tsunami that year. Sound scientist Brian Eno produced their next three albums, and by 1980's *Remain in Light*, Byrne and company were in the full embrace of Afrobeat, courtesy

of Nigerian bandleader Fela Kuti. Jonathan Demme directed their 1984 concert film, *Stop Making Sense*, a cinematic landmark, and Talking Heads spent the rest of that decade exploring huge swaths of musical styles while other 1970s upstarts fell by the wayside. The group's last album, 1988's *Naked*, arrived as fresh and full of ideas as its first. Talking Heads officially called it a day in 1991, but each member took off on a different trajectory, Byrne making solo albums and becoming a patron of world music with his Luaka Bop label. Married since 1977, Weymouth and Frantz founded their hit Tom Tom Club to explore early techno, while Harrison began a highly successful producing career. Despite their breakup, as long as art and rock intersect to turn up the groove, Talking Heads will remain in light.

Above: Jerry Harrison, Chris Frantz, David Byrne, and Tina Weymouth at the Entermedia Theater, New York City, August 10, 1978
📷 © **EBET ROBERTS**

Opposite, clockwise from top left:
Byrne at the Paradise Rock Club, Boston, 1978
📷 © **CATHERINE VANARIA**

Harrison, Byrne, Frantz, and Weymouth at the Keystone, Berkeley, CA, December 9, 1977
📷 © **HUGH BROWN**

Weymouth with her Gibson Recorder bass at the Palladium Ballroom, Dallas, 1978
📷 **JOE HUGHES**

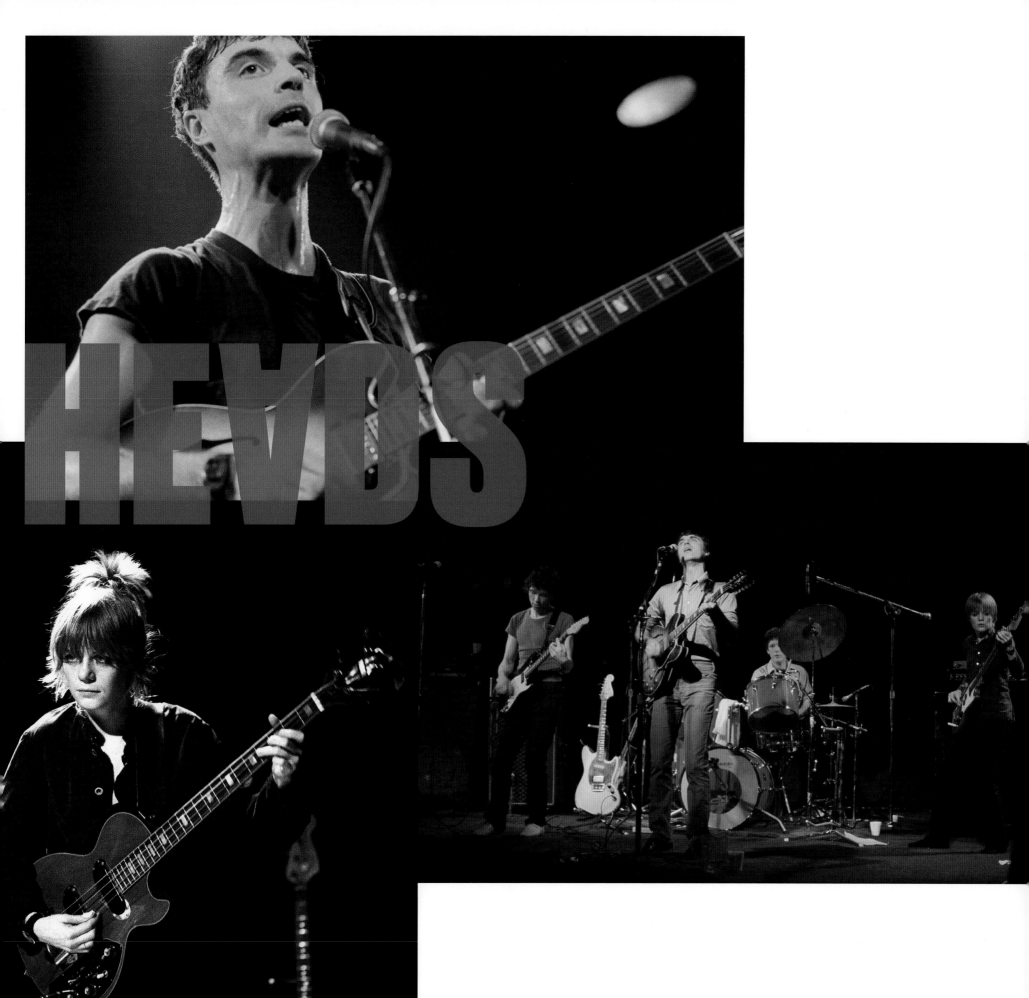

HEVDS

THE PRETENDERS

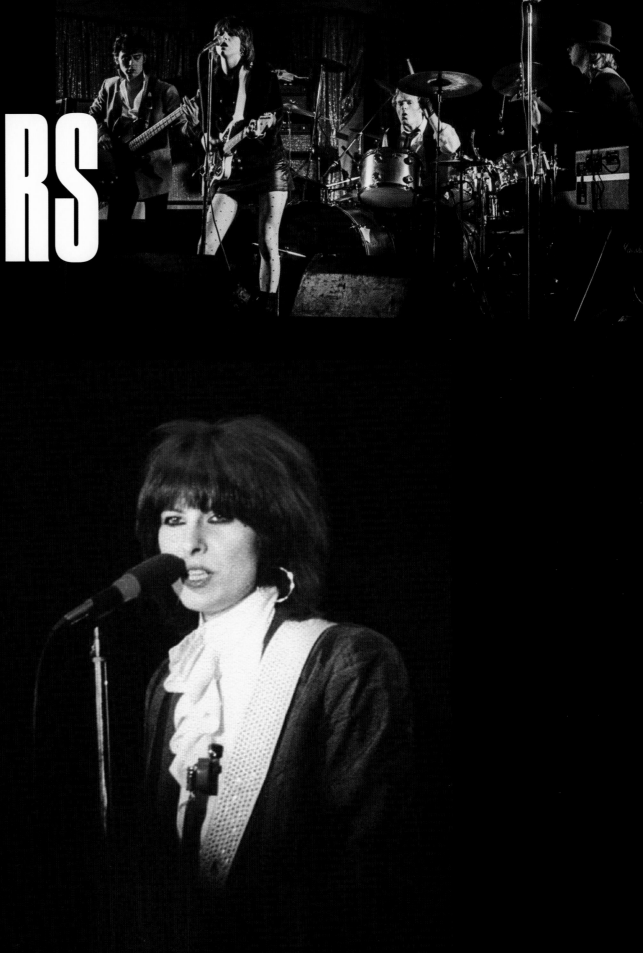

Tough-as-nails Akron, Ohio, native Christine Ellen Hynde (b. 1951) moved to London when she was twenty-one. Always active, always pushing boundaries, she had been an art student at Kent State University (and played in a band with Devo's Mark Mothersbaugh) when the National Guard killed four students there in 1970. Across the Atlantic, she worked in future Sex Pistols manager Malcolm McLaren's boutique and wrote for *New Musical Express*. From there, a rock and roll career was a short leap. She started the Pretenders in 1978 with guitarist James Honeyman-Scott (1956–82), bassist Pete Farndon (1952–83), and drummer Martin Chambers (b. 1951). Crossing punk aggression with detailed instrumental acumen, the group debuted the following year with a hypnotic cover of the Kinks' "Stop Your Sobbing," produced to perfection by Nick Lowe (and written by Hynde's future partner, Ray Davies). When "Brass in Pocket" followed that same year on the group's eponymous debut, with Hynde's thick, sultry delivery turning ferocious on opener "Precious," the Pretenders had arrived. Farndon and Honeyman-Scott died of drug overdoses less than a year apart, but Hynde and bedrock-beater Chambers girded the band's resolve and the Pretenders soldiered on, paying a touching homage to both men in "Back on the Chain Gang." The group's sophomore LP, 1984's *Learning to Crawl*, went Top 5 in the United States and had sold a million copies less than four months after its release. Band members came and went, but the boss lady, who titled the band's 2016 release *Alone*, remains the essence of the Pretenders. Her autobiography, *Reckless: My Life as a Pretender*, published in 2015, sneers at the doubters and nods to the believers. She's not pretending.

Top right: Peter Farndon, Chrissie Hynde, Martin Chambers, and James Honeyman-Scott at Barbarella's, Birmingham, UK, November 18, 1978
📷 © BOB GRUEN

Right: Hynde at the Main Auditorium, University of Arizona, Tucson, 1981
📷 DORIAN BOESE

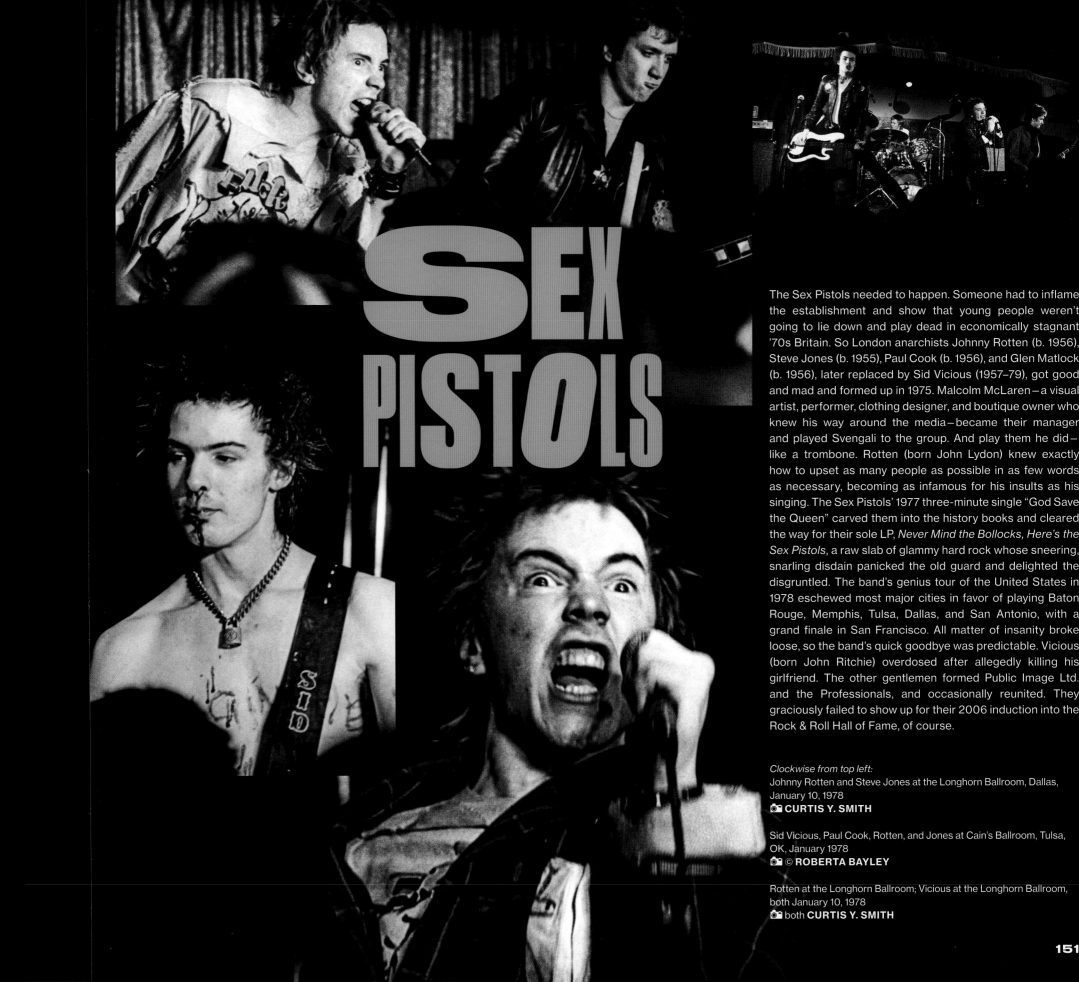

SEX PISTOLS

The Sex Pistols needed to happen. Someone had to inflame the establishment and show that young people weren't going to lie down and play dead in economically stagnant '70s Britain. So London anarchists Johnny Rotten (b. 1956), Steve Jones (b. 1955), Paul Cook (b. 1956), and Glen Matlock (b. 1956), later replaced by Sid Vicious (1957–79), got good and mad and formed up in 1975. Malcolm McLaren—a visual artist, performer, clothing designer, and boutique owner who knew his way around the media—became their manager and played Svengali to the group. And play them he did—like a trombone. Rotten (born John Lydon) knew exactly how to upset as many people as possible in as few words as necessary, becoming as infamous for his insults as his singing. The Sex Pistols' 1977 three-minute single "God Save the Queen" carved them into the history books and cleared the way for their sole LP, *Never Mind the Bollocks, Here's the Sex Pistols*, a raw slab of glammy hard rock whose sneering, snarling disdain panicked the old guard and delighted the disgruntled. The band's genius tour of the United States in 1978 eschewed most major cities in favor of playing Baton Rouge, Memphis, Tulsa, Dallas, and San Antonio, with a grand finale in San Francisco. All matter of insanity broke loose, so the band's quick goodbye was predictable. Vicious (born John Ritchie) overdosed after allegedly killing his girlfriend. The other gentlemen formed Public Image Ltd. and the Professionals, and occasionally reunited. They graciously failed to show up for their 2006 induction into the Rock & Roll Hall of Fame, of course.

Clockwise from top left:
Johnny Rotten and Steve Jones at the Longhorn Ballroom, Dallas, January 10, 1978
📷 **CURTIS Y. SMITH**

Sid Vicious, Paul Cook, Rotten, and Jones at Cain's Ballroom, Tulsa, OK, January 1978
📷 © **ROBERTA BAYLEY**

Rotten at the Longhorn Ballroom; Vicious at the Longhorn Ballroom, both January 10, 1978
📷 both **CURTIS Y. SMITH**

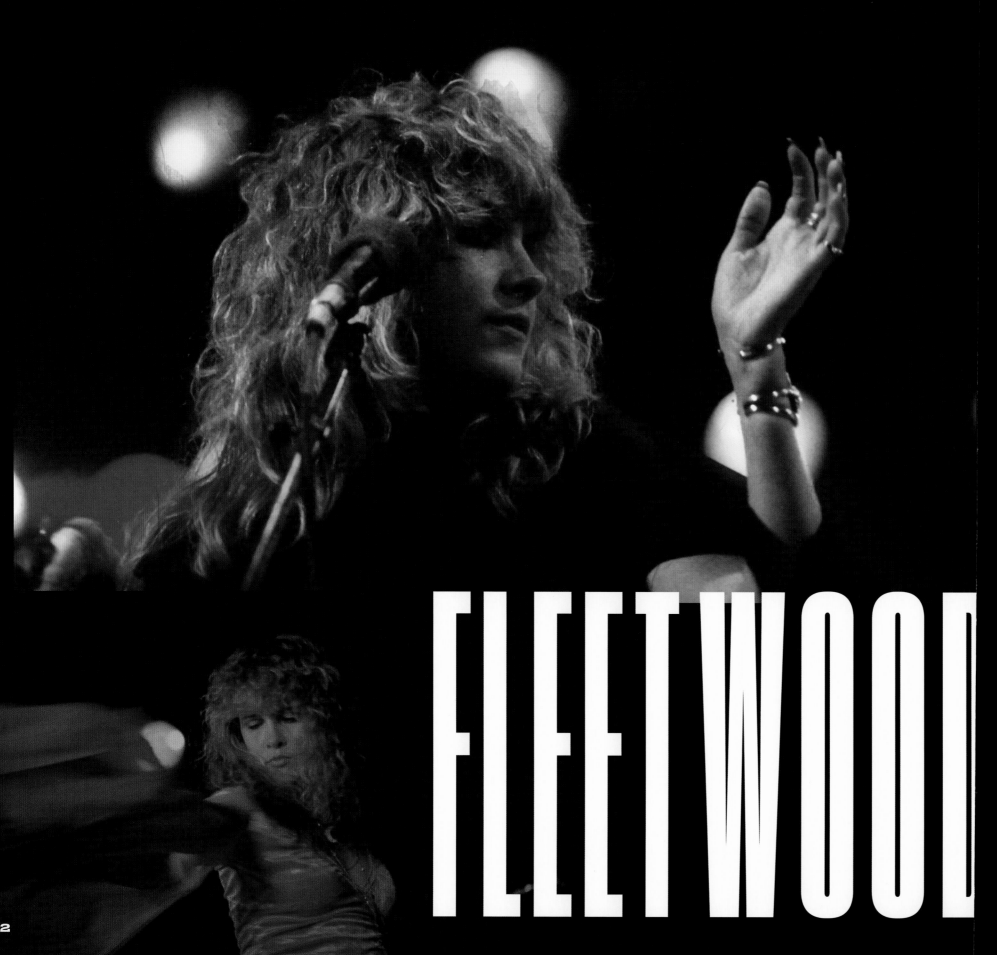

FLEETWOO

British blues constantly reinvents itself, and when super-guitarist Peter Green (b. 1946) left John Mayall & the Bluesbreakers to start his own group in 1967, his new band was no exception to the rule. Fleetwood Mac, he called it, a term he coined as a mashup of the surnames of his new rhythm section, drummer Mick Fleetwood (b. 1947) and bass player John McVie (b. 1945). Gutbucket but also spacey, the group achieved stardom in the U.K. fast enough that Green and fellow guitarist Jeremy Spencer hopped off the bandwagon. That's when Fleetwood Mac began swapping out bandmates: Christine Perfect, soon to become Christine McVie (b. 1943), joined in 1970 on keyboards and vocals, followed soon thereafter by singer-guitarist Bob Welch (1945–2012). All went swimmingly until 1974, when American couple Lindsey Buckingham (b. 1949) and Stevie Nicks (b. 1948) moved in following Welch's departure. That's when the skies opened up. The eponymous debut by the retooled band in 1975 hit No. 1 and included the anthems "Over My Head," "Say You Love Me," and "Rhiannon." Buckingham had genius ideas about how the music should sound, McVie and Nicks offered songs and mystical soul that grabbed the world's attention, and the rhythm section made metronomes practically obsolete. When *Rumours* followed two years later, draped in the drama of intraband romantic bust-ups and yielding four Top 10 singles, the album lofted the band to superstardom, becoming one of the best-selling albums in rock. The group emerged from their Olympian success with experimental double album *Tusk* in 1979. They've zigged (1987 smash *Tango in the Night*) and zagged (1990 dud *Behind the Mask*) ever since, but never count them out—the Mac always comes back.

Opposite top: Stevie Nicks on the Rumours tour at the Spectrum, Philadelphia, March 21, 1977
📷 **JOE SCHRIER**

Opposite bottom: Nicks spinning at Compton Terrace, Phoenix, 1980
📷 **DORIAN BOESE**

Right: Christine McVie at the US Festival, Glen Helen Regional Park, San Bernardino, CA, September 5, 1982
📷 **RICHARD MCCAFFREY**

Below: Mick Fleetwood (drums) and Lindsey Buckingham (guitar) at the Aladdin Theatre for the Performing Arts, Las Vegas, August 1977
📷 **DORIAN BOESE**

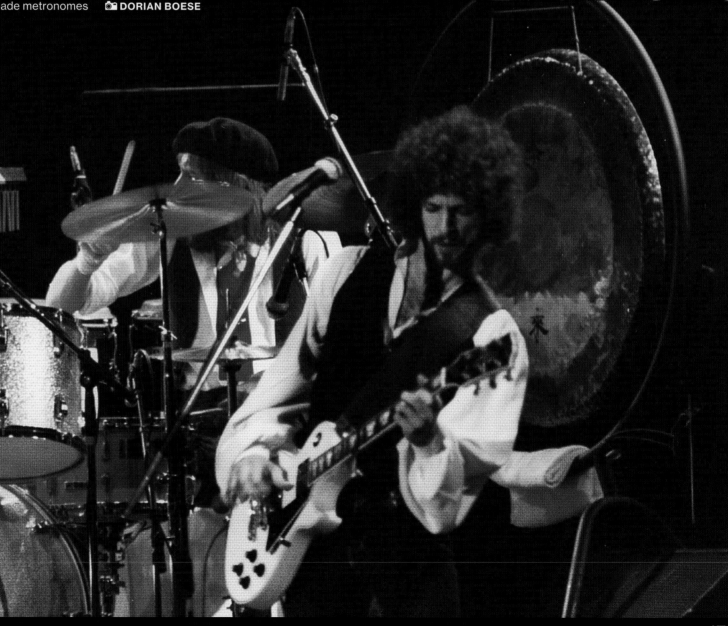

MAC

THE CLASH

British punk bands in the mid-1970s were in an internecine battle for supremacy. The Sex Pistols had blown open the gate in 1975, but now other—some would say more sophisticated—groups were swaggering through. The Clash was one such band, and they weren't interested in flash-in-the-pan stardom. Its members had futzed around in other groups, but none came to any lasting consequence. Yet when Joe Strummer (1952–2002), who once fronted the 101ers, Mick Jones (b. 1955), Paul Simonon (b. 1955), and early drummer Terry Chimes (b. 1956) got together in 1976, history happened. Their first songs sounded like violent transmissions from another planet, Strummer unleashing kinetic intensity and revolutionary rhetoric. As soon as Topper Headon (b. 1955) began powering the four with his polyrhythms, no genre—funk, reggae, dub, country, or rockabilly—proved beyond their powers. Within months, their volatile bulletins were heard in the United States, and their early tours had all the fervor of religious revivals. Debut single "White Riot" popped the top, and in 1979, their third album, *London Calling*, was a double-disc masterpiece of leather-wearing revolt. The band powered into the 1980s with the ideologically explosive three-LP *Sandinista!*, an ambitious work practically unparalleled in rock to date. Infighting, exhaustion, and feuds crippled the band a few years after the 1982 release of their Top 10 *Combat Rock*, and the ideologically and musically subversive group broke apart, leaving profound legacies in not only punk but in ska, reggae, and rock and roll itself.

Opposite: Mick Jones and Joe Strummer at Temple Beautiful, San Francisco, February 8, 1979
📷 © **RUBY RAY**

Left: Strummer at Clark University, Worcester, MA, September 28, 1979
📷 **CHRIS CUNEO**

Below left: Jones, Topper Headon, Strummer, and Paul Simonon at the Orpheum Theatre, Boston, September 19, 1979
📷 © **CATHERINE VANARIA**

Below: Simonon on bass at the Mesa Community Center, Mesa, AZ, June 13, 1982
📷 **DORIAN BOESE**

Tom Petty's laconic Florida drawl and laid-back persona have never camouflaged his sharp intellect and penetrating intuition. Meeting Elvis Presley at age ten, and seeing the Beatles on *The Ed Sullivan Show* in 1964, pointed Petty (b. 1950) toward an escape route from his abusive upbringing at the hands of his father, so he left home to follow a winding highway on his way to the Rock & Roll Hall of Fame. The singer-guitarist's early compositions cut deep, circling around an ineffable absence at the heart of American life, and audiences quickly identified. Petty moved ace six-stringer Mike Campbell (b. 1950), keyboard crackerjack Benmont Tench (b. 1953), bassist Ron Blair (b. 1958), and drum behemoth Stan Lynch (b. 1955) to Hollywood to chase the rock and roll dream as Tom Petty and the Heartbreakers. Their third LP, 1979's *Damn the Torpedoes*, shot "Don't Do Me Like That," "Here Comes My Girl," and "Refugee" up the charts, making the band standard-bearers for a new species of rock rooted in 1950s Americana—blues, country, folk, and even garage rock and pop. Petty and the Heartbreakers didn't follow the currents of the New Wave, and neither did southern rock define them. Through shifting lineups, solo endeavors, and his 1980s stint with the Traveling Wilburys—George Harrison, Bob Dylan, Roy Orbison, and Jeff Lynne—Petty carved out a unique place in American rock, and he did it with a knowing smile and a quiet laugh.

TOM PETTY AND THE HEARTBREAKERS

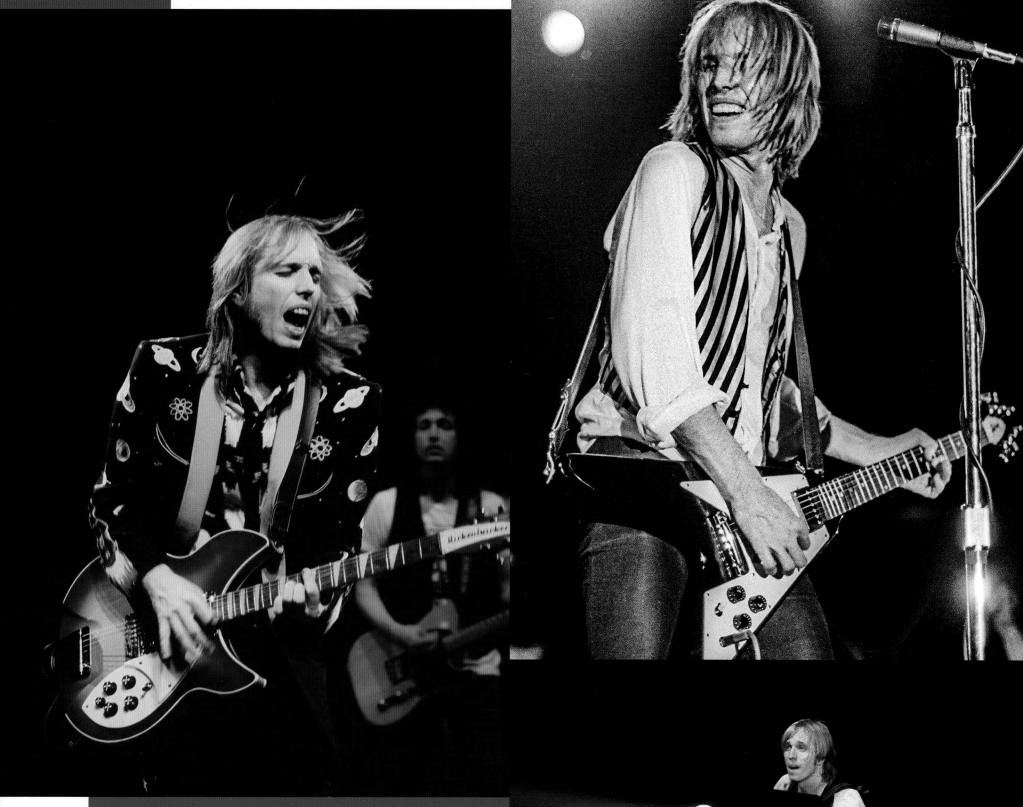

Opposite top: Benmont Tench, Stan Lynch, Mike Campbell, Tom Petty, and Ron Blair at the Palladium, New York City, November 11, 1979
📷 © **EBET ROBERTS**

Opposite bottom: Petty at Dooley's, Tempe, AZ, 1981
📷 **DORIAN BOESE**

Above: Petty and Campbell at Poplar Creek Music Theater, Hoffman Estates, IL, June 22, 1985
📷 © **EBET ROBERTS**

Above right: Petty at the Paradise Rock Club, Boston, July 16, 1978
📷 © **RON POWNALL**

Right: Petty at the Cow Palace, San Francisco, April 13, 1983
📷 **BOB LARSON**

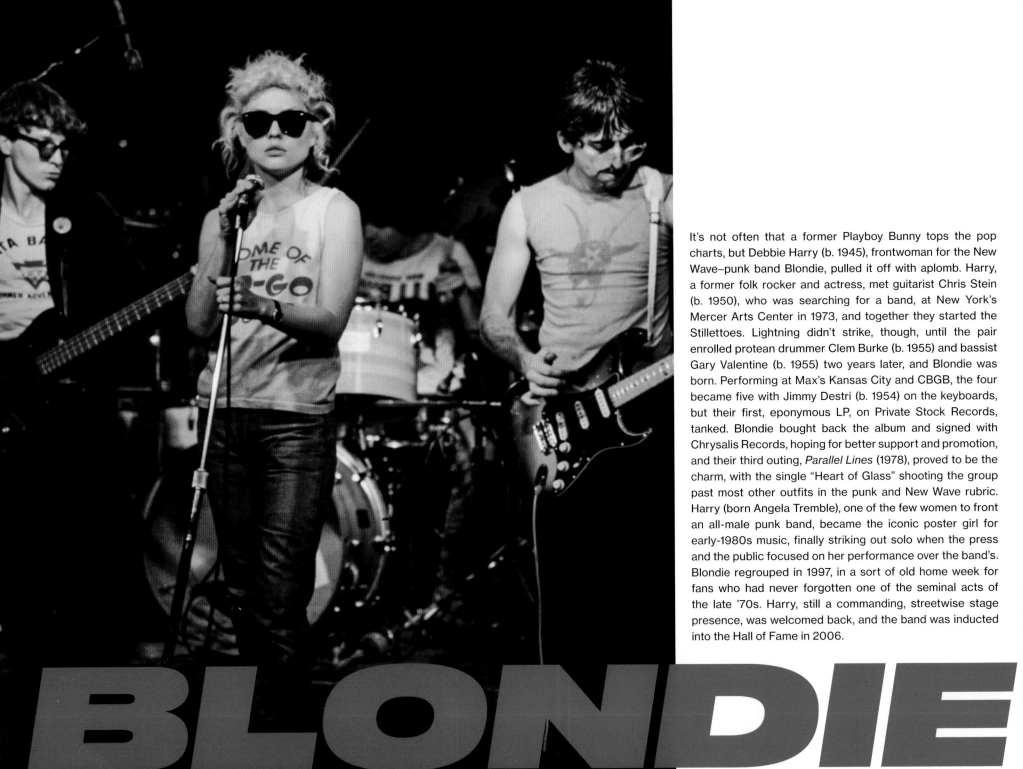

It's not often that a former Playboy Bunny tops the pop charts, but Debbie Harry (b. 1945), frontwoman for the New Wave–punk band Blondie, pulled it off with aplomb. Harry, a former folk rocker and actress, met guitarist Chris Stein (b. 1950), who was searching for a band, at New York's Mercer Arts Center in 1973, and together they started the Stillettoes. Lightning didn't strike, though, until the pair enrolled protean drummer Clem Burke (b. 1955) and bassist Gary Valentine (b. 1955) two years later, and Blondie was born. Performing at Max's Kansas City and CBGB, the four became five with Jimmy Destri (b. 1954) on the keyboards, but their first, eponymous LP, on Private Stock Records, tanked. Blondie bought back the album and signed with Chrysalis Records, hoping for better support and promotion, and their third outing, *Parallel Lines* (1978), proved to be the charm, with the single "Heart of Glass" shooting the group past most other outfits in the punk and New Wave rubric. Harry (born Angela Tremble), one of the few women to front an all-male punk band, became the iconic poster girl for early-1980s music, finally striking out solo when the press and the public focused on her performance over the band's. Blondie regrouped in 1997, in a sort of old home week for fans who had never forgotten one of the seminal acts of the late '70s. Harry, still a commanding, streetwise stage presence, was welcomed back, and the band was inducted into the Hall of Fame in 2006.

BLONDIE

Gary Valentine, Debbie Harry, Clem Burke, and Chris Stein at CBGB, New York City, 1976
📷 © **ROBERTA BAYLEY**

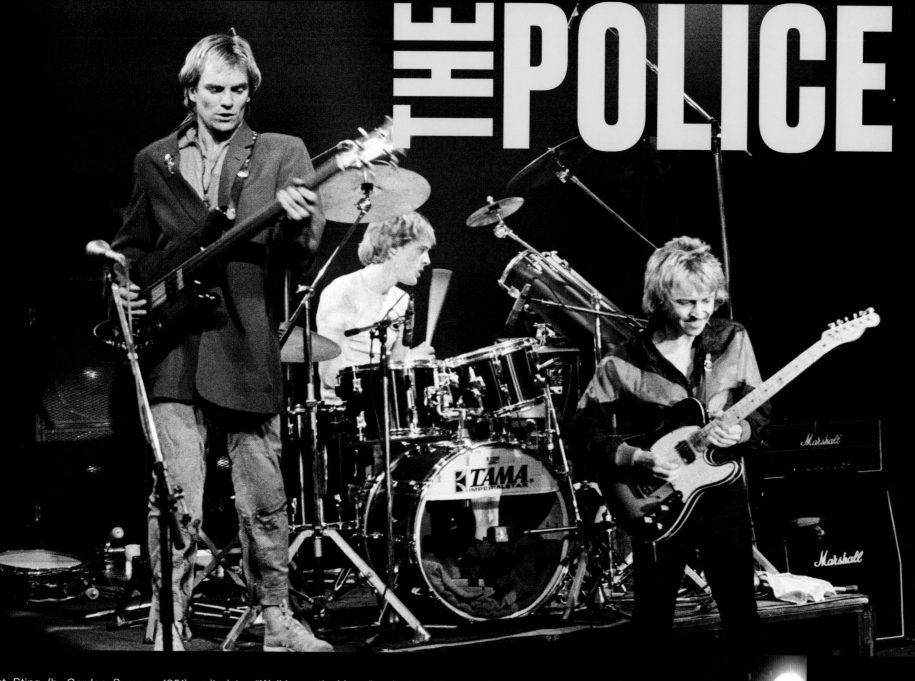

THE POLICE

Singer-bassist Sting (b. Gordon Sumner, 1951), guitarist Andy Summers (b. 1942), and drummer Stewart Copeland (b. 1952) dominated the rock scene in both their homelands, the United Kingdom and the United States, from the rise of 1970s punk and New Wave until midway through the following decade, when their front man spun his MTV charisma into a solo career. The supercharged trio, whose American beat keeper, Copeland, fused together a wild array of genres encompassing pop, progressive rock, reggae, soul, and even jazz, were unified by Sting's voice and compositions, which seemed to zap straight through the eardrum and into the brainstem. The Police's 1978 debut, *Outlandos d'Amour*, began radio's love affair with the trio by lodging "Roxanne" in the American Top 40, after which their four successive LPs topped U.K. charts. Follow-up *Regatta de Blanc* spun off a pair of No. 1 English singles, "Message in a Bottle" and

"Walking on the Moon," and nabbed the band the first of their six Grammys. Swan song *Synchronicity* crowned charts on both sides of the Atlantic in 1983 and volleyed four hit singles worldwide; "Every Breath You Take" remains the sort of song ideal for inclusion in an intergalactic time capsule intended to educate alien life about this crazy little genre called rock and roll. Sting, Summers, and Copeland sold more than 75 million albums and turned all comers into screaming fools during a 2007–08 reunion tour that reminded Planet Earth of their instrumental and melodic force.

Above: Sting, Stewart Copeland, and Andy Summers at Rockpalast Markthalle, Hamburg, Germany, January 11, 1980
📷 © **BOB GRUEN**

Right: Sting at the Paradise Rock Club, Boston, April 9, 1979
📷 **CHRIS CUNEO**

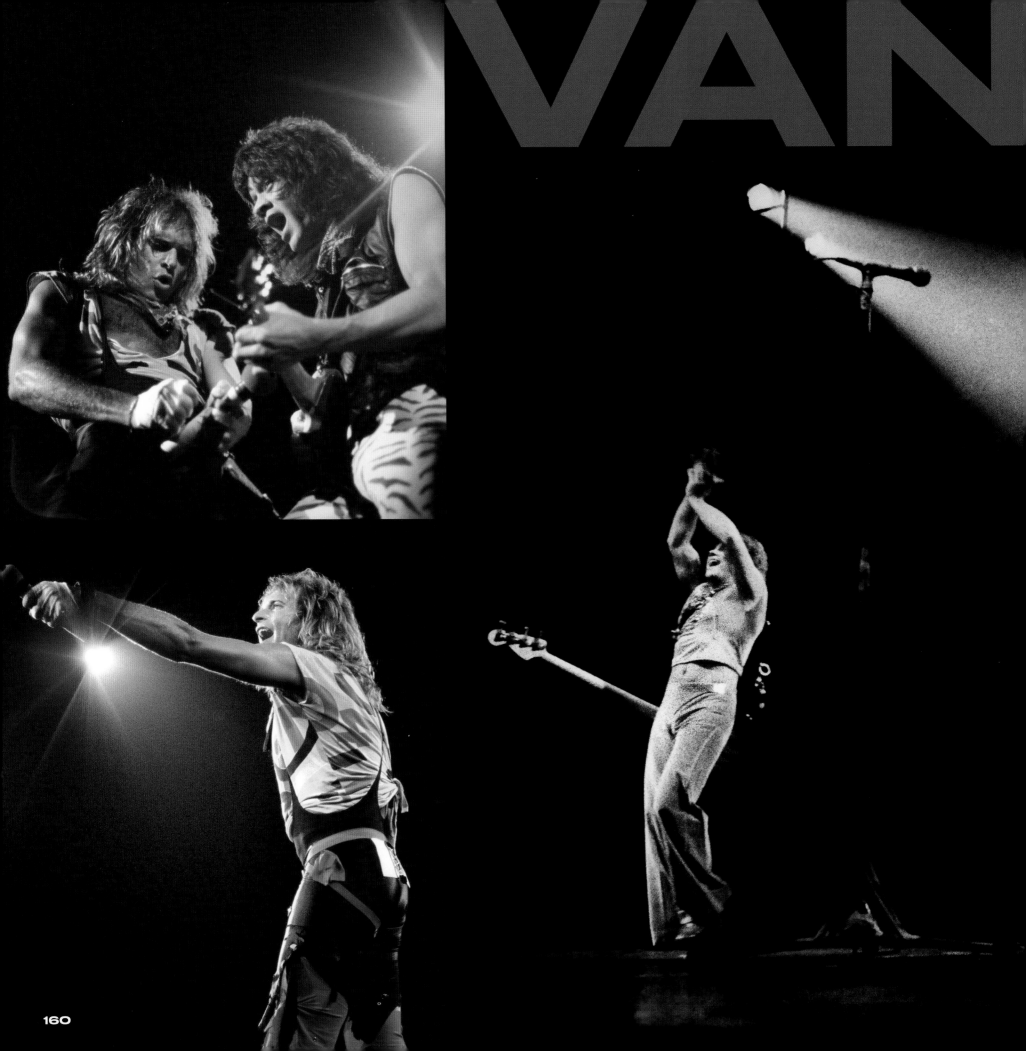

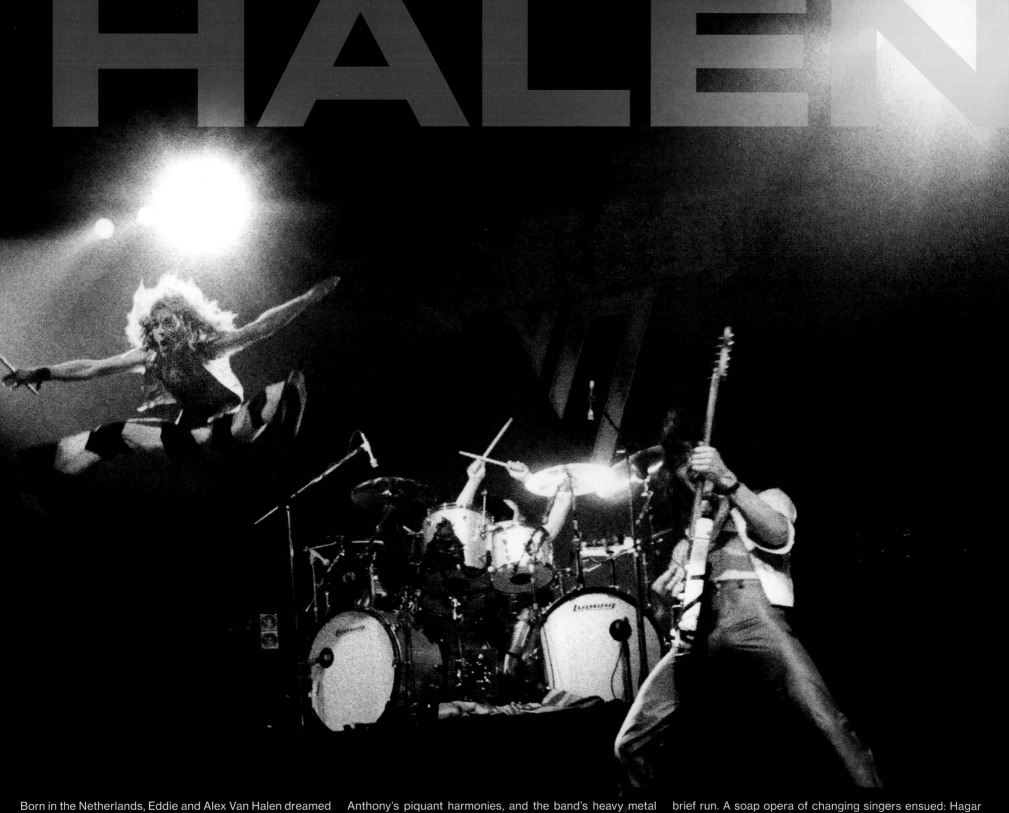

HALEN

Born in the Netherlands, Eddie and Alex Van Halen dreamed of becoming American rock and roll stars. And that's exactly what the brothers became, chasing the universal currency of musical fame with Eddie (b. 1955) on guitar and Alex (b. 1953) behind the drum kit. Forming under their surname in Pasadena, California, in 1972, they enlisted singer David Lee Roth (b. 1954) and bassist Michael Anthony (b. 1954) and started playing all the usual spots around Hollywood. Eddie's ability to turn ordinary chord progressions into death-defying melodic runs got the new quartet noticed immediately. Add in Roth's prancing, outlandish behavior and

Anthony's piquant harmonies, and the band's heavy metal stardom was a gimme from the get-go. In 1984, with five LP chart splashes under their spandex, "Jump"—from their album named for the year and the Orwell novel—hit No. 1 in the United States, and the future looked like roses. Except the next year, frictions between Eddie and Roth drove the latter out of the band and into a solo career, to be replaced by Montrose's lead singer, Sammy Hagar (b. 1947). It's rare for a platinum act to successfully switch singers midstream, but Van Halen only got bigger. In 1996, Hagar exited and Extreme singer Gary Cherone (b. 1961) stopped in for a

brief run. A soap opera of changing singers ensued: Hagar returned in 2003, was replaced by Roth three years later, and when Eddie's son, Wolfgang (b. 1991), replaced Anthony, the family circle was complete.

Opposite: David Lee Roth and Eddie Van Halen (top); Roth (bottom), both on the 1984 tour at McNichols Sports Arena, Denver, June 3, 1984 both **CHRIS DEUTSCH**

Above: Michael Anthony (bass), Roth, Alex Van Halen (drums), and Eddie Van Halen at the Rainbow Theatre, London, October 22, 1978 © **JILL FURMANOVSKY**

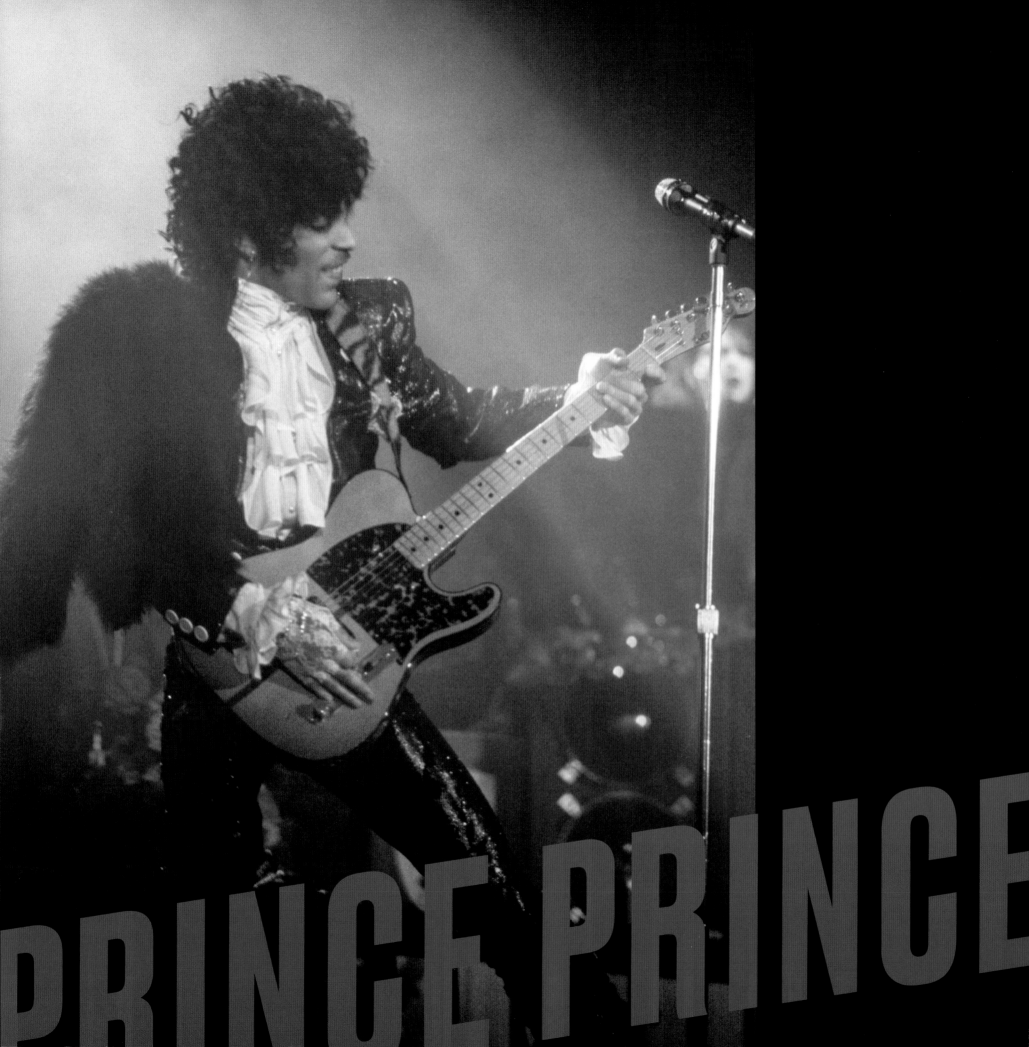

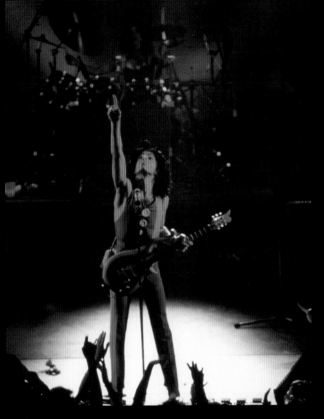

Prince Rogers Nelson (1958–2016): the name alone put him in a class completely his own. When his debut, *For You*, came out in 1978, the singer told his label, "Don't make me black." His demand not to be categorized proved astute: he transcended musical, racial, and even sexual classifications, creating music—and a persona—both raunchy and seductive, expansive and spiritual. With his Jimi Hendrix–like guitar playing and otherworldly rhythms, his stage costumes of flowing shirts, lingerie, psychedelia, and high-heeled boots, he didn't look or sound like anyone else of any color. Shy offstage, he was fearless onstage. By 1980's aptly titled third album, *Dirty Mind*, the young man from Minneapolis had touched off his very own Revolution, costarring flamboyant drummer Sheila E. and singing duo Wendy and Lisa. When Prince decided to make a movie in 1984, the deal spread financial responsibility between Warner Bros.' film and music divisions and himself. *Purple Rain* scored big at the box office, and its soundtrack, featuring "When Doves Cry," "Let's Go Crazy," and the title track, became one of the biggest sellers of the decade. Prince had gambled on himself, as he did throughout his life, and drew a royal flush. Thereafter, he challenged himself and his global audience, demanding artistic independence before it was fashionable. When he died unexpectedly in 2016, his fame skyrocketed higher still. Of all the accomplishments by the musician who, for a period, called himself by both an unpronounceable glyph and "the Artist Formerly Known as Prince," his most durable achievement is that there will never be another musician remotely like him. Prince is king.

Opposite: Prince at the Nassau Coliseum, East Garden City, NY, March 1985. *Above:* Prince at the Roseland Ballroom, New York City, October 3, 1988
📷 both © **BOB GRUEN**

Right: Prince at the Greensboro Coliseum, NC, November 14, 1984
📷 **JOHN ROTTET**

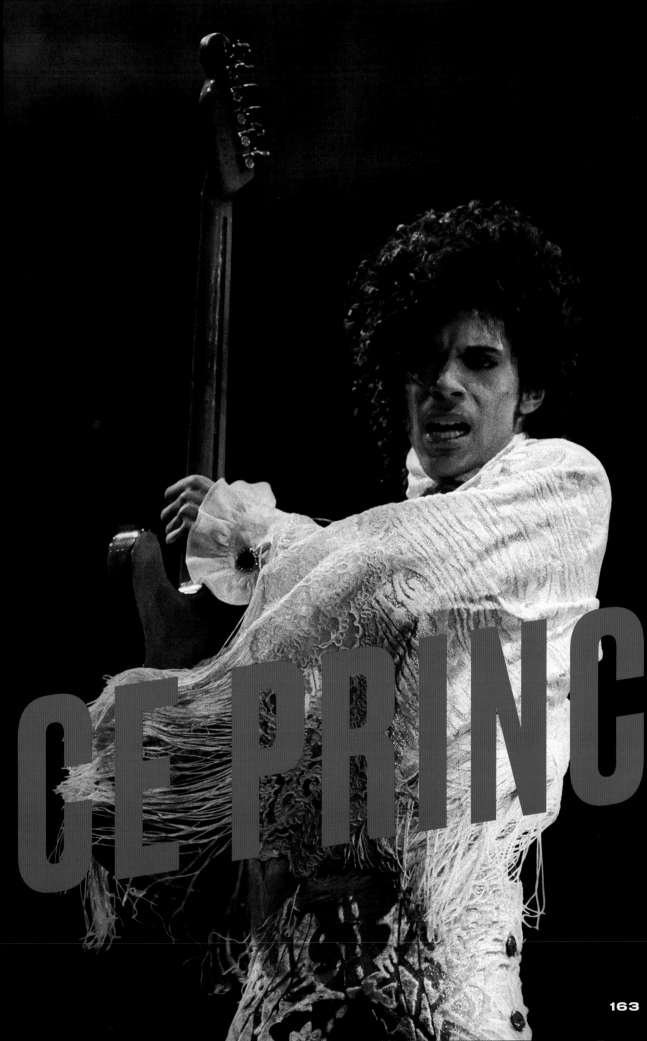

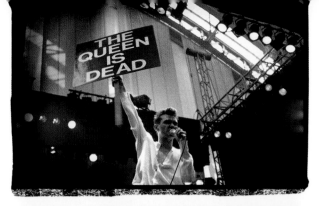

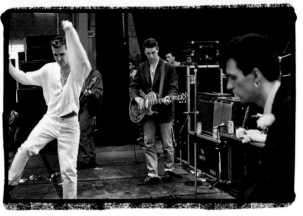

THE SMITHS

Manchester, England, 1982: With the country coming down from punk music's high, the future looked murky, so musicians mutated into new and independent styles. Singer Morrissey (b. Steven Morrissey, 1959), guitarist Johnny Marr (b. John Maher, 1963), bassist Andy Rourke (b. 1964), and drummer Mike Joyce (b. 1963) repurposed instrumental moves from dance and pop music, but the Smiths' music was a sneak attack on British synthesizer clichés. Swimming in Morrissey's deeply crooned, angst-ridden, openly emotional lyrics and fueled by Marr's ringing guitar, the band drew major inspiration from the New York Dolls, for whom Morrissey had once formed a fan club. The singer also counted himself a card-carrying fan of Dusty Springfield and Patti Smith, identifying strongly with female singers who steered clear of mirth. The Smiths' debut single, in 1984, was the aptly named "Heaven Knows I'm Miserable Now," which was also their first Top 10 U.K. hit, followed up with *Meat Is Murder* (1985) and *The Queen Is Dead* (1986). Despite the band's short life—they recorded only four studio LPs before disbanding in 1987—their far-reaching influence on contemporary music is still felt. The emo (short for "emotional") rock movement of the 1990s owed its deep-seated turmoil to Morrissey, and it's no coincidence that the letters *e*, *m*, and *o* are found in his name. His mordant wordplay drew music obsessives and established him as a kindred spirit to those who stay off the sunny side of the street. In his solo career, Morrissey still walks there, like a Pied Piper of unhappy passion, followed by his willing and woebegone subjects.

Above top and right: Morrissey. *Middle:* Morrissey, Johnny Marr, and Andy Rourke. All at G-MEX Centre, Manchester, UK, July 19, 1986
📷 all **IAN TILTON / CAMERA PRESS / REDUX**

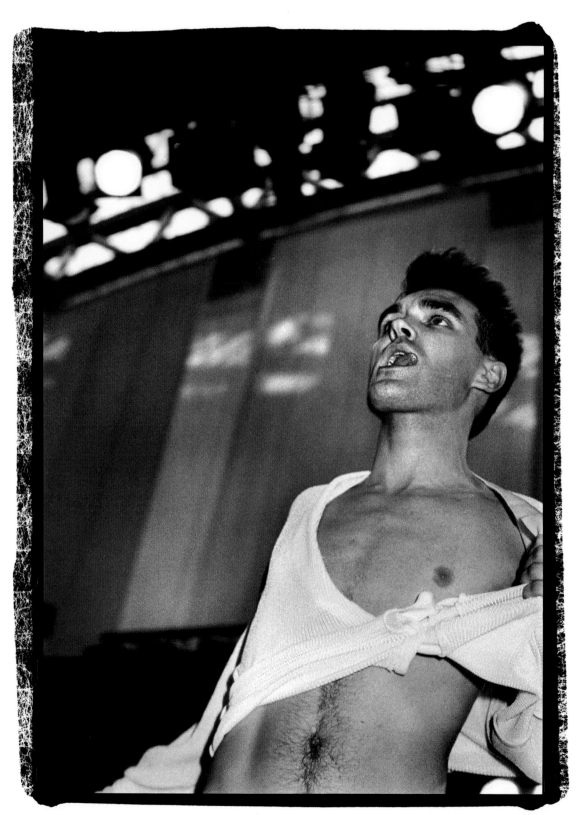

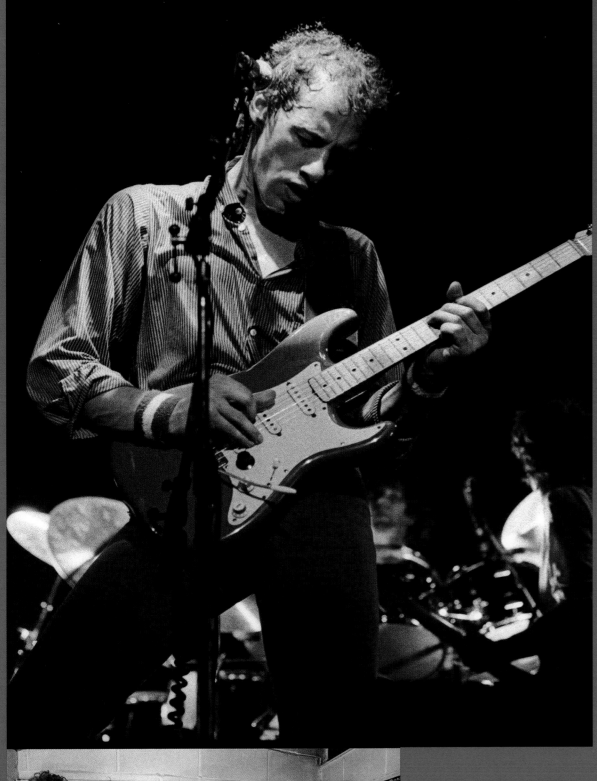

DIRE STRAITS

Rock and roll can be a grueling business. Ask any band down to its last pence; Dire Straits, for one, named itself after its own precarious finances. English guitarist Mark Knopfler (b. 1949) wrote for a newspaper before going full-tilt musician and cutting a five-song demo with younger brother David (b. 1952) on rhythm guitar, bassist John Illsley (b. 1949), and drummer Pick Withers (b. 1948). After taking the tape to Charlie Gillett, who had an influential program on BBC Radio London called *Honky Tonk*, the band wasn't sure how else to promote itself. Luckily, it didn't have to, because the demo snagged Dire Straits a label. The quartet's self-titled 1978 debut featured the previously demoed "Sultans of Swing," which blew up so fast that it peaked at No. 2 on the U.S. charts. The band's rootsy mix of rock, jazz, folk, and blues contrasted with punk's concurrent rise and quickly translated into a groundswell of global popularity. Three increasingly sophisticated albums followed, but no one could've been prepared for the reception of the fifth disc, *Brothers in Arms*, in 1985. Debut single "Money for Nothing," with guest Sting of the Police, became a theme song for MTV, which its lyrics name-checked, and propelled the album to the top-of-the-chart spot for nine weeks. Mark Knopfler fused a variety of influences in the personal blender of his Fender Stratocaster, resulting in soulful and heartfelt sounds like those of no other guitarist. One final Dire Straits album, *On Every Street*, followed in 1991 before the group dissolved and Knopfler moved on to myriad solo releases and successful soundtracks, but together the band made "Money for Nothing," and the rest of its work, into music of lasting value.

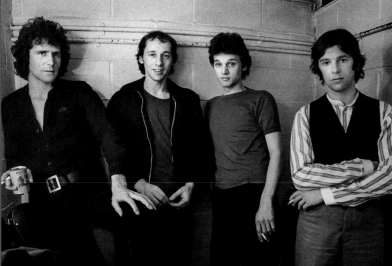

Top left: Mark Knopfler at Birmingham Odeon, UK, June 13, 1979.
Left: John Illsley, Mark Knopfler, David Knopfler, and Pick Withers at the Roundhouse, London, January 29, 1978
📷 both © JILL FURMANOVSKY

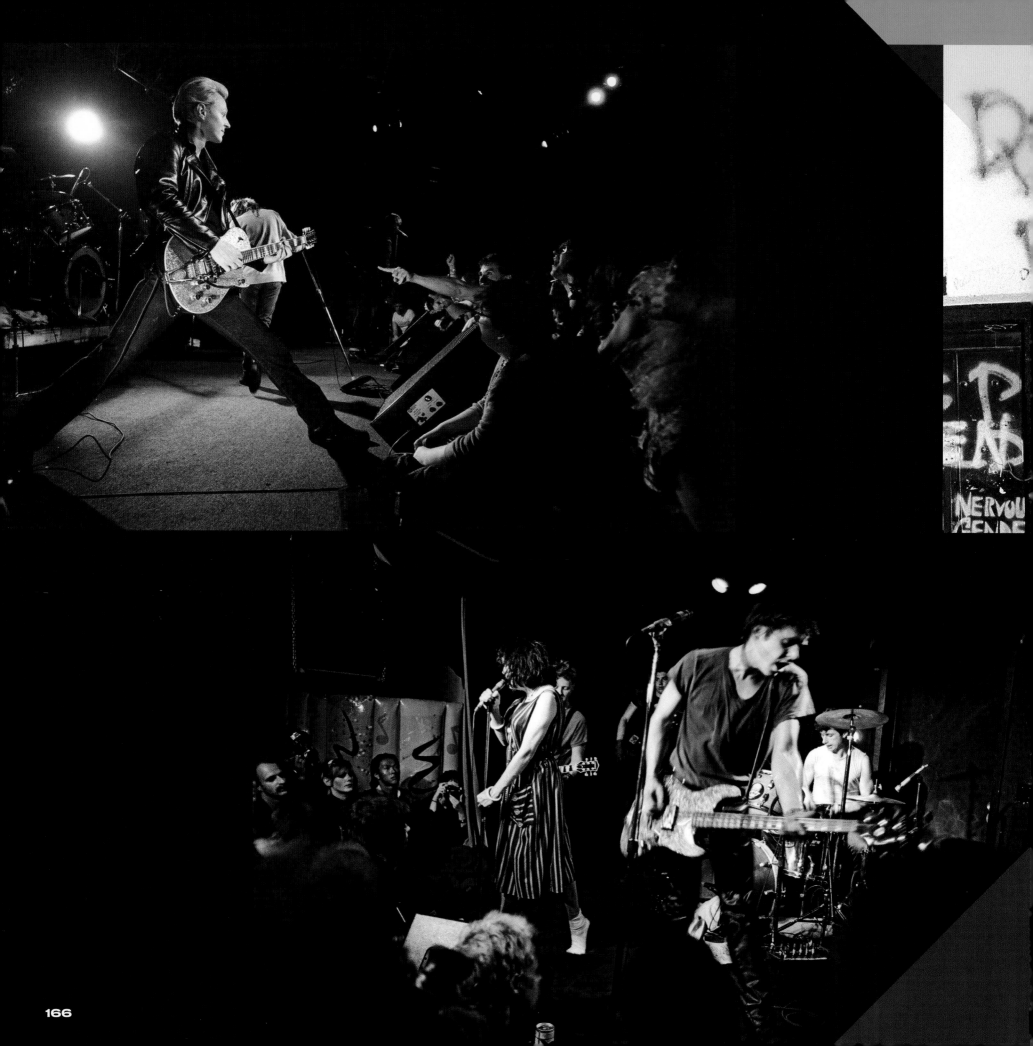

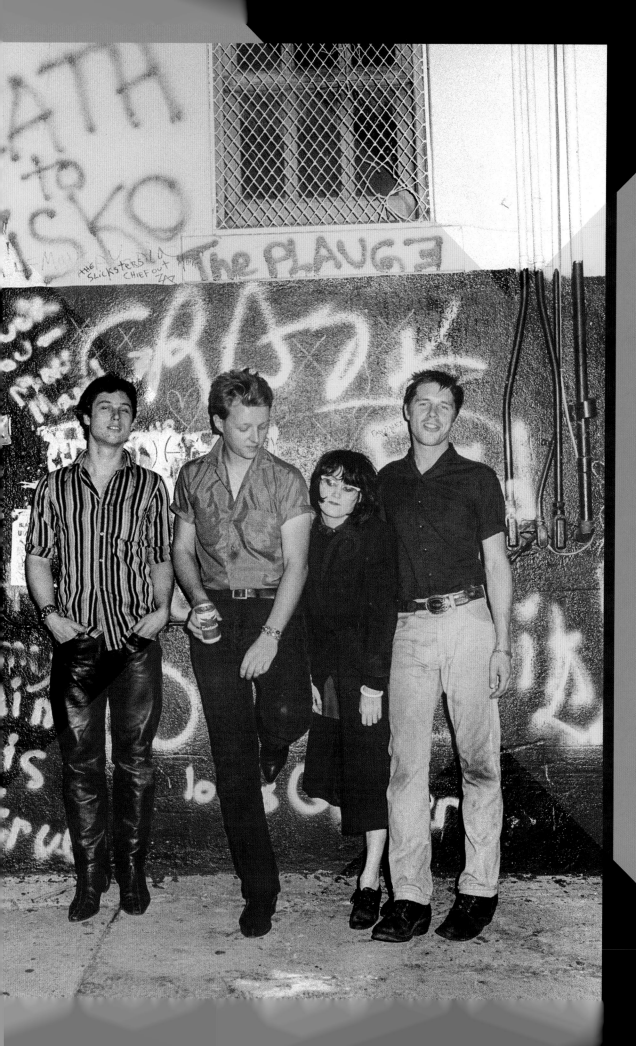

In the ebb and flow of rock and roll, different cities at different times generate their own genre-defining scenes. For punk in 1980, Los Angeles held all the cards. What had begun there as a bubbling cadre of bands three years earlier had grown into a citywide torrent of groups. X was at the head of the pack. Formed in 1977 when John Doe (born John Duchac in 1953) and Billy Zoom (born Tyson Kindell in 1948) got together to rehearse, they were joined on vocals by Exene Cervenka (born Christene Cervenka in 1956), who had been writing poetry and transformed her verse into lyrics. D. J. Bonebrake (b. 1955) filled the drum spot, and X was born. A 1978 single on Dangerhouse Records, featuring "Adult Books" on the A-side, showed promise, and shortly afterward, when Slash Records started, X became its franchise. First album *Los Angeles*, produced by Doors keyboardist Ray Manzarek, dropped in 1980 and shook the DIY underground like a West Coast quake. Songs such as "Johnny Hit and Run Paulene," "The Unheard Music," "Sugarlight," and a cover of the Doors' "Soul Kitchen" bottled the ethos of X's environment. *Wild Gift*, issued next in 1981, became one of *Rolling Stone*'s Top 5 Albums of the Year. The foursome graduated to a major label and continued their evolutionary climb, while the L.A. scene morphed into new styles and life went on. Still performing, X always marks the spot.

Opposite top: Billy Zoom, Exene Cervenka, and John Doe at Paradise Club, Boston, 1981
📷 © CATHERINE VANARIA

Opposite bottom: Cervenka, Zoom, John Doe, and D. J. Bonebrake at Berkeley Square, Berkeley, CA, 1979
📷 RICHARD MCCAFFREY

Left: Bonebrake, Zoom, Cervenka, and Doe outside the Masque, Los Angeles, 1979
📷 © JANETTE BECKMAN

peter gabriel

Fifty years of musical innovation can defy easy summary. Peter Gabriel, born in Surrey, England, embarked on drums even though his mother had taught him piano as a child. When he founded Genesis in 1967 with schoolmates, he moved to lead singer. Gifted with natural showmanship, Gabriel (b. 1950) took to the front-man role with an intense flair he never lost. When he went solo in 1975, he announced his intent via "Solsbury Hill," still a signature radio staple. When he recorded *So* in 1986, the singer chose a young Canadian producer named Daniel Lanois: a prophetic choice that resulted in the most successful of all the Englishman's releases. An early tech adopter, Gabriel created the video for the album's first single, "Sledgehammer," in a partly animated, never-before-seen style, and the clip won a record nine awards at the MTV Music Awards in 1987. He had found a new calling, but soon added yet another: an extensive interest in world music, capped by his founding of the World of Music, Arts and Dance (WOMAD) festival to celebrate international styles. His Real World Records releases music from all areas of the globe. Somehow, around his demanding recording and performing schedule, he also pioneered digital music distribution with the company On Demand Distribution (OD2), a harbinger of download sites. Gabriel received the Man of Peace award from the Nobel Peace Prize Laureates in honor of his ongoing work for human rights.

Clockwise from above left:
Peter Gabriel at the Auditorium Theatre, Chicago, April 1974
📷 **DAVID SLANIA**

Gabriel on Genesis's Lamb Lies Down on Broadway tour at the Arie Crown Theater, Chicago, February 1975
📷 **DAVID SLANIA**

Gabriel singing "Shock the Monkey" on the Security Tour, U.I.C. Pavilion, Chicago, December 2, 1982
📷 © **KESH SORENSEN**

Gabriel singing "Lay Your Hands on Me" on the Plays Live tour at the Agora Ballroom, West Hartford, CT, summer 1984
📷 **TIM DEVLIN**

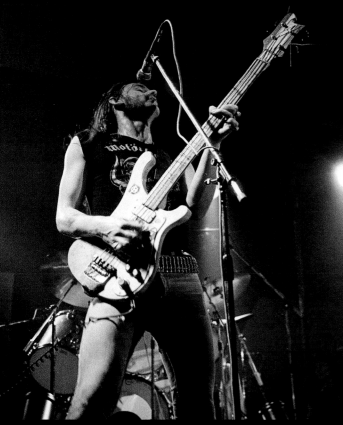

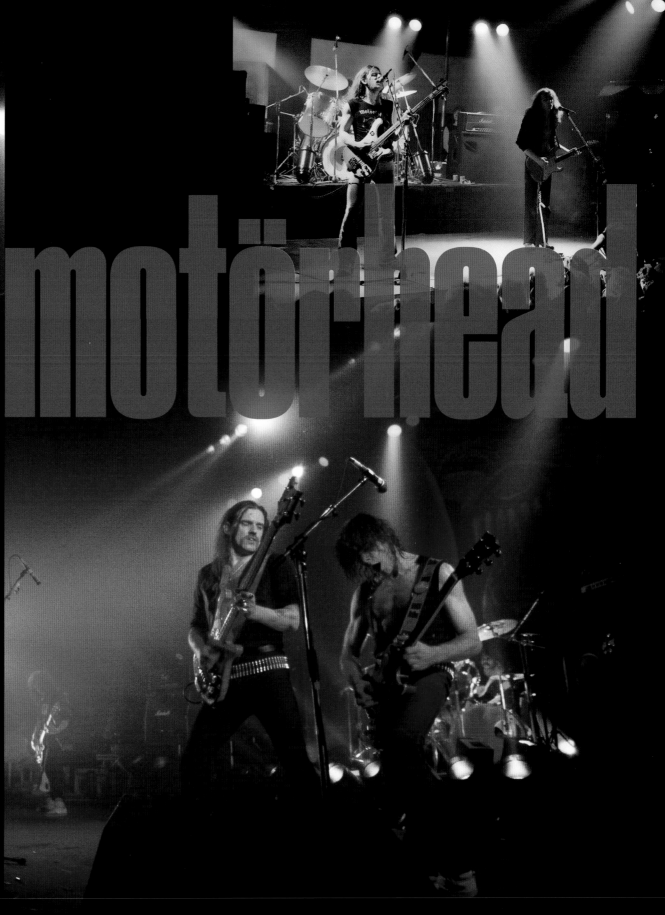

motörhead

Looks can be deceiving. Ian Fraser "Lemmy" Kilmister (1945–2015) cultivated the appearance of a metalhead, but he also deeply loved punk music and identified with its inward and outward meanings. So, when Motörhead mobilized in 1975, fans first assumed the group represented just the latest roar in the new heavy-metal thunder then coming out of Britain, but the singer/bassist had a keen ear for the Ramones and the Sex Pistols that never dulled. He had apprenticed in space-rockers Hawkwind, and after getting bounced for drug possession in Canada, he assembled his ultimate power trio, named after the final song he had written in his previous band. Motörhead did its ear-splitting best to fuse punk and metal over twenty-two studio albums, and appealed not only to every subset of metal fans—heavy, speed, thrash—but also to his beloved DIY tribe. As such, the band couldn't be tied down to any one movement, mostly because of Lemmy's larger-than-life stance. He became a music hero, yet was shy enough that he positioned the microphone higher than himself so he could look up while singing instead of at his audience. (And he still shut his eyes while he did it.) There was nothing introverted about Lemmy's lifestyle or his lyrics, which tear into society's hypocrisies, military madness, substance abuse, powermongering, and good versus bad. Motörhead's early-1980s peak defined the era as much as New Wave did. *Bad Magic* came out four months before Lemmy died. Today, Hollywood's Sunset Strip honors him with a statue outside the Rainbow Bar & Grill, his regular haunt. All hail Lemmy.

Top left: Lemmy Kilmister. *Top right:* Kilmister and "Fast" Eddie Clarke. Both at Music Machine, London, February 23, 1978. *Right:* Kilmister and Phil Campbell at the Saga Rockteater, Copenhagen, Denmark, March 28, 1987.
📷 all **PAUL SLATTERY / CAMERA PRESS / REDUX**

As the 1970s slid into a shiny new decade, hip-hop, rolling from the East Coast to the West, changed everything. One of its pioneers was Joseph Saddler, a.k.a. Grandmaster Flash (b. 1958), who had moved with his family from Barbados to the Bronx, accompanied by his father's prodigious record collection, and spent his youth experimenting on sound gear in his bedroom. He attempted to reproduce what he heard on those albums, developing a brand-new groove out of his innovative backspin technique, punch phrasing, and scratching. In the mid-1970s, he joined up with street poets Keef Cowboy (Keith Wiggins) (b. 1960), Kidd Creole (Nathaniel Glover) (b. 1950), Melle Mel (Melvin Glover) (b. 1961), Scorpio (Eddie Morris, also known as Mr. Ness) (b. 1960), and Rahiem (Guy Todd Williams) (b. 1963) to launch the Furious Five—and laid down a blueprint for the future of the new musical form. Their initial release, 1979's "Superrappin'," and their seven-minute 1981 classic "The Adventures of Grandmaster Flash on the Wheels of Steel" became rallying points for the new sound heard 'round the country, shifting popular music from live performance toward studio experimentation. Sampling became synonymous with hip-hop, and before long drum beats and instrumental lifts from music of all periods started showing up on the most popular songs. Grandmaster Flash and the Furious Five's call-to-arms 1982 track "The Message" delivered dark social commentary, and hip-hop soon became a brotherhood, youth culture across racial lines identifying with its message, fashion, and image. The Furious Five eventually fell into factions, which allowed new hip-hop acts to steal their thunder. There was no turning back the sound, though: Grandmaster Flash and the Furious Five had invented a new kind of music, and for a brief moment held its pole position.

Left: Kid Creole, Melle Mel, Grandmaster Flash, Cowboy, Rahiem, and Scorpio at the album cover shoot for *On the Strength*, New York City, 1988. *Below:* Grandmaster Flash and the Furious Five, London, May 12, 1982. 📷 both © **JANETTE BECKMAN**

GRANDMASTER FLASH
& THE FURIOUS FIVE

DEVO

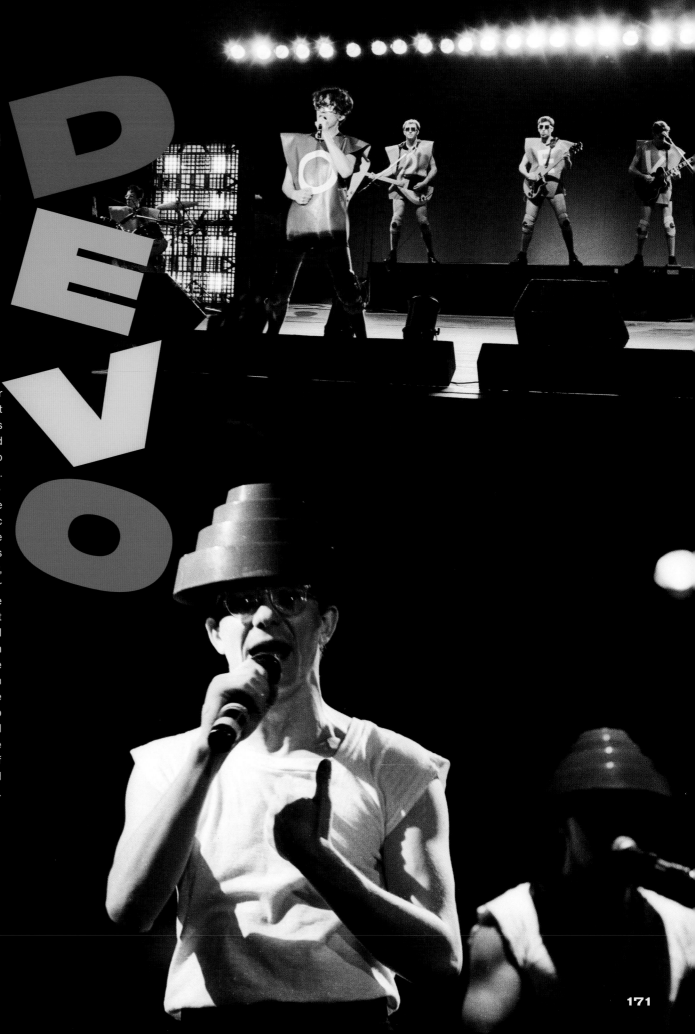

"Are we not men?" Has a more elemental question ever been asked in rock and roll history? Bizarro band Devo burst onto the early 1970s U.S. rock scene straight out of Ohio's Kent State University, clad in postapocalyptic jumpsuits and ready to turn the music world upside down. Featuring two sets of brothers—Mark (b. 1950) and Bob Mothersbaugh (b. 1952) and Gerald (b. 1948) and Bob Casale (1952–2014)—plus drummer Alan Myers (1955–2013), they sounded like no one before or since. Creating futuristic synthesizer music that wore its surreal humor on its sleeves, rolled up for the "de-evolution" of humankind (from which the band drew its name), they careened from satire to solemnity to philosophy, eschewing every rock and roll convention imaginable. Their first album, *Q: Are We Not Men? A: We Are Devo!*, became a surprise hit in 1978 and included a fabulously offbeat reconstruction of the Rolling Stones' signature song "(I Can't Get No) Satisfaction." Two years later, third album *Freedom of Choice* lashed out "Whip It," an inescapable hit employing a Minimoog synthesizer and a guitar riff from Roy Orbison's "Oh, Pretty Woman." Its video—featuring the band in "energy dome" helmets and using a bullwhip to strip an actress—was controversial but raised Devo's profile still further. Five more albums and innumerable theatrical stage performances followed before the "brain-eating species of ape," as Mark Mothersbaugh once termed his band, moved into solo careers as producers, filmmakers, and composers.

Top left: Mark Mothersbaugh as "Booji Boy" at the Old Waldorf, San Francisco, November 10, 1978
📷 **RICHARD MCCAFFERY**

Top right: Alan Myers, Mark Mothersbaugh, Gerald Casale, Bob Casale, and Bob Mothersbaugh at Yubin Chokin Kaikan, Tokyo, May 13, 1980
📷 © **BOB GRUEN**

Right: Mark Mothersbaugh and Bob Casale in Energy Dome hats at the Civic Center, Oklahoma City, December 1982
📷 **SCOTT BOOKER**

MICHAEL
JACKSON

If there exists but one true King of Pop, then Michael Jackson (1958–2009) is the chosen one. The eighth of ten children in his prodigy-filled family, he and his older brothers Jackie, Tito, Jermaine, and Marlon began winning talent contests in 1964 and turned professional three years later as the Jackson 5. Centerpiece of the Motown Records act, Michael cut his first solo disc, *Got to Be There*, in 1972, and the music business glimpsed its future in him. With his mesmerizing voice, and stage moves to match, he left audiences breathless from the outset, but when he teamed up with visionary producer Quincy Jones, the singer made quantum evolutionary leaps. Their *Off the Wall* (1979) spawned four Top 10 singles and a Grammy, but no one was prepared for *Thriller*, which came out in 1982 and produced seven Top 10 singles, won eight Grammys—including Album of the Year—and spent thirty-seven weeks at the top of the *Billboard* charts. It remains the best-selling album of all time (65 million and counting). "Beat It," "Billie Jean," and the title song grew so popular that MTV, which had been reluctant to air videos by African American acts, was forced to step up or lose out. On the 1983 TV special *Motown 25: Yesterday, Today, Forever*, Jackson debuted his gliding moonwalk, and the whole country gasped in awe. *Bad* (1987) and *Dangerous* (1991) followed, to lesser sales and acclaim, but Jackson persevered through personal turmoil and professional challenges until his premature death. Michael Jackson: King of Pop for the ages.

Opposite top: Michael Jackson at Rich Stadium, Buffalo, NY, August 26, 1984
📷 © **EBET ROBERTS**

Opposite bottom, left to right: Tito (guitar), Marlon, Randy, Jermaine (bass), and Michael Jackson (airborne) on the Victory tour at the Gator Bowl Stadium, Jacksonville, FL, July 1984
📷 © **HARRISON FUNK**

Right: Jackson at the Rosemont Horizon, Rosemont, IL, April 19, 1988
📷 **RAYMOND BOYD**

JOHN MELLENCAMP

The name game goes like this: John Mellencamp became Johnny Cougar became John Cougar became John Cougar Mellencamp became John Mellencamp again. "Johnny" and "Cougar" were *not* his ideas, but when the singer-songwriter left Indiana for New York and was offered a record deal, he was marketed as a pop idol, with a goofy name to match. In the music business, only inner strength can overcome that kind of typecasting, but resolve defines the life of John Mellencamp (b. 1951). He endured corrective surgery for a spina bifida birth defect as an infant, started a family right out of high school (after forming his first band, Crepe Soul, at fourteen), and became a grandfather at thirty-seven. Such challenges fueled his songs about the American heartland, where he still resides. "Hurts So Good" and "Jack & Diane," from 1982's *American Fool*, epitomize his plain-spoken worldview, one that realizes good intentions don't always turn into good lives. For Mellencamp, both music-making and life itself are driven by endurance: you ride the rollercoaster until it stops. Yet he's also been a social advocate from the start, critiquing presidents Ronald Reagan and George W. Bush, the Iraq War, and big-corporation farming. With Willie Nelson and Neil Young, he founded Farm Aid in 1985 to support small agriculture. Through his half-century hootenanny of performing, acting, painting, and activism, he has kept his eye on small towns and fair play, ideals that have stayed the same no matter his name.

Below, left to right: Kenny Aronoff, John Mellencamp, and Toby Myers at the Baltimore Civic Center, December 7, 1985
📷 **MIKE NIEDERHAUSER**

Right: Mellencamp at the Farm Aid Concert at Manor Downs Racetrack, Manor, TX, July 4, 1986
📷 © **EBET ROBERTS**

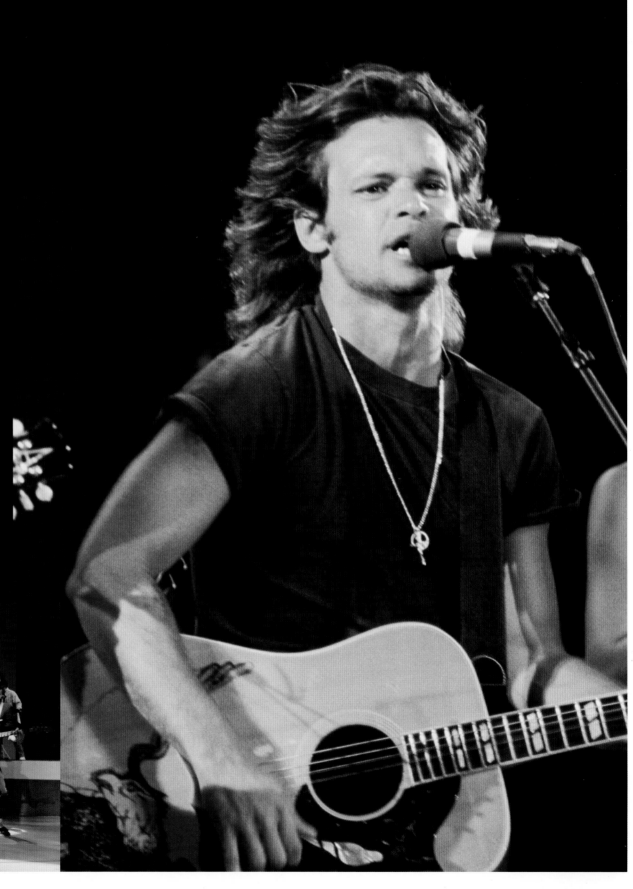

Heavy-metal thunder never sounded so ominous, and so awesome, as when Metallica first raised its ire in Los Angeles in 1981. The city raged with music in those days, with clubs stretching from the beach to East L.A. and from San Pedro to the far San Fernando Valley. Guitarist-singer James Hetfield (b. 1963) saw an ad in a local paper placed by drummer Lars Ulrich (b. 1963), the Danish son of a tennis pro, who sought like-minded metalheads for jams. The two founders enlisted second guitarist Dave Mustaine (b. 1961) and bassist Cliff Burton (1962–86), and together the band became famed for its super-aggro, super-fast style, which fused hardcore punk and British-style metal. *Kill 'Em All* came out in 1983, followed by *Ride the Lightning* and *Master of Puppets*, and a million heads began to bang. Eventually Metallica relocated to San Rafael, north of San Francisco, which happened to be the Grateful Dead's headquarters: an unlikely spot for the No. 1 act in thrash metal's Big Four (completed by Anthrax, Slayer, and Mustaine's Megadeth), but it worked. Metallica decimated all within hearing range—and survived Burton's death in a tour bus accident—and released metal's best-selling "Black Album" in 1991. In the new century, Hetfield, Ulrich, lead guitarist Kirk Hammett (b. 1962), and bassist Robert Trujillo (b. 1964) have solidified into the kind of global superbrand previously represented by the Rolling Stones. They've streamlined the progressive extremity of the 1980s into gargantuan classic rock over almost three decades, but that hasn't slowed Metallica's unrelenting velocity. Rather, it has allowed the band to keep building its colossal fan base. Horns up high and keep 'em there.

Right: James Hetfield at McNichols Sports Arena, Denver, May 15, 1986
📷 **CHRIS DEUTSCH**

Below: Cliff Burton, Hetfield, Lars Ulrich, and Kirk Hammett at Day on the Green at the Oakland Coliseum, CA, August 31, 1985
📷 **JOHN UMPHREY**

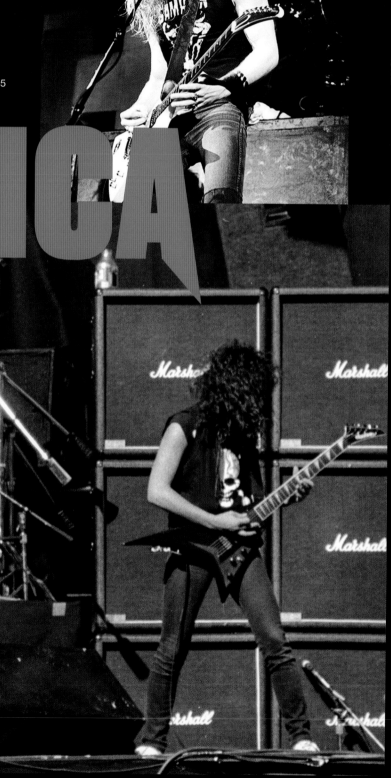

METALLICA

Outrageousness has its virtues, especially when the outrager is a joyous female such as Cyndi Lauper (b. 1953). The Queens-raised singer and her early band Blue Angel, whose first album appeared in 1980, had all the qualities to get over the top except timing; the release received little notice in the United States. Pushed into the retro-rockabilly category, where Lauper's bouncy glee couldn't shine, the band dissolved after its label declined to release a second album. Ironically, that was Lauper's big break. Working diligently on original songs and tweaking up those written for her by others, she drew together a strong backing band and produced *She's So Unusual* in 1983. Standing alone in terms of spirit and danceability, and displaying Lauper's four-octave range and punk-meets-Minnie Mouse style to advantage, it was a global hit. "Girls Just Want to Have Fun" and "Time after Time" ruled radio and MTV that year, and Lauper—the only female singer to have four Top 5 hits from a debut album—took home the Best New Artist Grammy in 1985. Thereafter Lauper happily set her sights on everything else she'd ever wanted to do, including releasing *True Colors* in 1986, acting, and composing music for *Kinky Boots*, the smash Broadway play, which landed her a Tony Award in 2013. Sometimes becoming an icon hems in an artist, but Lauper has continued to fly her freak flag on roads of her own choosing. Girls might just want to have fun, but Lauper has achieved a whole lot more than that.

Left: Cyndi Lauper at Irvine Meadows Amphitheatre, CA, 1984
📷 **ABEL ARMAS II**

Below: Lauper at the Palatrussardi, Milan, March 6, 1987
📷 **CHIRULLI / CONTRASTO / REDUX**

CYNDI LAUPER

STEVIE RAY VAUGHAN

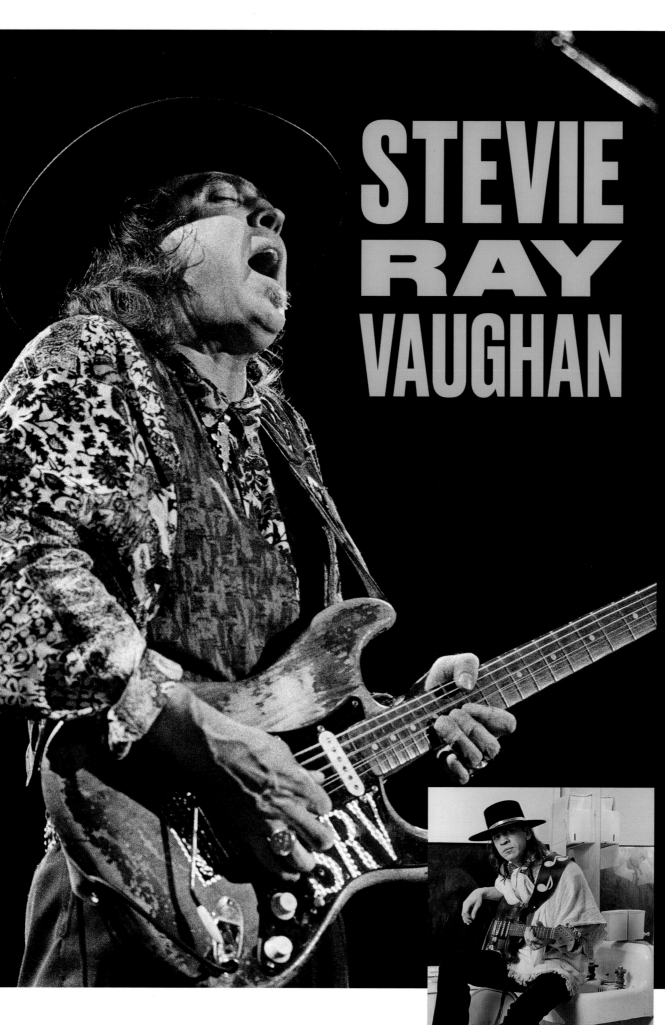

Rock and roll erupted out of the warp-speed collision of blues and country at midcentury, with the blues providing the sonic velocity needed to get its rural cousin off the ground. Ever since, it has been blues that moves to the front lines when rock music needs a stiff jolt. Stevie Ray Vaughan (1954–90) fell for the blues while growing up in the Oak Cliff section of Dallas. The Chantones, the Brooklyn Underground, Liberation, the Nightcrawlers, and Paul Ray and the Cobras were all early stomping groups for his beloved Fender. In Austin, the guitarist formed Stevie Ray Vaughan & Triple Threat Revue with W. C. Clark, Lou Ann Barton, and Freddie Pharaoh in 1977. Soon word spread of his otherworldly abilities. The guitar spoke to Vaughan, the way Jimi Hendrix's Stratocaster spoke to him, and those conversations took Vaughan into uncharted territories. His vocals also were becoming so powerful that he could silence a room. In 1978, Vaughan renamed the band Double Trouble with first Jackie Newhouse and then Tommy Shannon (b. 1946) (bass) and Chris Layton (b. 1955) (drums), and the spotlight moved permanently onto him. David Bowie and Jackson Browne took note in a nightclub at the Montreux Jazz Festival in 1982: the former employed Vaughan on two radio smashes, "Let's Dance" and "China Girl," while Browne offered free studio time for him to record an album in Los Angeles. *Texas Flood*, in 1983, was the result, and it thrilled blues lovers. Three more studio albums set Vaughan's reputation ablaze. His final album, *Family Style*, with brother Jimmie Vaughan, hinted at treasures to come, but a postconcert helicopter crash in Wisconsin in 1990 cut his life short. Yet Stevie Ray Vaughan remains the model of a musician becoming one with his instrument and sharing that experience with his audience.

Left: Stevie Ray Vaughan at the Oakland Coliseum, CA, December 3, 1989
📷 © JAY BLAKESBERG

Near left: Vaughan backstage, New York City, ca. 1980s
📷 JOHNATHAN POSTAL

Top: Vaughan at the Kabuki, San Francisco, 1983
📷 JOHN UMPHREY

U2

There's a better-than-even chance that legendary Dublin band U2 has found what it's looking for. Bono (b. Paul Hewson, 1960), the Edge (b. David Evans, 1961), Adam Clayton (b. 1960), and Larry Mullen Jr. (b. 1961) met as students at the Mount Temple Comprehensive School in 1976, when Ireland was still enduring its Troubles and punk rock was feeding youthful ire. The quartet set itself apart by fusing political and social *cris de coeur* with spiritual and transcendent concerns, Bono taking the lead-man position with assurance and the Edge developing the signature chiming guitar style that elevated their songs into anthems. Their debut LP, 1980's *Boy*, won popular attention, but it was their third album, *War* (1983), that broke the band worldwide on the strength of "Sunday Bloody Sunday" and "New Year's Day," the video for the latter hitting high rotation on MTV as a landmark of the European New Wave. The follow-up, 1984's *Unforgettable Fire*, produced by Brian Eno and Daniel Lanois, established the band as both activist and ardent in their music, reaching No. 1 in the United Kingdom and entering the Top 20 in the United

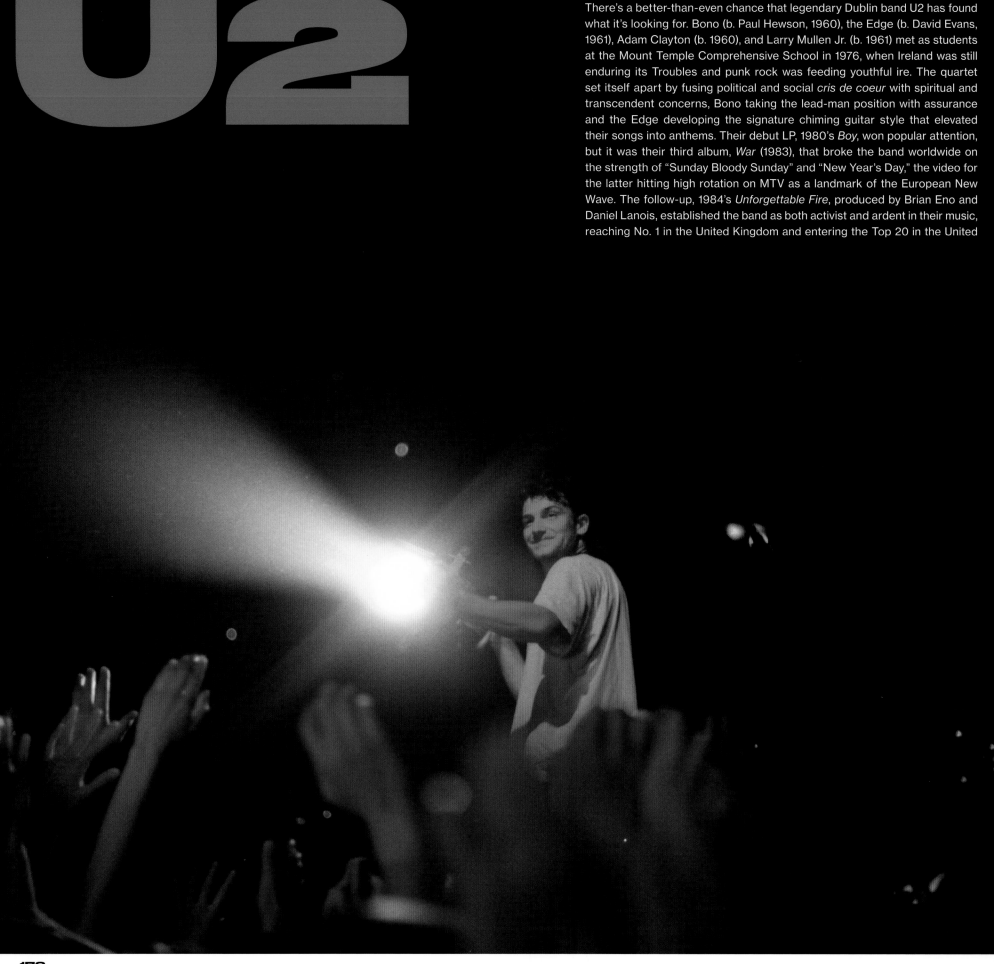

States on the strength of "Pride (In the Name of Love)," a tribute to the Rev. Martin Luther King Jr. As sales and fame exploded, the band stayed steady, releasing *The Joshua Tree* in 1987, with its larger-than-life songs "I Still Haven't Found What I'm Looking For," "With or Without You," and "Where the Streets Have No Name." *Rattle and Hum* followed in 1988, *Achtung Baby* in 1991, and the band toured with increasingly theatrical and elaborate productions. Today, forty years after its schoolyard founding, U2 continues to create, now global heroes who have, against the odds, managed to remain human.

Opposite: Bono at McNichols Sports Arena, Denver, March 17, 1985
📷 **CHRIS DEUTSCH**

Below: Mullen (drums), the Edge, Bono, and Clayton at the Forum, Inglewood, CA, 2015
📷 **ROZETTE RAGO**

Right: Larry Mullen Jr., Adam Clayton, the Edge, and Bono at KUSF radio station, San Francisco, 1981
📷 © **CHESTER SIMPSON**

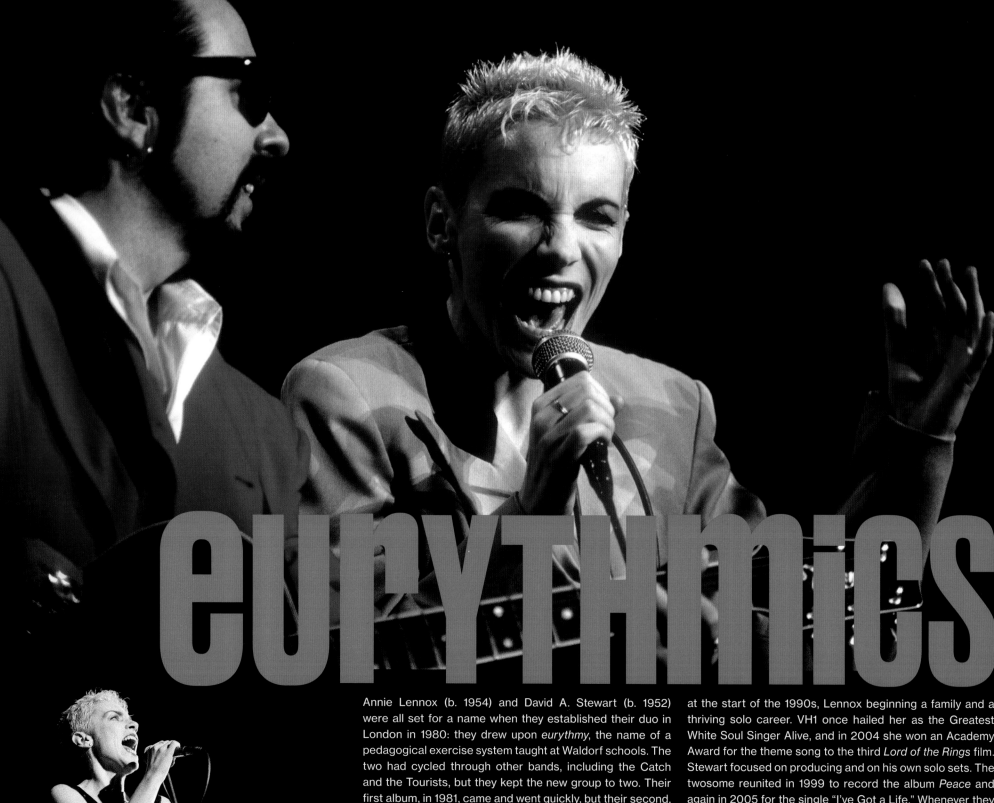

eurythmics

Annie Lennox (b. 1954) and David A. Stewart (b. 1952) were all set for a name when they established their duo in London in 1980: they drew upon *eurythmy*, the name of a pedagogical exercise system taught at Waldorf schools. The two had cycled through other bands, including the Catch and the Tourists, but they kept the new group to two. Their first album, in 1981, came and went quickly, but their second, *Sweet Dreams (Are Made of This)*, in 1983, sent its title track to the Top 5 in the United Kingdom and the Top 20 in the United States. Lennox's voice—invincible, dominant, and operatic—paired perfectly with Stewart's one-man army of technical wizardry. Together, as their songwriting reached maturity, they and their videos thrived in the MTV era. The Eurythmics worked together throughout the decade, releasing eight albums and accomplishing a longevity matched by few other bands during the bright and glitzy 1980s. With their usual shrewd sense of timing, the pair went their separate ways at the start of the 1990s, Lennox beginning a family and a thriving solo career. VH1 once hailed her as the Greatest White Soul Singer Alive, and in 2004 she won an Academy Award for the theme song to the third *Lord of the Rings* film. Stewart focused on producing and on his own solo sets. The twosome reunited in 1999 to record the album *Peace* and again in 2005 for the single "I've Got a Life." Whenever they share a stage, their electricity arcs back to the years when they took on the world, and won.

Above: David Stewart and Annie Lennox at the Palazzo dello Sport, Rome, October 27, 1989
📷 **ELIGIO PAONI / CONTRASTO / REDUX**

Left: Lennox at the Henry J. Kaiser Convention Center, Oakland, CA, November 19, 1989
📷 © **JAY BLAKESBERG**

THE POGUES

In 1982, employing tin whistles, banjos, citterns, mandolins, and accordions (for starters), the Pogues ventured into London clubs bearing Celtic music ramped up to 11 on the meter of unhinged joy. Founders Shane MacGowan (b. 1957), Peter "Spider" Stacy (b. 1958), and Jem Finer (b. 1955) gathered up James Fearnley (b. 1954), Cait O'Riordan (b. 1965), and Andrew Ranken (b. 1953), and immediately their shows devolved into semicontrolled madness, with inebriation pushing everything into the red zone. Front man MacGowan thrived on chaos, so there could be brawling among the bandmates as well as the audience before set's end. *Red Roses for Me*, in 1984, drew enough attention that the Pogues made the curiosity list of many listeners. It was the perfect time for them to appear: many punk bands had fallen into disrepair, there was an opening for something new, and the Pogues' brand of Celtic punk was nothing if not novel. Elvis Costello helped produce the band's next album,

Rum Sodomy & the Lash, which ginned up even more interest. *If I Should Fall from Grace with God* in 1988 solidified what fans had known straight out of the gate: the Pogues were the best new band around, punk or otherwise. For many reasons, including his manic behavior, MacGowan left the group in 1991, and without their anarchic centerpiece, the Pogues called it quits in 1996. Reunions in the new century started and stopped, but like a lot of unlikely occurrences, the Pogues were a band of their time, and when times changed, the quicksilver group disappeared faster than a pint of Guinness in an Irish pub.

James Feamley, Shane MacGowan, Jem Finer, "Spider" Stacy (whistle), and Andrew Ranken (drums) at the Ritz, New York City, June 1986
📷 © **BOB GRUEN**

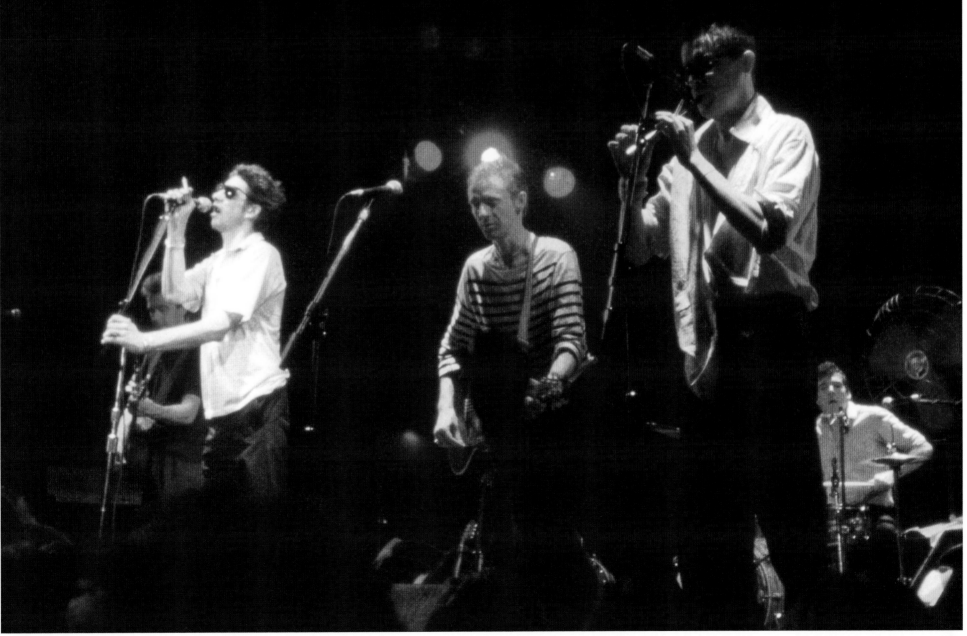

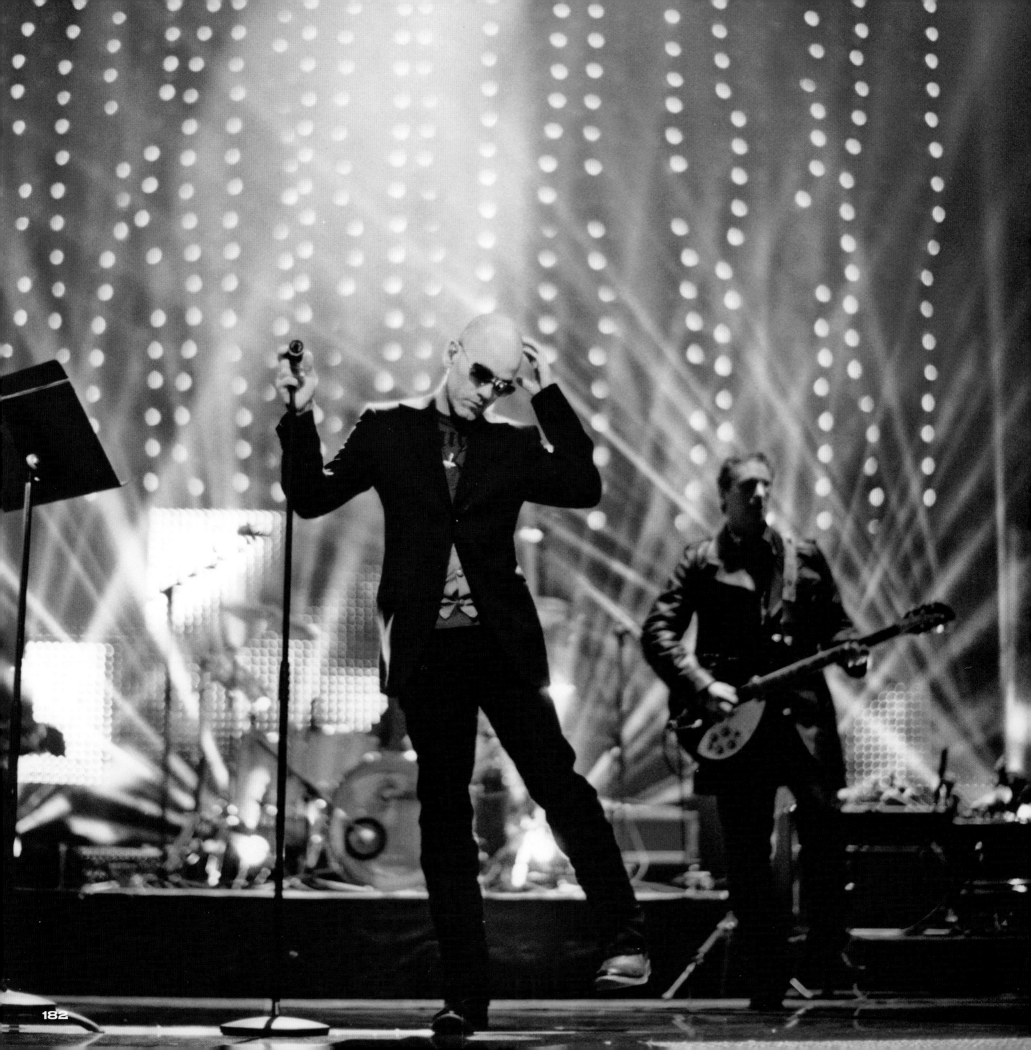

r.e.m.

Alternative music originated in the early 1980s among musicians who felt that major labels were monopolizing—and stifling—rock and roll. Any acts that didn't fit the standard parameters fell into the "alternative" bin, including Georgia's R.E.M., which raised that vague term to a badge of honor. In the college town of Athens, Peter Buck (b. 1956), Michael Stipe (b. 1960), Mike Mills (b. 1958), and Bill Berry (b. 1958) started out playing house parties and small clubs. Their first single, "Radio Free Europe," came out in 1981, and their 1983 full-length debut, *Murmur*, sealed the deal: from that moment onward, R.E.M.'s members fought the good fight, making exactly the music they wanted to make—including the enormously influential *Reckoning*, *Fables of the Reconstruction*, and *Out of Time*—promoting it as they wanted it promoted, and personifying independence until disbanding in 2011. What made them spectacular was the way their abilities fit together. Each member contributed a particular strength, and, as is true of all the greatest bands, had one element differed, the alchemy would not have worked. Stipe's vocals, with his words often obscured in a semimystical mumbled delivery, engendered the kind of devotion from listeners that few singers attain. Buck's guitar was simultaneously sensitive and muscular, providing a melodic assault with a deft touch. Mills and Berry weren't flashy but paired perfectly in rhythm. Together R.E.M. was not only one of the most successful rock bands of the past half-century but one of the most influential, with bands from Nirvana to Radiohead hailing its seminal model of alternative rock.

Opposite: Michael Stipe and Peter Buck at a sound check in 2005
📷 **DAVID BELISLE**

Above left: Stipe and Buck at Shea Stadium, New York City, August 18, 1983
📷 © **EBET ROBERTS**

Above right: Stipe, Buck, and Bill Berry at the Saenger Theatre, New Orleans, September 1986
📷 **MARTY PEREZ**

Left: Mike Mills and Stipe at the Beacon Theatre, New York City, July 21, 1984
📷 © **EBET ROBERTS**

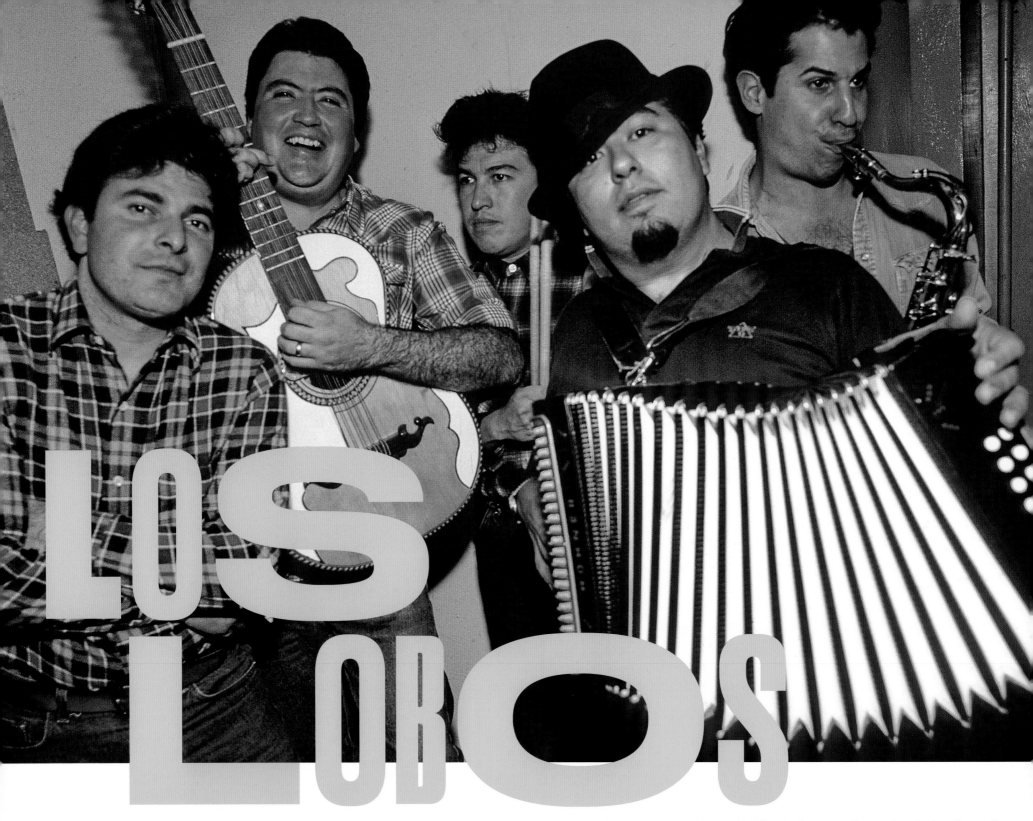

LOS LOBOS

These L.A. kingpins first called themselves Los Lobos del Este (de Los Angeles), or "The Wolves of the East (of Los Angeles)." David Hidalgo (b. 1954) and Louie Pérez (b. 1953) met in high school in the early 1970s and bonded over their taste for fringe music that didn't interest their other friends. As they listened to records together, they broke out pawnshop guitars and began to write their own songs. Joined by Cesar Rosas (b. 1954) and Conrad Lozano (b. 1951), Los Lobos explored Mexican and Latin American music—from norteños to cumbia to Tex-Mex and mariachi—and started to develop the sound they wanted: a loud and

adventurous borderlands mashup of their rich ancestral heritage and a wild spectrum of influences including hard rock, zydeco, and punk. No one had heard anything quite like it. Adjacent to Hollywood and the new music bursting the city's seams in the '70s, Los Lobos, whose line-up expanded to include saxophonist Steve Berlin (b. 1955), played alongside punk bands such as X and root rockers such as the Blasters. Their eponymous debut dropped in 1977, and Slash Records snapped them up in 1983. That year's follow-up, . . . *And a Time to Dance*, netted a Grammy, and the pride of East L.A. was on its way. In 1984, their masterwork *How*

Will the Wolf Survive? appeared, marrying the band's south-of-the-border musical mastery to American rock and soul in poignant originals that reflect Mexican Americans' struggle for cultural and political survival. Those songs set Los Lobos up for four decades—and counting—of recording, touring, and searching for musical horizons not yet crossed. These wolves have survived. And thrived.

Conrad Lozano, David Hidalgo, Louie Pérez, Cesar Rosas, and Steve Berlin at the Kabuki Theater, San Francisco, August 22, 1983
📷 © **CHESTER SIMPSON**

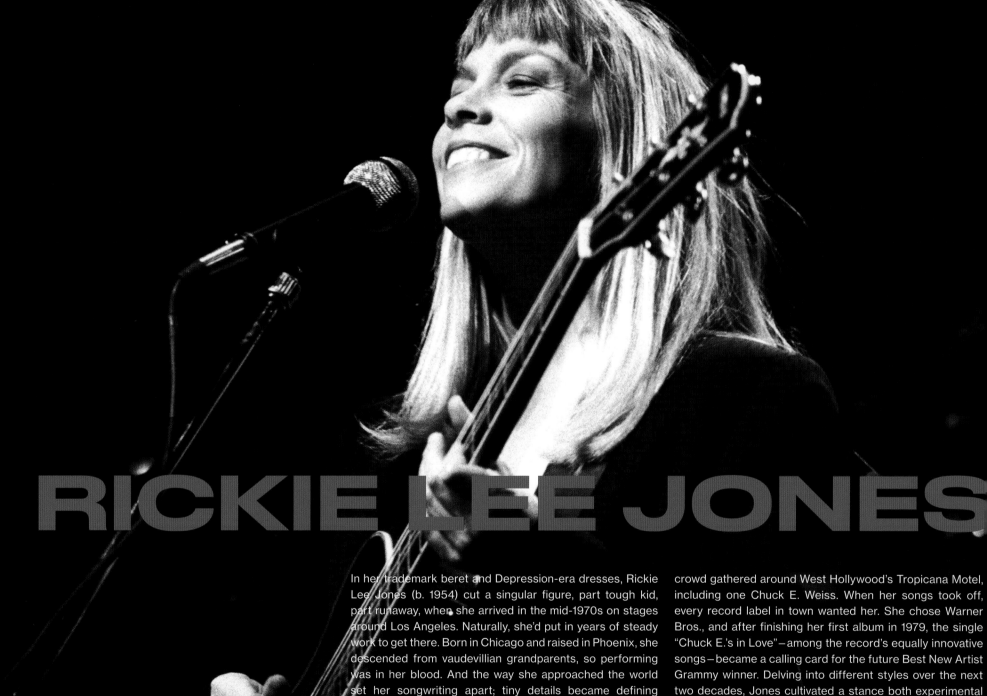

RICKIE LEE JONES

In her trademark beret and Depression-era dresses, Rickie Lee Jones (b. 1954) cut a singular figure, part tough kid, part runaway, when she arrived in the mid-1970s on stages around Los Angeles. Naturally, she'd put in years of steady work to get there. Born in Chicago and raised in Phoenix, she descended from vaudevillian grandparents, so performing was in her blood. And the way she approached the world set her songwriting apart; tiny details became defining moments. When she started singing at a small club in L.A.'s Venice enclave, there wasn't anyone else to match her beat-poet delivery, truth-serum lyrics, sharp eye for Hollywood absurdity, and imaginative narratives of life's dramas. Her songs unspooled like mini-movies. Vocally, she injected plenty of jazz inflections, and she soon got the attention of musicians such as Dr. John and Little Feat's Lowell George. She also became involved with Tom Waits and the boho crowd gathered around West Hollywood's Tropicana Motel, including one Chuck E. Weiss. When her songs took off, every record label in town wanted her. She chose Warner Bros., and after finishing her first album in 1979, the single "Chuck E.'s in Love"—among the record's equally innovative songs—became a calling card for the future Best New Artist Grammy winner. Delving into different styles over the next two decades, Jones cultivated a stance both experimental and grittily urban. Eventually moving to New Orleans, a city that reenergized her bonhomie and her artistic independence, Jones finally found home.

Rickie Lee Jones at the Wiltern Theatre, Los Angeles, February 1982
📷 HENRY DILTZ / MORRISON HOTEL GALLERY

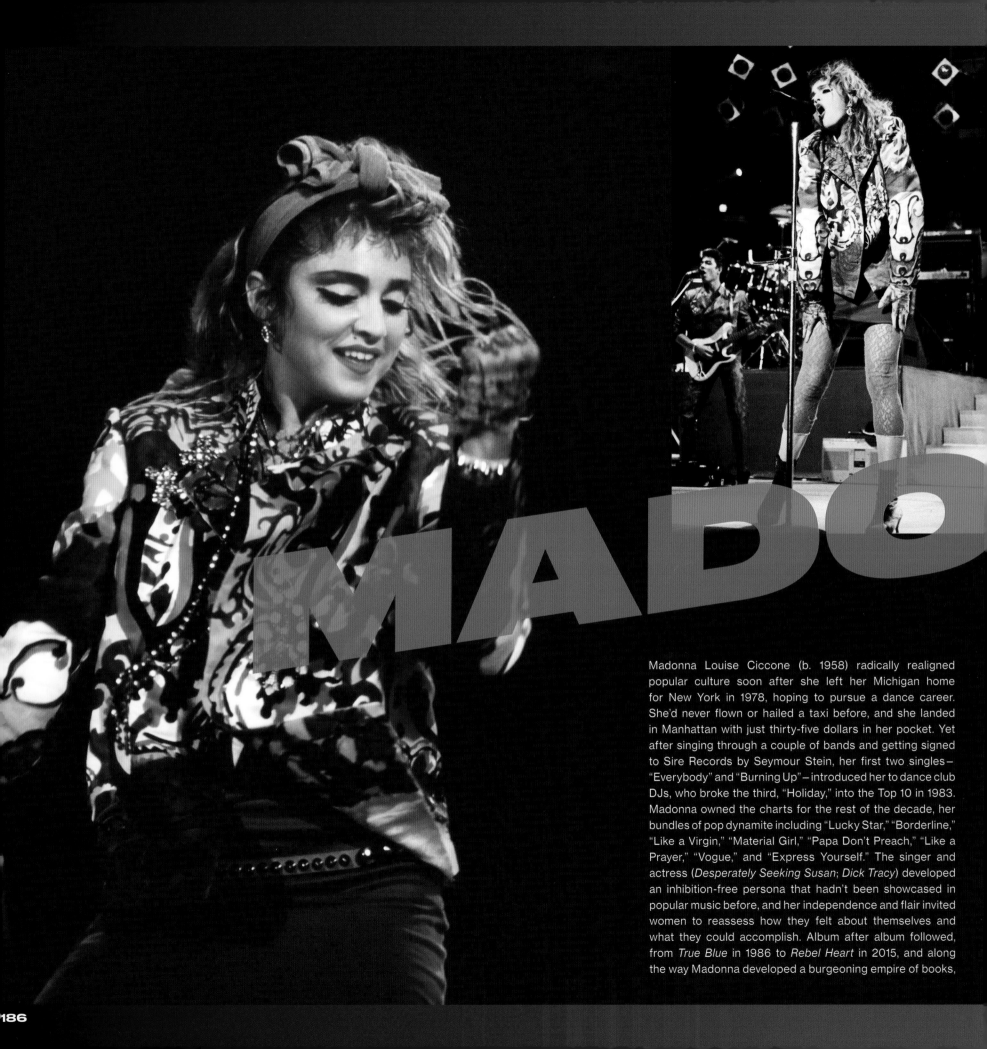

MADO

Madonna Louise Ciccone (b. 1958) radically realigned popular culture soon after she left her Michigan home for New York in 1978, hoping to pursue a dance career. She'd never flown or hailed a taxi before, and she landed in Manhattan with just thirty-five dollars in her pocket. Yet after singing through a couple of bands and getting signed to Sire Records by Seymour Stein, her first two singles—"Everybody" and "Burning Up"—introduced her to dance club DJs, who broke the third, "Holiday," into the Top 10 in 1983. Madonna owned the charts for the rest of the decade, her bundles of pop dynamite including "Lucky Star," "Borderline," "Like a Virgin," "Material Girl," "Papa Don't Preach," "Like a Prayer," "Vogue," and "Express Yourself." The singer and actress (Desperately Seeking Susan; Dick Tracy) developed an inhibition-free persona that hadn't been showcased in popular music before, and her independence and flair invited women to reassess how they felt about themselves and what they could accomplish. Album after album followed, from True Blue in 1986 to Rebel Heart in 2015, and along the way Madonna developed a burgeoning empire of books,

movies, and fashion through her entertainment company Maverick, which has made her one the country's highest-grossing performers. Her infectiously danceable pop hits remain as influential as her style (ranging from street urchin to soigné), proving that her sound instincts haven't failed her. She knows what people want and how to give it to them. If no one else has crowned her the Queen of Pop, let's do so now.

Opposite left: Madonna at the U.I.C. Pavilion, Chicago, May 1985
📷 **LINDA MATLOW / PIXINTL**

Opposite right: Madonna at Madison Square Garden, New York City, June 1985
📷 © **BOB GRUEN**

Above: Madonna at Madison Square Garden, July 13, 1987
📷 © **EBET ROBERTS**

Right: Madonna at the Oakland Coliseum, CA, May 18, 1990
📷 © **JAY BLAKESBERG**

BEATS BRAVADO & BEAUTY
ROCK AND ROLL TO THE RESCUE

Audience at Rockstar Energy Drink
Mayhem Festival, Isleta Amphitheater,
Albuquerque, July 12, 2014
JUSTIN BAUER

CHAPTER 7

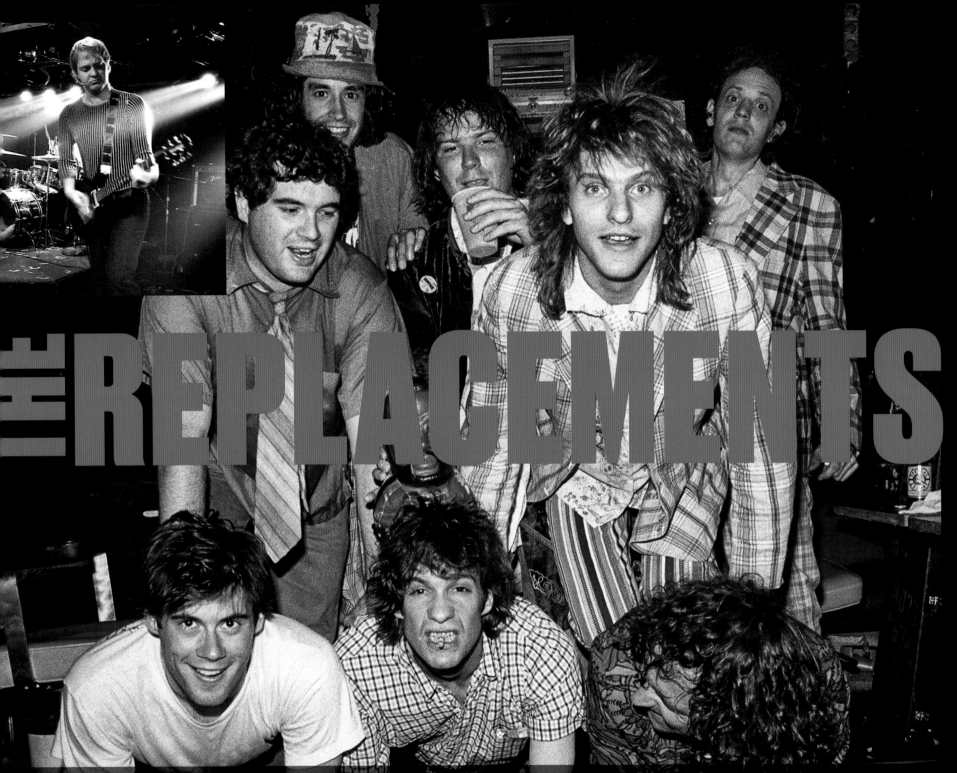

THE REPLACEMENTS

formers who considered themselves permanent delin-
ents, and who chose their self-deprecating moniker
cause they filled in for other bands, the Replacements
erve the tag "Last Best Band of the '80s," bestowed on
m by *Musician* magazine. Yet Paul Westerberg (b. 1959),
thers Bob (1959–95) and Tommy Stinson (b. 1966), and
is Mars (b. 1961) turned zero promise into unassailable
ievement. One day in 1978, Bob bought eleven-year-old
mmy a bass guitar to keep him out of trouble, and the
neapolis brothers started Dogbreath with drummer Mars.
sterberg heard the trio rehearsing one day when he was
break from his janitorial duties in a U.S. senator's office,
d soon found himself a member of the band, temporarily
amed the Impediments. He began to write songs mashing

up romance, heartbreak, and satire in a manner no one had
heard before. In 1980, Twin/Tone Records cofounder Peter
Jesperson heard the Replacements' demo and offered them
a contract, an arrangement that peaked in 1984 on *Let It Be*.
Major labels came a-courtin', and Sire Records—home of the
Ramones, Talking Heads, and Madonna—won. The group
reached deep for the 1985 masterpiece *Tim*, produced by
Tommy (Ramone) Erdelyi, which became Bob Stinson's last
Replacements album when he got booted for questionable
behavior. Mainstream success beckoned after the release
of the 1989 single "I'll Be You," but the group's deep-seated
"burn all the bridges" mentality began to manifest itself.
Westerberg soon wanted out, and the band's last album,
1990's *All Shook Down*, was actually his solo debut disguised

as a Replacements effort. Reunions twenty-five years after
the band's demise didn't change his mind. The Bastards of
Young are no more.

Top left: Bob Stinson at the Rathskeller, Boston, early 1980s
📷 © **WAYNE VIENS**

Above: The Replacements and the Young Fresh Fellows at First
Avenue, Minneapolis, MN, May 1987; bottom row: Tad Huchinson
(YFF), Paul Westerberg, Scott McCaughey (YFF); middle row:
Chuck Carroll (YFF), Tommy Stinson; back row: Chris Mars,
Jim Sangster (YFF), Slim Dunlap
📷 **MARTY PEREZ**

RED HOT CHILI PEPPERS

If the mission involves both funk and rock, alert the Red Hot Chili Peppers. The band was born in the City of Angels in 1983, and its grooves galore both demonstrate what makes people move and provide the muscle to drag them onto their feet. Singer Anthony Kiedis (b. 1962), bassist Flea (b. Michael Balzary, 1962), guitarist Hillel Slovak (1962–88), and drummer Jack Irons (b. 1962) were the Peppers 1.0, and they could turn a refrigerated warehouse into a sweatbox. Adventurous albums started to seep out in 1984. Slovak died of a heroin overdose and Irons flew the coop, but new drummer Chad Smith (b. 1961) and guitarist John Frusciante (b. 1970) made the Chili Peppers' chemistry atomic. The latter's unfettered shredding fit perfectly with Flea's and Smith's one-head assault on the bottom and Kiedis's far and wide swinging on the mic. Rick Rubin helmed 1991's *Blood Sugar Sex Magik*, whose singles "Give It Away" and "Under the Bridge" catapulted the boys into the upper echelons of alternative music. Life got crispy for Frusciante, who was replaced by Jane's Addiction guitarist Dave Navarro (b. 1967) in 1994. Yet the juju wasn't there, so Frusciante returned in

time for 1999's *Californication*, the peak foursome's biggest album to date. *By the Way*, three years later, topped that, and they encored with the double-disc *Stadium Arcadium*, but then Frusciante left again. For 2016's *The Getaway*, the core trio and Frusciante acolyte Josh Klinghoffer (b. 1979) called on producer Danger House to mix up the deck. Turns out the musicians whose sound has been called everything from funk metal and rap rock to nü metal are still bent on chasing the groove.

Left: Michael (Flea) Balzary, Dave Navarro, and Anthony Kiedis at Woodstock '94, Saugerties, NY, August 14, 1994
📷 © EBET ROBERTS

Top left, top to bottom: Jack Sherman, Flea, Kiedis, and Cliff Martinez in an alley behind their rehearsal space, Hollywood, CA, ca. 1984
📷 IVY NEY

Top right: Jack Irons (drums), Flea (bass), Hillel Slovak (guitar), and Kiedis (vocals) in Los Angeles, ca. 1982
📷 © ANN SUMMA

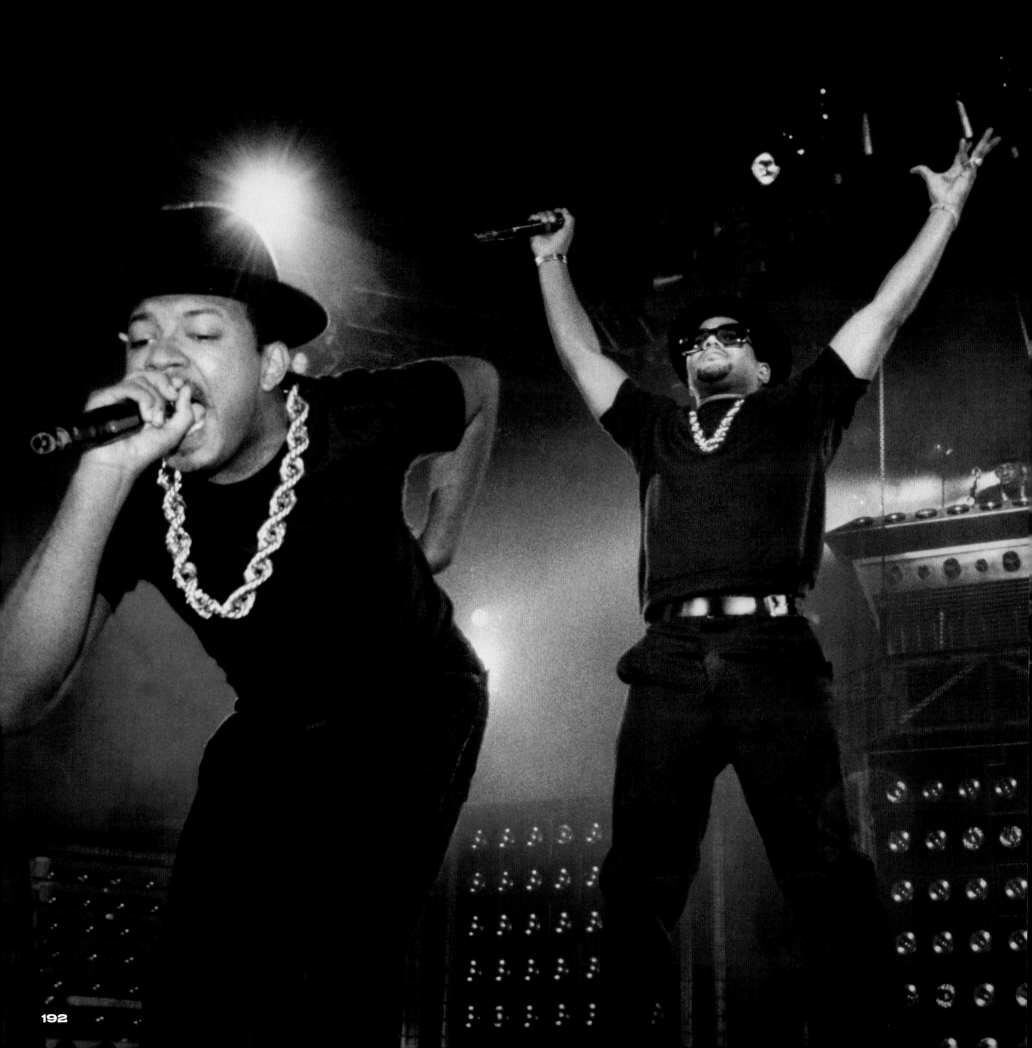

When studying groundbreaking acts, it's essential to check out their stats. Among Run-D.M.C.'s highlights: they were the first hip-hop act to have a gold, platinum, and multiplatinum album; the first hip-hop act to receive a Grammy; the first hip-hop act to appear on *American Bandstand*, the cover of *Rolling Stone*, and MTV; the first hip-hop act to perform in an arena; and the only hip-hop act to perform at Live Aid in 1985. Joseph "Run" Simmons (b. 1964), Darryl "D.M.C." McDaniels (b. 1964), and Jason "Jam-Master Jay" Mizell (1965–2002) came early to the hip-hop party, forming up in 1981 in Queens when Simmons's music-promoter brother Russell encouraged the three to pool their talents. From their first single, 1983's "It's Like That/Sucker MCs," the band proved instrumental in combining the roles of the MC and the DJ in a single group. They also infused old-school hip-hop with gritty street aesthetics and a hard-rock sound on *King of Rock* (1985) and *Raising Hell* (1986), which featured a game-changing collaboration, "Walk This Way," with rock band Aerosmith, which introduced new audiences to hip-hop's rapidly evolving sounds. It was Run-D.M.C.'s moment, and they became the forerunners of a fresh hip-hop style that still dominates today. Breaking up after Jam-Master Jay's death, they remain the three men from Queens who remade hip-hop and brought it to the top of the modern musical galaxy.

RUN DMC

Opposite: Joseph "Run" Simmons, Darryl "D.M.C." McDaniels, and Jason "Jam-Master Jay" Mizell (in back). *Below:* Darryl "D.M.C." McDaniels, Jason "Jam-Master Jay" Mizell, and Joseph "Run" Simmons. Both at the U.I.C. Pavilion, Chicago, June 1984
📷 both **RAYMOND BOYD**

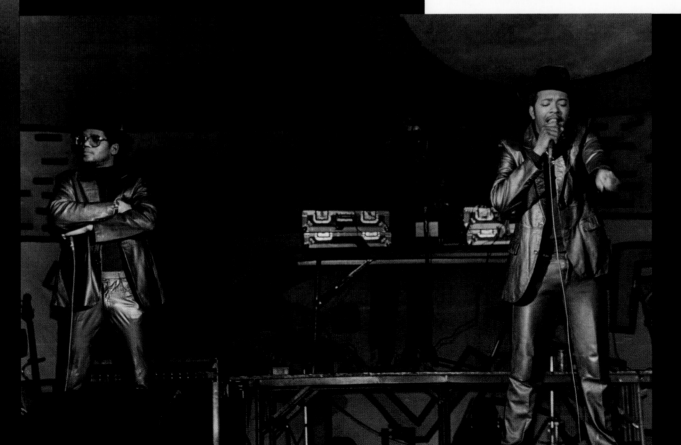

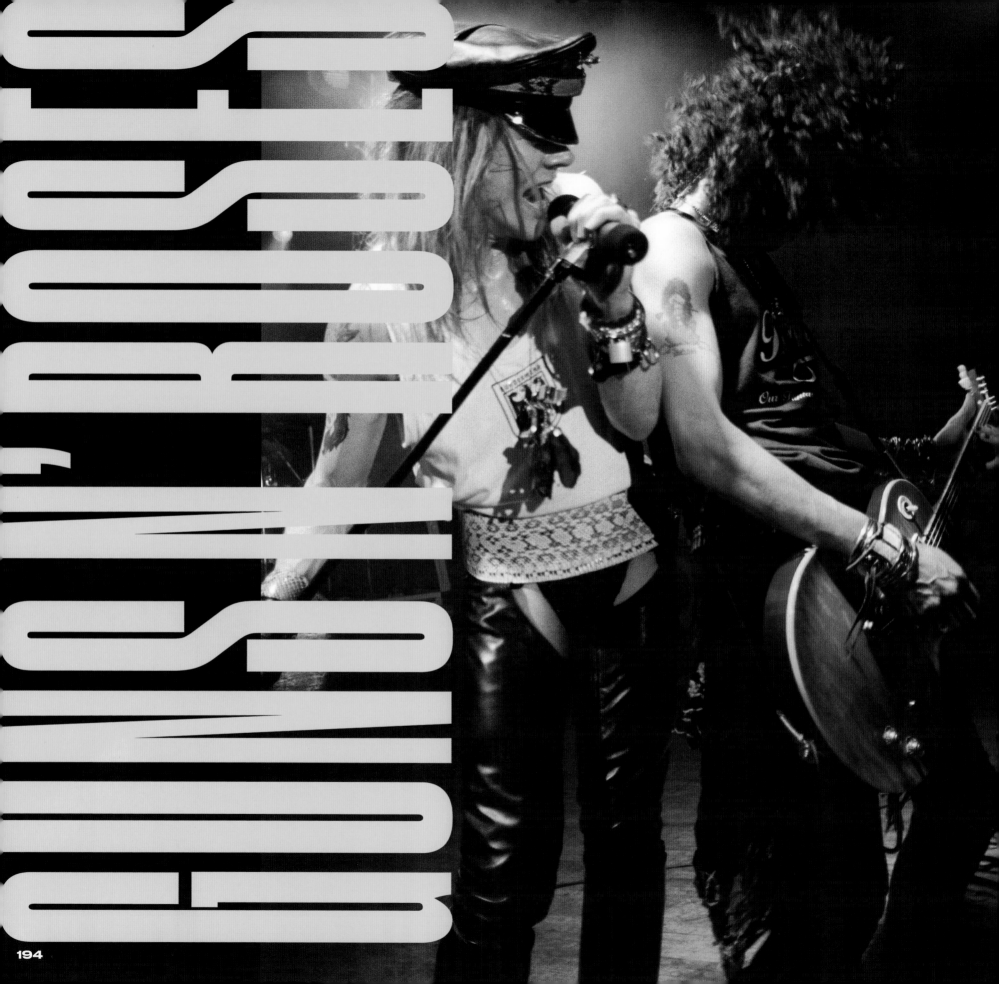

GUNS N' ROSES

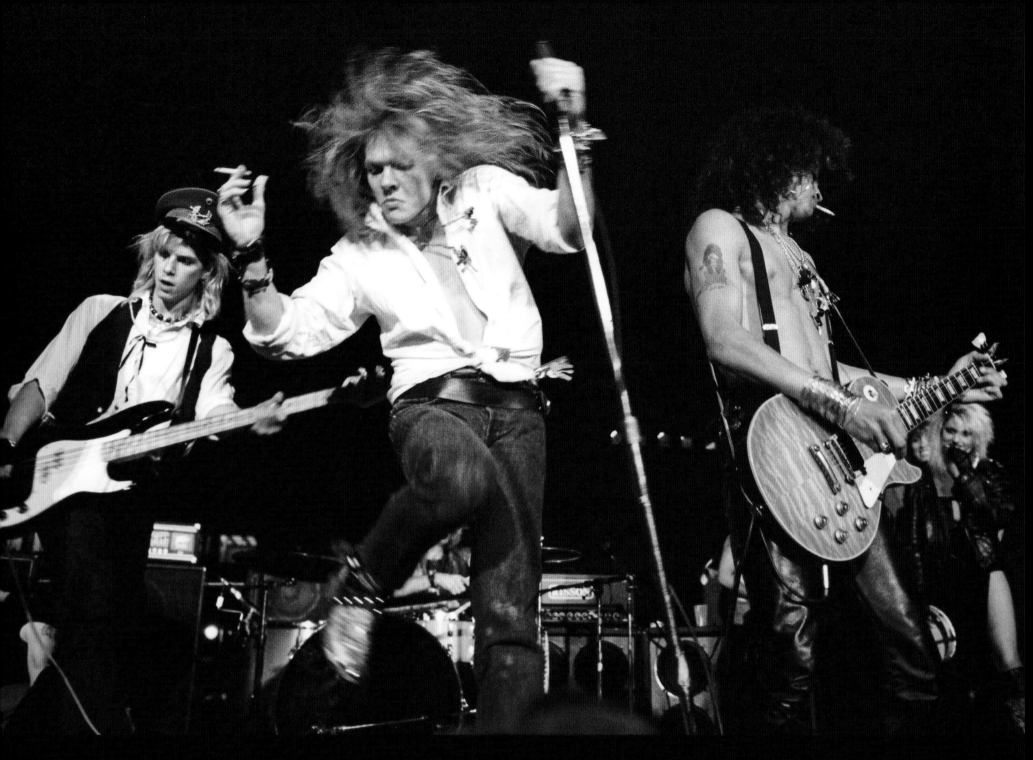

Every era experiences its excesses. Guns N' Roses calling its full-length 1987 debut *Appetite for Destruction* solidified the truth of that dictum. Singer Axl Rose (b. William Rose Jr., 1962), lead guitarist Slash (b. Saul Hudson, 1965), rhythm guitarist Izzy Stradlin (b. Jeffrey Isbell, 1962), bassist Michael "Duff" McKagan (b. 1964), and drummer Steven Adler (b. Michael Coletti, 1965) had already terrorized clubs on the Sunset Strip with glam-ripped hard rock for a couple of years, turning Geffen Records execs into fervent believers and backers of the band's every move. Even so, no one predicted the commercial and critical reception of *Appetite*. Force-of-nature "Sweet Child o' Mine" moved the Gunners past

ordinary success and into a league all their own, becoming the quintet's only No. 1 single (although not for lack of trying). The album reached the same spot by racking up gold-rush-level sales and becoming the best-selling debut of all time. In 1991, the band doubled down by pushing out two albums at once, *Use Your Illusion I* and *II*, which debuted in the top two chart slots. Guns N' Roses seemed to have the Midas touch, but *"The Spaghetti Incident?"* in 1993, which covered T. Rex and a range of punk classics, marked the beginning of the end for the group. Or at least for the band as everyone but Rose saw it. One by one, its original members fell away, but Rose, the last man standing, spent the next fifteen years in

a creative bunker to work on 2008's *Chinese Democracy*. As the Guns N' Roses rulebook maintains: Do what you want, when you want.

Opposite: Axl Rose and Slash at the Roxy, West Hollywood, CA, March 28, 1986
📷 **JACK LUE**

Above: Duff McKagan, Rose, and Slash at the Los Angeles Street Scene festival, September 28, 1985
📷 **MARC CANTER**

BEASTIE BOYS

A hard-core punk band lurks behind one of the most seminal hip-hop groups of the past forty years. Calling themselves the Young Aborigines when they emerged in New York in 1978, they played as loud and as fast as they could, and when their experimental 12-inch "Cooky Puss" found a following, the band switched to hip-hop full-time. The Beastie Boys lineup solidified into Michael "Mike D" Diamond (b. 1965) on vocals/drums, Adam "MCA" Yauch (1964–2012) on vocals/bass, and Adam "Ad-Rock" Horovitz (b. 1966) on vocals/guitar, with original drummer Kate Schellenbach (b. 1966) dropping out. The trio dug deep into the fledgling hip-hop of the 1980s by recording beats and vox and adding guitars and bass for a distinctive take on the new sound. For one show, they needed a DJ and found producer-to-be Rick Rubin, a student at New York University. Their full-length debut, *Licensed to Ill* (1986), found them their niche, with *Rolling Stone's* favorable review appearing under the headline "Three Idiots Create a Masterpiece." Rubin formed Def Jam Records with fellow producer Russell Simmons, and a scene was born. *Licensed to Ill* became the best-selling hip-hop album of the 1980s, and the Beasties took liberties with their sound to record pivotal platters *Paul's Boutique* (1989) and *Check Your Head* (1992), which spread their hip-hop, right alongside Grandmaster Flash and the Furious Five and Run-D.M.C., to the masses. Their freewheeling and often funny raps opened the genre to millions of new fans. MCA died of cancer in 2012, and Mike D and Ad-Rock retired the Beastie Boys name in 2014 out of respect for him. Hip-hop nation will never forget them.

Left: Michael Diamond, Adam Yauch, and Adam Horovitz.
Right: Horovitz. Both at the Centrum, Worcester, MA, April 9, 1987
📷 both © **EBET ROBERTS**

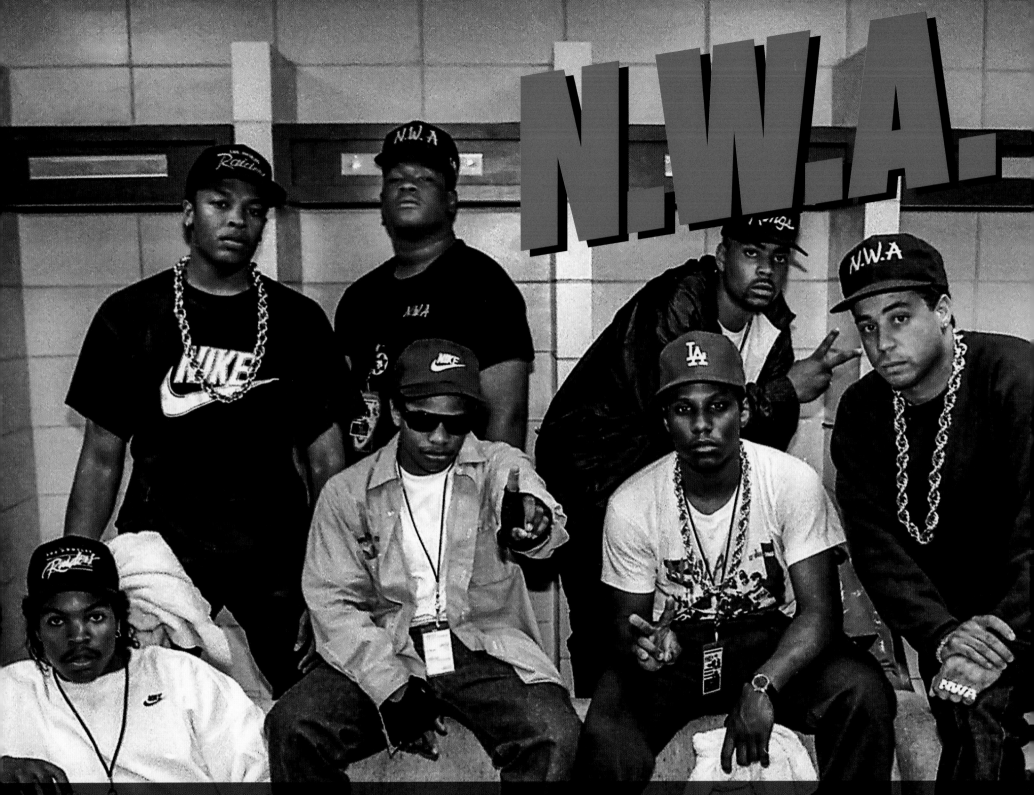

N.W.A.

Some music must be made. The times call for it, the people call for it, history calls for it, because music can document life in ways that other arts cannot. N.W.A., the earliest gangsta rap group, coalesced in Compton, California, in 1986. The city, in Los Angeles County, was then ravaged by poverty, drugs, and violence, and the young locals in N.W.A. rapped explicitly about their everyday life-and-death negotiations. That shocked a lot of people, but it compelled them, too. Eazy-E (b. Eric Wright, 1963–95), Dr. Dre (b. Andre Young, 1965), Ice Cube (b. O'Shea Jackson, 1969), and Arabian Prince (b. Kim Nazel, 1965) were in the original group, joined by DJ Yella (b. Antoine Carraby, 1964) and

MC Ren (b. Lorenzo Patterson, 1969). Their debut, *Straight Outta Compton* (1988), focused attention on West Coast rap, which soon became an equal player to the East Coast scene. Anger-hemorrhaging songs such as "F— tha Police," "Dopeman," and "Gangsta Gangsta" exposed real life for all to experience. The album sold 10 million copies (and spun off a $200 million box-office bonanza in the gritty, Academy Award–nominated 2015 film of the same title). Government agencies and law enforcement departments got their hackles up, but there was no stemming the upheaval. The N.W.A. members became instant celebrities and were pulled into disputes with other rap acts over territory and insults.

Sophomore LP *Niggaz4Life* (1991) became the first hardcore rap album to reach No. 1, but it would be the group's last outing: they split up amid intraband rivalries. Yet their funk-infused, beat-heavy music, controversial lyrics, and no-holds-barred lives continue to influence and shape hip-hop and its artists generations afterward.

Clockwise from top left: Dr. Dre, Laylaw (of Above the Law), the D.O.C., DJ Yella, MC Ren, Eazy-E, and Ice Cube before a show on the Straight Outta Compton tour at Kemper Arena, Kansas City, MO, June 1989
📷 **RAYMOND BOYD**

As time marches on, everything will be part of post-this or post-that someday. Fugazi began in Washington, D.C., in 1987 and soon was labeled "post-hardcore." Yet genres hardly mattered to the DIY band, which fostered an entirely independent outlook on its output. The music industry, in Fugazi's view, employed insidious business practices, and the band wanted no part of that game. After all, Fugazi took its name from Mark Baker's book *Nam*, in which the terms stands for "F— Up, Got Ambushed, Zipped In" (to a body bag). In their early days, guitarist-singer Ian MacKaye (b. 1962), bassist Joe Lally (b. 1963), drummer Brendan Canty (b. 1966), and soon guitarist-singer Guy Picciotto (b. 1965) ramrodded what the front man described as "the Stooges with reggae." Other early goals included a $5 admission limit, which morphed into a pay-what-you-can fee for downloads of live shows. Such gestures inspired instant devotion from fans already enthralled with Fugazi's music, cementing a bond between audience and band that remains a gold standard in rock. The band's touring schedule was voluminous, and as the 1990s started, it performed nonstop across the country and abroad. Live, Fugazi amalgamated punk's velocity and spirit with funk and reggae rhythms into an assaultive spike, and MacKaye's and Picciotto's vocals differed in delivery and manner, which gave the band two distinct dimensions. No other group did it like this, and even with the extended band hiatus that began in 2003, nothing is written regarding whether its members will join forces again. Whatever happens, it will be Fugazi's way or no way at all.

Below: Brendan Canty (drums), Joe Lally, Guy Picciotto, and Ian MacKaye at the Duncan Arena, Winnipeg, Manitoba, August 14, 1991
📷 **DOUG HUMISKI**

Bottom left: Picciotto at the Melody Ballroom, Portland, OR, May 5, 1993
📷 © **JAMES REXROAD**

Bottom right: Picciotto at the Capitol Theater, Olympia, WA, August 25, 1991
📷 **CHARLES PETERSON**

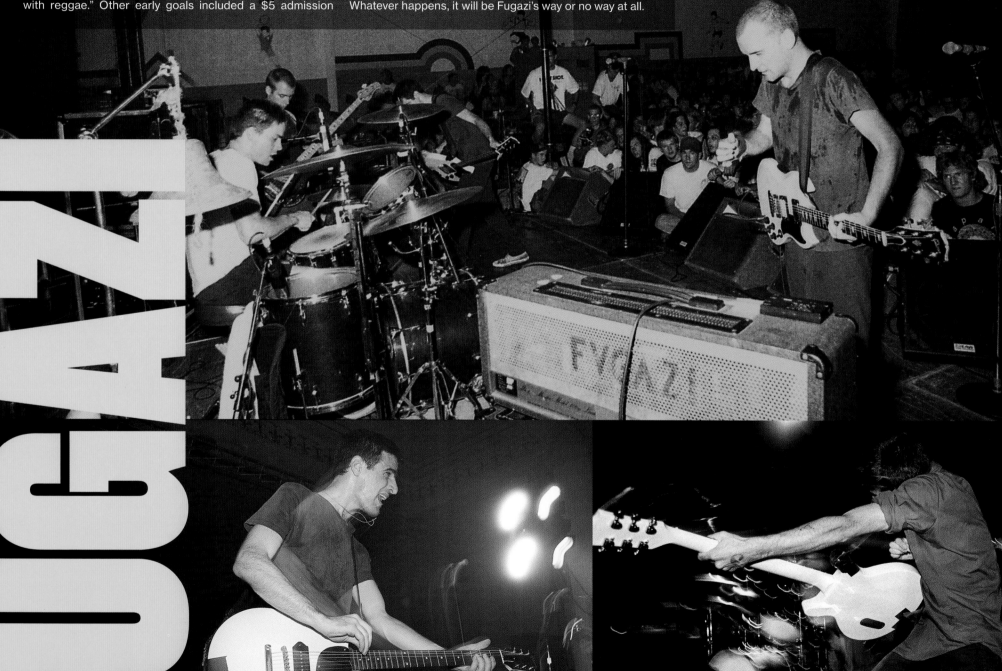

FUGAZI

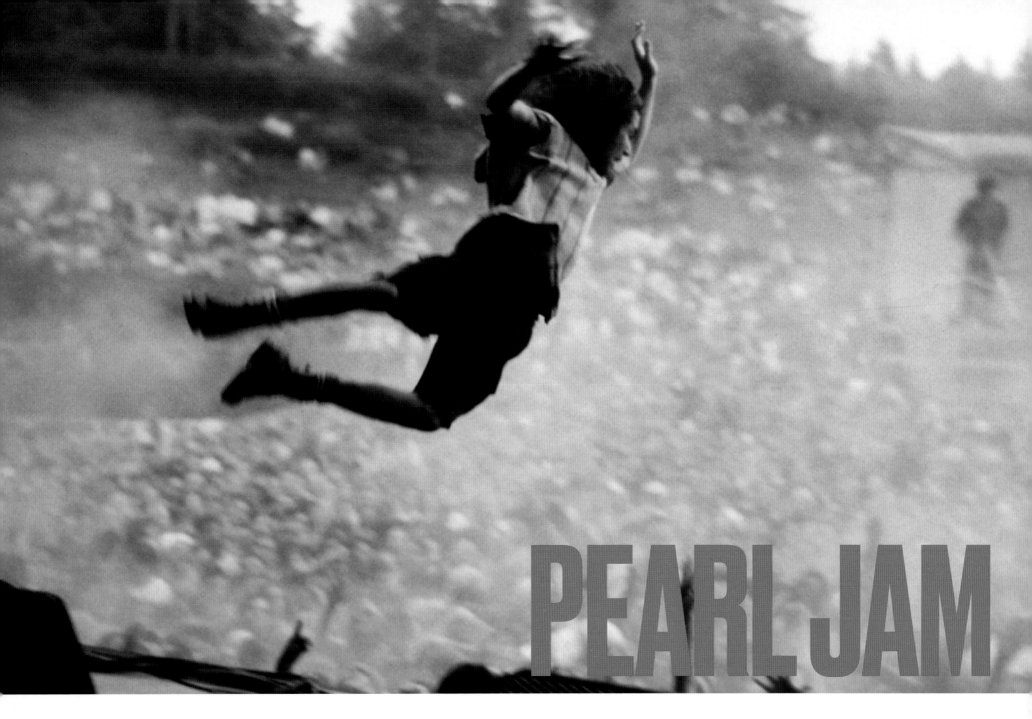

PEARL JAM

Seattle was silly with bands in the mid-1980s. Groups sprang up everywhere, a phenomenon that one musician attributed to rain: People didn't want to go outdoors, so they played instruments in their dens and garages. An outgrowth of the period was the band Green River, a pre-supergroup of sorts, which coupled future Pearl Jam core Stone Gossard (b. 1966) and Jeff Ament (b. 1963) with Mudhoney members-to-be Mark Arm and Steve Turner, plus drummer Alex Vincent. When Green River ran dry, Gossard and Ament put together Mother Love Bone, whose singer, Andrew Wood, died before the debut album came out; the pair then joined up with Mike McCready (b. 1966) and Eddie Vedder (b. 1964) in 1990, and Pearl Jam was born. Percussion rotating, the main four redefined American rock, beginning with their debut, *Ten*, in 1991. During a decade when both "grunge" and "alternative music" tags were fastened onto so many bands, Pearl Jam's terse, emotive charge harked back to classic rock bands such as the Doors and the Who. Matt Cameron (b. 1962) locked down the drum slot in 1998. When the band members took on Ticketmaster, and the music business as a whole on a variety of fronts, they always came out on the other side together and with their ideals intact. Albums delved into ecological and political areas hand in hand with the music. Vedder, who was working at a gas station when he sent the band an audition tape, never forgot his humble beginnings and grew naturally into the role of spokesman for change. All of Pearl Jam's members enjoy outside projects, but the mothership abides. In 2011, Rock the Earth named them Planet Defenders. Seattle lives on.

Eddie Vedder stage diving at Thunderbird Stadium, University of British Columbia, Vancouver, July 21, 1992
LANCE MERCER

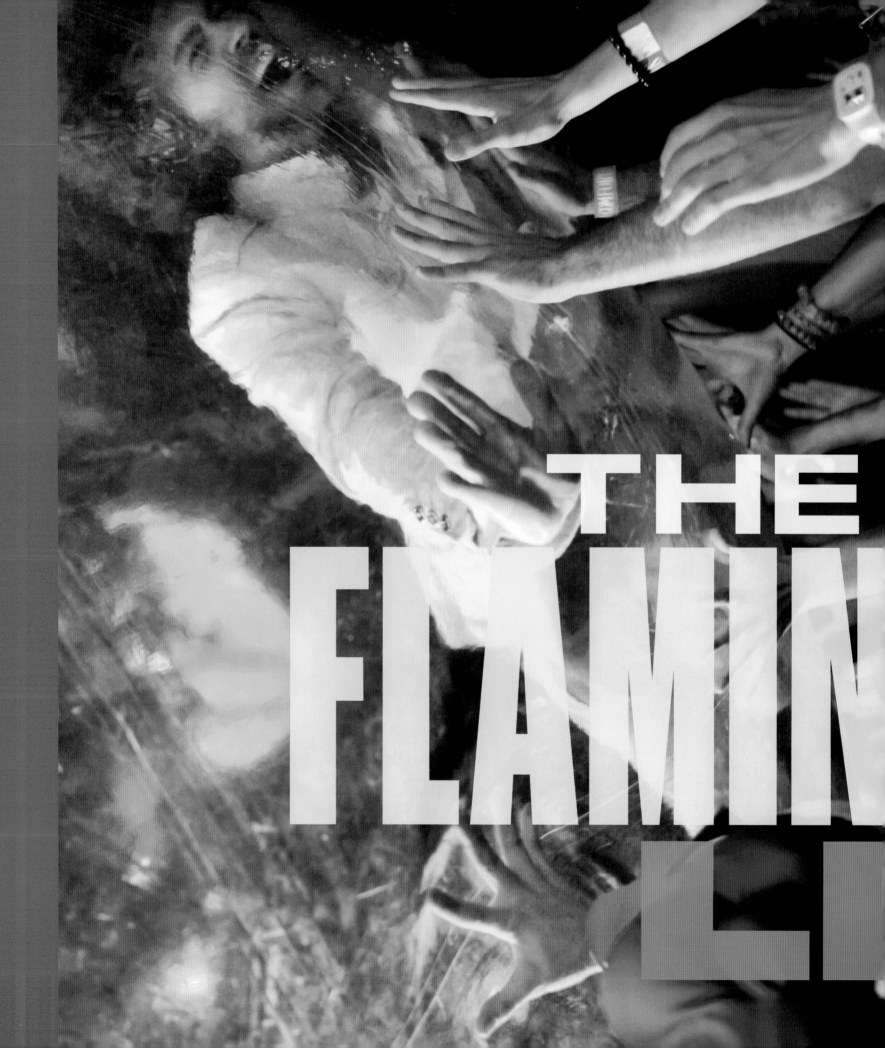

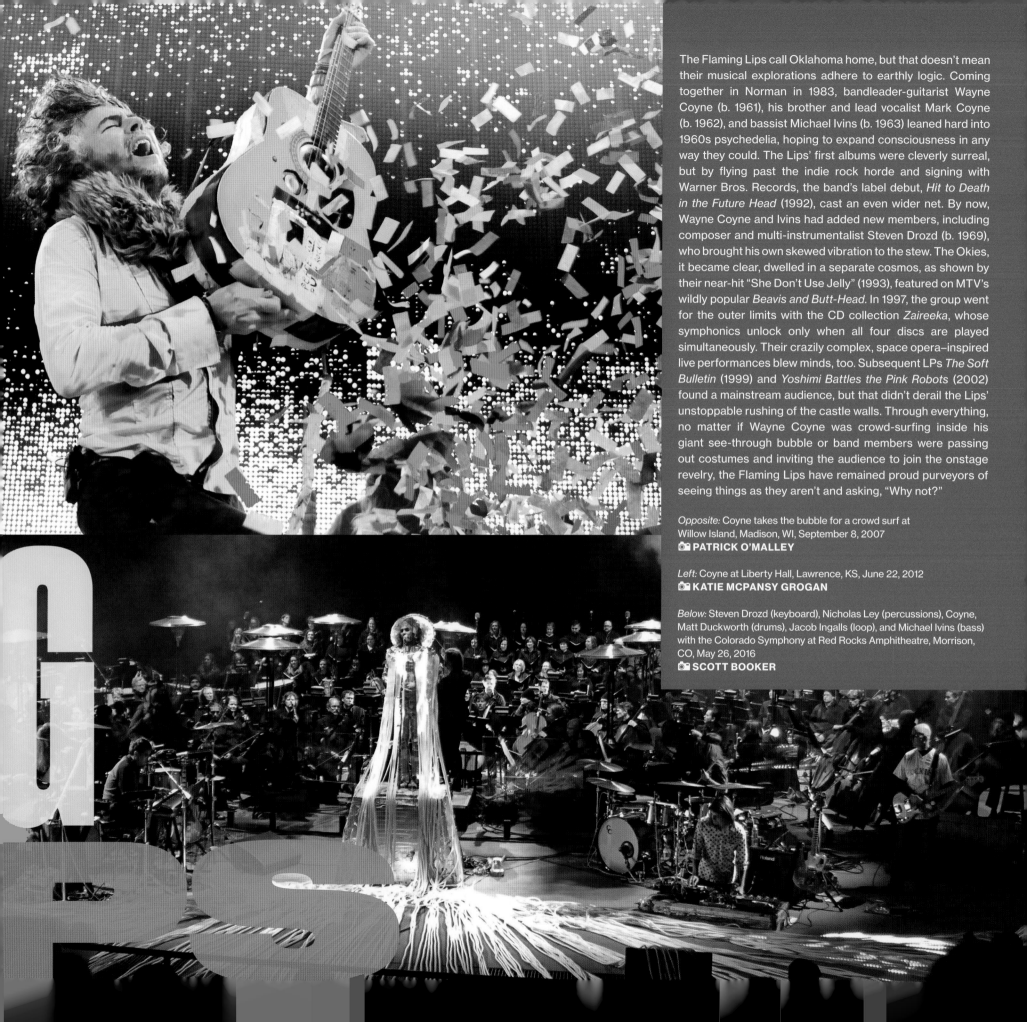

The Flaming Lips call Oklahoma home, but that doesn't mean their musical explorations adhere to earthly logic. Coming together in Norman in 1983, bandleader-guitarist Wayne Coyne (b. 1961), his brother and lead vocalist Mark Coyne (b. 1962), and bassist Michael Ivins (b. 1963) leaned hard into 1960s psychedelia, hoping to expand consciousness in any way they could. The Lips' first albums were cleverly surreal, but by flying past the indie rock horde and signing with Warner Bros. Records, the band's label debut, *Hit to Death in the Future Head* (1992), cast an even wider net. By now, Wayne Coyne and Ivins had added new members, including composer and multi-instrumentalist Steven Drozd (b. 1969), who brought his own skewed vibration to the stew. The Okies, it became clear, dwelled in a separate cosmos, as shown by their near-hit "She Don't Use Jelly" (1993), featured on MTV's wildly popular *Beavis and Butt-Head*. In 1997, the group went for the outer limits with the CD collection *Zaireeka*, whose symphonics unlock only when all four discs are played simultaneously. Their crazily complex, space opera–inspired live performances blew minds, too. Subsequent LPs *The Soft Bulletin* (1999) and *Yoshimi Battles the Pink Robots* (2002) found a mainstream audience, but that didn't derail the Lips' unstoppable rushing of the castle walls. Through everything, no matter if Wayne Coyne was crowd-surfing inside his giant see-through bubble or band members were passing out costumes and inviting the audience to join the onstage revelry, the Flaming Lips have remained proud purveyors of seeing things as they aren't and asking, "Why not?"

Opposite: Coyne takes the bubble for a crowd surf at Willow Island, Madison, WI, September 8, 2007
📷 **PATRICK O'MALLEY**

Left: Coyne at Liberty Hall, Lawrence, KS, June 22, 2012
📷 **KATIE MCPANSY GROGAN**

Below: Steven Drozd (keyboard), Nicholas Ley (percussions), Coyne, Matt Duckworth (drums), Jacob Ingalls (loop), and Michael Ivins (bass) with the Colorado Symphony at Red Rocks Amphitheatre, Morrison, CO, May 26, 2016
📷 **SCOTT BOOKER**

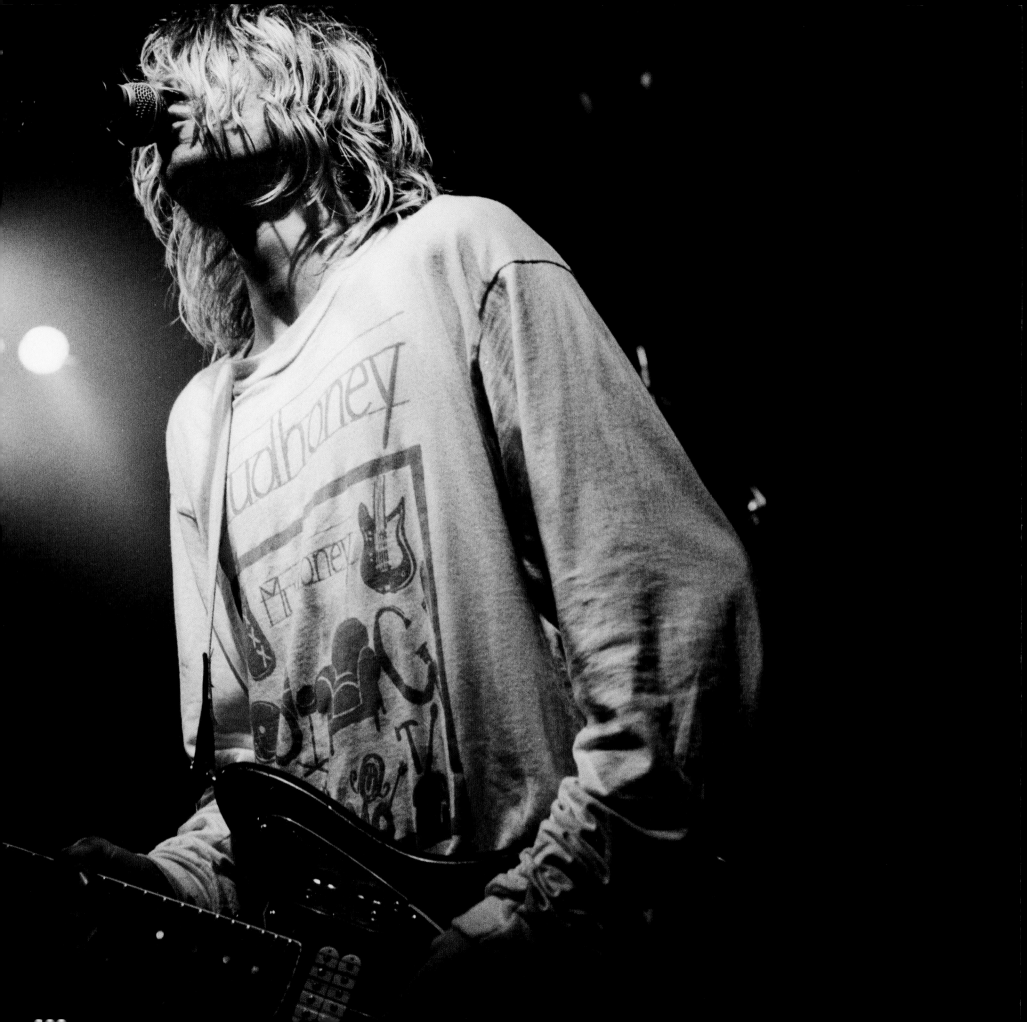

NIRVANA

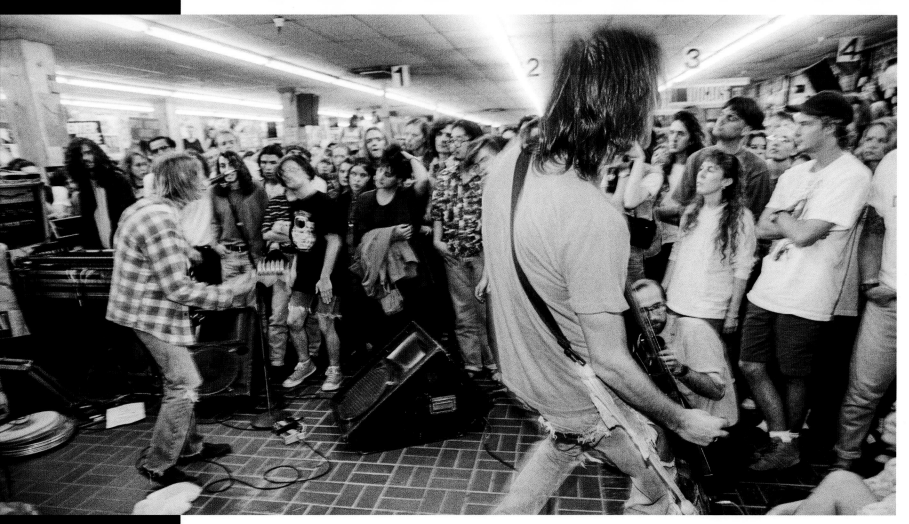

Comets flash across the sky and disappear. So, too, did Kurt Cobain (1967–94). After a childhood marked by domestic turmoil, during which he'd made curious artworks in a search for inner peace, Cobain and bassist Krist Novoselic (b. 1965) started Nirvana, named for the Buddhist paradise, in 1987 in Aberdeen, Washington. Predominant local label Sub Pop Records released Nirvana's debut LP, *Bleach*, in 1989, just as the Seattle scene was building. Most everyone spotted the band's ferocious talent for raging rock, which belied a central vulnerability in the songs. Adding D.C. hardcore-punk drummer Dave Grohl (b. 1969) before the band's second album, 1991's *Nevermind,* the trio tapped a universal vein with their first single, "Smells Like Teen Spirit." The accompanying video documents Cobain's desperation as he plays to a fictional high-school audience. Together they spoke to Gen X, which wasn't seeing many alternatives to workaday life in America, then roiled by the first U.S. war

rolling across Iraq. Nirvana put the generation's confusion and animosity into song, and its music spread like fire on gasoline. The third release, *In Utero* (1993), continued the band's signature mixture of pop and hard-rock styles, but Cobain struggled with superstardom. After his suicide in 1994, the band broke apart and its other members went on to other fruitful projects — Grohl to the Foo Fighters, Novoselic to politics — but Nirvana had forever placed "alternative" rock firmly in the mainstream.

Opposite: Kurt Cobain on the Nevermind tour at Nachtwerk, Munich, November 13, 1991
📷 **RAB G. P. LEWIN**

Above: Cobain and Krist Novoselic at Beehive Records, Seattle, September 16, 1991
📷 **CHARLES PETERSON**

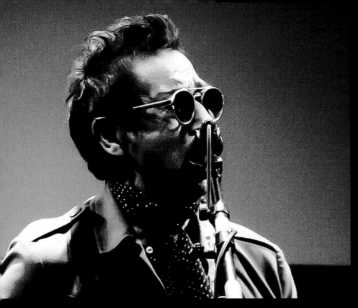

Alejandro Escovedo (b. 1951), a middle child in a musician-rich family, has blazed an adventurer's road since his birth in San Antonio. By the end of the 1970s, he'd moved to San Francisco, where his older brothers Coke and Pete Escovedo had played in Santana. Alejandro jumped into California punk via the Nuns, and the band toyed with the idea of making a movie about a band that can barely play its instruments. Instead the Nuns opened for the Sex Pistols' last performance. When the group stalled, Escovedo set out for Austin to join the nascent cowpunk band Rank and File. Endlessly energetic, the Texan left after one album and formed the True Believers with his younger brother Javier Escovedo and Jon Dee Graham. The band's hard-roots punk and ardent songs grabbed national notice, but it, too, ended suddenly, and Escovedo finally went solo in the early 1990s. By the end of the decade, *No Depression* magazine had called him Artist of the Decade. In the new millennium, Escovedo suffered from recurring health issues, but they didn't slow his recording, or the peer accolades celebrating it, which have included *Por Vida* (2003), a tribute album of his songs recorded by admiring musicians. His songs have matured into piercing depth. A trio of albums – including *Real Animal* (2008) and *Street Songs of Love* (2010) – produced by David Bowie muse Tony Visconti has taken him to new heights, and R.E.M.'s Peter Buck and the Minus 5's Scott McCaughey produced 2016's *Burn Something Beautiful*, a dynamic comeback. Escovedo's story of survival is one for the ages.

Above: Alejandro Escovedo at the Kessler Theatre, Dallas, July 30, 2016
📷 **NANCY RANKIN ESCOVEDO**

Right: Escovedo with the Nuns at Mabuhay Gardens, San Francisco, 1978
📷 © **CHESTER SIMPSON**

ALEJANDRO ESCOVEDO

BECK

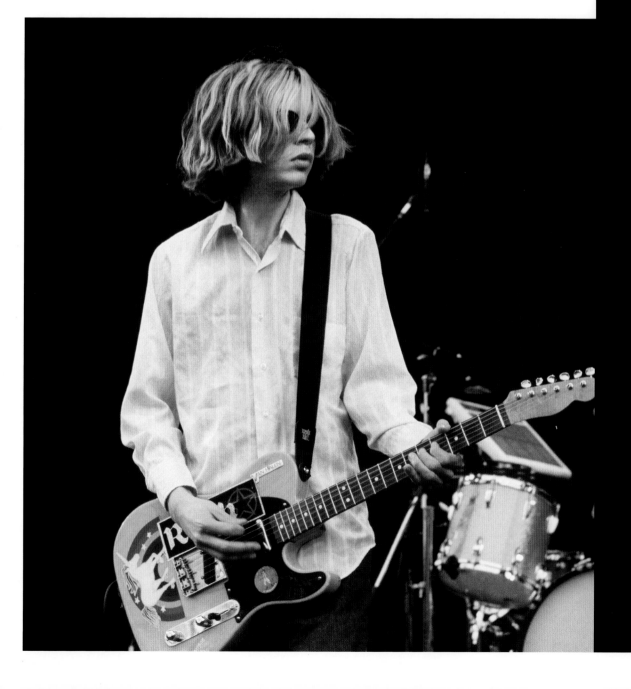

Originality comes in all flavors, including Beck Hansen (b. Bek Campbell, 1970). His musical DNA was set from the beginning, courtesy of his Canadian father, the celebrated composer and popular music arranger David Campbell, and his mother, the Norwegian-Swedish Warhol superstar Bibbe Hansen. The family lived in parts of Los Angeles that felt like foreign cities to the young Beck, whose early guitar playing reflected the influences of country blues and American folk music. He left school after junior high to dig deep into every sound he could find, so his parents sent him to live with his paternal grandparents in Kansas, where his grandfather was a Presbyterian preacher and taught the teenager the dynamics of moving an audience. Back in Los Angeles, Beck busked on the street while developing unique capabilities on guitar and boom box. A sideline excursion to New York led him to the anti-folk movement, and by the time he returned to the West Coast, the musician was fully formed. His hip-hop/alt-rock single "Loser" (1993), created while he lived in an alleyway shack, swept the city and led to Indie Nation's quickly growing enchantment with the young man, his guitar, and his sliced-and-diced tapes full of youthful promise. *Mellow Gold* (1994) made Beck a 1990s golden boy, and the follow-up, *Odelay*, in 1996 ("Devil's Haircut," "Where It's At") turned his pop-hop into a phenomenon. His ascension from street serenades to winning the Album of the Year Grammy in 2014 for *Morning Phase* didn't visibly alter the musician, who seems as though he could do it all over again from the corner of Hollywood and Vine with just two turntables and a microphone.

Above: Beck at the *LA Weekly* Detour Fest, downtown Los Angeles, October 7, 2006
📷 **NGA LUU**

Left: Beck at the Shoreline Amphitheatre, Mountain View, CA, June 10, 1994
📷 © **JAY BLAKESBERG**

GREEN DAY

Who would have guessed, when a bunch of fourteen-year-olds calling themselves Sweet Children played their first shows in the mid-1980s, that they'd develop into punk's greatest commercial band? Growing up in temperate Northern California, singer-guitarist Billie Joe Armstrong (b. 1972) and bassist Mike Dirnt (b. Michael Pritchard, 1972)—later joined by drummer Tré Cool (b. Frank Wright III, 1972)—sometimes thought life was a blur of boredom. But once they found their way to 924 Gilman Street in Berkeley, an all-ages performance space and collective of like-minded souls, their raison d'être revealed itself, and Armstrong's crunching guitar and lyric broadsides began to aim at holes in the American dream. Green Day's second album, *Kerplunk* (1991), came out on local indie Lookout! Records as a shot across the bow of musical complacency. It caught the attention of major labels, and when Reprise Records A&R man Rob Cavallo showed up at the studio with a guitar, the boys found a new HQ. *Dookie* (1994) blew the game open for the band, with sales topping 10 million. The band's buzz-saw guitars, pounding drums, and jackhammer bass remained intact, and Armstrong's vocal and lyrical concoctions left heads spinning. A movement had begun, one audiences would've been foolish to miss. The band's aspirations grew, and in 2004 Green Day released the rock opera *American Idiot* (which became the musical of the same name in 2009). Now a broad-based audience was paying attention, and alternative music followed the band in a tougher direction, a march that Green Day still proudly leads.

Mike Dirnt, Billie Joe Armstrong, and Tré Cool at Philips Arena, Atlanta, August 23, 2005
📷 **CHRIS MCKAY**

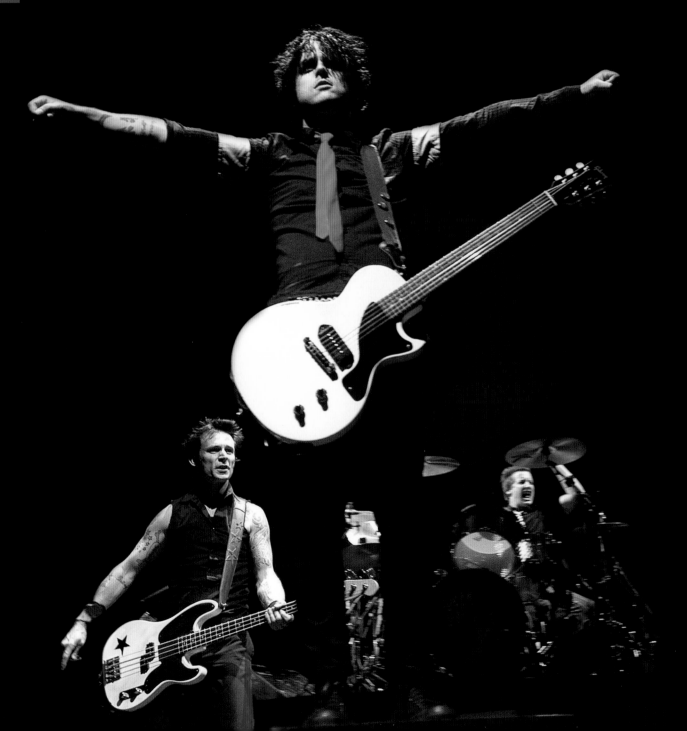

WILCO

Wilco's life story proves the truth of the old cliché that in every ending lies a new beginning. When Jay Farrar and Jeff Tweedy's seminal roots band Uncle Tupelo broke up in 1994, Tweedy (b. 1967) saw an opportunity to reshape his music. Previously, the singer-songwriter and multi-instrumentalist from Belleville, Illinois, had taken a back seat to bandleader Farrar, but he had been storing up songs. Along with the remainders of the Tupelo line-up—bassist John Stirratt (b. 1967), multi-instrumentalist Max Johnston (b. 1969), and drummer Ken Coomer (b. 1960)—Tweedy formed Wilco, whose 1995 debut, *A.M.*, caught the goodwill of the press. Sophomore effort and double album *Being There* (1996) conveyed the band's sweeping confidence in the growing Americana music movement, although Tweedy was shaping his group into an American band, not an Americana act. Their pop prize *Summerteeth* (1999) received enthusiastic notice, but the group's label, Warner Bros./Reprise, was in the middle of a shakeup. Wilco's forced departure and subsequent rebirth on affiliated imprint Nonesuch assured fame for 2001's *Yankee Hotel Foxtrot*. The album's modern sheen blended folk, pop, and progressive rock and paved the way for Wilco to become a Great American Band—as evidenced in the biopic *I Am Trying to Break Your Heart: A Film about Wilco* (2002) and the group's subsequent albums. Wilco's arc from second-fiddle spinoff to flagship trendsetters escaped no one. Tweedy gambled on himself and won, and in the process offered that same hope to anyone who picks up a guitar and writes a song. Adversity never sounded so good.

Top left: Jeff Tweedy, John Stirratt, and Pat Sansone. *Top right*: Nels Cline, Mikael Jorgensen, Tweedy, Glenn Kotche, and Stirratt. Both at Wolf Trap, Vienna, VA, July 8, 2009
📷 both **JIM SAAH**

Left: Jeff Tweedy at Mercury Lounge, New York City, December 1996
📷 **TED BARRON**

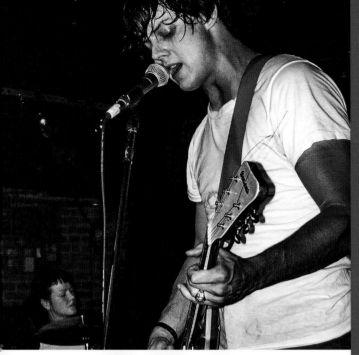

Jack White briefly considered attending seminary school and becoming a priest, but then he found out he couldn't take his guitar amplifier with him. Two decades of groundbreaking garage rock have followed. Born John Gillis in Detroit in 1975, the youngest of ten children first made his name in the White Stripes, the guitar/drums duo he helmed alongside his then-wife, Meg White. Other hard-bitten outfits, including the Raconteurs and the Dead Weather, followed, as did production dream jobs such as Loretta Lynn's *Van Lear Rose* (2004). White started his own label in 2001, opening Third Man Records & Studio (and record shop and books imprint) after he moved to Nashville. White, a proponent of minimalism, vinyl, and analog recording, seems on a mission to save the roots of rock and roll, as is evidenced by his guitar style, a Jimmy Page–meets–James Williamson slash 'n' burn. You'd never know he started out as a drummer in Goober & the Peas. Now on the board of the Library of Congress's National Recording Preservation Foundation, which saves all genres of music cylinders and vinyl records, White has

collected eleven Grammys to date, and his Third Man has joined Tidal, Jay-Z's digital streaming network. The one-man recording booth at White's Nashville headquarters, which allows instant gratification for those ready to sing and play, exemplifies the musician's DIY values and allows visitors to capture their music for posterity, much as Elvis Presley did in 1953 when he walked into Sun Records in Memphis to make a disc for his mother.

Left: Meg White and Jack White at Mercury Lounge, New York City, September 10, 2000
📷 **CHRISTOPHER POLINSKY**

Below left: Jack White and Lillie Mae Rische at the 26th Annual Bridge School Benefit Concert, Shoreline Amphitheatre, Mountain View, CA, October 21, 2012
📷 © **JAY BLAKESBERG**

Below: The White Stripes at the Cantos Music Foundation, Calgary, June 29, 2007
📷 **DARYL-ANNE THOMSON**

JACK WHITE

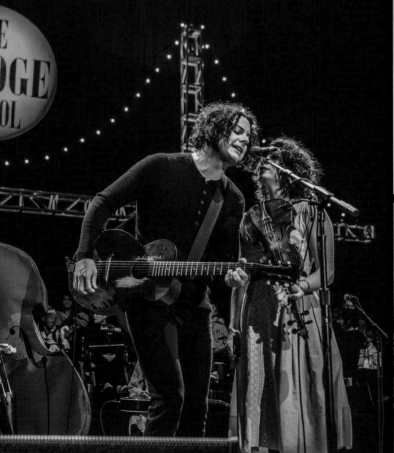

She sounded as though she had stabbed herself in the heart every time she took the stage. Amy Winehouse (1983–2011) never hid her pain; when she sang, all her emotions bled out. Like Billie Holiday, Dinah Washington, and Aretha Franklin, she dove headfirst into a sea of soul. Her parents divorced when the singer was nine, and after she bought a guitar at fourteen, music became her solace. Her jazz-flavored debut, *Frank* (2003), caused a stir in her native England, and as sales climbed and awards rolled in, Winehouse searched for something more. Her knocked-out contralto and distinctive looks now influenced by 1960s girl groups, she and super-producers Mark Ronson and Salaam Remi fashioned 2006's *Back to Black* as a blast from the past, with such honest and heartfelt vocals that it sometimes sounded like an open wound. Winehouse knew the back alleys of self-destruction, and her breakout "Rehab" belligerently rebuffed those hoping for a less rocky road for the artist. She owned the 2008 Grammy Awards, winning Record of the Year, Song of the Year, Best Female Pop Vocal Performance, Best Pop Vocal Album, and Best New Artist. The next years of touring, with the media following her every move, vacillated between hallelujah choruses and hellhounds on her trail. The dark side finally took her at twenty-seven, with the cause listed as "death by misadventure." Dead, but not gone.

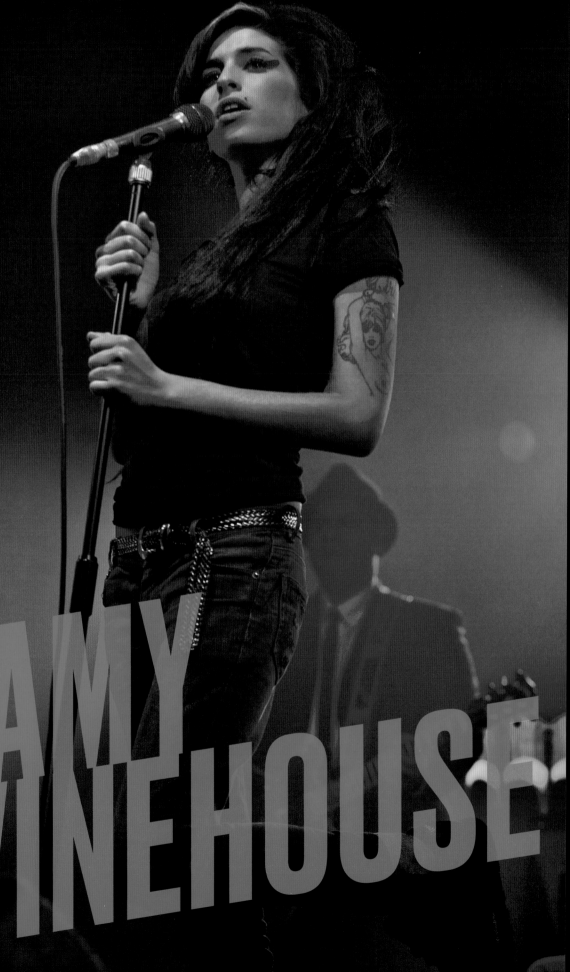

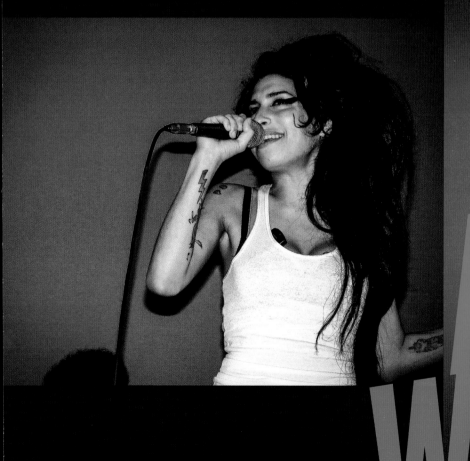

Right: Amy Winehouse at the Octagon Centre, Sheffield University, Sheffield, UK, March 3, 2007
📷 **GRENVILLE CHARLES**

Above: Winehouse at the Black Lily Festival, Philadelphia, May 6, 2007
📷 **VICTORIA FORD**

AMY WINEHOUSE

Adele

Some say Adele single-handedly keeps the record business afloat. From her 2008 debut through her winning of 2017's Album of the Year Grammy, her trio of albums, *19*, *21*, and *25*, named for the ages at which she created them, have affected global culture like comets. Together they recall a bygone era when powerhouse vocalists connected to audiences for life. And to think that she hadn't planned on a stage career. Born Adele Laurie Blue Adkins in London in 1988, she attended the BRIT School for Performing Arts & Technology with the goal of becoming a record label A&R director. Once she started to perform in public, however, things happened fast; after a friend posted a song from her three-track demo on MySpace, XL Recordings chief Richard Russell rang his contracts department. When "Chasing Pavements," the second single from her debut, became a global success, a star was born. The singer's ability to channel raging emotion on a song such as "Set Fire to the Rain" is astonishing. In a time when technological advances often produce results bearing little resemblance to the natural voice, Adele remains profoundly human, her singular soul expressions arising organically from her life. One Academy Award (for the James Bond theme "Skyfall") and fifteen Grammys later, she is still only getting started, gifted with a voice seemingly made to rule music.

Adele at the Staples Center, Los Angeles, August 5, 2016
📷 **STEVE ROSE**

ALABAMA SHAKES

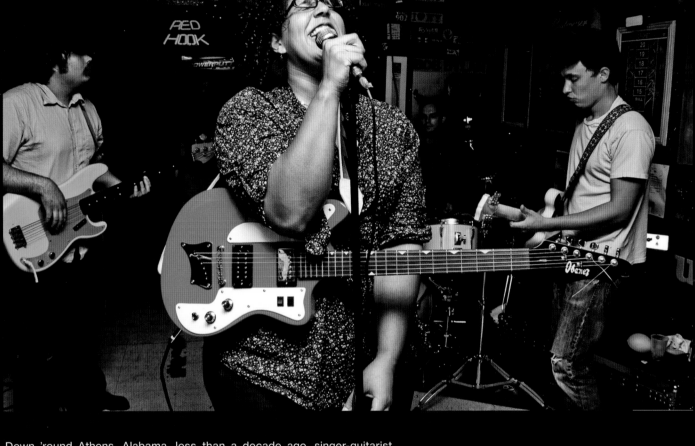

Down 'round Athens, Alabama, less than a decade ago, singer-guitarist Brittany Howard (b. 1988), guitarist Heath Fogg (b. 1984), bassist Zac Cockrell (b. 1988), and drummer Steve Johnson (b. 1985), then all still in school, would meet up after class and on weekends to jam. Gradually, the Shakes jelled into the Alabama Shakes, with Howard teaching herself piano, guitar, bass, drums, and lyrics. Once they had enough material, the band toured the Southeast. At first their sound was equal parts garage and swamp rock, mixed with primal wailings; as they've evolved their signature roots rock, there has never been any artifice about them, merely raunchy soul music and guitar. Soon Alabama Shakes recorded a self-named EP, offered it digitally, and voilà! They had management companies and record labels beating down their rehearsal room door within days. The band's full-length 2012 debut, *Boys & Girls*, grew white-hot with Grammy nominations and other hosannas. Through it all, the band hasn't bothered with overwrought arrangements or tricky dance steps. Instead Howard has planted herself squarely on terra firma and lets fly whatever comes out of her heart. Their follow-up, *Sound & Color* (2015), debuted at No. 1 on the *Billboard* Top 200 chart, a miraculous feat for an act so new, and the band's three Grammys—so far—have completed the Cinderella story.

Above: Zac Cockrell, Brittany Howard, Steve Johnson (drums), and Heath Fogg at Egan's Bar, Tuscaloosa, AL, July 10, 2010. *Right:* Howard at Egan's Bar, November 23, 2012
📷 both **DAVID A. SMITH**

ARTIST LIST

ACKNOWLEDGMENTS

SIXTY YEARS AGO, WHEN I WAS SIX AND FIRST HEARD ELVIS PRESLEY, I started down a path I didn't even know I was on. That's the way life happens. But rock and roll, and music of all kinds, seemed to be my guide. When I first learned that writing about it was allowed, I knew I was home. Now, through the gracious invitation of Smithsonian Books, I have a map of where I started and where I've gone. Hopefully it will make sense to others and capture the joy of my journey.

Thanks to Matt Litts for opening the door, inviting me into the Smithsonian world, and always believing in me. I will be forever grateful to the leadership of Carolyn Gleason. Christina Wiginton is as fine a book editor as anyone could hope for, and Jody Billert as fine an art director–designer. Jaime Schwender and Leah Enser always helped make everything come together, even when I got lost, and they continue to do so. Tess Pfeifle, in charge of new media strategies, is shining a fine light as well.

Susan Brisk took on the daunting task of photo research and became a five-star general, not only going through the thousands of photographs submitted to the Smithsonian website for consideration, but also going boldly into the professional photographic jungle in search of the unseen and unique. She knows that world as very few still do, and she loves and cares about music. There was no way to do that job justice without possessing both of these wonderful qualities.

Raoul Hernandez took my big mess of words and helped whip them into shape, as he's been doing for me for more than a quarter-century at the *Austin Chronicle*. Jonathan "Gatorman" Foose, no stranger to the wilds of rock and roll and so much else, delivered his always reliable guide skills to bring it home in the clutch, and he never fails to show me what a real best friend is. Writer Jimmy "No Breaks" McDonough has told me to write a book since we first met all those years ago at a Jimmy Scott show, and he never once let me off the hook. James BigBoy Medlin and Bob Merlis came through with permanent class.

In 1974, when the *Austin Sun* was born, Jeffrey Nightbyrd let me be a writer before I really was one; when someone believes in you, there is no finer gift. Jay Levin invited me to Los Angeles in 1980 to keep trying my writing hand at the *L.A. Weekly*. He's a brave man. Linda Forman and Pete Johnson, for reasons I'm still trying to fathom, had Warner Bros. Records give me an office and a typewriter in 1986, and I got to call 3300 Warner Blvd. in beautiful downtown Burbank, California, home for twenty years. That's what most of us there called the jackpot. Through it all, I kept thinking that I wanted to be a writer someday. I'm still trying.

Some of us find our true center later in life, often in ways that aren't obvious. When I first met Lou Reed in 1988 and we started working together, I knew I would learn a lot. Although he left us in 2013, I'm still learning from him. Thank you, Lou.

I began chasing music while growing up in Houston, and sometimes my decidedly dicey destinations put the big scare into my parents. But Mama and Daddy always backed my play. Life is a wild ride, and for so much of mine I've had the unbelievable gift of being part of a family that makes every day a surprise; Melissa, Chet, and Wyatt are my world, and this book—and everything else—is for them. May we all listen with our ears and eyes forever.

EXTENDED PHOTO CREDITS

15, 42 (left), 66 (left): **ALEC BYRNE / ÜBER ARCHIVES**

20 (lower left), 27 (lower left), 31 (top), 206: **CHRIS MCKAY / CONCERTSHOTS.COM**

21: © **PHOTOSHOT / UPPA / ZUMA PRESS**

22: © **GLOBE PHOTOS / ZUMA PRESS**

24: **MARY GERBER / *MINNEAPOLIS STAR TRIBUNE* / ZUMA PRESS**

32–33, 87 (left): **GERED MANKOWITZ © BOWSTIR LTD 2017 / MANKOWITZ.COM**

39 (left), 53 (top and bottom left): © **GUY WEBSTER / ÜBER ARCHIVES**

50: **LARRY C. MORRIS / *NEW YORK TIMES* / REDUX**

51: © **STEPHEN SHORE. COURTESY 303 GALLERY, NEW YORK AND ART + COMMERCE**

54–55, 65, 85 (main image, lower left, and lower right), 91 (left), 100, 110 (top left and lower left), 111, 120 (top), 128 (top), 130, 150 (top right), 159 (top), 162, 163 (top), 171 (top right), 181, 186 (upper right): © **BOB GRUEN / WWW.BOBGRUEN.COM**

56–57 (all): **DON HOGAN CHARLES / *NEW YORK TIMES* / REDUX**

80 (main image), 94, 106, 107 (top right), 108 (central images, lower left to top right), 114, 115 (top left), 134 (top left), 144 (main image), 161, 165 (both): © **JILL FURMANOVSKY–ROCKARCHIVE.COM**

101: **THE KEITH MORRIS ARCHIVE (WWW.KEITHMORRISPHOTO.CO.UK)**

117 (lower right): **STEVE EMBERTON / CAMERA PRESS / REDUX**

129 (bottom), 135 (middle right), 160 (top and lower left), 175, 178: **CHRIS DEUTSCH / FRONT ROW CONCERT PHOTOS**

133, 168 (top right): © **KESH SORENSEN / PHOTOSOLUTIONS**

134 (below): © **KEVIN C. GOFF / ÜBER ARCHIVES**

147 (lower left): **SCOTT SEGELBAUM / ROCK ART SHOW**

164 (all): **IAN TILTON / CAMERA PRESS / REDUX**

169 (all): **PAUL SLATTERY / CAMERA PRESS / REDUX**

176 (lower right): **CHIRULLI / CONTRASTO / REDUX**

180 (top): **ELIGIO PAONI / CONTRASTO / REDUX**

209: © **VICTORIA FORD / WWW.SNEAKSHOT.NET**

Title page photo:
Muzz Skillings and Corey Glover
of Living Colour, Foster Auditorium,
Tuscaloosa, AL, 1991
📷 © **KRISTEN FERNEKES**

TEXT © 2017 BY SMITHSONIAN INSTITUTION
All rights reserved. No part of this publication may be reproduced or
transmitted in any form or by any means, electronic or mechanical, including
photocopying, recording, or information storage or retrieval system, without
permission in writing from the publisher.

This book may be purchased for educational, business, or sales promotional
use. For information, please write: Special Markets Department, Smithsonian
Books, P. O. Box 37012, MRC 513, Washington, DC 20013

PUBLISHED BY:	Smithsonian Books
DIRECTOR:	Carolyn Gleason
CONCEPT DEVELOPMENT:	Mark Bauman
ACQUIRING EDITOR:	Matt Litts
CREATIVE DIRECTOR:	Jody Billert
SENIOR EDITOR:	Christina Wiginton
EDITOR:	Laura Harger
EDITORIAL ASSISTANT:	Jaime Schwender
ROCKANDROLL.SI.EDU:	Todd Stowell, Perrin Doniger, Leah Enser, and Tess Pfeifle
DESIGNED BY:	Smithsonian Books
TYPESET BY:	Caroline Gut
EDITED BY:	Raoul Hernandez
PHOTO RESEARCH BY:	Susan Brisk

Library of Congress Cataloging-in-Publication Data
NAMES: Bentley, Bill, 1950–author.
TITLE: Smithsonian rock and roll: live and unseen / Bill Bentley.
DESCRIPTION: Washington, DC: Smithsonian Books, [2017] | Includes index.
IDENTIFIERS: LCCN 2017017729 | ISBN 9781588346001 (hardcover)
SUBJECTS: LCSH: Rock musicians—Portraits. | Singers—Portraits.
CLASSIFICATION: LCC ML87 .S57 2017 | DDC 781.66092/2–dc23
LC record available at https://lccn.loc.gov/2017017729

Manufactured in China, not at government expense
21 20 19 18 17 5 4 3 2 1

For permission to reproduce illustrations appearing in this book, please
correspond directly with the owners of the works, as seen at the end of the
image captions and on p. 215. Smithsonian Books does not retain reproduction
rights for these images individually or maintain a file of addresses for sources.

781.6609
22
SMI

Smithsonian rock and roll.

JAN 1 0 2018